READING WOMEN

LITERARY FIGURES AND CULTURAL ICONS
FROM THE VICTORIAN AGE TO THE PRESENT

Literary and popular culture has often focused its attention on women readers, particularly since early Victorian times. In *Reading Women,* an esteemed group of new and established scholars provides a close study of the evolution of the woman reader by examining a wide range of nineteenth- and twentieth-century media, including Antebellum scientific treatises, Victorian paintings, and Oprah Winfrey's televised book club, as well as the writings of Charlotte Brontë, Harriet Beecher Stowe, and Zora Neale Hurston.

Attending especially to what, how, and why women read, *Reading Women* brings together a rich array of subjects that sheds light on the defining role the woman reader has played in the formation not only of literary history, but of British and American culture. The contributors break new ground by focusing on the impact representations of women readers have had on understandings of literacy and certain reading practices, the development of book and print culture, and the categorization of texts into high and low cultural forms.

(Studies in Book and Print Culture)

JANET BADIA is an associate professor in the Department of English at Marshall University.

JENNIFER PHEGLEY is an associate professor in the Department of English at the University of Missouri – Kansas City.

READING WOMEN

Literary Figures and Cultural Icons from the Victorian Age to the Present

Edited by Janet Badia and Jennifer Phegley

UNIVERSITY OF TORONTO PRESS
Toronto Buffalo London

© University of Toronto Press Incorporated 2005
Toronto Buffalo London
Printed in Canada

Reprinted in paperback 2006

ISBN 0-8020-8928-3 (cloth)
ISBN 0-8020-9487-2 (paper)

Printed on acid-free paper

Library and Archives Canada Cataloguing in Publication

Reading women : literary figures and cultural icons
from the Victorian age to the present / edited by Janet Badia
and Jennifer Phegley.

(Studies in book and print culture)
Includes bibliographical references.
ISBN 0-8020-8928-3 (bound). – ISBN 0-8020-9487-2 (pbk.)

1. Women in literature. 2. Reading in literature.
3. Women in art. 4. Reading in art. 5. American fiction –
Women authors – History and criticism. I. Badia, Janet
II. Phegley, Jennifer III. Series

PR830.A79R42 2005 813′.0093522 C2005-900954-3

University of Toronto Press acknowledges the financial assistance to its pub-
lishing program of the Canada Council for the Arts and the Ontario Arts
Council.

University of Toronto Press acknowledges the financial support for its pub-
lishing activities of the Government of Canada through the Book Publishing
Industry Development Program (BPIDP).

Contents

Illustrations

Acknowledgments

We are indebted to many friends and colleagues who have helped shape this collection. We would like to thank those who offered encouragement at the project's inception, including the Ohio State University English Department's First Draft Group, and those who have exchanged ideas with us at various conferences over the years. We are especially grateful to our friends who have kindly read and offered insightful feedback on portions of the manuscript, including Kim Banks, Kellie Bean, Beth Dolan, Laurie Ellinghausen, Jane Greer, Daniella Mallinick, Michael Pritchett, Sherri Smith, George Williams, Lara Vetter, Lachlan Whalen, and John Young. We also wish to thank Lorna Condit for her assistance with the proofs and our editor, Jill McConkey, at the University of Toronto Press for her patience, support, and enthusiasm.

We are grateful for the research awards and grants we received from Marshall University and the College of Arts and Sciences and the Department of English at the University of Missouri-Kansas City. Both universities supported us generously by granting the time and funds that allowed us to complete this project.

Finally, we would like to dedicate this collection to all the reading women in our lives who continually inspire our admiration for and interest in this subject.

Ruth Hoberman, '"A Thought in the Huge Bald Forehead": Depictions of Women in the British Museum Reading Room, 1857–1929,' first appeared in *Feminist Studies* 28:3 (Fall 2002), 489–512, and is used by permission of the publisher, *Feminist Studies*, Inc. Barbara Hochman, 'The Reading Habit and "The Yellow Wallpaper,"' first appeared in *American Literature* 74:1, 89–110. Copyright 2002, Duke University Press.

All rights reserved. Used by permission of the publisher. Jennifer Pheg-ley, '"I Should No More Think of Dictating ... What Kinds of Books She Should Read": Images of Women Readers in Victorian Family Literary Magazines,' first appeared in a different form in *Educating the Proper Woman Reader: Victorian Family Literary Magazines and the Cultural Health of the Nation*. Copyright 2004, Ohio State University Press. Used by per-mission of the publisher.

READING WOMEN

LITERARY FIGURES AND CULTURAL ICONS
FROM THE VICTORIAN AGE TO THE PRESENT

Introduction: Women Readers as Literary Figures and Cultural Icons

JENNIFER PHEGLEY AND JANET BADIA

The images in this magnificent book of postcards capture the tranquil sanctuary and sublime beauty of women deeply immersed in the pages of a book. Just as the reading woman submits to her imagination and becomes absorbed in a story, so does the viewer briefly leave her own life and enter that of the painting. There lie the boundless horizons of possibility, the opportunity for enlightenment, and the seductive retreat from the burdens of everyday life.

> – from Pomegranate's *The Reading Woman: A Book of Postcards*

She is absorbed, content, perhaps quietly thrilled. She may be stealing a moment from her daily routine to take comfort in a book. Or she could be searching its pages for a means to transform her life. The reading woman, as she is elegantly depicted in this calendar's superb paintings, is a beautiful enigma: she is herself an untold tale, a moment in time, set free of its long, complex story ... Just as the reading woman is lost in a story and separated from her life's narrative, so can the viewer briefly leave her own life and enter that of the painting.

> – from Pomegranate's *The Reading Woman: 2001 Calendar*

A painting of a woman reading – completely absorbed in the pages of anything from a loved novel to a fascinating documentary – tells its own story: the woman is peaceful, contented, or perhaps silently thrilled and awakened by the words on the page. Is she stealing a moment from her daily routine to indulge in the comfort of a book? Or, is she searching the pages studiously for answers to private questions? Is reading the vehicle by which she will change her life? Each of the beautiful paintings included in this

folio of notecards portrays the reading woman as admirable – perhaps even enviable in her enjoyment of the printed page.

– from Pomegranate's *The Reading Woman: Notecards*

If you're what the literary novelty company Bas Blue calls a 'modern bluestocking,' you may well recognize the text of our epigraphs. You may even own at least one of the products that make up Pomegranate's stationary line *The Reading Woman*, which includes not only the calendar, postcards, and note cards cited above but also a lavishly illustrated journal. Each of these products reproduces a series of paintings of women readers, primarily from the nineteenth and early twentieth centuries. Promoted in mail order catalogues like *Bas Blue* and often sold alongside other literary products, Pomegranate's line joins a larger trend within consumer culture to market images of women readers to educated, professional women. Taking this trend as a starting point, we open our collection of essays with an examination of Pomegranate's marketing of these images that emphasizes both the continued popularity of the figure of the woman reader throughout the past two centuries and the provocative rhetoric that often surrounds her. Our examination of Pomegranate's marketing of such images indicates that the woman reader is a multivalent symbol that, on the one hand, reflects nostalgia for an idealized past of middle-class leisure and clearly defined gender roles, and on the other hand, serves as an icon of early feminism and intellectual independence for professional women.

While Pomegranate is not the only recent distributor of images of reading women, we have chosen to focus on their series of products because we think that they raise many of the same issues about women and reading that preoccupy the contributors to our collection and thus serve as a fitting introduction to the essays that follow, each of which examines the visual and textual construction of women readers.[1] More specifically, we hope that our investigation of these products serves as a framework for thinking about what is perhaps the largest issue raised by the essays in this collection: why representations of women reading matter. That is, why are consumers so interested in images of women reading? What is it about the images that continues to hold our attention and compels women today, the two of us included, to shell out fifteen dollars for a few postcards that, because of email, are almost superfluous? More broadly, what do the images, their messages, and their consumption say about women readers, their reading practices, and the ways both have been

understood and valued culturally over the past two hundred years? How exactly did the figure of the woman reader become transformed from a subject represented in art and literature – and very often from the perspective of the male gaze – to an image venerated by women today?[2] Perhaps one cause of this veneration, and thus the desirability and circulation of her image, is the fact of her survival: often the object of society's and literary culture's fears, she has overcome their efforts at repression and containment, and importantly, with her book still in hand.

By analysing the appeal of Pomegranate's products, we can begin to explain how images of women readers function in our own lives. At the same time, Pomegranate's use of nineteenth- and early-twentieth-century images allows us to consider how these visual depictions of women reading may have been received in the past. Paying attention to both the contemporary and historical contexts for these images, then, provides us with the opportunity to trace the significance of the woman reader throughout the past two centuries and enriches our understanding of women readers as both literary figures and cultural icons. While Pomegranate markets these images today by focusing on their expression of qualities such as tranquility, retreat, and serenity, the original audiences for many of these images would likely have viewed them as somewhat subversive and dangerous. Moreover, when Pomegranate acknowledges the anxious undertones contained within these images it does so in order to empower women today, to join them with the supposedly rebellious women readers of the past. For example, in the introduction to *The Reading Woman* journal, Maxine Rose Schur describes the nineteenth-century woman reader as 'a new heroine in direct conflict with traditional conventions' (n.p.). This new heroine, seen as self-absorbed or overly intellectual, imperiled 'a world whose economy, government and culture were dominated by men.' Thus, this mysterious woman of the past is packaged as an inspiration to those who would buy the journal in order to allow their 'hearts to beat not only a little more quickly but also in rhythm with the hearts of others.'

Despite the competing views of women readers these images may offer different audiences, we hope to show that there is at least one important idea that remains constant from one period to the next. That is that the act of reading for women is often an assertion of individuality, a separation from societal restrictions and expectations, or to use Janice Radway's words, a 'declaration of independence' (7). While historicizing women as literary figures and cultural icons is crucial to understanding the nuances of reading at various times and places, attending to the

transhistorical links between women's reading and female subjectivity is also important to understanding how reading can be constructed as both a potentially rewarding and potentially dangerous act.

As our epigraphs illustrate, Pomegranate's rhetoric targets contemporary women by appealing to their apparently competing personal and professional responsibilities, and indeed to the sense of inner conflict that, according to the cultural script, has left today's working women nostalgic for the apparent leisure of the nineteenth and early twentieth centuries so often portrayed in their images. The idea of lost leisure is most apparent in Pomegranate's use of the phrases 'tranquil sanctuary' and 'seductive retreat,' which are evoked by what seem to be depictions of peaceful, content, and enlightened women of the past. In adopting language that idealizes the past in order to sell its reproduced image, Pomegranate participates in a commercialized longing for the nineteenth century that, as John Kucich and Dianne Sadoff argue, characterizes much of contemporary consumer culture. Kucich and Sadoff note, for example, that recent home decorating books and magazines hearken back to the Victorian period by teaching us 'how to load a mantel with curios and kitsch, people a wall with sepia-toned family photos, and choose for the drawing room a patterned wallpaper or chintz' and thus 'to aestheticize contemporary reality' (xii). Like the kitsch that may decorate our homes, Pomegranate's pleasing note cards and calendars aesthetically package not only the nineteenth century but also the act of leisurely reading. The result of their efforts is the romanticization of the very idea of the reading woman. The message Pomegranate sends to women today is that in the midst of the chaos of their working women's world, they too can become 'deeply immersed' and 'quietly thrilled' by 'the boundless horizons of possibility' that reading offers. Pomegranate thus packages a kind of intellectual retreat that invites women to discover themselves through reading as well as to transform their lived experience into art, or at least into journal entries or old-fashioned letters written to friends on note cards. In other words, viewing Pomegranate's images offers today's woman the opportunity to leave her own hectic life and enter an idealized past of bourgeois leisure defined by its opportunities for daily reading and – because the products are stationary, after all – daily writing.

This possibility of tranquil retreat is perhaps best exemplified in the image that opens Pomegranate's 2001 calendar and is featured in both the note cards and the book of postcards, Frederick Leighton's *The Maid*

with the Golden Hair (c. 1895). In this popular Pre-Raphaelite painting (fig. 0.1), the 'maid' epitomizes the escapism promised by Pomegranate: she is relaxed, seated comfortably in her nightdress, and completely absorbed in her book within a setting that is decidedly absent of all markers of everyday life. By featuring the woman against a dark background while simultaneously bathing her in warm light and golden tones, the image further heightens the feeling that the woman has a space of her own she's able to retreat to without interruption. In fact, many of Pomegranate's images emphasize this kind of aestheticized tranquility, including Winslow Homer's *The New Novel* (1877) and Henry Wilson Watrous's *Just a Couple of Girls* (1915), both included in the series of note cards. In these paintings the women readers languidly peruse their books while lying stretched out on a bed of grass or sitting comfortably on a chaise lounge covered by sumptuous pillows.

But if Pomegranate's images are any indication, the desire for tranquility is not the only thing that motivates the reading woman. Just as often, it would seem, she is as much in need of a space for intellectual inquiry and enrichment as she is a space for escape from her daily life, a possibility suggested in those images from Pomegranate's collection that feature women reading in libraries, including Sir William Rothenstein's *The Browning Readers* (1900) and Edouard Gelhay's *Elegant Women in a Library* (c. late 1800s). In the latter (fig. 0.2), two women are clearly engrossed in scholarly pursuits in what appears to be the family library. Whereas many of the company's images draw on reading as a simple pleasure, here the emphasis seems to be on excited intellectual inquiry and educational advancement, as the studious expression on the woman's face, the number of books, their size, and their scattered placement across the table together indicate. Still, while the aim of reading may be different here, the corollary is much the same: elevated and idealized by the very act of reading and its implication of leisure, the reading woman is, as Pomegranate puts it, 'admirable – even enviable in her enjoyment of the printed page.'

When considered alongside the company's promotional rhetoric, then, Gelhay's *Elegant Women in a Library* and Leighton's *The Maid with the Golden Hair* together suggest that Pomegranate hopes to appeal to contemporary women by selling products that facilitate both retreat and enrichment. Just like the women in the images who are lost in books, the woman purchasing *The Reading Woman* products now has an intellectual space of her own, whether note card or journal, in which to lose herself or, alternatively, discover or express her own thoughts. Also

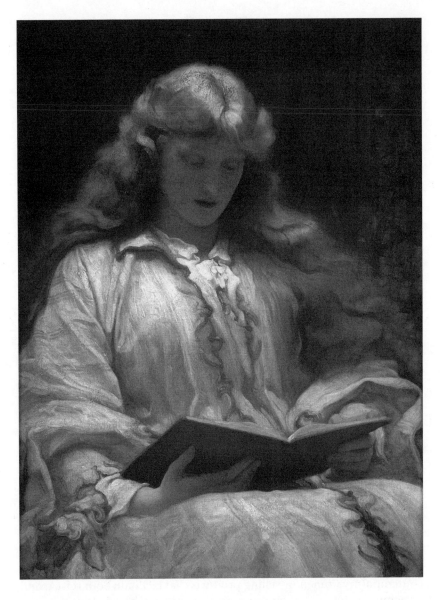

Fig. 0.1. *The Maid with the Golden Hair,* Frederick Leighton (c. 1895). Christie's Images, London, U.K./Bridgeman Art Library.

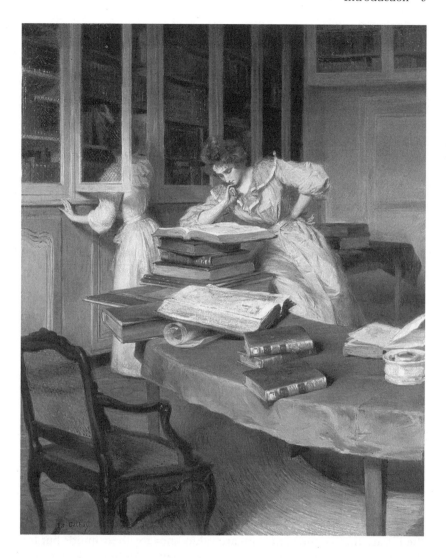

Fig. 0.2. *Elegant Women in a Library,* Edouard Gelhay (c. late 1800s). Waterhouse and Dodd, London, U.K./Bridgeman Art Library.

worth noting is that the images and their promotional text further imply that the acts of both viewing the images and using the products – writing letters to friends in the note cards or reflecting on one's day in a journal – connect today's woman to her literary foremothers and feminist forerunners, providing her in turn the opportunity to become her own reading (and writing) woman. A compelling sell, indeed, and a story many consumers, including us, have no doubt embraced.

However, this interpretation tells only one side of the reading woman's story, which, as the essays in this collection demonstrate, is complex, multivalent, and at times even contradictory. Pomegranate's promotional rhetoric suggests some of these historical complexities, though they may be less obvious to current audiences. While the packaging of *The Reading Woman* line constructs the act of reading for women as one of opportunity, enlightenment, and self-transformation, it also hints at the potential dangers of reading and the cultural anxieties those dangers have often produced. It does so in its reference to the woman reader as an 'enigma' who is not only 'silently thrilled and awakened' but also 'lost in a story and separated from her life's narrative.' Certainly, the depiction of the woman reader as 'lost' and 'separated' casts a cloud over the appearance of serenity offered in the images. Indeed, when one historicizes the images, the element of peril present in the paintings but only implied in Pomegranate's packaging becomes difficult to ignore.

In Leighton's *The Maid with the Golden Hair,* for example, the erotic display of the woman's loose hair and flowing nightgown, together with the darkness that envelops her, operates to undermine the peacefulness present on the surface of the image. Furthermore, the gaze of the male painter on the private act of reading places this self-absorbed woman in a vulnerable and sexualized position that is somewhat discomforting. Similarly, in Gelhay's *Elegant Women in a Library*, the suggestion of an idealized intellectual pursuit is diminished by the title itself: these women are first and foremost 'elegant' ladies who apparently do not belong in the library they occupy and who are valued not for their minds but for their representation of their family's class status. Additionally, the posture of the woman in the foreground, who leans rather awkwardly over the table instead of being comfortably seated, suggests her misplacement in the library, or at the very least her tentativeness in using the space in the first place. Read in this light, then, the strewn books, previously interpreted as a sign of the women's intellectual engagement, might just as well signal their hurriedness and fear of interruption. Such menacing

overtones would certainly have been apparent to nineteenth-century viewers given the negative discourse that surrounded women readers and saturated popular and literary culture at the time.

Further indicating the differences between past and present conceptions of women readers are the many Pomegranate images that depict women who are supposedly enjoying their reading experiences despite their uncomfortable and awkward reading positions: they are often sitting on the edges of seats, lying down, propped on elbows (with pillows to support them if they're lucky), strolling, or standing. For example, Frank Dicey's *The Novel* (c. late nineteenth century) features a woman awkwardly propped on her elbow as she lies on a blanket reading, while Lovis Corinth's *A Woman Reading Near a Goldfish Tank* (c. turn of the century) depicts a particularly uncomfortable looking woman perched on the very edge of her seat, apparently ready to run and attend to her duties whenever called. Similarly, the unattributed painting *Woman Reading in the Garden* (c. 1920) shows a woman lingering over a chair in the garden as she reads, while Edmund Blair Leighton's *Sweet Solitude* (1919) displays a woman who reads as she strolls through a garden. Insofar as all of these images feature women in the act of reading while walking, standing, or sitting precariously and, importantly, in places often outside the home, they surely suggest a conflict between women's desire to read and any number of competing demands, including the tentative and fleeting nature of the act of reading itself for women, their need to be elsewhere, and their lack of privacy within the home.

Indeed, Pomegranate's use of the phrase 'seductive retreat from the burdens of everyday life' implies the ways women's reading has been, and perhaps still is, believed to disrupt family life and the functions of society. In this way, Pomegranate certainly does capture the woman reader as a threatening figure. However, for contemporary audiences, this 'threat' can be construed as empowering for women who insist on taking time for themselves. What may have threatened the social order of the nineteenth century is recast in Pomegranate's packaging as an act of self-assertion. This is reinforced by Pomegranate's juxtaposition of the very nineteenth-century idea of reading as a 'seductive' retreat (one that might dangerously seduce the woman into antisocial behaviour or draw her away from proper conduct and responsibilities) against the contemporary concept of escaping the 'burdens of everyday life.' This juxtaposition allows us all to feel more comfortable, since the act of reading can now be understood as one that involves a needed escape from 'burdens' rather than a dangerous shirking of responsibilities.

We have selected the Victorian age as the starting point for *Reading Women* because it was during this period that the figure of the secular woman reader and discourses about her began to pervade Anglo-American mass culture. The importance of these discourses in the nineteenth century has been the subject of a number of recent studies, most notably Kate Flint's *The Woman Reader 1837–1914* (1993), Jacqueline Pearson's *Women's Reading in Britain, 1750–1835* (1999), and Catherine Golden's *Images of the Woman Reader in Victorian British and American Fiction* (2003).[3] As Pearson's study indicates, what is most surprising about the image of the woman reader just prior to the Victorian era is simply its 'ubiquity ... in discourses of all kinds – of gender and sexuality, education, economics, class, "race," social stability and revolution, science, history, and so on' (219–20). Furthermore, such preoccupations with the woman reader only increased as literacy rates rose and the publishing industry grew dramatically throughout the nineteenth century. As Flint argues, despite the widespread interest in images of women readers throughout history, 'it is difficult to reconstruct a coherent body of theory concerning women and reading before the eighteenth century, or even to observe the persistent recurrence of stereotypes. It is still harder to collect accounts by women of their reading experiences' (24). By the 1830s, this material is much more readily available. Indeed, the advent of mass production and mass readership transformed literate society and increased interest in reading practices. While much of the discourse surrounding reading addressed the reading practices of men and of working-class readers,[4] the vast majority of discussions and images focused on the effects of reading on middle-class women. Since middle-class women represented the well-being of the family and of the nation itself, their reading practices became the subject of great concern among writers, critics, and artists in both American and European contexts. Thus, the Victorian period marks the pinnacle of society's concern with women readers, who perhaps inevitably became objects not only of beauty and desire but of intense anxiety.

As one of the first scholars to examine women readers during this critical period, Kate Flint introduces the very terms by which our collection seeks to understand the figure of the woman reader. In the introduction to her book, she argues that '"woman as reader" is a fashionable topic in feminist criticism, but ... with a few notable exceptions, most of the current debate has either focused on the practice of women reading today, or has looked at the construction of the woman reader primarily as a textual phenomenon divorced from a fuller socio-

historical context' (16). In suggesting we consider the figure of the woman reader not simply for her reading practices but for her significance as a cultural phenomenon, Flint moves beyond reader-response approaches like Janice Radway's *Reading the Romance* (1984), Elizabeth Flynn and Patrocinio Schweickart's *Gender and Reading* (1986), and Sarah Mills's *Gendering the Reader* (1994), all of which focus on the ways readers respond to texts rather than on the ways readers are constructed within them at a particular historical moment. In its study of the figure of the woman reader, *Reading Women* similarly hopes to expand current theories of reader-response criticism and reading practices to include the rhetorical and visual construction of readers within their socio-historical contexts, and thus addresses the gap Flint identified in 1993. At the same time, our collection does what Flint's work does not: it traces the trajectory of the figure of the woman reader through two centuries and, in turn, examines the relationship between past and present literary and cultural preoccupations with women as readers. By doing so through a combination of essays that consider representations of women readers in both traditional and nontraditional, even surprising, contexts, *Reading Women* enriches current conversations about readers in history.

Thus, *Reading Women* is situated within the growing field of 'book history,' which encompasses the interdisciplinary study of the economics and technology of book production, marketing, and distribution as well as the socio-historical aspects of authorship, literacy, readership, and reading practices. The landmark works *The English Common Reader* by Richard Altick and *The Rise of the Novel* by Ian Watt – both published in 1957 – and a series of studies by Roger Chartier, William Charvat, Robert Darnton, Elizabeth Eisenstein, Carlo Ginzburg, and Natalie Zemon Davis established what by the late 1980s emerged as an official discipline accompanied by its own scholarly society, SHARP (the Society for the History of Authorship, Reading, and Publishing). The proliferation of university press series in book history, print culture studies, and readership studies further indicates the growing interest in the field. In response to all of this activity, several important collections have been published over the past decade or so, including Cathy Davidson's *Reading in America* (1989), James L. Machor's *Readers in History* (1993), James Raven, Helen Small, and Naomi Tadmor's *The Practice and Representation of Reading in England* (1996), Roger Chartier and Gugliemo Cavallo's *History of Reading in the West* (1999), and Barbara Ryan and Amy Thomas's *Reading Acts: Readers' Interactions with Literature, 1800–1950* (2002).

Exploring readers in American, British, and world history, these collections each seek to uncover the impact that actual reading practices and ideas about reading in society have had on the literature, culture, economics, and politics of the Western world. In doing so, they have effectively formed a cross-disciplinary field of study focused not only on 'the objects of reading' and 'the changing readerships' indicated by 'developments in the production and distribution of texts' (Raven, Small, & Tadmore 4), but also on the more nuanced relationships among readers and socio-historical contexts that James Machor describes as

> (1) the exploration of ... readers as members of historically specific – and historiographically specified – interpretive communities; and (2) the analysis of the way literary texts construct the reader's role through strategies necessitated and even produced by particular historical conditions. (xi)

Our collection seeks to continue the tradition set forth in these studies as it follows Flint's and Machor's calls for a more historicist literary analysis of reading. *Reading Women* heeds this call while also breaking new ground by focusing on the impact both written and visual representations of women readers have had on understandings of literacy and certain reading practices, the development of books and print culture, and the categorization of texts into high and low cultural forms. For, as Cathy Davidson points out in the introduction to her collection, 'Readers (both general and professional) play a crucial role as judges who, on some level, also help to determine what kinds of books will be published' (20). We would, of course, add to Davidson's formulation that public and professional perceptions of readers necessarily influence how books already published are further valued, marketed, and discussed within their historically situated contexts. We would also insist on the centrality of gender to that influence. After all, it is the image of the *woman* reader one encounters again and again in the consumer culture we discuss at the start of this introduction. It is also the image of the woman reader that seems to incite the greatest degree of anxiety and unease in literary culture. Thus, while critical attention within book history and print culture studies has focused on readers, we would argue that ideas about women readers have shaped literary and popular culture to a greater degree than past and current trends within literary studies suggest. The essays in this collection, then, focus on specific representations of women readers, their evolution over the past two centuries, and their cultural currency today in order to demonstrate the

critically important role such representations have played in defining literacy, literature, and even women's roles within society over the past two hundred years.

Bringing together a rich array of subjects, the essays included look at representations of women readers in a wide range of media, from ante-bellum American book reviews, letters, and scientific treatises; to Victorian magazines, novels, and paintings; to turn-of-the-century cartoons, library plans, and accounts of women's reading clubs; to twentieth-century reception histories, autobiographies, films, and television shows. In the process, they provide a close study of the evolution of the figure of the woman reader from 1837 to the present day, and shed light on the defining role she has played in the formation not only of literary history but of Anglo-American culture. Indeed, the essays collectively argue that women readers – and our assumptions about them – have been instru-mental in the development of literary aesthetics, gender roles, and the very foundations of our current cultural and literary establishments.

We have arranged the essays in this collection chronologically both to emphasize the continuities as well as the changes in images of women readers over time and to avoid reducing these rich, multilayered essays to any specific heading or catch-phrase. However, it is clear that the essays resonate with common themes, including the ones we have addressed in our analysis of Pomegranate's images of women readers: the perceived dangers of women's uncritical and unregulated reading practices; the fear of the effects of reading on women's bodies; the plea-surable escape from everyday life and the personal – and even social – transformation that reading provides; and the intellectual empower-ment and progress that reading enables. Departing from the book's chronological order, we would like to introduce each essay by highlight-ing these common themes and suggesting possible avenues of inquiry that connect the diverse approaches presented in *Reading Women*.

The regulation of the content and practice of women's reading is an important and prevalent theme in both the nineteenth and twentieth centuries. The characterization of women's reading as inherently dan-gerous, as we show in our reading of Pomegranate's products, is often a subtle and even insidious subtext of many images of women readers. Several essays in this collection address this concern, including those by Janet Badia, Michele Crescenzo, and Barbara Hochman. Badia's '"One of Those People Like Anne Sexton or Sylvia Plath": The Pathologized Woman Reader in Literary and Popular Culture' assesses the apparent threat women's reading sometimes poses to literary culture, as well as to

society more generally. Focusing specifically on a recent film image of a young woman reading Plath's work, Badia traces what she identifies as the figure of the Plath-Sexton reader within literary and popular culture. Of particular interest to her is the way both establishments have pathologized the Plath-Sexton reader, turning her into a woman whose reading practices are defined symptomatically, which is to say, as either a sign of her illness or a potential cause of it. To demonstrate this, Badia juxtaposes her discussion of the pathologized reader within popular culture with an examination of several key moments in the reception of Plath's and Sexton's work in which critics, while ostensibly evaluating the poets' work, reveal a troubling preoccupation with women readers and their perceived subliterary reading practices. In fact, Badia's examination demonstrates that the Plath-Sexton reader has from the early reception of both poets' work been largely gendered female, diagnosed as sick and depressed, and assessed as an uncritical consumer of bad literature. Underscoring the significance of this particular construction of women readers, Badia concludes her essay with an examination of the larger cultural anxieties about the relationship between women's intellects and their pathologies that are clearly embedded in the image of the Plath-Sexton reader.

While Badia's essay challenges unfounded concerns over women's reading, Michele Crescenzo's 'Poor Lutie's Almanac: Reading and Social Critique in Ann Petry's *The Street*' explores women's mis-reading and how it can in fact be dangerous to women's personal identities. Lutie Johnson, the protagonist of Petry's 1946 novel, is a single mother and a working-class black woman living in 1940s Harlem, yet she insists that 'if Ben Franklin could live on a little bit of money and could prosper, then so could she' (64). Through her examination of Lutie as an uncritical and naïve reader, Crescenzo argues that Petry's novel suggests ways in which literacy simultaneously functions as liberation and limitation for black women. As a reader, Lutie contends with literal narratives of the 'American dream,' including Benjamin Franklin's autobiography, as well as the texts of subway advertising and her wealthy white employer's 'country living' magazines. The novel contrasts these print media with traditional African-American ways of knowing – folk wisdom, oral culture, and root medicine – all of which Lutie rejects. Whereas previous criticism on *The Street* emphasized its protagonist's misplaced reliance on the myth of the American dream, Crescenzo takes this analysis further by analysing how Petry uses reading as social critique, revealing the limitations of literature for realizing black female subjectivity.

Just as Crescenzo's essay shows authorial concern for women's uncritical reading practices, Barbara Hochman's essay 'The Reading Habit and "The Yellow Wallpaper"' focuses on Charlotte Perkins Gilman's fears about women's reading. As Hochman demonstrates, Gilman's story provides a powerful image of a reader who is temporarily exhilarated but ultimately destroyed by her absorption in a mesmerizing text and thus conveys culturally typical anxieties about certain kinds of fiction reading, especially the practice of reading for escape. Underscoring the significance of reading in the story, Hochman further argues that the figure of the narrator in 'The Yellow Wallpaper' reflects Gilman's own intensely conflicted relationship to reading, including her inability to read at all during the period of emotional upheaval on which the story is based. This recognition of the story's self-reflexive concern with the dynamics of reading elucidates not only Gilman's own reading practices but also her effort to shape reader response. In fact, by dramatizing the social as well as the psychic consequences of the narrator's 'reading habit' Gilman encourages her own readers, in contrast to the reader in the story, to approach 'The Yellow Wallpaper' in a more critical or intellectual mode – in other words, to regulate their own reading.

Expanding this discussion of the perceived and sometimes real dangers of women's reading, Suzanne Ashworth, Antonia Losano, and Ruth Hoberman each explore the fear of women's bodies often evident in representations of women readers. Ashworth's 'Reading Mind, Reading Body: Augusta Jane Evans's *Beulah* and the Physiology of Reading' shows how *Beulah* dramatizes women's reading graphically and deliberately, illuminating the relationship between the reading body, the textual body, and gender. Indeed, Ashworth illustrates how *Beulah* urges us to think about gendered reading as an interpretive operation that is firmly grounded in the body; she argues that Beulah's embodied reading subjectivity is shaped by historical discourses that make sense of the body, specifically by sociomedical conceptions of the relationship between mind and body, self and sex. To demonstrate this, she turns to best-selling domestic medical manuals, as well as treatises on the science of physiognomy and passion theory, that posit a relationship between reading mind and reading body. Ashworth shows how these texts shed light on Beulah as the psychosomatic reading subject that mainstream medical discourses created. *Beulah* teaches us that because reading brings a psychosomatic body into play – because it sculpts the subject from the outside in, and the inside out – it is a prime vehicle of gender formation within both authoritative and popular discourses.

Looking at the importance of women readers' bodies in visual and literary texts, Antonia Losano's 'Reading Women/Reading Pictures: Textual and Visual Reading in Charlotte Brontë's Fiction and Nineteenth-Century Painting' shows how women's privately and domestically embodied reading practices become less threatening when compared to women's publicly and critically embodied art-viewing practices. Specifically, Losano contrasts acts of reading texts with acts of reading images by exploring nineteenth-century representations of women readers and women art viewers in paintings and novels. Based on her analysis of paintings of women reading books and paintings of women viewing art, Losano argues that women readers are embodied as physically passive figures who unthreateningly fade into the background, while women art viewers are represented as bodies that are more dangerously active, public, and on display. Pairing this visual imagery with textual imagery found in Charlotte Brontë's novels *Jane Eyre* and *Villette,* Losano contends that nineteenth-century anxieties about women readers were significantly compounded when languid private reading was transformed into bold public viewing.

Continuing Losano's treatment of women in public domains, Ruth Hoberman's '"A Thought in the Huge Bald Forehead": Depictions of Women in the British Museum Reading Room, 1857–1929' explores a variety of reactions to women's reading bodies in one of the most intellectual public spaces in London. During the late nineteenth century, as women intent on careers in literature, journalism, and social activism flocked to the British Museum Reading Room, fictional and journalistic images of women reading in the room became part of an ongoing debate about the relation of women to the public sphere. Hoberman's examination of these images reveals that while women readers were initially depicted as comfortable if unobtrusive participants in the culture of the domed Reading Room from its opening in 1857, they became increasingly disruptive in late-nineteenth-century representations as conflict over their presence in public life intensified. To emphasize the significance of this shift in attitude towards women readers, Hoberman also looks at the ways women writers such as Virginia Woolf and Dorothy Richardson responded to the 1907 redecoration of the room, which placed the names of male writers around the dome's moulding and did away with ladies' seating. Hoberman argues that these women writers rejected the space altogether, preferring rooms of their own to participation in a public sphere that defined them – in Virginia Woolf's famous words – as only 'a thought in the huge bald forehead.'

In contrast to those essays that emphasize the fears and dangers generated by women's reading, Elizabeth Fekete Trubey, Sarah Wadsworth, and Mary Lamb each examine reading's potential for women's personal transformation and social activism, commenting on the continuities and tensions between the two modes of change. Trubey's '"Success Is Sympathy": *Uncle Tom's Cabin* and the Woman Reader' provides a close study of scenes of reading within Harriet Beecher Stowe's *Uncle Tom's Cabin*, as well as first- and second-hand accounts of Northern and Southern women's responses to the novel. In analysing both fictional constructions of reading and actual readers' responses, Trubey complicates romanticized notions of the nineteenth-century woman reader and the cultural work performed by sentimental reading. She argues that the hope Stowe articulates in the novel and elsewhere for the mobilization of an army of feeling women remained unfulfilled. As the responses Trubey examines in the essay show, sympathetic women did not engage in the political sphere as Stowe had hoped. In fact, Trubey's analysis reveals that beneath this lack of public action lay a self-perpetuating, *private* pleasure that countered nineteenth-century ideals of the woman reader. This pleasure was expressed in both bodily sensations and domestic practice and indicates, contrary to popular assumptions, that sentimental reading was not solely a means of conveying a true womanly ideal. In showing that women sought to recreate the joys of reading as often as possible, Trubey suggests that readerly pleasure, decried by Victorian moralists, was central to nineteenth-century women's experiences with literature.

Sarah Wadsworth's 'Social Reading, Social Work, and the Social Function of Literacy in Louisa May Alcott's "May Flowers"' examines similar tensions between the desire to occupy one's time pleasurably and the desire to do good works. One of Louisa May Alcott's last stories, 'May Flowers' reflects the author's lifelong commitment to social reform as well as her conviction that the act of reading fundamentally informs and shapes the moral character of the individual. Wadsworth argues that Alcott uses a series of vignettes focusing on the activities of a young ladies' book club both to illustrate how the social functions of reading transcend the homely middle-class sociability of the sewing circle and to provide an intellectual context for reform as well as a means for crossing boundaries of gender, class, and ethnicity. At the same time, she maintains that the story continually reminds readers of the differentials in culture and privilege that reinforce those boundaries. Building on historical research into nineteenth-century women's reading clubs, as well

as current theories of literacy and cultural consumption, Wadsworth's essay interrogates the problematic relationship between social reading and social work in Alcott's narrative.

Taking up similar issues in the present day, Mary Lamb's 'The "Talking Life" of Books: Women Readers in Oprah's Book Club' analyses the rhetoric of women's reading espoused by Oprah Winfrey's televised book club. Lamb argues that Winfrey's performance advocates a reading practice consonant with a mediated, apolitical version of consciousness raising, a practice that encourages women readers to read for personal adjustment to social ills. Accordingly, Lamb argues that Winfrey's notion of women readers perpetuates women's responsibilities for adapting to social strictures in the form of a mediated 'pro-woman' line that reflects some feminist discourses but offers little progressive feminism. Recognizing this limitation of Winfrey's project, Lamb nevertheless demonstrates that the televised book club makes a cultural space accessible for women readers that fosters the realization of the power of narrative to work through complicated social issues, even as it only simulates the barest outline of such work.

Focusing not on the strictures of women's reading but on its possibilities, Jennifer Phegley and Tuire Valkeakari analyse women's attempts at intellectual development through reading and the concomitant difficulties of achieving intellectual goals in the face of public resistance. Phegley's '"I Should No More Think of Dictating ... What Kinds of Books She Should Read": Images of Women Readers in Victorian Family Literary Magazines' examines how family literary magazines worked towards establishing an intellectual culture of women's reading in the nineteenth century. In *Belgravia Magazine,* Mary Elizabeth Braddon combated the portrayal of improper reading as a particularly female malady and attempted to reshape the discourse of disease surrounding women readers by authorizing women to make their own critical judgments about what and how to read. Phegley argues that Braddon revolutionized the typical critical conception of women readers as dangerous and corruptible by comparing the illustrations and discussions of women readers in her periodical to those contained in another popular middle-class literary magazine, William Thackeray's the *Cornhill.* Like *Belgravia,* the *Cornhill* was optimistic about the intellectual ability of women readers. However, in contrast to *Belgravia*'s images of solitary women who read for their own enjoyment and edification, the *Cornhill* consistently depicted women's reading as beneficial to their families. Phegley concludes that while both magazines encouraged women's intellectual

development, only in the pages of *Belgravia* were women explicitly shown how pleasurable and empowering reading could be if they could make their own choices and develop their own active reading skills that were not reliant on the regulation of the men or the critics around them.

While Phegley focuses on the intellectual development of nineteenth-century readers of periodicals, Tuire Valkeakari turns to the twentieth century to look at one African-American woman writer's intellectual development through reading primarily white, male canonical texts. Valkeakari's '"Luxuriat[ing] in Milton's Syllables": Writer as Reader in Zora Neale Hurston's *Dust Tracks on a Road*' challenges the assumption that Hurston dedicated only one chapter of her 1942 autobiography to her literary career, and argues that the narrative of Hurston's professional identity permeates a larger body of the work than previous criticism has acknowledged. To demonstrate this, Valkeakari examines Hurston's self-portrait as a reader, focusing particularly on the autobiography's construction of the young Zora as an avid reader, as well as a learner of oral tradition. She finds that while Hurston's discussion of Zora's early reading refrains from pitting the oral and the written against each other, it entails another polarization: the literary tradition that she explores is solely white, whereas her representation of black culture largely freezes African American-ness at the stage of the oral, folksy, and rural, suggesting that for Hurston and her contemporaries the African-American canon did not yet exist as an established concept or an unequivocally desirable literary affiliation. That Hurston remains largely silent about her familiarity with African-American literary tradition indicates, Valkeakari argues, that her relationship with it was deeply troubled by the ambiguity accompanying the label 'marginal.'

From Losano's treatment of women readers in nineteenth-century paintings to Lamb's work on contemporary readers in Oprah's book club, the essays in our collection demonstrate that the line between nineteenth-century and today's women readers is not at all a straight one. By arranging the essays in chronological order while also drawing connections between them here, we hope to show the circularity of the history of women readers – the way it defies a clear trajectory even as it seems to move along an axis of similar concerns about what, how, and why women read. Given this strange pattern of development, it is perhaps fitting that Kate Flint, whose work has so clearly inspired and shaped the essays featured in *Reading Women* and in many cases served as their starting point, should have the final word in the collection. Along

with assessing the significance of the collection, Flint provides a narra-
tive of her own history as a reading woman and points to remaining
work to be done in the field.

And there is certainly a lot of work to be done, especially in terms of
understanding the diversity of women readers. Several essays in our
collection, including those by Trubey, Wadsworth, Valkeakari, and
Crescenzo, begin this work insofar as they directly take up issues of race
and class as part of their investigations. Still, we recognize that the essays
in *Reading Women* focus on implicit constructions of mostly white, mostly
middle-class women. In this way, the essays included here reflect the
visual images being marketed today. What Pomegranate's collection of
images does, in fact, is make clear that the general image of the reading
woman is one very much inflected by white, middle-class ideology.
Among all the images packaged by Pomegranate, only one stands out as
an exception, William McGregor Paxton's *The House Maid* (1910), which
depicts a young woman stealthily breaking away from her dusting duties
to read a book (fig. 0.3). In its depiction of a white working-class woman,
the painting clearly disrupts the middle-class narrative that emerges
from the other works, yet it also conveys many of the same idealized
aspects of reading for women. As Pomegranate might put it, the house
maid is absorbed in her reading, having stolen a moment from her daily
routine, perhaps to search the book's pages for a means to transform her
life. At the same time, the fact that she is still holding her feather duster
under her arm and is merely paused over the table she is dusting sug-
gests that her reading experience is a fleeting one. Furthermore, the title
of the painting makes clear that she cannot transcend her class position,
despite her access to books: unlike the women in the other images who
are often identified as 'reading women' in the titles, this woman is 'the
house maid,' plain and simple. That her image is also juxtaposed with
the Asian art of her bourgeois employer further serves to put her in her
social and economic place and to emphasize her position as an object of
the painter's gaze rather than as a reading subject. Contrary to Pome-
granate's claim, then, this working-class woman cannot be separated
from her life's narrative, even at the moment of reading.

While an isolated instance, the image of *The House Maid* hopefully
suggests ways of broadening our understanding of women readers and
of thinking about their diverse history. Very recent studies, like Eliza-
beth McHenry's aptly titled work *Forgotten Readers: Recovering the Lost His-
tory of African American Literary Societies* (2002) and Jonathon Rose's *The
Intellectual Life of the British Working Classes* (2001), already show signs of a

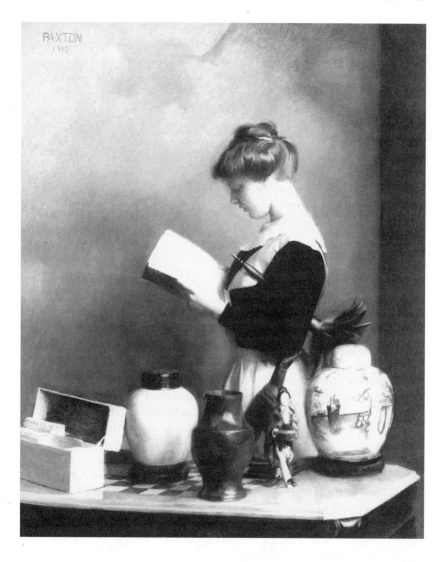

Fig. 0.3. *The House Maid*, William McGregor Paxton (1910). Corcoran Gallery of Art, Washington, D.C. Museum Purchase, Gallery Fund.

new interest in those readers who have been left out of the popular image. Yet if the submissions we received in response to the call for this collection are any indication, the study of women readers is still primarily the study of a narrow selection of readers. The gap alone says much, we think, about how far the subject of women readers as a site of serious investigation within literary and cultural studies has come, even as it reveals how far it has to go in terms of recognizing the diversity of readers. And of course, since our collection begins with 1837, it also leaves considerable room for additional inquiry not only into issues of race and class but into prior historical periods. In any case, we hope that the essays in this collection will provide a foundation for future scholarship that addresses the diversity of visual and literary representations of women readers that is undoubtedly out there, waiting to be recovered.

NOTES

1 The essays in this collection focus primarily on British and American representations of women readers, though some of the paintings we discuss are from continental European countries. Images of women readers from these nations are relevant to our study because they emerged from and contributed to similar discourses surrounding women readers and are marketed as part of Pomegranate's coherent vision of the woman reader today.
2 Not surprisingly perhaps, the images recirculated in Pomegranate's collection are largely portraits by male artists. While the issue of the male gaze is outside the scope of this introduction, it certainly represents an important line of inquiry for future scholarship about representations of women readers.
3 For discussion of women readers before 1837, see Erler, Michaelson, McManus, Taylor and Smith, and Thomas. As well, a conference entitled 'The Emergence of the Female Reader, 1500–1800,' organized by Heidi Hackel and held at Oregon State University on 18 May 2001, featured papers by Margaret Ferguson, Mary Kelley, Catherine Kelly, Janice Knight, Mary Ellen Lamb, Janice Radway, and Eve Sanders.
4 See Rose, and Thompson.

WORKS CITED

Altick, Richard. *The English Common Reader.* Chicago: U of Chicago P, 1957.

Chartier, Roger, and Gugliemo Cavallo. *History of Reading in the West.* Trans. Lydia G. Cochrane. Amherst: U of Massachusetts P, 1999.

Davidson, Cathy N., ed. *Reading in America.* Baltimore: Johns Hopkins UP, 1989.

Erler, Mary Carpenter. *Women, Reading, and Piety in Late Medieval England.* Cambridge: Cambridge UP, 2002.

Flint, Kate. *The Woman Reader 1837–1914.* Oxford: Clarendon P, 1993.

Flynn, Elizabeth, and Patrocinio Schweickart. *Gender and Reading: Essays on Readers, Texts, and Contexts.* Baltimore: Johns Hopkins UP, 1986.

Gelhay, Edouard. *Elegant Women in a Library.* c. late 1800s. Bridgeman Art Library, London.

Golden, Catherine. *Images of the Woman Reader in Victorian British and American Fictions.* Gainesville: U of Florida P, 2003.

Kucich, John, and Dianne Sadoff, eds. *Victorian Afterlife: Postmodern Culture Rewrites the Nineteenth Century.* Minneapolis: U of Minnesota P, 2000.

Leighton, Frederick. *The Maid with the Golden Hair.* c. 1895. Bridgeman Art Library, London.

Machor, James L., ed. *Readers in History.* Baltimore: Johns Hopkins UP, 1993.

McHenry, Elizabeth. *Forgotten Readers: Recovering the Lost History of African American Literary Societies.* Durham: Duke UP, 2002.

McManus, Caroline. *Spenser's Faerie Queene and the Reading of Women.* Newark: U of Delaware P/London: Associated UP, 2002.

Michaelson, Patricia Howell. *Speaking Volumes: Women, Reading, and Speech in the Age of Austen.* Stanford: Stanford UP, 2002.

Mills, Sarah. *Gendering the Reader.* New York and London: Harvester Wheatsheaf P, 1994.

Paxton, William McGregor. *The House Maid.* 1910. Corcoran Gallery of Art, Washington, DC.

Pearson, Jacqueline. *Women's Reading in Britain, 1750–1835.* Cambridge: Cambridge UP, 1999.

Radway, Janice. *Reading the Romance: Women, Patriarchy, and Popular Literature.* Chapel Hill: U of North Carolina P, 1984.

Raven, James, Helen Small, and Naomi Tadmor, eds. *The Practice and Representation of Reading in England.* Cambridge: Cambridge UP, 1996.

The Reading Woman: A Book of Postcards. Rohnert Park, CA: Pomegranate Communications, n.d.

The Reading Woman: Notecards. Rohnert Park, CA: Pomegranate Communications, n.d.

The Reading Woman: 2001 Calendar. Rohnert Park, CA: Pomegranate Communications, 2001.

Rose, Jonathan. *The Intellectual Life of the British Working Classes.* New Haven: Yale UP, 2001.

Ryan, Barbara, and Amy M. Thomas. *Reading Acts: U.S. Readers' Interactions with Literature, 1800–1950.* Knoxville: U of Tennessee P, 2002.

Schur, Maxine Rose, ed. *The Reading Woman: A Journal.* San Francisco: Pomegranate Artbooks, 1991.

Taylor, Jane H.M., and Lesley Smith, eds. *Women and the Book: Assessing the Visual Evidence.* Toronto: U of Toronto P, 1996.

Thomas, Claudia. *Alexander Pope and His Eighteenth-Century Women Readers.* Carbondale: Southern Illinois UP, 1994.

Thompson, E.P. *The Making of the British Working Classes.* New York: Vintage, 1963.

Watt, Ian. *The Rise of the Novel.* Berkeley: U of California P, 1957.

1 Reading Women/Reading Pictures: Textual and Visual Reading in Charlotte Brontë's Fiction and Nineteenth-Century Painting

ANTONIA LOSANO

Reading Pictures

When the young Jane Eyre takes her seat in the curtained alcove in the opening pages of Brontë's novel, she brings with her a book to read. But as Jane says herself, she takes care that the book should be one 'stored with pictures.' Jane, famously, proceeds to 'read' the pictures of birds in Bewick's *The History of British Birds*. Pictures in *Jane Eyre* are never simply viewed; they are also read, mined for narrative potential while their visual qualities remain largely forgotten. Visual 'reading' offers Jane food for creative imagination; she writes of one Bewick image, 'The two ships becalmed on a torpid sea I believed to be marine phantoms ... *Each picture told a story,* mysterious often to my undeveloped understanding and imperfect feelings, yet ever profoundly interesting: as interesting as the tales Bessie sometimes narrated on winter evenings, when she chanced to be in good humour' (6, italics mine). Visual images in Bewick tell stories as interesting as verbal narratives told by Bessie, which are taken, Jane later realizes, from literary texts by Samuel Richardson and John Wesley.

Yet while Jane insists that 'the letterpress thereof I cared little for,' written text is not entirely uninteresting to her: she confesses that 'there were certain introductory pages that, child as I was, I could not pass quite as a blank' (6). As Jane examines Bewick, 'The words in these introductory pages *connected themselves with* the succeeding vignettes,' she explains (5, italics mine). Jane translates the verbal text into visual images: 'Of these death-white realms I formed an idea of my own: shadowy, like all the half-comprehended notions that float dim through children's brains' (6). In the introductory pages of the novel, then, Jane

shifts the meaning of the term 'read' to include the visual perception of images as well as the interpretation of text.

Jane's collapse of – or rather her desire to simultaneously perform – reading and viewing is modelled on Brontë's own textual practice. Brontë's style has often been characterized by critics as radically pictorial; George Henry Lewes, in his review of *Jane Eyre* in *Fraser's Magazine*, was but the first of many critics to note the strong visual elements of Brontë's novel. More recently, Lawrence Starzyk argued for 'the centrality of the pictorial in the development of [Jane's] world view' (289), and Christine Alexander, in her productive research into Brontë's early artistic endeavours, found sources for Brontë's 'fondness for the vignette, her method of analyzing a scene as if it were a painting, and her tendency to structure the novel as if it were a portfolio of paintings' (Alexander and Sellars 56). Brontë presents her own painting of sorts in the opening scene of the novel. While Jane is 'shrined in double retirement' with her book, Jane also views the outside landscape. In fact, her enclosure makes possible the framing and aestheticizing of the landscape: 'Folds of scarlet drapery shut in my view to the right hand; to the left were the clear panes of glass, protecting, but not separating me from the drear November day. At intervals, while turning over the leaves of my book, I studied the aspect of that winter afternoon' (5). Jane neatly frames the visible world with scarlet drapes (classically artistic) on one hand and glass on the other. Simultaneously, of course, the reader of *Jane Eyre* is looking at Jane as if she is within a frame (bound by curtains and windows); the picture Brontë verbally represents here is precisely a picture.

G.H. Lewes describes Brontë's methods in a very pictorial manner himself when in his *Fraser's* review he praises the novel's ability to *paint* reality, to represent what he calls 'the material aspect of things':

> We have spoken of the reality stamped upon almost every part; and that reality is not confined to the characters and incidents, but is also striking in the descriptions of the various aspects of Nature, and of the houses, rooms, and furniture. The pictures stand out distinctly before you: they *are* pictures, and not mere bits of 'fine writing.' The writer is evidently painting by words a picture that she has in her mind. (23)

But Brontë is not simply using the pictorial mode as she writes; she is, rather, submitting visual images to the faculty of 'reading,' suggesting that viewing and reading are similar modes of aesthetic perception. She

writes to Lewes, 'Then, too, Imagination is a strong, restless faculty, which claims to be heard and exercised: are we to be quite deaf to her cry, and insensate to her struggles? *When she shows us bright pictures, are we never to look at them, and try to reproduce them?*' (quoted in Gaskell 267–8, italics mine). The 'bright pictures' that imagination shows Brontë are reproduced in prose; Brontë performs a translation from one medium (visual images) to another (the written word). This is, obviously, necessary given Brontë's medium (although when her publishers offered her the option of illustrating *Jane Eyre* herself, she refused). Jane's ekphrasis, however, always translates images into stories; she describes not the visual appearance of images (of birds, or her own paintings later in the novel) but the *narrative potential* of visual images. When she produces for the reader an ekphrastic description of her three watercolour paintings that Rochester critiques during their first formal meeting, Jane 'reads' the watercolours as if they told stories, as do the images she encounters in Bewick's *History of British Birds.*

Gayatri Spivak, in her essay famous for its exposé of imperialism in women's fiction, offers a brief analysis of the connection between the visual and the textual in *Jane Eyre*. Spivak notes that Jane's attention is curiously focused on the pictures in the book she holds, rather than the text: 'She cares little for reading what is *meant* to be read: the "letter-press." *She* reads the pictures.' Spivak terms this practice of reading only the pictures a 'singular hermeneutics' (246) and links it to Jane's study of the outside scene beyond the glass: both ways of 'reading' 'can make the outside inside' (246). We have seen, however, that Jane both reads text and views images as text. Therefore, Jane's 'singular hermeneutic' is in fact a doubled hermeneutic: to understand Jane's perceptual actions we must take into account both the textual and visual reading that Jane undertakes. The young Jane cannot, or does not choose to, distinguish reading from viewing; for her they are similar modes of aesthetic consumption. Reading may eventually win the battle here, although not simply because *Jane Eyre* is a novel and not a painting. For all the novel's emphasis upon the visual, for all its pictorial moments, the opening scene of the novel forces us to acknowledge a profound *readerly* impulse that is never overshadowed by the imagistic. Jane, like Brontë, continually forces the visual to submit to the verbal; even when Jane views images, she does so in readerly fashion. I suggest that this is because the activity of reading, rather than viewing, resonates with the character Brontë wishes to develop for Jane and with the particular kind of feminist argument Brontë is making in her novel. It is reading as a

culturally determined action that is most suitably symbolic for Brontë's purposes; viewing, as we shall see, evokes a radically different complex of significances for nineteenth-century audiences. Given the cultural and historical moment, Jane must be represented as a reader rather than a viewer.

Certainly the young Jane neatly encapsulates many of the critical issues evoked by women readers of texts in the nineteenth century. She begins as a *voluntarily* secluded reader, having positioned herself in 'double retirement' because she is not, as Mrs. Reed complains, a properly 'sociable' child (5). Her book of choice is, significantly, a book of birds – and she chooses, out of all the various birds depicted by Bewick, to focus upon wild, solitary, and mysterious birds (a 'black, horned thing' (6) rather than, say, a sparrow). The symbolic connection between Jane and birds is emphasized when she becomes, in the Red Room, a caged bird – *involuntarily* secluded because of her forbidden reading.[1] Reading for Jane is dangerous (it gets her in trouble, marks her as different) and empowering (it gives her a creative outlet in her bleak world) simultaneously, which suggests that Brontë's representation of Jane's experience of reading participates in the dominant cultural discourse on women readers that saw in the reading process evidence of a possibly radical subjectivity. In her study of the cultural meaning of the woman reader in the period 1837–1914, Kate Flint (1993) argues that the self-absorption of the reading woman hinted at a dangerous interiority, potentially disruptive of social codes of femininity; Flint sees visual and textual representations of women reading as consistently negotiating this possible interiority. Mark Hennelly in his article 'Jane Eyre's Reading Lesson' writes that reading itself is a 'retreat from life' (695). Within the scene of reading the woman reader withdraws into herself, just as Jane withdraws into the curtained recess at Gateshead; the scene of reading in literature and art becomes, in the words of Mary Jacobus, a 'temporary form of madness' that is necessarily both frightening and potentially empowering (13). Reading becomes a space that 'involves concepts or unconscious phantasies of inner and outer, absence and boundaries' (9). Jane's reading does precisely this: at the opening of the novel, it signals the arrival of a heroine whose imaginative interiority is nothing if not socially disruptive. For Jane, reading becomes 'an act of individualism and imaginative rebellion against the confining circumstances of her life' (695).

But what, then, do we make of Brontë's continual insistence that Jane is *also* a viewer – one who, famously, must translate the visual world for

her blind and maimed husband at the novel's end? This essay attempts to trace further connections and contrasts between reading texts and reading images in representations of women in nineteenth-century paintings, with a view to understanding the cultural discourse with which Charlotte Brontë's representation of Jane as a reader and a viewer might engage. Charlotte Brontë would have understood, and been invested in, the cultural politics of women and the visual arts. She herself wished to be a painter before her eyesight failed and she turned to writing. But even after her decision to give up painting, Charlotte and all the Brontë siblings were thoroughly knowledgeable about the visual arts, a fact attested to by the frequent appearance of scenes of painting in Charlotte and Anne Brontë's novels. As children the Brontës had access to numerous engravings of famous paintings, as well as several drawing masters; in her adult life Charlotte regularly visited galleries in London. She would have been familiar with the prevailing discourses surrounding the woman viewer; even if not familiar with precisely the paintings I will discuss here, Brontë would have been highly conscious of how her cultural moment represented women as artists and art spectators. Her fiction allows us to see her engagement with these cultural debates over women's access to the aesthetic realm, and in fact shows her to be in the vanguard of such debates.

The visual representations of women readers in the middle and late nineteenth century, when contrasted with images of female spectators of art during the same period, offer possible reasons why Jane becomes a 'reader' of pictures, transforming the visual into the narrative. I argue that by looking at these two alternate techniques for representing the status of women's aesthetic consumption in relation to one another, we gain insight into the motivations behind – and cultural resonance of – both representations.

Robert Martineau's 1863 painting *The Last Chapter* shows us in visual form the disruptions and rebellions that reading women can occasion.[2] A young, elegantly dressed woman kneels before the hearth, intent upon a novel. The light from the fire falls softly upon her cheek, neck, and white hand, and part of her rich satin dress creeps alarmingly towards the fire. But her attention is utterly fixed upon her novel; she gives no evidence of acknowledging the fire or the viewer. Her awkward posture makes her seem oddly foreshortened, but she is still overwhelmingly the central image in the composition; the rest of the room recedes into the background or falls away from the side of the frame. If she were to stand, her head and her book would disappear from the picture; her

posture thus seems to mirror her forced attention to the 'frame' of the book. She is on her knees because the book has somehow dragged her to that position. Reading deforms a nice girl's body, makes her forget the hour and her dignity, and draws her literally closer to the fire of knowledge. The young woman's head shares a horizontal plane with one windowpane; within this pane is framed the clearest image of the outside world available in this very cloistered image. Like Jane Eyre, the young woman represented here is in a liminal state between enclosure and freedom. From her head, then, can arise the desire to follow the winding river visible in the background, the desire to connect with a dark and gothic world outside the self and the domestic sphere. Her absorption in the book is visually echoed by the threat of her absorption into the painting's background.

A similar scene, although at first less erotically charged, appears in John Callcott Horsley's *A Pleasant Corner*. Even the title suggests a certain quietness; this is a 'pleasant' corner, not a secret or hidden one. However, if we compare it with Martineau's work, we see key similarities: the girl's dress draws near the fire, suggesting the possible danger of her reading, while her head is at the same height as the window, positioning her within reach of the outside world. Unlike the woman in *The Last Chapter*, however, Horsley's figure looks up from her book (an imposing leather-bound volume, which bears no resemblance to a sensation novel); her attention does not appear to be entirely fixed on the text. She seems to be looking at the viewer/painter, but not quite. That is, her gaze is unfocused, her exact line of sight unreadable. Her expression suggests pensive musing, a 'lost in thought' state of mind (and sight). We are still invited to watch her reading – or thinking about her reading – but her gaze threatens to connect with ours at any moment.

For nineteenth-century viewers, any woman in this state of porous availability to textual influx raised grave doubts, but also offered a delectable sight. We cannot experience what the woman reader experiences; thus, there is a powerful sense of secrecy and attendant subjectivity gained from that hidden experience, which mutates into eroticism. As Flint suggests, 'the very relaxation of outward social awareness which we observe [in the woman reader] prompts the idea of another element: the eroticism of the female subject for the male spectator or commentator' (1993, 4). Certainly the Martineau image foregrounds the erotic charge offered by the reading woman; her position near the floor, rather than steadily upright, signals the ease with which she might fall, literally and metaphorically. In both Martineau's and Horsley's works,

the movement of the women's dress towards the danger of the fire can be read similarly, as a dangerous movement towards worldly knowledge.

Let us now examine a contrasting image that shows us the possible dangers of a woman *viewing* images. In Gustave Courbet's enormous (almost eleven by twenty feet) *The Studio of the Painter: A Real Allegory Summing up Seven Years of My Artistic Life* (1855), a painter's model stands naked in the centre of the canvas, gazing rather bemusedly at the painting upon which the painter works. The painting, significantly, is a landscape painting in which the nude model does *not* appear. Why, then, is she there? Since Courbet has pointedly titled his painting an allegory, one looks first for allegorical meanings of the nude female figure. Michael Fried, in his masterly analysis of the painting, argues that the central grouping of painter, boy, and nude serves to allegorize the experience of painting itself; that is, the group dramatizes the process of painting the picture. Fried sees the nude model as part of the landscape painting on the easel; he connects the flow of the waterfall from the canvas with the flowing draperies of the model, and notes also that her body is only visible within the same plane as the landscape painting. Thus, he argues, the nude 'may be regarded as a synecdoche for that picture ... [she is] subsumed within the painting he is making' (162). Other critics insist that the figure is in fact 'freed of the allegorical burdens placed upon her by innumerable academic artists' (Eisenman 224). In other words, the painting might be an allegory but the nude is not; she is 'a model and nothing more,' as Eisenman writes, 'reduced to [a] mere passive vehicle of painterly dexterity and authority' (224). Yet if she is simply a model, then the question remains: Why is she in the studio, and naked, when she is not actually needed for the production of the landscape currently underway?

For an answer, one needs to consider the other two figures in the painting who, like the nude model, look at the painting: a small boy and a playful cat (the cat's line of sight is not entirely clear, but the twist of its neck suggests that it too could be looking upward at the painting). A nude woman, a young boy, a cat: these are the representatives of the viewing public in Courbet's allegory. None of these possesses social or symbolic power; each is a figure for passivity, vulnerability, or dispossession – and pointless frivolity, if you toss the ball of yarn into the mix. All three, in fact, are feminized objects (the woman because she is female, the child because children are associated with women, and the cat because feline character is culturally feminized).[3] Viewing thus becomes explicitly aligned with femininity, youth, and dependency. For the actual

viewer of Courbet's painting, the subject positions offered seem disempowered; one must therefore reposition one's self as viewer if one does not wish to identify with the nude, the boy, or the cat. We are invited, then, to shift our gaze and become aligned instead with other figures that appear in the right corner of the painting and are all apparently engaged in viewing the nude rather than the painting. The seated male viewer appears to be staring directly and intently at the nude's backside; similarly, the four male figures beyond him in the background must be staring at the nude, for she blocks their line of sight to the landscape painting on which the artist works.

We are asked to take pleasure in the sight of a nude woman who is preoccupied with her own viewing. Because the model is temporarily 'off duty,' and so lost in her own contemplation of art that she lets the drapery begin to slip, we are seeing, we feel, what we are not officially invited to see. In Fried's argument, the nude, because she is subsumed into the landscape on the easel and hence becomes an object rather than a viewing subject, loses her status 'as an independent beholder of that picture' (163). While I agree with his reading, I would suggest that her status as a beholder is *necessarily* 'neutralized,' as he terms it, not only because she blends into the landscape but also because she is a figure of passivity whom the viewer rejects as a point of identification. Instead, she becomes an object whose attractions are heightened because of her activity (viewing). She looks at the painting, not at the actual viewer; she appears lost in thought, her opinions unreadable.

In this she might begin to sound similar to a woman reader, and indeed many visual representations of women reading and women viewing display striking similarities, in particular the tendency to depict the woman in question as pensive, languorous, absorbed to the point of immobility and of utterly disregarding her surroundings. However, there are striking differences between the paintings by Martineau and Courbet – not least, of course, that the female spectator is stark naked and the reading woman decently clothed. This might seem a trivial point, but it aptly expresses in blatant terms what I will argue exists in more subtle fashion in many nineteenth-century texts and pictures (and what Brontë's fiction reinforces, as we shall see): women readers are hidden objects, while women art viewers are seen as more public, active, and on display. Female spectators of art are always threatened with the possibility of becoming metaphorically nude – vulnerable, looked at, absolutely available in a way that women readers never are, with their interiority upheld by their tightly circumscribed relation to the book.

The Disappearing Woman Reader

Generally speaking, pictures of women reading make women *disappear.*
Let me clarify this. Pictures of women reading painted by Western artists
during the nineteenth and early twentieth centuries frequently depict
the woman reader in question as vanishing into the background scene,
blending into the scenery in an often radically elusory way. It is as if the
women in these pictures, by virtue of their pastime, are slipping slowly
but steadily into their environment, losing their individual outline and
becoming almost literally 'one with' the background scene, whatever it
may be.[4] Such blending, obscuring, or fading generally happens at the
level of colour or outline – often both. Occasionally figural composition
lends itself to such a reading, but most frequently it is the execution of
the composition, rather than the position of the painted woman herself,
that suggests such a reading. Several examples from French, British, and
American painters manifest such characteristics.

In Renoir's *Madame Claude Monet Reading* (c. 1872), for example,
Madame Monet's dress and skin partake so powerfully of the colour
components of the sofa on which she reclines that her body seems in
danger of becoming no more than part of the sofa cushions. The blue
stripes of her dress outline her against the sofa, but the central two pan-
els of her dress, her collar, and even her face and hair echo, in colour,
the sofa fabric. Furthermore, the blue 'outline' links the figure firmly to
the wall, sinking her even further *back* into the recesses of the picture.
Tea Time by Marie Bracquemond (French 1841–1916), painted in 1880,
shows a young woman in a white summery dress sitting at a table in a
garden with her book. The preponderance of blue in her dress and cap
strongly connects the woman reading with the slice of sky and distant
hillside visible in the left background, and a white-flecked pattern on
her dress becomes so tree-like in its relationship to the light in the paint-
ing that the woman blends more and more into the scenery.

Berthe Morisot's *La Lecture (Reading)* again links a reading woman's
dress with the painting's background, in terms of both colour and line
(fig. 1.1). In the painting a young woman sits in a delicate lattice-work
chair on a balcony or porch; behind her are the rising fronds of a palm.
The blues and greens of the woman's dress repeat the blues and greens
of the palm fronds behind the railing; even more startling is the similar-
ity of line. The dress appears to be made of palm leaves – Morisot's
brush-strokes make the fabric of the dress seem painted with the back-
ground pattern itself. Similarly, in Winslow Homer's *Sunlight and Shadow*

Fig. 1.1. *La Lecture (Reading)*, Berthe Morisot, 1888. Museum of Fine Arts, St Petersburg, Florida. Museum purchase in memory of Margaret Acheson Stuart.

(also 1872), the woman in the hammock is just barely distinguishable from the harmony of greens behind her.[5] Mary Cassatt's *Young Woman Reading* (1876) offers evidence that Cassatt was aware of such a tradition: the dress of the young woman reading on the sofa is partially a vivid, distinct blue – and part an orange stripe that duplicates the upholstery of the sofa. Half of the woman stands out; half begins to sink into

her surroundings. *Woman Seated in a Garden* (1914) by Frederick Carl Frieseke (American 1874–1939) offers an almost entirely invisible female figure reading on a garden chair in the distance.

Numerous other images share in this tendency: Corot's *A Woman Reading* (1869) and *Interrupted Reading* (1870); Sargent's *Zuleika* (1907) and *Rose-Marie Ormon Reading in a Cashmere Shawl* (c. 1908–12); and Renoir's *Woman Reading* (1875–6).[6] All depict women disappearing as they read, becoming part of the environment that shelters their solitary activity. One might argue that many of these examples could be loosely lumped together under the category of Impressionism, in which the kind of colour harmony I am pointing out would have been a common characteristic of *all* paintings in the style. Certainly within many Impressionist paintings the figure, if figure there is, does bleed quietly into the landscape. But one must consider that the reading woman was a frequent subject for Impressionist painting (almost all the central Impressionist painters executed at least one painting on this subject) precisely *because* the woman reader, as a traditional subject for painting, was the perfect choice of a figure who blended into the background. One must also consider that images of men reading from the period tend to display the male reader in stark contrast to the surroundings. For instance, in Toulouse Lautrec's painting *M. Desire Dihau, Bassoonist of the Opera* (1890), a man in a large top hat sits in the centre of a garden path with his back to the viewer. He is reading a newspaper or magazine whose text blurs into the play of light and shadow. His clothes are dark; he stands out starkly in the midst of the pleasant garden scene. His chair, too, looks bizarre, stuck as it is in the middle of a garden path. It seems to be a dining chair, straight-backed and dark, liberated from the domestic space, rather than a proper garden chair. Male readers, unlike female readers, appear in bold relief from their surroundings, suggesting an independence or power denied to the female figures; male readers, like the bassoonist, also turn completely away from the viewer, refusing to become aestheticized objects.

Nineteenth-century art belonging to schools other than Impressionism or its close relations also share this characteristic dissolve of the woman reader. In Albert Moore's *A Reader* (1877) we again see the disappearance of the female figure, but not through soft brush strokes and dappled sunlight. While this woman is certainly in the foreground of the painting (though the painting is not particularly deep – in fact it is strangely shallow, which contributes to this disappearing act by making the woman appear part of a single flat plane, rather than an individual

in an environment), the colour and texture of her dress make her appear part of the tapestry behind her and the rug in front of her. She is not what one might consider an 'individual' – she is a geometric shape. Furthermore, to believe that the woman in *A Reader* is actually reading is impossible: she is standing, so obviously posing for a picture that the book in her hand seems almost like a joke. People rarely read standing up.[7] What, then, is the book for? Let us consider what the painting would look like if the woman was drawn with crossed arms, rather than with one forearm lifted to support the thin book. To begin with, the woman's downcast gaze would need another explanation; her absorption here is comprehensible, safely explained. As Flint (1993) has suggested, the image of the woman reader provided a simple way to make women viewable; a woman who reads is absorbed, and therefore unaware of her surroundings – hence, she is available to be watched without any threat of a returned gaze.

What conclusions can be drawn from the prevalence of this formal characteristic of paintings of women reading? The woman in each of these images literally retreats into the background; she is absorbed by the colour and line around her, even when – as in Moore's painting – the book itself stands out boldly. One can read this several ways. Certainly the sense of harmony and unity these paintings provide suggests a positive spin on this blending into the background, as if women were being offered a vision of a fantasy of (at least) partial absorption into the beauty of the material world (be it natural or interior). On the other hand, it cannot be ignored that these paintings also offer a vision of self-loss through reading – yet again, this self-loss can be read as a positive or negative option for the reader depicted. For the viewers of the painting, the reading woman becomes merely another part of the landscape, an additional object of pleasure upon which to gaze, and an undifferentiated object at that.[8]

The Public Woman Viewer

Images of women viewers, by contrast, offer a different narrative, as we saw in the Courbet painting. Representations of women viewing paintings offer another illustration of the dangers of female aesthetic consumption, but with certain key contrasts. Women viewing paintings are forced to share their viewing experiences; in most paintings we *can* see what the woman viewer sees, and we participate in her experience of viewing. We can feel connection with her activity, or we can (as in the

Courbet painting) attempt to replace her as spectator. The female spectator as subject allows artists to position women within a visible, public, interpretive community. Reading is radically private, most paintings suggest,[9] but viewing art is a public endeavour, done in art galleries, studios, museums, or wealthy people's homes. Art-viewing, in the nineteenth century, was a radically public event: visits to the Royal Academy were part of the social rounds; the opening exhibit of the RA each year signalled the official opening of the London social season. As Flint writes, 'by stressing ... social gathering rather than the paintings themselves, depictions of art shows, whether in paintings or in periodical publications, ultimately serve to reinforce the point that spectators are participating in social rituals, however much any individual act of spectatorship may involve individualized, subjective apprehension and judgment' (*The Victorians* 176). Women who participated in these events were therefore open to public scrutiny in a way that they would not be had they chosen to simply remain at home and read 'in private.' Viewing opened a woman up to extreme public scrutiny, while paradoxically at the same time offering her a socially sanctioned excuse to engage with the public realm.[10]

Recent criticism, drawing on Lacan, Foucault, Debord, and others, has exploded with interest in the 'Victorian visual imagination,' as Christ and Jordan have termed it. Conclusions are mixed, but consensus does seem to have been reached about one thing: Victorian culture in England was embarking upon what one critic has termed a 'sort of frenzy of the visible' (Comolli 122). Critics of nineteenth-century illustration regularly note that the Victorian experience of reading was heavily visual: books, newspapers, journals, and other printed texts were in fact multimedia events, heavily dependent upon images. The proliferation of visual images – illustrations, engravings, paintings in galleries, advertisements, photographs, and more – turned the Victorians into visual fanatics, 'fascinated,' as Kate Flint has recently written, 'with the act of seeing, with the question of the reliability – or otherwise – of the human eye' (*The Victorians* 1). Martin Meisel's *Realizations: Narrative, Pictorial, and Theatrical Arts in Nineteenth-Century England* offers a wide-ranging look at how this fascination with the visual affected the arts; writers, painters, and dramatists, argues Meisel, shared a common *pictorial–narrative* style.

Women's role in this culture of the visible has been less clearly investigated. The best recent work on women in the Victorian art world focuses upon women as cultural producers – painters, sculptors, and so

on – rather than as spectators of the fine arts.[11] The closest thing to a theory of the female spectator of art is available in the recent treatments of early women art historians. Any nineteenth-century representation of women viewing must call to mind the rise to prominence of female art critics during the period. Recent critics and historians have renewed our acquaintance with the numerous excellent female art historians of the Victorian period: the works of Anna Jameson, Lady Dilke, Elizabeth Rigby (Lady Eastlake), Maria Graham (Lady Callcott), Ellen Clayton, Vernon Lee, and others have been rediscovered and their contributions to public taste and art history re-evaluated.[12]

Such female commentators on art had an easier time publishing their work than one might expect given the cultural moment. Female art historians made excellent use of a prevailing cultural belief in woman's greater powers of perception, their potent aesthetic sensibility. In fact, many male writers on women painters of the day, in order to justify their exclusion of women from the ranks of aesthetic producers, relegated women to the role of supreme consumers of art – a tactic that gave women approved access to the realm of art criticism. Elizabeth Rigby, when speaking of women travellers, insisted that there was a 'peculiar power inherent in ladies' eyes ... that power of observation, which, so long as it remains at home counting canvass stitches by the fireside, we are apt to consider no shrewder than [men's], but which once removed from the familiar scene, and returned to us in the shape of letters or books, seldom fails to prove its superiority' (98–9). Her comments on female travellers could easily extend to female spectatorship; and indeed, other writers echo Rigby's characterization of women as peculiarly visually perceptive.[13]

It was this very belief in women's susceptibility to images that, of course, fueled the cultural concern over women's viewing practices. The positioning of the female spectator is highly regulated in the period, as viewing was seen as conferring a certain power upon the spectator. It is rather a cliché to suggest that the position of beholder confers such power while the object-of-the-look is positioned as vulnerable or weak, and that the position of beholder is regularly aligned with the masculine subject position while the object is coded feminine. Cultural critics from John Berger to Laura Mulvey to feminist Freudians and Lacanians[14] have investigated this troublesome structure of the visual act: 'In a world ordered by sexual imbalance,' writes Mulvey, 'pleasure in looking has been split between active/male and passive/female' (19). The simplicity of this paradigm has recently been radically complicated; the easy bifur-

cation along gender lines has been shown to be historically and theoretically problematic. However, if we confine ourselves to how the act of looking at paintings is represented within paintings, we can see that the 'powerful male beholder/vulnerable female object' paradigm is unavoidably apparent; we can therefore envision what a female subject would be up against in stepping into the position of masculine beholder within the frames of a painting.

For a woman to step out of the frame, so to speak, and become a viewer in her own right meant negotiating a dangerous path. What do representations of women viewers suggest was at work in the cultural reaction to their viewing? One answer comes from a genre of painting that I call the 'female invasion of the studio' genre, which includes such works as William Merritt Chase's *In the Studio* (1880), *In the Studio* (1892), and *In the Studio, Interior: Young Woman at a Table* (c. 1892–3); and Matisse's *The Painting Lesson* (1916). The genre's most famous representative, however, is Jean-Baptiste-Camille Corot, who painted an entire series of female invasions (fig. 1.2). Corot's series is, on the surface, surprisingly like a reading woman series. His female figures are indulging in moments of private absorption, for which reading, not viewing, is the model. However, their viewing oscillates between the public and the private, because the figures in Corot's series are models, and they are always essentially *intruders* in the studio space. That is, they have a function there to be looked at, not to look; the space does not belong to them, as it does in most of the reading women images (which show the women in their own bedrooms or parlours or gardens) and the models all appear to be taking a rest from their proper role of being looked at to perform a bit of looking of their own. This intrusion, I argue, is characteristic of almost all the woman viewing images; women do not belong in the position of viewer, as we saw in the painting by Courbet, and any viewing activity is explicitly or implicitly a transgression.

As in the Courbet painting, if on a different scale, each painting in Corot's studio series offers the viewer two images to look at: the model herself in the studio and the painting on the easel. Unlike images of women readers, in which the viewer cannot see what the woman reads, in Corot's paintings we are vouchsafed a vision of whatever the model herself sees. This does several things. First, it bifurcates the viewer's gaze, releasing some of the attention directed at the woman, which is not the case in an image of a woman reader. Additionally, this forces the viewer to imagine the viewing woman as an interpretive presence in her own right, part of the interpretive community with which we must join if

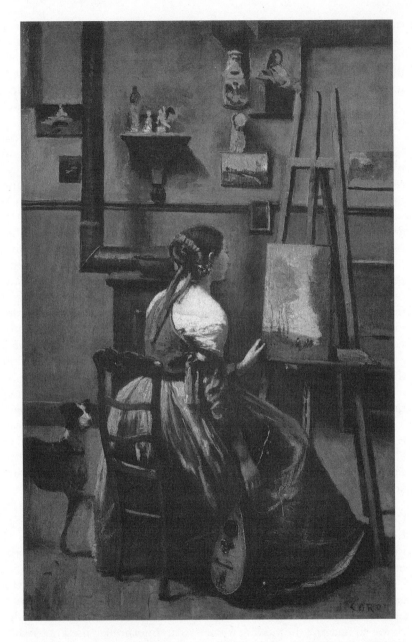

Fig. 1.2. *The Artist's Studio*, Jean-Baptiste-Camille Corot (c. 1868). The Widener Collection, Image ©2004 Board of Trustees, National Gallery of Art, Washington.

we are to fully engage the painting. She is thinking about the painting on the easel in some way, considering it, judging it. As with the nude model in the Courbet painting, the viewing model in the Corot series becomes our alter ego as a viewer; we are forced to recognize her as a viewing subject even as we attempt to reposition her as an aesthetic object.

Perhaps it is the shared activity – she is looking, we are looking – which makes images of women viewing so distinctive and potent. If we look at Corot's painting of a woman reading, *La Lettre* (1865), a compositional (indeed, postural) distinction between women reading and women viewing becomes apparent: the woman reader has her head tilted downward, her eyes modestly cast down at the letter; women viewers look up. While this is an anatomical fact of life (one rarely views paintings in one's lap), it also signals a symbolic difference between representations of reading and viewing. Reading can preserve the modest downcast look proper to ladies, while viewing art requires an erect posture suggestive of outward rather than inward focus. Furthermore, the woman reading the letter is enclosed within the protective circle of the chair, whose arm provides a barrier between the reading figure and the viewer. Although the figure is a model – and indeed close observation of the painting reveals that the scene is Corot's studio just as in the other sequence – she is profoundly separate from the viewer; she is engaged in an activity that we cannot share.

Viewing Pictures

Representations of women viewing – and this is no surprise, perhaps – negotiate women's position in the visual aesthetic order. That is, the cultural formation with which artists who depict women viewing must contend involves the 'classic' aesthetic scenario of male viewer/female art object; artists like Courbet, Corot, or Cope seem to strive to uphold this primal aesthetic scene. Charlotte Brontë provides one way out of this aesthetic bind. In *Jane Eyre*, reading – and the complex of associations reading implies – offers Brontë's heroine a retreat from the tyrannies of the visual. But to understand more fully Brontë's use of the visual, let us consider a scene from her final novel, *Villette*, which features the heroine Lucy Snowe in an art gallery – perhaps the most famous literary representation of the attempted regulation of female spectatorship in British fiction of the period. The scene shows that Brontë would have been aware of the social hindrances to female spectatorship, the way viewing in public was highly problematic for the exercise of indepen-

dent female perception. After Lucy Snowe's 'nervous fever,' she convalesces with her friends the Brettons; to amuse her, Dr John Bretton escorts her to a museum. As Lucy tells us, 'I liked to visit the picture-galleries, and I dearly liked to be left there alone.' She continues:

> In company, a wretched idiosyncrasy forbade me to see much or to feel anything. In unfamiliar company, where it was necessary to maintain a flow of talk on the subjects in presence, half an hour would knock me up, with a combined pressure of physical lassitude and entire mental capacity. I never yet saw the well-reared child, much less the educated adult, who could not put me to shame, by the sustained intelligence of its demeanour under the *ordeal of a conversable sociable visitation of pictures.* (189, italics mine)

Picture-going, for the bulk of the public whom Lucy describes, is a social activity, as her experience in the gallery demonstrates; she watches groups of gallery-goers chat together, walk together, as they examine the paintings. Lucy, being a Brontë heroine, is naturally perverse: she wishes to treat picture-viewing like reading, and in fact she makes the connection by insisting, 'it seemed to me that an original and good Picture was just as scarce as an original and good book' (190). Remember that Jane, in Spivak's words, 'cares little for reading what is *meant* to be read' (246): similarly, Lucy cares little for the publicity of viewing. She longs for the privacy of reading, and attempts to transform the visual experience into a solitary interpretive moment.

The picture Lucy describes most fully is an enormous canvas that 'seemed to consider itself the queen of the collection,' depicting Cleopatra. Lucy has no praise for the image, considering the larger-than-life, scantily clad, reclining figure morally repugnant. Not for its indecency, however. Rather, Lucy is offended by the languorousness and size of the woman: 'She lay half-reclined on a couch: why, it would be difficult to say; broad daylight blazed round her; she appeared in hearty health, strong enough to do the work of two plain cooks; she could not plead a weak spine; she ought to have been standing, or at least sitting bolt upright. She had no business to lounge away the noon on a sofa' (191). Similarly, it is not the figure's nudity that disgusts Lucy, but her inefficiency as a domestic manager: 'out of abundance of material – seven-and-twenty yards, I should say, of drapery – she managed to make inefficient raiment. Then, for the wretched untidiness surrounding her, there could be no excuse' (191). Lucy makes no mention of the figure as sexually immoral; this is not the moral axis upon which Lucy judges

the figure. The erotic shock of the painting is, however, deeply distressing to M. Paul, the despotic Catholic professor with whom Lucy works, and who eventually becomes her fiancé. He discovers her in the gallery and is, famously, appalled to find her – an unmarried woman – encountering such a painting. What is acceptable for men or 'des dames' to view is not at all appropriate for a young woman; instead, M. Paul drags Lucy off to a corner and forces her to look at a series of four paintings representing 'The Life of a Woman' – sentimental, traditional representations that Lucy finds 'bloodless and brainless' (193).

The scene dramatizes the seminal elements in the cultural negotiations surrounding women's spectatorship in England in the mid-nineteenth century. First, viewing is a public matter, done in galleries and in company. Looking at paintings involves talking about them, actively and immediately interpreting them, and vocalizing that interpretation in public: Lucy, after M. Paul leaves, takes a turn around the gallery with Dr John, and the two carry on a dialogue about the merits and faults of various paintings. For someone who 'dearly liked to be left ... alone,' Lucy has now been forced to hold *two* aesthetic conversations during one brief trip to a gallery. Second, museum-going brings women almost unavoidably into proximity with the human nude, which could heighten their awareness of human sexuality.[15] Novels (especially French ones, thought the British) might contain erotic scenes, but they rarely offered detailed descriptions of human anatomy.

The first element of spectatorship – its public side – is unique to painting. Scenes of women viewing illustrate public transgression, while scenes of women reading focus on the representation of individual interiority (which, for women in the period, was also a kind of transgression). Viewing offers Lucy Snowe a chance to exercise her powers of social rebellion, but also forces her to submit, at least in part, to the public middle-class codes of female spectatorship. Lucy has, privately, translated the image of Cleopatra into her own narrative (of lethargy and indolence), just as Jane proffered her own 'reading' of the Bewick birds. Lucy's narrativizings, however, are pushed out into the verbal, public realm – she must articulate her ideas about the paintings in question to M. Paul or Dr John, and she must receive their judgments in return. Lucy is forced, because of the public nature of spectatorship, into direct conflict with masculine control of the visual realm in the figures of the tyrannical M. Paul and the more conventional Dr John. Both attempt – and to a certain extent are able – to force Lucy to accept (or at least countenance) their aesthetic interpretations.

Lucy's aesthetic experience has the same result as Jane's: both are 'locked up' physically – Jane is locked up literally, in the Red Room; Lucy is figuratively locked into the social confines of sitting where M. Paul tells her and walking through the gallery with Dr John. The punishment for reading by yourself is to be locked away by yourself: Jane's statement of her own independence (by reading privately) is punished in kind. On the other hand, Lucy's punishment for her independence in viewing alone is to be placed *in company* – to be locked into a public environment and visually regulated. The punishments fit, not the crimes (since what *both* heroines want is solitude), but the public conceptions of the acts of reading and viewing: the reader is forced to endure the ultimate in readerly solitude, the viewer is forced to be in company.

If we return again to *Jane Eyre*, we can see at last the repercussions of her curious blending of the verbal and the visual. Remember that Jane's reading was solitary, dangerous, yet striking in its ability to introduce radical female subjectivity. Reading, for Brontë, is simultaneously dangerous and empowering. It makes Jane – and women in pictures of women reading – able to disappear. This can signify a powerful liberation from social observation, yet it can turn ugly, as it does with Jane: reading makes you vulnerable in your secluded retreat, and so John Reed finds Jane easily, because she has literally boxed herself in. Neither can the women reading in the paintings 'hide' entirely from the viewer; their activity makes them easy prey for prying eyes. Viewing is another story: women view in public and are much easier prey, yet they are also socially engaged, exercising a public power, with (as we have seen with Lucy) social sanction for their endeavour. Neither position is without danger, but neither is without potential rewards. Brontë seems to have tried them both on for size in her continued struggle to represent independent-minded nineteenth-century women.

Edgar Degas's painting of Mary Cassatt and her sister at the Louvre (fig. 1.3) offers a fitting conclusion to this argument. The painting shows two women in a gallery space; the sisters in the image are not only biological sisters, but nod towards the relation between the 'sister arts,' and can be read as a metaphoric meeting of Charlotte Brontë's two heroines, Jane Eyre and Lucy Snowe. The figure of Cassatt's sister in the foreground sits behind what is probably the guide for the gallery exhibition;[16] the figure in the background (Cassatt herself) heads out into the exhibition space beyond. The reading figure is tucked in a nook as Jane was, 'safe,' while the viewer is heading out into the space

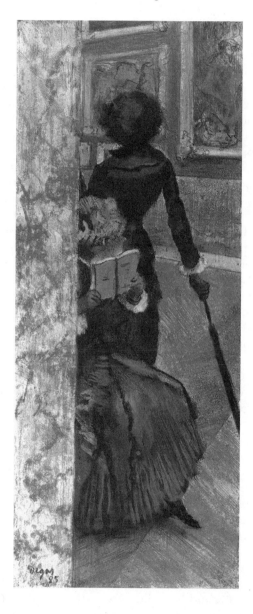

Fig. 1.3. *Mary Cassatt at the Louvre: The Paintings Gallery*, Edgar Degas, 1885.
Bequest of Kate L. Brewster. Reproduction, The Art Institute of Chicago.

of the public, of possible danger, like Lucy Snowe who charges off alone to the Continent to try her fate. Like the figure of Cassatt in the painting, however, Lucy stands with her back to us, retaining some semblance of privacy in a public arena.[17] The reading woman sits still for our gaze, but the viewer's back is to us, and we cannot create subjectivity for the figure. She is upright, in motion, heading out into the public arena. Similarly, Brontë's earlier heroine Jane remains in a reading posture, so to speak, throughout the novel. Jane might try her luck in the wide world, but she always ends up back inside, with her family (as at the Moor House) or in private. She sits still and forces us to acknowledge her internal subject-position, the intensity of her internal cogitations. Yet the reading figure here is also nearly obscured by the very book she holds; the book along with the wall provides a 'nook' from within which the female figure can engage in her own private speculations. In fact the 'reader' appears – like Jane – to be viewing as well, looking out sideways at a painting from behind the guide. Hence, at the same time as these figures are set in apparent contrast, Degas's image also dramatizes the intimate connection between the two aesthetic activities that Brontë herself insisted upon. Given the preponderance of disappearing female readers and overly visible female viewers that mid-century painting has to offer, it seems likely that Brontë was herself writing into and out of a tradition that saw the two modes of female consumption as representing different dangers for the women involved in them. In *Jane Eyre*, reading provides a retreat from the dangers of the visual. Perhaps Rochester's famous punishment at the end of the novel is not only Brontë's way of subduing a powerful hero, as Gilbert and Gubar and others have argued, but also her way of forcing him to enter into a verbally based mode of perception rather than a visual mode – a mode that has threatened Jane throughout the novel, ever since she was forced to stand on a platform at Lowood to be stared at by her classmates. The entire novel could therefore be seen as a determined if incomplete eradication of the dangers of the visual, culminating in the eventual creation of a world in which Jane can look freely,[18] but where no one else can look at Jane. Even when Rochester's vision partially recovers at the end of the novel, Brontë is careful to tell us that he turns his fuzzy vision on candles, a necklace, and his child's eyes – but never on Jane. She, like many of her later nineteenth-century counterparts in paintings, has disappeared from his view.

NOTES

1 It is not only that Jane's reading of Bewick leads to her cousin's cruelty and hence to Jane's anger and imprisonment; it is also that her rebuttal to her cousin John Reed ('you are like the Roman emperors!') comes directly from her reading ('I had read Goldsmith's "History of Rome"') (8).

2 Flint's brief reading of this painting in *The Woman Reader* is my starting point for what follows.

3 Cats, says Freud ('On Narcissism'), are in a class with women, criminals, and children as supreme examples of narcissism.

4 While this essay considers paintings and texts from the nineteenth and early twentieth centuries, later paintings also share this trait: see, for example, *Macarina Reading* (1979) by Ruby Aranguiz. The face and lower body of the figure blend entirely into the background; only the green jacket allows the woman to become visible against the background. The book also shares the fate of the woman's lower body, as both become part of the orange and brown background pattern.

5 Another Homer image, *The New Novel* (1877), breaks with this pattern. The painting shows a young woman lying on her side in the grass with a novel in one hand; her dress is a clear vivid orange that stands out dramatically from the dark, obscure background.

6 John George Brown, *Girl by the Seacoast*, offers another startling contrast to this tradition: the woman reading in his picture is alarmingly, almost dangerously, set apart from her surroundings, high upon a rock that is jutting out into the sky.

7 Gwen John's work offers an exception to this rule; in *A Lady Reading* (1910–11) and *Girl Reading at the Window* (1911), the female figures are standing while they read, apparently so involved in their books that they ignore the chairs available to them. Note, too, that in both of John's paintings the woman reader emphatically does not disappear into the background. John critiques this tradition by making her figures radically separate in colour and form from their backgrounds; neither of the figures can be read as losing identity or position by reading.

8 This movement towards objectification is what allows such paintings as Martineau's *The Last Chapter* to become a kind of 'disappearing woman' image even though neither its composition nor its colouring justifies such a reading. The woman in Martineau's painting is extremely foregrounded, which makes it quite rare amongst nineteenth-century representations of reading women. However, Martineau's point seems to be that the woman reading

should be part of her own background – that is, she should be in bed (suggested by the reclining couch behind her). Reading keeps her out of her proper background.

9 There are, of course, numerous images from the nineteenth century that show women reading in public – in libraries, with friends or relatives, and the like. However, the reading experience remains private, even in a public space; the woman reader's absorption is in conflict with the public space.

10 The Lady of Shalott, who might stand as a representative of the repercussions of female looking, meets a symbolic fate: because she dares to look she is condemned not only to death but to be stared at by a crowd of people. Lancelot's verbal epitaph for her, 'she had a lovely face,' also signals her punishment: to be looked at.

11 See Cherry; Nunn; Chadwick, chap. 6; Marsh; and Orr.

12 See, in particular, Sherman and Holcomb, chaps. 1–7. Also see Schaeffer, *The Forgotten Female Aesthetes.*

13 See Uzanne, 'Women Artists and Bluestockings'; Moore, 'Sex in Art'; and Scott, 'Women at Work: Their Functions in Art'; all in Harrison, Wood, and Gaiger.

14 See Mulvey, and Grosz.

15 This last, indeed, was a frequent complaint by writers in England during the Victorian era; statues and paintings were famously draped to hide their genitals, and young women were refused admittance to art schools because they were not allowed to study 'from the life,' that is, the nude.

16 There are numerous British engravings, such as one by Mary Ellen Edwards ('At The Royal Academy,' from *The Graphic*, 1871), that show women in galleries looking dutifully at gallery guides. Just as both men in *Villette* attempt to 'guide' Lucy's interpretation of paintings, so, too, might the presence of these guides suggest a forceful re-positioning of women out of the potentially powerful viewing position and back into a more vulnerable readerly position. Lucy rejects such guidance, and Jane skilfully reinterprets the reader-position into a less vulnerable, radically independent one. (I thank Jennifer Phegley for bringing to my attention the numerous representations of women reading gallery guides.)

17 Critics have noted that Lucy lies to us. She hides data from the reader in a way utterly foreign to Jane, whose first-person narrative foregrounds an angry forthrightness. Lucy, on the other hand, spends much of her narrative withholding information, metaphorically turning her back to us. See Cherry 53–64; Gillett 158–72; Dodd, in Orr, 188–90.

18 For an excellent reading of the novel as the triumph of Jane's literal and metaphoric point of view, see Gezari (chap. 3).

WORKS CITED

Alexander, Christine, and Jane Sellars. *The Art of the Brontës*. Cambridge: Cambridge UP, 1995.

Asleson, Robyn. 'Nature and Abstraction in the Aesthetic Development of Albert Moore.' In *After the Pre-Raphaelites: Art and Aestheticism in Victorian England*, ed. Elizabeth Prettejohn. New Brunswick, NJ: Rutgers UP, 1999.

Bal, Mieke. 'Enfolding Feminism.' In *Feminist Consequences: Theory for the New Century*, eds. Elisabeth Bronfen and Misha Kavka. New York: Columbia UP, 2001.

Brontë, Charlotte. *Jane Eyre*. New York: Norton, 1987.

– *Villette*. New York: Bantam, 1990.

Chadwick, Whitney. *Women, Art, and Society*. London: Thames and Hudson, 1996.

Cherry, Deborah. *Painting Women: Victorian Women Artists*. London: Routledge, 1993.

Christ, Carol, and John Jordan. *Victorian Literature and the Victorian Visual Imagination*. Berkeley: U of California P, 1995.

Comolli, Jean-Louis. 'Machines of the Visible.' In *The Cinematic Apparatus*, eds. Teresa de Lauretis and Stephen Heath, 121–42. London: Macmillan, 1980.

Dodd, Sara. 'Art Education for Women in the 1860s: A Decade of Debate.' In Orr, 187–98.

Eisenman, Steven. 'The Rhetoric of Realism: Courbet and the Origins of the Avant-garde.' In *Nineteenth Century Art: A Critical History*, ed. Steven Eisenman, 206–24. London: Thames and Hudson, 1994.

Flint, Kate. *The Victorians and the Visual Imagination*. Cambridge: Cambridge UP, 2000.

– *The Woman Reader 1837–1914*. Oxford: Oxford UP, 1993.

Freud, Sigmund. 'On Narcissism: An Introduction.' In *The Standard Edition of the Complete Psychological Words of Sigmund Freud*. Vol. 14. London: Hogarth, 1914.

Fried, Michael. *Courbet's Realism*. Chicago: U of Chicago P, 1990.

Gaskell, Elizabeth. *The Life of Charlotte Brontë*. Oxford: Oxford UP, 1996.

Gezari, Janet. *Charlotte Brontë and Defensive Conduct: The Author and the Body at Risk*. Philadelphia: U of Pennsylvania P, 1992.

Gilbert, Sandra, and Susan Gubar. *The Madwoman in the Attic*. 2nd ed. New Haven and London: Yale UP, 2000.

Gillett, Paula. *Worlds of Art: Painters in Victorian Society*. New Brunswick, NJ: Rutgers UP, 1990.

Grosz, Elizabeth. *Jacques Lacan: A Feminist Introduction*. London: Routledge, 1990.

Harrison, Charles, Paul Wood, and Jason Gaiger. *Art in Theory, 1815–1900: An Anthology of Changing Ideas*. Oxford: Blackwell, 1998.

Hennelly, Mark. 'Jane Eyre's Reading Lesson.' *ELH* 51.4 (Winter 1984): 693–717.

Jacobus, Mary. *Psychoanalysis and the Scene of Reading*. Oxford: Oxford UP, 1999.

Lewes, George Henry. Review of *Jane Eyre*. *Fraser's Magazine*, December 1847.

Marsh, Jan. *The Pre-Raphaelite Sisterhood*. New York: St Martin's P, 1985.

Meisel, Martin. *Realizations: Narrative, Pictorial, and Theatrical Arts in Nineteenth-Century England*. Princeton: Princeton UP, 1984.

Mulvey, Laura. *Visual and Other Pleasures*. London: Macmillan, 1989.

Nunn, Pamela Gerrish. *Victorian Women Artists*. London: Woman's P, 1987.

Orr, Clarissa Campbell, ed. *Women in the Victorian Art World*. Manchester: Manchester UP, 1995.

Rigby, Elizabeth (Lady Eastlake). 'Lady Travelers.' *Quarterly Review* 76 (June 1845): 153–85.

Schaeffer, Talia. *The Forgotten Female Aesthetes*. Charlottesville: UP of Virginia, 2000.

Sherman, Claire Richter, and Adele Holcomb, eds. *Women as Interpreters of the Visual Arts 1820–1979*. Westport, CT: Greenwood, 1981.

Spivak, Gayatri Chakravorty. 'Three Women's Texts and a Critique of Imperialism.' *Critical Inquiry* 12 (Autumn 1985): 243–61.

Starzyk, Lawrence J. '"The Gallery of Memory": The Pictorial in *Jane Eyre*.' *Papers in Language and Literature* 75 (1991): 288–309.

2 'Success Is Sympathy': *Uncle Tom's Cabin* and the Woman Reader

ELIZABETH FEKETE TRUBEY

In an 1852 review of Harriet Beecher Stowe's *Uncle Tom's Cabin,* George Sand explains that the novel's political efficacy depended upon its ability to foster affective identification between its readers and characters. 'We should feel,' she states, 'that genius is heart, that power is *faith,* that talent is *sincerity,* and, finally, *success is sympathy,* since this book overcomes us, since it penetrates the breast, pervades the spirit, and fills us with a strange sentiment of mingled tenderness and admiration for a poor negro' (461). She points out that the book's power to persuade its audience of slavery's evil originates in the sympathy aroused by characters like Uncle Tom. Stowe's descriptive language practically invades readers' bodies, filling them with the sensation of kinship – 'mingled tenderness and admiration' – which is the surest sign that *Uncle Tom's Cabin* has performed its office properly. Sand's claim that, for Stowe, 'success is sympathy' was historically correct on two levels. First, the arousal of 'feminine' sympathy caused many readers to '*feel right,*' as Stowe put it, to know in their hearts that slavery is wrong (*Uncle Tom's Cabin* 385); second, the extent of the proliferation of this sympathy was manifested in the novel's unprecedented commercial success. Significantly, Stowe, in the novel and elsewhere, also imagined a third version of 'success' that extended beyond feeling: her women readers' proper feeling would lead to action in the public sphere that would bring about slavery's end. Responses to *Uncle Tom's Cabin* suggest, however, that this ultimate victory remained elusive, as Stowe and her readers often ended up at cross-purposes. While *Uncle Tom's Cabin* aimed to revise the social function of women's reading by reaching into the political arena, its sympathetic women readers often collapsed the distinction between private feeling and public action. This reading experience begs us to

rethink our understanding both of Stowe's women readers and of nine-teenth-century women's reading in general: in fostering pleasure that was simultaneously domestic and political in nature, reading tended to focus women's attention more on their own circumstances than on the plight of slaves.

In connecting abolitionism with sentimental reading, *Uncle Tom's Cabin* effectively blurs the boundary between public politics and private affect. Stowe recasts the significance of a woman's ability to read sympa-thetically so that, instead of ostensibly serving as a means to instruct readers in true womanhood as in many nineteenth-century sentimental novels, reading as a woman takes on the weight of a nation's fate. By associating sentimental, identificative reading practice with ending sla-very, *Uncle Tom's Cabin* fundamentally alters the relationship between women and politics traditionally imagined by the discourse of true wom-anhood. A woman's innate sympathy and sensitivity do not de facto exclude her from public politics, the novel suggests, but rather demand her participation in a sphere to which traditionally she has not had access. This tension between the rhetoric Stowe uses to exhort her women readers and the end to which she writes is evident in women's responses to the novel, which often focus as much on the issue of femi-nine propriety as on that of slavery. *Uncle Tom's Cabin* encourages its audience to merge an abolitionist sensibility with domestic femininity, yet the very excesses of 'womanly' emotion the novel fosters tended to overshadow the possibilities for anti-slavery mobilization in sympathetic readers. The pain of slavery and the pleasure of reading *Uncle Tom's Cabin* mingled to focus women's eyes on the deepening tension over the limits of 'feminine' propriety and the domestic sphere itself, in turn revealing how the act of reading itself became caught up in nineteenth-century conflicts over gender.

As scholars concerned with race and gender have revived the study of the novel, they have typically focused on the first two aspects of sympa-thy's 'success': its ability to convert readers to abolitionism and to make *Uncle Tom's Cabin* a commercial triumph. Like Sand, they tend to tie the novel's sentimental qualities – its religiosity, emotionalism, and empha-sis on the female-centred domestic sphere – to its political and cultural power among readers. Feminist critics have placed particular weight on Stowe's assumption that mothers are uniquely suited for the empathy necessary to abolish slavery, a belief that sets her women readers at the epicentre of her political and moral crusade. Jane Tompkins, for one, reads *Uncle Tom's Cabin* as 'a monumental effort to reorganize culture

from the woman's point of view' (124). By 'resting her case [against slavery], absolutely, on the saving power of Christian love, and on the sanctity of motherhood and the family,' Stowe 'relocates the center of power in American life ... in the kitchen. And that means that the new society [she envisions] will not be controlled by men, but by women' (145). Stowe's women readers, by virtue of their femininity, are imagined as the bearers of far-reaching cultural power, responsible for ending slavery and establishing a utopian, domestic America.

At the very heart of this potential power shift is Stowe's imagined ideal reader; indeed, by combining calls for reader-character identifications with detailed metatextual instructions, Stowe schools her implied audience in the correct way to interpret the novel and to respond to its political exhortations.[1] At the end of *Uncle Tom's Cabin*, Stowe asks 'what can any individual do' to end slavery, answering that 'they can see to it that they *feel right*. An atmosphere of sympathetic influence encircles every human being; and the man or woman who *feels* strongly, healthily and justly, on the great interests of humanity, is a constant benefactor to the human race. See, then, to your sympathies in this matter!' (385). Stowe's discussions of sympathy rely upon a set of assumptions about women's inherent ability to empathize and identify with others, and these moments throughout the text establish that this right feeling is in its essence 'feminine.' Specifically, Stowe zeroes in on maternal affect. As Kate Flint explains, maternity was thought to carry with it 'the ability to venture with sympathetic identification into the lives of others,' and thus 'women's susceptibility to identificatory modes of reading was perceived to be related to the inescapable facts about the way in which her biological make-up influenced the operations of her mind' (31). By virtue of what was considered to be their physiological and psychological nature, the women Stowe includes among her implied audience possess the potential to become ideal readers.

For Stowe, it is mothers, fictional and real, who are most capable of identifying with the slaves in need of their assistance. For instance, early in the novel the kindly Mrs Shelby excoriates her husband's decision to sell a young slave boy because to do so would separate him from his mother, Eliza, and would disrupt the sanctity of the family. Likewise, a girl like Eva St Clare can have her developing maternal feelings aroused by the injustice of slavery – she loves the rambunctious Topsy because the girl hasn't '"any father, or mother, or friends,"' and therefore assumes a familial role herself (245). The most poignant example of the power of motherly sympathy comes as Eliza, fleeing north from the

Shelby plantation with her son in tow, is able to gain protection from a white family by forming a maternal bond. She asks Mrs Bird if she has ever lost a child, a question that Stowe then turns outward to include her readers, writing, 'oh! mother that reads this, has there never been in your house a drawer, or a closet, the opening of which has been to you like the opening again of a little grave?' (75). Indeed, it is this bond between mothers originating in a sense of loss that Stowe claims inspired the book itself: 'I have been the mother of seven children, the most beautiful and the most loved of whom lies buried near my Cincinnati residence. It was at his dying bed and at his grave that I learned what a poor slave mother may feel when her child is torn away from her,' Stowe wrote in an 1852 letter to abolitionist Eliza Cabot Follen. She continued, 'much that is in [Uncle Tom's Cabin] had its root in the awful scenes and bitter sorrow of that summer. It has left now, I trust, no trace on my mind except a deep compassion for the sorrowful, especially for mothers who are separated from their children' (413). While the novel presents a variety of arguments against slavery – including George Harris's use of revolutionary language to decry America's betrayal of equal rights and St Clare's theory of the destructive power of slavery as a social institution – it is Stowe's deployment of maternal identification that most frequently and touchingly makes her case.

Importantly, Stowe links this maternal capacity for sympathy with the ability to read the Bible 'correctly,' which she in turn suggests leads to 'feeling right' and to abolitionism. Rhetoric of true womanhood posited that the source of female strength lay in a woman's inherent religiosity and piety, and Uncle Tom's Cabin explicitly connects these 'feminine' traits to sentimental literacy.[2] Stowe teaches her white characters – and her white readers – the proper way to deal with the Bible before showing them how to interpret slavery. One of the novel's more overtly political tactics is to guide readers through the contemporary debate over the role of the Bible in justifying either slavery or abolitionism, ultimately teaching them that slavery is counter to God's will. In the years leading up to the publication of Uncle Tom's Cabin, the

debate over who was misinterpreting the Bible and therefore blaspheming was conducted at a [high] pitch. Because of the unquestioned authority of the Bible, it became the favorite weapon of both pro- and antislavery forces. The abolitionists positioned themselves as driven by a Christian imperative to combat evil, and the South responded by 'discovering' the Biblical defense of slavery. (O'Connell 21)

Within this debate, abolitionists tended to have a more difficult time using the Bible to support their cause than those who supported slavery. For those who adhered to a literal interpretation of the text, as many Protestant abolitionists did, anti-slavery passages were hard to find: Old Testament patriarchs owned slaves; Moses regulated slavery but did not condemn it; Jesus said nothing against slavery; and St Paul advised the slave Onesimus to return to his master. Against this daunting evidence, abolitionists tended to turn to the Golden Rule or to logical arguments against using the Bible to promote slavery. Lydia Maria Child, for example, claimed that although Christ had never explicitly forbidden Christians to own slaves, he also never forbade counterfeiting; it was illogical, she suggested, to conclude that Christ's silence implied acceptance.[3]

In *Uncle Tom's Cabin*, Stowe rehearses both sides of the debate, using ironic descriptions of pro-slavery clergy to suggest that the Bible, as the source of Christian moral authority, necessarily teaches that slavery is wrong. For example, Stowe describes a conversation between several ladies and gentlemen on the boat that carries Uncle Tom to New Orleans. A pro-slavery clergyman tries to convince his listeners that the curse God levies on Ham for seeing his father, Noah, naked applies to Africans:

'It's undoubtedly the intention of Providence that the African race should be servants, – kept in a low condition ... "Cursed be Canaan; a servant of servants shall he be," the scripture says.'
 ... [He continued,] 'It pleased Providence, for some inscrutable reason, to doom the race to bondage, ages ago; and we must not set up our opinion against that.' (107)

The 'Cursed be Canaan' passage Stowe refers to was frequently cited by pro-slavery advocates; Mary H. Eastman, for instance, in the introduction to her 1852 anti-Tom novel *Aunt Phillis's Cabin; or, Southern Life as it Is*, quotes it and asks, 'Is it not preposterous that any man, any Christian, should read these verses and say slavery was not instituted by God as a curse on Ham and ... [his] posterity?' (14). Eastman goes on to claim that abolitionists' reliance on the Golden Rule 'is absurd: it might then apply to the child, who *would have* his father no longer control him; who *would* no longer that the man to whom he is bound should have a right to direct him. Thus the foundations of society would be shaken, nay, destroyed' (19). Stowe suggests this interpretation of the Bible is impure, corrupted by the economic forces of slavery; St Clare says that if

the price of cotton should drop, another reading of scripture would arise: 'What a flood of light would pour into the church, all at once, and how immediately it would be discovered that everything in the Bible and reason went the other way!' (160).

Given this heated rhetorical battle over the 'proper' interpretation of the Bible, Stowe's emphasis on reading scripture becomes particularly relevant to an understanding of the power to change society she locates in her audience. Stowe's female characters possess an innate ability to read the Bible correctly and consequently can convert men to an anti-slavery point of view. Mrs Shelby, Mrs Bird, and Eva are exemplars to men, teaching them that religion-fuelled empathy – not the reasoning used by politicians and businessmen, which has a way 'of coming round and round a plain right thing' (70) – demands one abhor slavery. For instance, Mrs Bird tells her senator husband, "'I don't know anything about politics, but I can read my Bible; and there I see that I must feed the hungry, clothe the naked, and comfort the desolate"' (69). Because she understands that the Bible demands sympathy for those in need, she can see beyond political exigencies to the moral grounds that underlie slavery; she can thus convince Senator Bird, who had voted for the 1850 Fugitive Slave Act, to aid Eliza in her escape. To Stowe, it is only once one has learned to read the Bible properly, with a sympathetic heart, that one can begin to 'feel right' about slavery. All readers, male and female, must thus learn to read as women before their emotions can be properly aroused to 'awaken sympathy and feeling for the African race' (xiii).

Stowe politicizes the act of sentimental reading, engaging her audience in the slavery debate by virtue of their skills as Bible readers. The extent to which Stowe thus associates ending slavery with the development of readerly sympathy has led feminist critics who follow Tompkins to emphasize what they see as the culturally subversive power of feminine affect. Elizabeth Barnes claims that 'the dynamic process of sympathy that attempts to break down barriers between real and fictive bodies' helps a 'nation of readers on the brink of war ... [form] filial attachment[s] to create and sustain the idea of the American democratic family' (95, 98). Similarly, Karen R. Smith posits the potentially radical implications of 'the reader [who] takes on and is transformed by the suffering of the represented victim,' examining 'images of reading as a form of martyrdom that metaphorically bestows upon the emphatically suffering reader the power to transcend difference' (352). Smith and Barnes both emphasize the power of sentimental reading to form bonds that subvert the racist ideology that underlies slavery; as white readers

identify with suffering black characters, they are moved to a more expansive notion of democracy and to the desire to change their behaviour to better help those victims. Robyn Warhol explains the political ramifications of such sentimental identification: 'Stowe evidently intended the realism – or, what she saw as the "*living dramatic reality*" – of her novel to work magic among her readers, to move them to sympathy and to action' (287). Such descriptions of the 'magic' performed by the novel open the compelling possibility that the piety, purity, submissiveness, and domesticity attributed to the mid-nineteenth-century cult of true womanhood could be interpreted as a sign not of patriarchal oppression but of matriarchal strength.

However, this mainstream feminist argument for the radical cultural power of sentimental readership does not fully account for the reactions of actual readers in literary reviews and fan mail. Without including the thoughts of actual respondents, such interpretations can focus only on Stowe's vision of her ideal reader. Attempts to extrapolate the cultural effect of the novel's depiction of sentiment and women's reading from this constructed ideal are necessarily limited, leading scholars to make several problematic assumptions about Stowe's actual readers. First, claims for the power of the novel's vision of a slavery-free America presuppose a friendly and sympathetic audience; in fact, there were probably just as many resistant readers as receptive ones. Second and more important here, while both Stowe and feminist critics imagined that feeling right would inevitably move readers, as Warhol says, 'to sympathy and action,' women's responses to *Uncle Tom's Cabin* present an inward-looking form of engagement, calling into question a continuum of increasingly politicized and public action posited by Stowe.

The novel's female characters represent the most traditional end of the continuum of responses to slavery that Stowe envisions. The female exemplars in *Uncle Tom's Cabin* are all roused by reading and experience to translate their abolitionist emotions into private, politicized deeds. Mrs Bird, for example, a sensitive woman whose 'unusually gentle and sympathetic nature' is thrown into a passion by 'anything in the shape of cruelty,' has become an abolitionist because of her Bible reading (68). Her 'proper' reading, notably, has given her the impetus to resist her husband and try to influence his thinking about the Fugitive Slave Act. However, she goes a step further than simply denouncing the law, exclaiming, '"It's a shameful, wicked, abominable law, and I'll break it, for one, the first time I get a chance; and I hope I *shall* have a chance, I do!"' (69). Mrs Bird here states a willingness to take illegal steps to end

an institution she feels violates God's will and the dictates of her own heart. Jean Fagin Yellin admiringly calls Mrs Bird 'the most important model for Stowe's readers among women' (96). However, it is important to point out that her activism is radically contingent – it is conditional upon Eliza's arrival at her doorstep. She *hopes* to have the chance to break the law, but will not on her own take measures to ensure that she will be put in this position. Once Eliza appears, though, Mrs Bird welcomes the opportunity to act and, within the safe confines of the domestic sphere, breaks public law.

Eva St Clare's plan, when compared to Mrs Bird's, marks a more activist place on Stowe's continuum of appropriate female responses to slavery. Eva desires to '"buy a place in the free states, and take all our people there, and hire teachers, to teach them to read and write"' (230). She wants to teach slaves to be 'Biblically literate' so that they can fully experience the reality of God's word; she believes that it is through the act of reading that the gospel can become manifest.[4] However, in the early 1850s, there were laws on the books in most southern states prohibiting teaching slaves to read and write. Most of these laws did not make it into the revised Black Codes of the mid-1850s, but slaves who were caught reading were still (at least apocryphally) subject to beatings, brandings, and amputations. Eva wants not only to break laws prohibiting black literacy, but also to relocate her household and free her slaves in order to do so; her new home in the North will become a politicized refuge for blacks seeking education. As Yellin argues, Eva's plan signals a need for women to take exceptional measures to end slavery's injustice (92–3). However, Eva's plan can never be put into action because of her untimely death.

Mrs Bird and Eva are examples of good women who *desire* to take action, but the effectiveness of their plans is to a degree undercut by the conventions of sentimental fiction: providential coincidence and melodramatic death detract from the power of both characters' proposals. Their efforts are bounded by the domestic sphere and the ideology of true womanhood; each plan, while requiring action that breaks public law, allows women to maintain a sense of 'feminine' propriety. In the novel's conclusion, however, Stowe advocates a response that is less constrained by the limits of domestic femininity. Even as Stowe writes in her 'Concluding Remarks' that the 'one thing that every individual can do' is to '*feel right*,' she advocates that women take measures that fit notions of activism more familiar to today's readers (385). Stowe writes that Northerners – women included – need to realize that slavery is not 'a

thing to be defended, sympathized with, passed over in silence,' implying that her readers must actively lend their voices to the abolitionist cause (384). But she is even more direct in her challenge, asking, 'Shall the doors of churches and school-houses be shut upon [slaves]?' (385). She answers her question with an activist plan of recolonizing slaves to Liberia: 'Let the church of the north receive ... [slaves] to the educating advantages of Christian republican society and schools, until they have attained to somewhat of a moral and intellectual maturity, and then assist them in their passage to those shores, where they may put in practice the lessons they have learned in America' (386). By referring to churches and schools, Stowe looks to social institutions traditionally located within women's sphere but outside the home, rousing her women readers to righteous work. Mobilizing churches and schools gives women the means to enter into a more public phase of the abolition movement; instead of strictly keeping women's efforts within the home, in the novel's final moments Stowe pushes for action that exceeds the purely domestic arena.

One could perhaps argue that because Stowe frames her exhortations as questions at the end of *Uncle Tom's Cabin*, the call to action is implied at best. However, in the years following the novel's publication, Stowe claimed that women should move towards an even more expansive notion of public activism than she put forth in the novel. In 1854, as the debate over the Kansas-Nebraska Act grew more heated, she reiterated that, for women, the development of sympathy should be the root of larger-scale action against slavery:

> The first duty of every American woman at this time is to thoroughly understand the subject for herself, and to feel that she is bound to use her influence for the right. Then they can obtain signatures to petitions to our national legislature. They can spread information upon this vital topic throughout their neighborhoods. They can employ lecturers to lay the subject before the people. They can circulate the speeches of their members of Congress that bear upon the subject.
>
> Above all, it seems to be necessary and desirable that we should make this subject a matter of earnest prayer. (Charles Edward Stowe, 259–60)

As at the end of the novel, here Stowe indicates that before any 'political' action can be taken, women must first come to understand the issues that surround slavery and abolitionism, presumably through reading books like her own. But once they 'feel right,' women ought to

become agents of change: through grassroots measures in the public sphere, they should spread the abolitionist word through their communities and – surprisingly, given the novel's disavowal of a corrupt political arena – engage directly with legislators. Stowe even associates 'earnest prayer' with this kind of explicitly political action; it, too, is a means of becoming engaged in public abolitionist discourse. By 1854 Stowe had reached the conclusion that domestic sentiment and limited female response are not sufficient; women must more directly influence the public domain in order to be effective in ending slavery.

Stowe offers a number of potential measures by which women can facilitate the end of slavery, ranging from wielding emotional influence over husbands, to limited domestic civil disobedience, to weighing in on public discourse. These strategies originate in acts of proper reading, moments in which sentimental, feminine identification allows women temporarily to elide the differences between themselves and the slaves about whom they read. Reading is thus both a means to information, teaching women about slavery's evil, and a means to action, fostering the necessary sympathy and tears. Implicit in Stowe's concept of sentimental readership is a redefining of womanhood. In the novel and in her later writing Stowe appropriates the rhetoric of true womanhood, in particular pushing to its 'logical' end language that emphasizes women's moral and emotional superiority over men. If women are indeed naturally sympathetic beings who bear the burden of training their children to be good Christians and good citizens, as this vision of womanhood would suggest, then contained within this ideal is room for certain types of action. Stowe claims that because women possess the identificative ability necessary to understand slavery's evil, it is fundamentally *feminine* to work to end slavery. That work can range from changing the opinions of men to taking more activist, grassroots measures. But most important, while *Uncle Tom's Cabin* suggests that the *desire* to end slavery is nearly as effective a tool for ending slavery as taking more direct measures, it still maintains that action is necessary.

It is clear why the ideal of this mobilized sentimental woman reader is desirable: for Stowe, it galvanizes women with a voice through which they could influence an inaccessible political sphere while still emphasizing appropriate 'feminine' qualities. Likewise, for many feminist critics, it signals a radical expansion of the notion of true womanhood beyond the confines of home and heart. Although the cultural power of this ideal is undisputed, a look at a number of responses to *Uncle Tom's Cabin* suggests that the effects of reading the novel were somewhat dif-

ferent than what Stowe and feminist critics have hoped. In spite of the novel's tremendous success and millions of devoted readers, Stowe's efforts to move women 'to sympathy and to action' against slavery seem to have prompted self-reflection in readers more than the outward-looking, grassroots measures she describes.[5]

Uncle Tom's Cabin was a literary phenomenon unmatched in the nineteenth century. While Hawthorne's *The Scarlet Letter* sold a very respectable 7,800 copies in his lifetime, Stowe's novel sold 10,000 copies in its first few days in print in its complete form; within a year, 300,000 copies had been sold in the United States alone. These numbers do not even begin to tell the whole story, as one review reminded readers: 'we must not forget, that ... Uncle Tom has probably ten readers to every purchaser, and in a calculation of the readers we must stretch our powers of arithmetic to a degree far beyond to what they have been tasked by the numbers of purchasers [*sic*], and try to expand the hundred thousands into millions' ('Uncle Tom Epidemic' 355). The novel's ubiquity sparked the production of plays, poems, songs, toys, games, dioramas, china figurines, dresses, hats, and commemorative plates based on its plot – even gold and silver spoons bearing a portrait of Stowe and a picture of the cabin itself.[6]

With this unparalleled commercial success, *Uncle Tom's Cabin* was poised to influence the millions of readers. Rufus Choate, a prominent pro-slavery lawyer and former senator from Massachusetts, was quoted in the *Independent* as stating a fear that the novel could make 'two millions of abolitionists' (137), while a sympathetic review in the *New Englander* proclaimed that Stowe 'has made the public realize ... the unspeakable wickedness of American slavery ... [She] has brought the dreadful meaning of facts into contact with millions of minds' (Review 588–9). Stowe's sympathetic reviewers almost universally linked the novel's popularity to the particular effectiveness of her 'feminine' framing of the abolitionist case; they tended to focus on the power of her religious argument and its emotional language. A review in *The Literary World* titled 'The Uncle Tom Epidemic' found that the novel 'appeals strongly to the domestic feelings' and as such 'never fail[s] to awaken sympathy, and ... arouse indignation in every human heart' (355). By describing the novel's effect on the 'human heart' and its deployment of religious pathos and domestic feelings, *The Literary World* ascribes the power of *Uncle Tom's Cabin* to qualities in both author and readers that nineteenth-century culture generally attributed to women. The London *Times* pointedly emphasized that it was Stowe's gendered depiction

of slavery that made the novel persuasive: 'With the instinct of her sex, the clever authoress takes the shortest road to her purpose, and strikes at the convictions of her readers by assailing their hearts. She cannot hold the scales of justice with a steady hand, but she has learnt to perfection the craft of the advocate ... Who shall deny to a true woman the use of her true weapons?' (Review 478). The *Times* makes clear that even though Stowe, by virtue of her sex, does not have direct access to policy, her ability to affect her readers' hearts is the key to the novel's success. The reviewer's comment that emotional appeal is the innate weapon of a 'true woman' implies that Stowe's women readers are, by their nature, similarly armed to spread the word. As in the novel, an essentialized notion of womanhood enables – demands, even – female action and agency.

The sheer force of these emotional reactions to *Uncle Tom's Cabin* raised two specific fears in the minds of some anti-slavery reviewers. First, the author of 'The Uncle Tom Epidemic' was concerned that the novel would 'excite inconsiderate popular feeling' against slavery that would make the issue harder to resolve without bloodshed (358); the *Times* similarly worried that the book's 'effect will be to render slavery more difficult than ever of abolishment ... It will keep ill-blood at the boiling point, and irritate instead of pacifying those whose proceedings Mrs. Stowe is anxious to influence on behalf of humanity' (Review 481–2). Despite the legitimacy of this concern, the fear that the novel's emotionalism would not be backed up by the continuum of politicized action Stowe describes was just as common. Charles F. Briggs's 1853 review in *Putnam's Monthly* points to just this problem: he states that 'it is the consummate art of the story teller that has given popularity to *Uncle Tom's Cabin*, and nothing else. The anti-slavery sentiment obtruded by the author in her own person, upon the notice of the reader, must be felt by everyone, to be the great blemish of the book; and it is one of the proofs of its great merits as a romance, that it has succeeded in spite of this defect' (100). Briggs, valuing the novel's artistry over its propagandistic qualities, dilutes Stowe's abolitionism into pure sentimentalism.

Despite the book's popular success, America's political ire was generally slow to awaken, particularly where women readers were concerned. In fact, it was in England – where sales of *Uncle Tom's Cabin* totaled approximately one million in 1852, as compared to three hundred thousand in the United States – that the largest-scale, traditionally political mobilization of women readers was seen. A group of English ladies

called upon American women to 'raise your voices to your fellow-citizens, and your prayers to God, for the removal [of slavery's] affliction' (qtd. in Johnston 271). Their petition, known as the Stafford House Appeal, garnered half a million signatures; they sent the 'Affectionate and Christian Address' to Stowe in the hopes of galvanizing American women. The scale of their political activism, however, was not echoed by their target audience. The *Southern Literary Messenger*, responding to the petition in an article titled 'Woman's True Mission,' was relieved to note that the novel had not had the same effect in the United States:

> Fortunate it is for America, that [Stowe] has succeeded so much better than the mother country in ... teaching [women their] mission ... [T]hanks be to the wisdom-imbued mothers of America, that reprobate woman stands almost alone ... And though she may be a fitting recipient for the caresses of English women, the daughters of America feel that she has been carried far ... from their sympathies and their respect. (305–6)

The article applauds the 'wise' American women who avoid this sort of activism, which the *Messenger* deems not only politically wrong but in violation of woman's proper place.

When more sympathetic responses to *Uncle Tom's Cabin* than the *Messenger*'s are examined, it becomes clear that while 'feminine' sentimental readership was indeed responsible for converting many readers to the abolitionist cause, the attention of individual women seems to have been turned inward, rather than to the variety of activist measures that Stowe recommends. Although, as New York lawyer George Templeton Strong wrote in his journal, the novel 'set all Northern women crying and sobbing over the sorrows of Sambo,' evidence of grassroots mobilization is scarce (qtd. in Gossett 167). Women's responses to reading the novel were typically rooted in the domestic sphere, but intriguingly they tended to collapse Stowe's implied distinction between affect and action. Like Mrs Bird, women readers felt the desire to do *something* to end slavery, but their rhetoric points to a more insistent concern with their own place within the true womanly ideal.

For instance, women most frequently were inspired not to intervene publicly in the slavery debate but to reinterpret activities in the home through the novel's lens. In a satirical letter to the editor of the Portland, Maine, *Eclectic* entitled 'A Voice From a Sufferer,' a man identifying himself as Mr Tyke, 'The man who never read *Uncle Tom's Cabin*,' described the behaviour of his wife and daughters:

Mrs. Tyke read [*Uncle Tom's Cabin*] in the New Era long ago, – and she, as well as the little Tykes, has been reading it in two volumes ever since. Never was a mortal so hunted down by a book before. I have no peace – morning, noon or night. Indian cake at breakfast suggests sympathetic allusions to the thousands of poor Uncle Toms at the South, who must eat hoe cake or die; dinner is enlivened by conversation upon the incidents of the work; and I am pestered every evening after tea, by my eldest daughter's imploring me to hear 'the last sweet song about little Eva.'

The young ladies are working fancy sketches of Uncle Tom's physiognomy in black worsted; the baby has a woolly headed doll *whom* she tries to call Topsy ... Our youngest has fortunately been christened – but Mrs. Tyke gives dark and mysterious hints about naming somebody else Eva one of these days, if circumstances permit. (5)

Despite the obviously derogatory humour of this sketch, the behaviour Tyke details is fairly typical of women's sympathetic responses to the novel. One of the most common actions taken by women after reading the book appears to have been naming daughters after Eva; in fact, by the end of 1852, approximately three hundred babies in Boston alone had been christened with that name (Hirsch 305). This private gesture suggests a deeply felt affinity for the beautiful death of the little girl, but does not necessarily point to a desire to pursue the sort of abolitionist work Eva advocated.

More specifically, the behaviour that Tyke rails against is firmly rooted in the domestic sphere. The Tyke women have turned everyday womanly activities – cooking, sewing, taking care of children – into small-scale abolitionist protests. As a result of reading *Uncle Tom's Cabin*, traditionally separate spheres have been intermixed in such a way as to allow women to comment upon public debate from within the confines of the home. Their household objects have given them a forum in which they can express political sentiments to which they did not traditionally have access. As the Tyke women have turned their home into an abolitionist haven, they have also asserted their power in the home. In their hands, Uncle Tom becomes not a martyr who has found in his faith the power to resist physical abuse, but a piece of homespun art they can display; Topsy is a toy for the baby. Characters who are property in the novel essentially are figured as commodities to be enjoyed – objects of delight for free women. Mrs Tyke and her daughters derive pleasure from thus taking the novel into their home and hearts; not only have they gained toys and leisure activities from their reading, but they have also assumed

a position of moral authority from which to 'pester' Mr Tyke. As a result of 'properly' reading Stowe, the Tyke women have redefined their home around their beliefs and pleasure.

The Tykes embody the shift within many responses to the text; their reaction simultaneously domesticates slavery and politicizes domesticity while turning attention to the home and women's place in it, rather than to slavery's wrongs. A second example demonstrates even more how such rhetorical turns put the focus on women readers' own struggle with gender roles, as opposed to on anti-slavery activism. In a letter to Stowe, her friend Georgiana May writes:

> I sat up last night long after one o'clock, reading and finishing 'Uncle Tom's Cabin.' I *could not* leave it any more than I could have left a dying child; nor could I restrain an almost hysterical sobbing for an hour after I laid my head upon my pillow. I thought I was a thorough-going Abolitionist before, but your book has awakened so strong a feeling of indignation and compassion, that I seem never to have had *any* feeling on this subject till now. But what can we do? Alas! alas! what *can* we do? This storm of feeling has been raging, burning like a very fire in my bones, all the livelong night, and all through my duties this morning it haunts me, – I *cannot* do away with it. Gladly would I have gone out in the midnight storm last night, and, like the martyr of old, have been stoned to death, if that could have rescued these oppressed and afflicted ones. (qtd. in Gossett 167)

In this letter, May expresses the 'right' feelings that Stowe tries to inculcate in her audience: her 'storm of feeling' burns 'like a very fire' without end. Although she had had abolitionist feelings before reading *Uncle Tom's Cabin*, she seems 'never to have had *any* feeling on the subject' until she picked up the book. As in the novel itself, the maternal desire to protect and heal one's baby becomes a lens through which she understands the novel's plot. May writes that she '*could not* leave [the book] any more than [she] could have left a dying child'; through the reading process she becomes willing to do the same for slaves. For May, the novel is like Eva herself – a dying child who must be tended to, who inspires religious feelings, who pushes one towards abolitionism. The text itself becomes humanized, a child in need of her attention, a talisman of sentiment and right feeling.

The excess of maternal feeling that May experiences as a result of her reading takes its form in language of both delightful and uncomfortable bodily sensation. May's repeated use of corporeal images signals the log-

ical extreme of a discourse of womanhood that privileges tears as a mode of expression while it also denotes May's failure to live up to a disembodied feminine ideal. Specifically, this response to *Uncle Tom's Cabin* exposes the conflicted nature of true womanly concepts of the female body – that it is at once a means of visibly communicating sympathy and yet a vessel of unfeminine corporeality that theoretically should not exist in a proper lady, a figure whose emotions and piety transcend the limits of her flesh. May is overwhelmed by right feeling to such an extent that emotion exceeds propriety. That these sensations 'haunt' her suggests that she is aware that what she feels is somehow wrong, but that she will not let go of this fantasy that has taken physical root inside her.

In May's case, Stowe's novel has aroused abolitionist sentiment that is given form in a body politic – or, more accurately, in *her* body politic. As the Tyke women's household chores become politicized by the interpolation of abolitionist feeling into a domestic routine, so May's own body becomes a site of mingled pain and pleasure that gives her the means to express a gendered, maternal condemnation of the political sphere.[7] Her unrestrained 'hysterical sobbing' and the feeling that burns 'like a very fire' in her bones are themselves expressions of a politicized feminine subjectivity. May's letter thus demonstrates the ways in which Stowe's women readers were put in a position to exceed the limits of true womanhood by the novel's very rhetoric: encouraged to feel right, May's sympathy is embodied and her body is in turn politicized by approaching the novel as a true sentimental reader should. May's response suggests further that this 'improper' position gives voice to a sense of self-righteousness that is pleasurable and enabling. The 'indignation and compassion' that *Uncle Tom's Cabin* fosters empower May to consider herself to be 'like the martyr of old.' Even as she identifies with the pain of 'oppressed and afflicted ones,' May takes pleasure in knowing that her feelings put her on the side of moral and political 'right.'

However, as significant as the development of this female voice is in testing the limits of true womanhood, the strong feeling of 'indignation and compassion' aroused by the book appears ultimately to keep May's attention on herself. May's letter gives no indication that she has been inspired by her reading to engage in direct political action. She asks, echoing Stowe, 'But what can we do? Alas! alas! What *can* we do?' But while Stowe offers a continuum of responses that extends beyond feeling right, May's repetition of the question suggests a sense of helplessness. She writes, 'Gladly *would* I have gone out in the midnight storm last night, and, like the martyr of old, have been stoned to death, *if that*

could have rescued these oppressed and afflicted ones.' In its use of the conditional voice, this statement resembles Mrs Bird's when she says she hopes to have the chance to aid a runaway slave; without the coincidental appearance of such a person, the possibility of engagement is effectively shut down. May's emotions have collapsed in on themselves – she *would have* taken action if she thought that it would save the lives of slaves, but the sheer force of her passion does not open the door for practical politicking. The pleasure and pain that May feels do give her a voice that pushes at the limits of nineteenth-century notions of proper womanhood, but these feelings are more self-reflexive than they are outward looking. In a culture that promoted female self-abnegation and erasure, this focus on the self, this turning inward of political issues, suggests a pleasurable rejection of confining roles, but it does not seem to open up the possibility of the activism Stowe describes.

The responses of these sympathetic Northern women readers suggest that Stowe's aim to manipulate her audience's 'feminine' emotions through identification with slaves was successful in converting readers to a frenzy of abolitionism but not in encouraging them to act beyond the limits of the home. The solipsistic pleasures of 'feeling right' provided female readers with an important mode of agency that counteracted contemporary notions of women's self-denying, apolitical natures and their lack of physical passion, but they were not necessarily an impetus to engage in action beyond sympathizing. These responses to the novel counteract the image of the woman reader on which so many recent feminist critics have relied. The readers of *Uncle Tom's Cabin* were, as such scholars suggest, deeply affected by the book, and often revised not only their feelings about abolitionism but their thinking about their domestic possessions because of the experience of reading. However, being moved to sympathy for the plight of slaves apparently turned readers' eyes to their own circumstances more than it did to the political sphere.

Yet even as responses to *Uncle Tom's Cabin* reveal the flaws in our own contemporary concepts of the cultural role of the nineteenth-century woman reader, they also signal a resistance to Victorian America's notions of what women should read and what female readership *does*. Stowe's expectations that reading about slavery would lead to public action against it may not have been met, but the effects of her changes to women's sentimental reading material are palpable. As both Cathy N. Davidson and Susan K. Harris have noted, sentimental literature was typically directed at a female audience; it primarily was a tool for female

education, teaching women about new subjects and about their proper gender role. Such novels at once allowed women to imagine a variety of social possibilities while overtly advocating a traditional, domestic feminine ideal.[8] *Uncle Tom's Cabin*, with its connection between empathetic reading, identification with characters, and conversion to abolitionism, explicitly broadens the reach of sentimentalism. Her presentation of the horrors of slavery within the conventions of the sentimental novel in and of itself alters the prevailing model of female readership. While still, like most sentimental texts, teaching women about their proper role in society, *Uncle Tom's Cabin* demands that this role include a stake, albeit a largely indirect one, in the political arena. Prevailing ideas about female readership required books to teach women to be better wives and mothers; Stowe plainly shifts the terms of what proper womanhood entails to include a deeply felt abolitionism. When women like Mrs Tyke read the novel, their very notion of what 'home' entails expanded to include abolitionism, even if in practice this expansion did not include any of the modes of politicized response that Stowe advocated.

Women's experiences with *Uncle Tom's Cabin* also push at expectations about what women's reading is *not* supposed to do. As the novel grew in prominence as a literary form through the eighteenth and early nineteenth centuries, anxieties about the pernicious effects reading novels could have on 'true women' were prevalent. Novels were thought to be dangerous to women, arousing uncontrollable sexual passion that unsexes their readers. The concern was that, as the imagination is stimulated by fiction, so will be the body to the extent that the reader is no longer recognizably 'feminine'; the excesses of novel-reading, it was feared, will ruin not only otherwise true women, but entire families and communities.[9] Although this anti-novel discourse was declining by the middle of the nineteenth century, concerns about the effects that certain types of sensational fiction would have on the health and virtue of women readers remained common. Given this concern about the propriety of women and girls reading novels, many women writers refused to categorize their works as fiction, instead emphasizing, like Stowe, the religious and educative qualities of the book as well as its inherent truth.

Intriguingly, Stowe's Southern detractors made a particular point of claiming that *Uncle Tom's Cabin* was a 'dangerous' book for female readers, citing the same reasons as those who railed against novels in general. Louisa McCord, in a lengthy review of the novel for the *Southern Quarterly Review*, claims that the book is 'a collection of "tales of wonder," which would rival in horrors those of Monk Lewis' (109). This statement

not only undermines Stowe's claims for the truth of *Uncle Tom's Cabin*, but also places the book in the sensational gothic genre. Indeed, she suggests that the book is 'spiced too high' with the 'vilest kind' of incidents so as to 'leave the diseased taste of the reader, who has long subsisted on such fare, sick, sick and palled as it is with the nauseous diet, still with a constant craving, like that of the diseased palate of the opium eater, for its accustomed drug' (85–6). In *Aunt Phillis's Cabin*, Mary H. Eastman similarly notes that Stowe's is a 'book of romance' – as opposed to a realist work – the sort that 'sells well, for the mass of readers are fond of horrors' (271). The two authors suggest that the popularity of *Uncle Tom's Cabin* is not due to a positive sympathetic reaction to tales of truth, but to something addictive and destructive that appeals to readers' basest, unladylike desires.

Eastman goes on to make the point that reading such 'romances' as *Uncle Tom's Cabin* is especially dangerous for innocent women. While describing the life of Susan, an unhappy slave who is 'seduced' by abolitionists into running away from an idyllic life in the South to a miserable one in the North, she notes that the girl 'was fond of hearing her favorite books read aloud. For the style of books that Susan had been accustomed to listen to, as she sat at her sewing, Lalla Rookh would be a good specimen' (57). *Lalla Rookh,* an 'eastern romance' by Thomas Moore first published in 1817, tells the story of an Indian princess who, on her way to be married, falls in love with a poet who turns out to be her future husband in disguise. It is the type of romance that many warned young girls about; it also subtly tells the story of romantic heroes and heroines who rise up to resist tyrants. This is Susan's favourite book and the possible cause of her 'fall' to the abolitionists; her imagination, fired up by her reading, makes her susceptible to the 'lies' of Northerners who convince her to run away. In essence, Eastman has recast anti-novel discourse, replacing the innocent girl who is seduced because she has read too many novels with the naïve slave who mistakenly gives up her life on the plantation because of her reading.

Eastman's and McCord's claims that *Uncle Tom's Cabin* was a dangerous book when in women's hands lead them to disparage Stowe for her lack of true womanhood. McCord pointedly states that she hopes that the 'ten thousand dollars [Stowe earned for writing the novel] was ... worth risking a little scalding for. We wish her joy of her ten thousand easily gained, but would be loath to take it with the foul imagination which could invent such scenes, and the malignant bitterness (we had almost said ferocity) which, under the veil of Christian charity, could

find the conscience to publish them' (84). McCord's sense of self-righteous indignation is aroused by the profit Stowe has made on the book; the money apparently comes at the price of Stowe's femininity. Eastman is even more explicit about the connection between Stowe's writing and unladylike bodily arousal. She describes a nameless '*she Abolitionist*' who 'writes for the Abolition papers' as sexually profligate: 'she wants Frederick Douglass to be the next president, and advocates amalgamation ... She is so lost to every sense of propriety that it makes no difference to her whether a man is married or not' (229–30). Female abolitionists like Stowe, Eastman asserts, have neither propriety nor sexual mores; politicization of women becomes tantamount to sexual licentiousness – and, it is hinted, miscegenation. Both women recall fears that novel-reading and writing endanger the mental and physical purity and even the marriageability of women readers.

Georgiana May's testimony about her reaction to *Uncle Tom's Cabin* clearly demonstrates that the novel did arouse the very sort of excessive bodily sensations that anti-novel advocates and Stowe's Southern detractors railed against. The 'storm of feeling' she suffers through has distinctly sexual overtones: 'I seem never to have had *any* feeling on this subject till now ... This storm of feeling has been raging, burning like a very fire in my bones, all the livelong night ... I *cannot* do away with it.' May's reading experience recalls Roland Barthes's notion of a reader's orgasmic *jouissance*. The mingling of a sense of maternal bereavement with readerly passion caused by *Uncle Tom's Cabin* suggests that it serves as what Barthes calls a 'text of bliss': 'the text that imposes a state of loss, ... unsettles the reader's historical, cultural, psychological assumptions' (14). The pleasure May has found in reading *Uncle Tom's Cabin* has disrupted her sense of the world around her, redefining the terms on which she interprets her role in her home and as a mother. That it is her maternal body which channels May's readerly and physical pleasure is suggestive. Her experience with Stowe's novel contradicts notions of passionless, disembodied Victorian women, but also counteracts the prevailing idea that women's reading should be for moral edification and not for pleasure. Such highly embodied reactions to the novel indicate that women were not only subject to the 'depravity' feared by those who railed against the genre, but that they enjoyed feeling such pleasure. They sought to recreate that physical, readerly pleasure by writing effusive letters to Stowe, by turning their household chores into games that recalled the text, and simply by reading and rereading the book as often as they could.

An examination of women's responses to *Uncle Tom's Cabin* demands a revision of our notions of the nineteenth-century woman reader and the cultural work done by sentimental reading. We must first realize that the claims made by Stowe and her recent defenders for the mobilization of an army of feeling women to do battle against slavery are exaggerated; sympathetic women did not engage in the public, political arena as Stowe hoped they would. This lack of public action, however, signals a deeply felt, self-perpetuating, inward-looking readerly pleasure that is important to a feminist understanding both of women's reading practices and of nineteenth-century ideals of women readers. This pleasure is not limited to true womanly domestic practice, but is expressed in bodily sensations; as such, this textual pleasure indicates that reading was not simply a means of teaching women their proper place. That women sought to recreate the many joys of reading and responding to books as often as possible suggests that such pleasure, although often outwardly decried by Victorian moralists, was absolutely central to nineteenth-century women's experience with texts. Indeed, rather than simply promote the ideal of the domestic, true woman, the act of reading sentimental novels like *Uncle Tom's Cabin* reveals the seeds of ideological conflict: reading simultaneously enables a domestic ideal and reveals that pleasure and authority come when the limits of that ideal are pushed.

NOTES

1 Iser determines that the ideal reader 'is a purely fictional being' who has 'an identical code to that of the author' and would thus 'be able to realize in full the meaning potential of the fictional text' (29). Here, I differentiate the ideal reader of *Uncle Tom's Cabin* – a construction Stowe develops in the novel to suggest perfect sentimental interpretation – from her *implied* readers, also constructions of the text. The implied reader 'embodies all those predispositions necessary for a literary work to exercise its effect' (Iser 34); in the case of *Uncle Tom's Cabin,* the implied reader is a person who is capable of learning to *feel right* and to read *right,* but needs to be taught by the text to do so.

2 See Welter for the quintessential statement of a true woman's traits: 'The attributes of True Womanhood, by which a woman judged herself and was judged by her husband, her neighbors and society could be divided into four cardinal virtues – piety, purity, submissiveness and domesticity' (152).

3 See Gossett (122–5) for a detailed discussion of the battle between abolition-
ists and proponents of slavery over biblical interpretation and Stowe's own
position in this debate.
4 Janet Cornelius contrasts what she terms 'Bible literacy' with 'liberating liter-
acy.' Whereas the former's 'prime motive was the conservation of piety,' the
latter 'facilitates diversity and mobility' (171).
5 Since I am primarily concerned with women readers, I have focused on arti-
cles published in journals geared towards a female readership; essays, books,
and letters written by women; and other texts by both men and women that
address the issue of female readership directly. See Gossett and Hirsch for
wider surveys that include published and unpublished reactions among
Northerners and Southerners, men and women, blacks and whites.
6 See Gossett and Hirsch for discussions of the cultural phenomenon spawned
by *Uncle Tom's Cabin*.
7 See Noble (141–3) for an interpretation of the masochism inherent in May's
response.
8 Harris writes that mid-nineteenth-century letters and diaries indicate that
women readers were particularly interested in books that told historical or
fictional stories of exceptional women, that provided intellectual substance
that would give them 'power in the world of ideas,' and, more specifically,
that featured heroines who had to become professionally or emotionally self-
sufficient (30). Although Davidson discusses republican sentimentalism, she
similarly stresses the imaginative possibility of such fiction, suggesting that
'sentimental novels fulfilled the social function of testing some of the possi-
bilities of romance and courtship – testing better conducted in the world of
fiction than in the world of fact' (113).
9 See Davidson (38–54) for a discussion of anti-novel discourse and shifting
attitudes towards the novel in the late eighteenth and early nineteenth cen-
turies.

WORKS CITED

Barnes, Elizabeth. *States of Sympathy: Seduction and Democracy in the American Novel.*
New York: Columbia UP, 1997.
Barthes, Roland. *The Pleasure of the Text.* Trans. Richard Miller. New York: Hill
and Wang, 1975.
Briggs, Charles F. 'Uncle Tomitudes.' *Putnam's Monthly* 1 (1853): 97–102.
Choate, Rufus. Review of *Uncle Tom's Cabin*, by Harriet Beecher Stowe. *Indepen-
dent*, 26 August 1852: 137.

Cornelius, Janet. '"We Slipped and Learned to Read": Slave Accounts of the Literacy Process, 1830–1865.' *Phylon* 44:3 (1983): 171–83.

Davidson, Cathy N. *Revolution and the Word: The Rise of the Novel in America.* New York: Oxford UP, 1986.

Eastman, Mary H. *Aunt Phillis's Cabin; or, Southern Life as it Is.* 1852. New York: Negro UP, 1968.

Flint, Kate. *The Woman Reader 1837–1914.* New York: Oxford UP, 1993.

Gossett, Thomas F. *Uncle Tom's Cabin and American Culture.* Dallas: Southern Methodist UP, 1985.

Harris, Susan K. *19th-Century American Women's Novels: Interpretive Strategies.* New York: Cambridge UP, 1990.

Hirsch, Stephen A. 'Uncle Tomitudes: The Popular Reaction to *Uncle Tom's Cabin.*' *Studies in the American Renaissance* (1978): 303–330.

Iser, Wolfgang. *The Act of Reading: A Theory of Aesthetic Response.* Baltimore: Johns Hopkins UP, 1978.

Johnston, Johanna. *Runaway to Heaven: The Story of Harriet Beecher Stowe.* New York: Doubleday & Company, 1963.

McCord, Louisa S. 'Uncle Tom's Cabin.' In *Selected Writings*, ed. Richard C. Lounsbury, 83–118. Charlottesville: UP of Virginia, 1997.

Noble, Marianne. *The Masochistic Pleasures of Sentimental Literature.* Princeton, NJ: Princeton UP, 2000.

O'Connell, Catharine E. '"The Magic of the Real Presence of Distress": Sentimentality and Competing Rhetorics of Authority.' In *The Stowe Debate: Rhetorical Strategies in Uncle Tom's Cabin*, eds. Mason I. Lowance, Jr., Ellen E. Westbrook, and R.C. DeProspo, 13–36. Amherst: U of Massachusetts P, 1994.

Review of *Uncle Tom's Cabin*, by Harriet Beecher Stowe. *New Englander* 10 (November 1852): 588–613.

Review of *Uncle Tom's Cabin*, by Harriet Beecher Stowe. *The Times* (London), 2 September 1852. Rpr. in Stowe, *Uncle Tom's Cabin*, 478–83.

Sand, George. Review of *Uncle Tom's Cabin*, by Harriet Beecher Stowe. *La Presse*, 17 December 1852. Rpr. in Stowe, *Uncle Tom's Cabin*, 459–63.

Smith, Karen R. '*Resurrection, Uncle Tom's Cabin*, and the Reader in Crisis.' *Comparative Literature Studies* 33:4 (1996): 350–71.

Stowe, Charles Edward, ed. *The Life of Harriet Beecher Stowe, Complied from Her Letters and Journals.* New York: Houghton, Mifflin, 1891.

Stowe, Harriet Beecher. *Uncle Tom's Cabin.* Ed. Elizabeth Ammons. New York: W.W. Norton, 1994.

– Letter to Eliza Cabot Follen. 16 December 1852. Rpr. in Stowe, *Uncle Tom's Cabin*, 413–14.

Tompkins, Jane. *Sensational Designs: The Cultural Work of American Fiction, 1790–1860*. New York: Oxford UP, 1985.

'The Uncle Tom Epidemic.' *The Literary World*, 4 December 1852: 355–8.

'A Voice From a Sufferer.' *Eclectic* 3 (1852–3): 5.

Warhol, Robyn R. 'Poetics and Persuasion: *Uncle Tom's Cabin* as a Realist Novel.' *Essays in Literature* 13:2 (Fall 1986): 283–97.

Welter, Barbara. 'The Cult of True Womanhood: 1820–1860.' *American Quarterly* 18:2 (Summer 1966): 151–74.

'"Woman's True Mission," or, The Noble Ladies of England.' *Southern Literary Messenger* 19 (1853): 303–6.

Yellin, Jean Fagin. 'Doing It Herself: *Uncle Tom's Cabin* and Woman's Role in the Slavery Crisis.' In *New Essays on Uncle Tom's Cabin*, ed. Eric J. Sundquist, 85–105. New York: Cambridge UP, 1986.

3 Reading Mind, Reading Body: Augusta Jane Evans's *Beulah* and the Physiology of Reading

SUZANNE M. ASHWORTH

In a long letter, dated 15 July 1863, to Jabez Lamar Monroe Curry, influential Alabama legislator and Confederate colonel, Augusta Jane Evans defines (white, elite) Southern womanhood in no uncertain terms. Waxing philosophical, she details the aptitudes, faults, and frailties of her sisters below the Mason-Dixon line. '[T]heir imagination(s) [are] more vivid and glowing,' she declares, 'their susceptibility to emotions or impressions of beauty or sublimity, infinitely keener.' For Evans, nineteenth-century Southern women were almost a distinct race – at least they constituted a singular breed of femininity, one marked by an active inner life and an acute receptivity to external stimuli. Add to that 'more leisure for the cultivation of their intellects, and the perfection of womanly accomplishments' and in her judgment, Southern women were potentially 'perfect instruments for the advancement of Art.' But their bodies and their habitat betrayed them. According to Evans, Southern women were not realizing their inborn potential. '[L]ook at the physical and mental status of Southern women,' she exclaims, 'Are they not enervated, lethargic, incapable of enduring fatigue, and as a class, afflicted with chronic lassitude?' She attributes this collective debility to the 'fact that having a number of servants always at hand ... the Southern matron accustoms herself to having every office in the household performed by others, while she sits passive and inert, over a basket of stockings, or the last new novel' (Evans, Papers). Evans held that Southern women did not exercise their intellects or their imaginations any more than they exercised their bodies. With legions of slaves to do their bidding, they did not have to.

Evans was not advocating abolition with this disputation, and by no stretch of the imagination was she a Yankee sympathizer.[1] But this isn't

an essay about Evans's politics or slaveholding mentalities or Southern womanhood. Not directly, at least. I open with this earnest exposition of Southern womanhood to foreground the complex relationship that anchors this investigation: a relationship between reading, the body, and female ideality. Evans theorized that Southern women were physically and culturally equipped to receive 'Art.' By her culture's logic, all women were. According to Kate Flint, Victorian women had 'greater sensitivity and sensibility' than their more stoic male counterparts (54). As one nineteenth-century physician put it, female nerves 'are smaller, and of a more delicate structure. They are endowed with greater sensibility, and, of course are liable to more frequent and stronger impressions from external agents on mental influences' (qtd. in Smith-Rosenberg and Rosenberg 112). This sexually specific physiology rendered women highly sensitive to sensual and intellectual influences. For Evans, female physiology colluded with social placement to make Southern women prime conduits of culture. But both 'chronic lassitude' and unhealthy reading habits – their passivity before 'the last new novel' – made it impossible for them to embody this sociobiological possibility. In this lexicon, images of women's reading and the female body punctuate the representation of both 'perfect' and 'enervated' gendered subjects, and I aim to make better sense of this juxtaposition in the analysis that follows.

Such norms of gender and reading intermingle with regional allegiances and geographical pockets of identity. The South that was so integral to Evans's sense of self ('I am an earnest and most uncompromising Secessionist,' she wrote) was a world of its own, and Victorian trends and ideals were refracted within it (Fox-Genovese xvi).[2] Indeed, the South – as an identity-marker and a geography – is the backdrop of Evans's *Beulah* (1859), the novel that put her on the American literary map. Contemporary reviewers celebrated *Beulah* as a well-crafted 'contribution to a distinct southern literature,' and twentieth-century scholarship positions the novel firmly within a singular tradition of southern domestic fiction (Fox-Genovese xv).

While I do not mean to efface the South altogether or proffer an 'a-geographical' reading of the novel, it's important to underscore the fact that *Beulah* spoke to audiences and ideologies that exceeded Dixie's borders. I'm interested in *Beulah* because of its paradigmatic status within the genre of domestic fiction, because it was a near-bestseller in its time, because it's a literary artifact that resounds with national import: twenty-two thousand copies of *Beulah* were printed in the first

nine months after its release, and its plot, style, and themes mirror those of *St. Elmo* (1867), the clear-cut blockbuster Evans would publish eight years later (Fox-Genovese xiv, x). As Elizabeth Fox-Genovese so succinctly affirms, *Beulah* attends to 'all of the great theological, moral, and intellectual questions of the mid-nineteenth century' (xii). In light of its cultural scope and popularity, one can engage *Beulah* as a representative text, as a literary artifact that preserves norms, values, and habits that were extant across regional borders. In methodological terms, therefore, I approach the novel as a discursive emblem of beliefs and practices that pervaded Victorian America, despite local variations, political distinctions, and geographic positioning.

As a classic 'woman's fiction,' *Beulah* tells the story of a young girl's search for home, family, God, and husband in the late 1850s. At not quite fourteen, Beulah is the studious and homely ward of an asylum for orphaned children. In the novel's opening chapters, she is farmed out as a nursemaid and loses her only sister, first to adoption and then to death. Sick with grief and entirely alone, she is taken in by Guy Hartwell, a wealthy, brooding bachelor-doctor. Beulah becomes both his charge and his intellectual protégé. But as she matures, Beulah's need for financial and intellectual independence asserts itself. She leaves the comfortable, privileged home that Hartwell provides for her, supporting herself as a teacher and reading voraciously. Delving into philosophy and metaphysics, Beulah flirts with atheism and quests for literary fame. After years of this solitary, striving existence, Beulah finds herself alone, surrounded by books, longing for Hartwell. At long last, Hartwell returns from the Orient, they marry, and the novel ends with the promise of his religious conversion.

As this dominant plotline unfolds, the woman reader takes centre stage in the text. *Beulah* dramatizes women's reading graphically and deliberately, and in the process, it goes a long way towards illuminating the relationship between the reading body, the reading mind, and gendered ideality. Indeed, when Beulah reads, the narrative pays scrupulous attention to her emotional, mental, and physical anatomy – detailing her cognitive and affective responses to texts, positioning her body in space, placing her hands on the book or different parts of her body, and describing the emotional import of her face, lips, eyes, and forehead as she scans the page. To a certain extent, Beulah's reading postures reflect her author's conception of Southern femininity: its 'susceptibility to ... impressions of beauty or sublimity' and its archetypal status as an 'instrument' of art. But as we shall see, Beulah is no sedentary

Southern matron passively imbibing the latest new novel. And her read-
ing practices – her reading mind and reading body – resonate far
beyond Southern ideals and ideologies to reflect the sociomedical
truths of her age.

Beulah pushes us to more fully consider the body, to think about gen-
dered reading as a fully embodied practice – as an interpretive operation
that is firmly grounded in the body. It's my contention that this embodied
subjectivity is shaped (in part) by historical discourses that make sense of
the body – by mainstream conceptions of the relationship between mind
and body, self and sex. So I turn to physiognomy and best-selling house-
hold medical manuals[3] with the understanding that this literature com-
ments on the physiology of reading at work in Evans's novel.[4]

Roger Chartier's work encourages the revaluation of the significance
of both body and movement in the novel's successive – very physical –
images of Beulah reading. Chartier writes: 'A history of reading must
not limit itself to the genealogy of our own contemporary manner of
reading, in silence and using only our eyes; it must also (and perhaps
above all) take on the task of retracing forgotten gestures and habits
that have not existed for some time' (8–9). The physical incarnation of
Beulah's interpretive experiences may reflect some of the 'forgotten
gestures and habits' of mid-century reading practices, and at the very
least, Beulah's embodied response to the text reinforces Chartier's
contention that 'reading is not uniquely an abstract operation of the
intellect: it brings the body into play, it is inscribed in a space and a rela-
tionship with oneself or with others' (8).

Of course. Chartier's observation serves as a valued reminder of
something we think we already know: *of course* there's a body doing the
reading – a hand holding the book, a heart quickening, a tear falling on
the page; *of course* that body reads in material surroundings – a library, a
bedroom, alone or with others. Recent scholarship pays lip service to
how important the body is to the reading experience itself.[5] It has
become something of a critical commonplace to nod to the reader's
body, acknowledging that it makes a difference whether or not that
body is male or female, black or white, straight or gay, whether it's sick
or hungry or cold, whether it's reading before a cozy familial fireside or
in a darkened garret. But we have yet to fully reckon with *how* the body
makes a difference, and in its images of a woman reading, *Beulah* raises
that question. In the process, the novel enhances our understanding of
the 'body-play' at work in mid-century constructions of gendered read-
ing processes.

Given my interest in the interplay between reading body and reading mind, I focus much of this analysis on the novel's initiatory scenes of reading, on those moments when we're introduced to Beulah and come to understand who she is and how she reads. Those moments propel this essay because they introduce us to the physiology of her reading practices and to the science that premises it. As we shall see, a psychosomatic physicality – a body/mind continuum – is central to the physiology of reading enacted here. This continuum acts as an agent of both female ideality and disorder. As it represents this psychosomatic connection, *Beulah* teaches us that because reading brings the body into play – because it isn't purely an abstract operation of the intellect – reading is a privileged, embattled site of identity formation, a site where the norms and ideals of gender vie for control of the reading subject. As it's represented, reading works in, on, and through the reading mind and body, sculpting gendered subjects from the inside out and the outside in.

The Physiognomy of a Woman Reader: A Psychosomatic Self

Our historical moment increasingly refuses to separate biology from the cultural discourses and the personal perceptions that render biology meaningful,[6] but the nineteenth century negotiated the boundary between body and mind differently. Within Victorian medical lore, the body was an immutable sign and site of individual character – a fixed index of the soul. Physiognomy, pathognomy, and phrenology taught that one could gauge interior reality by its outward manifestations, be they the forms and colours of the face, passing facial expressions, or the shape of the head. These 'sciences' bear witness to a complex and historically contingent relationship between subject and object, body and mind. In this historical interval, identity was literally psychosomatic. Within the nexus of individual character, body and mind were reciprocal, coeval, and mutually conditioning. As Charles E. Rosenberg explains it, 'There were no categorical boundaries between the realms of body and mind in late eighteenth- and early nineteenth-century medical theory' (78). The body not only reflected the interior 'truths' of intellect, emotion, and spirit, but sensual and mental stimuli could also alter outward face and form. *Beulah* is uniquely invested in this mind/body relationship. Thus, examining the novel against the physiognomical codes it invokes is a productive way to begin an exploration of how Victorian notions of mind and matter inform literary spectacles of reading.

The first physical description of Beulah comes barely one page into the novel when the narrative presents her face in vivid detail, and with a nod to 'the curious physiognomist,' it cues the reader to pay close attention to the visage before her:

> Reader, I here paint you the portrait of that quiet little figure, whose history is contained in the following pages. A pair of large gray eyes set beneath an overhanging forehead, a boldly-projecting forehead, broad and smooth; a rather large but finely cut mouth, an irreproachable nose, of the order furthest removed from aquiline, and heavy black eyebrows, which instead of arching, stretched straight across and nearly met. (6)

The leading physiognomist of the age – Johann Caspar Lavater – affirmed that facial features revealed the innermost reaches of character, and Evans mines that sociomedical truth in this depiction of Beulah. By way of repetition and extended description, this passage meticulously attends to certain features of Beulah's face: the youthful heroine seems all forehead, nose, and eyebrows. On the heels of this description, we learn that this 'quiet little figure' reads. In fact, she reads a great deal. We see her hide a volume in her workbasket when the asylum ladies approach; we learn that Eugene, an old orphan friend, has 'sent her a book and a message'; and more provocatively, the novel links Beulah's countenance – its delicacy and its pallor – to her solitary and unrestrained reading habits (7, 8). '"There is not a better or more industrious girl in the asylum,"' Mrs Williams (the asylum matron) explains, '"but I rather think she studies too much. She will sit up and read of nights, when the others are all sound asleep; and very often, when Kate and I put out the hall lamp, we find her with her book alone in the cold"' (8). With the inaugural description of Beulah's face, therefore, the novel presents the physiognomy of a reader. And so the questions become: What can this physiognomy tell us about the 'body play' at work in Beulah's reading experiences? What can it tell us about the meaning of reading practices that are both the object of paternalistic concern *and* so integral to the character of our heroine?

Lavater's immensely popular *Physiognomische Fragmente* (1772) can help us answer that question, providing a useful frame for understanding the corporeal signposts of character invoked in the description above.[7] Scholars tell us that Lavater developed a science of physical difference, dividing the face into three diagnostic domains: the forehead mirrored the understanding; the nose and cheeks reflected the moral

life; and the mouth and chin signified animal appetites. With this tripartite division, Lavater's physiognomy encompassed the basic building blocks of identity in Victorian America: mind, body, and spirit. As Lavater writes: 'the nose [indicates] taste, sensibility, and feeling; the lips, mildness and anger, love and hatred; the chin, the degree and species of sensuality; the neck ... the frank sincerity of the character; the crown of the head, not so much the power, as the richness, of the understanding; and the back of the head the mobility, irritability, and elasticity' (qtd. in Graham 48). The face within Lavater's system was a window on the deepest recesses of character.

When we view Evans's portrait of Beulah through this physiognomic lens, we see the predilections of mind and body that rule her character. Her pronounced, 'boldly-projecting' forehead signifies the questing strength of her intellect, and with this detail, the narrative foreshadows the mental courage that will attend Beulah's forays into arduous philosophical texts. Her 'irreproachable nose' represents a highborn sensitivity. In fact, George Jabet's *Notes on Noses* (1852) provides a representative ranking of nasal shapes and sizes that clarifies what it means to have a nose ranked within 'the order furthest removed from the aquiline.' Within Jabet's hierarchy, the 'Class I' or aquiline nose was 'rather convex, but undulating,' which indicates 'great decision, considerable Energy, Firmness, Absence of Refinement, and Disregard for the *bienseances* of life' (9). Its antithesis (Beulah's nose) is the 'Class II' or 'Greek' nose, which is 'perfectly straight,' 'fine and well-chiselled, but not sharp,' signifying 'Refinement of character, Love for the fine arts and *belles-lettres*, Astuteness, Craft ... Its owner is not without some energy in pursuit of that which is agreeable to his tastes; but, unlike the owner of the Roman nose, he cannot exert himself in opposition to his tastes' (9). According to this codification, Beulah's nose and forehead reflect a superior intellect, an exquisite taste, and an inborn penchant for 'fine' literature. In proportion and effect, these features indicate that Beulah is 'naturally' endowed with the makings of an ideal female reader: a reader who reads the 'right' books (history, biography, moral and religious works, select poetry, and travel narratives) 'rightly' (with generous doses of self-improvement and moral discipline). Advice manual adages held that reading should function as a form of 'social education' (Flint 81). '[E]very book read makes us better able to understand others,' Matilda A. Mackarness summarizes in her *Young Lady's Book* (1876); '[W]e cannot fail to recognize the importance of [girls] reading such books as will be likely to strengthen and develop the moral faculties and

judgment' (41).[8] Given physiognomic indicators, Beulah certainly has the innate refinement to select the 'appropriate' texts – and enough mental fortitude to read them with the proper measure of moral rigour.

But her physiognomy also challenges her claim to ideality. In particular, Beulah's eyebrows and her mouth bespeak a subversive sensuality. Recall that within Lavater's physiognomy the mouth mirrors an individual's 'animal life,' or the carnal appetites that rival intellect and morality for control of the Victorian subject.[9] The largeness of Beulah's mouth reveals the aggregate health of such drives within her character. More tellingly, the fact that her eyebrows grow straight and nearly touch one another betrays powerful bodily forces. 'The eyebrows are only significant of [mental power],' Lavater explains, 'when they are unperplexed, equal, and well disposed' (177). 'Strong eyebrows,' like Beulah's, 'speak ... bodily power' (qtd. in Graham 46). Thus, this science of the face reveals the dangerous vigour of Beulah's animal life, and, as we shall see, her body will prove a force to reckon with – especially as she reads. For now, it's enough to recognize that within the confines of her face, the novel encodes the suspicious, disturbing primacy of Beulah's body.

Punctuating that primacy, the reading practices that shape this body are not the only object of communal scrutiny, regulation, and anxiety; the body *itself* is likewise the repeated object of punishing gazes and acerbic critique. This (reading) body is named 'ugly' over and over again. For instance, in the first three chapters alone, Miss Dorothea White (the horrible orphan matron who sends Beulah out as a nursemaid) demands, 'Just look at her face and hands, as bloodless as a turnip' (9). Mrs. Grayson (the wealthy, blue-blooded socialite who adopts Beulah's sister) remarks, on first seeing her, 'that girl yonder is ugly' (17). The spoiled Martin children have an extended conversation about Beulah's pallid homeliness, remarking that '"she is horribly ugly"' and that '"[h]er forehead juts over, like the eaves of the kitchen"' (28). Beulah hears each of these pronouncements in chastened silence, and to a certain extent, she internalizes this perceptual truth. Ugliness becomes a formative aspect of the body that she lives. After the Martin children callously call her 'strikingly ugly,' she sees '"horribly ugly" inscribed on sky and water' (28). And as a result of this cruel declaration (and others like it), throughout the novel Beulah habitually shrinks from public attention of any kind (28). In addition, she often refuses food – perhaps loath to nourish the body that is deemed so 'ugly' (28). Oddly, however, this unpalatable body exhibits a strange immunity to contagious disease, escaping the scarlet fever, yellow fever, and typhus epidemics that rage

throughout the novel. In these ways, the narrative asks us to consider Beulah's body as a pivotal aspect of her character.

Beulah herself understands the body as the locus of her identity, and that understanding is deeply implicated in both *what* and *how* she reads. In fact, the centrality of Beulah's body within her own self-conception gives rise to the central questions that propel her reading: 'True, she had read that identity was housed in "consciousness," not bones and muscles? But could there be consciousness without bones and muscles?' (131). Beulah wonders about the nature of the body – the relationship between body and self, flesh and spirit: '"What constitutes the difference between my mind and my body?"' she asks herself, '"Is there any difference? If spirit must needs have body to incase it, and body must have a spirit to animate it, may they not be identical?"' (209). The narrative will eventually answer these questions with conventional platitudes. (By the end of the novel Beulah will undergo a prototypical conversion experience and fulfil her domestic destiny as Guy Hartwell's wife and spiritual exemplar.) But for the bulk of the story, Beulah's identity is disturbingly and subversively rooted in the body. And because she understands the body as the '"stuff" of subjectivity,' Beulah finds herself doubting religious tenets that divorce the self from the 'bones and muscles' that give it an intelligible form (Grosz xi). More specifically, the enigmatic relationship between the physical and the metaphysical becomes the focal point of the intellectual hunger that keeps Beulah reading, drawing her to the works of Byron, Carlyle, Coleridge, Cousin, Cowper, Descartes, Emerson, Goethe, Kant, Lamb, Locke, Poe, Ruskin, Shelley, Swedenborg, Spinoza, Tennyson, and others.

This inquiry takes the principles of physiognomy to their logical outpost. To be sure, Beulah's physiognomy signifies a 'spirit' that is so 'identical' with the body that it literally shapes the face – actually creating the countenance of her character. Thus, Beulah's physiognomy does just what Evans's disputation on Southern womanhood does: it brings the body – and reading – front and centre, forcing us to question what both have to do with the kind of femininity Beulah represents.

Body 'Bad,' Mind 'Good': The Ideal Reading Subject

Beulah's fully embodied character seems to challenge Victorian ideals of reading that wanted to take the body out of the reading equation – that wanted to exile and expel what Lavater would have called the reader's 'animal life' from any textual encounter. A popular guide to

young women's improvement, for example, cautions, 'It is worthy of your observation, that the Most High ... has wisely made the gratifications arising from [the senses] in a great measure momentary. To prolong these inferior enjoyments, is the laborious task of the slaves of appetite and fancy ...' (*Young Lady's Own Book* 39–40). Such prohibitions against the body made fiction-reading a dangerous pastime; by nineteenth-century standards, it was better to centre oneself in texts and methods that were far removed from the '"realities of material and animal existence"' (qtd. in Flint 79). Within the adages of domestic advice literature, to fully embrace the body and its 'gratifications' (the senses, appetite, and fancy) was a sign of personal debasement. More pointedly, nineteenth-century physicians viewed the reading female body as a highly suspect entity. Dr Hugh L. Hodge cited reading as an exciting cause of 'morbid irritation' of the uterine system. Reading, he asserts, acts 'through the medium of the imagination and passions – through the brain – on the ovaries and uterus.' And 'the indulgence of voluptuous imaginings ... generated by the reading of romances, novels, plays, or books still more impure,' Hodge goes on to explain, have a 'terrible influence' on female physiology (233).

But the inaugural scenes of Beulah reading underscore the reality that the body was not simply or uncontrovertibly 'bad.' On the contrary, *Beulah* shows us that the body could be enlisted in the formation and representation of an ideal reading subject. And in the interplay between reading mind and reading body, we come to understand that, like Beulah, the ideal reading subject was a psychosomatic being.

In the first sustained textual encounter the novel presents (a highly idealized encounter, I might add), we're introduced to the mind/body continuum that will gauge Beulah's proximity to exemplary modes of reading and paradigmatic (pious, self-improving) femininity. In this scene, Beulah reads at the edge of a wood and beneath a cloudless sky: 'An open volume lay on her lap; it was Longfellow's Poems, the book Eugene had sent her, and leaves were turned down at "Excelsior," and the "Psalm of Life." The changing countenance indexed very accurately the emotions which were excited by this communion with Nature' (14). The object of Beulah's gaze is not the book, but the 'majestic beauty' of the landscape, and Longfellow's poetry serves only to heighten and encapsulate emotions Beulah already feels – faith, reverence, spiritual fortitude. Inspired by this fellowship with the book and the natural world, Beulah sings the 'Psalm of Life' as if it were a hymn: 'Her soul echoed the sentiments of the immortal bard, and she repeated again

and again the fifth verse: "In the world's broad field of battle, / In the bivouac of life; / Be not like dumb driven cattle, / Be a hero in the strife'" (14). In this instance, reading moves Beulah to a very physical response – to singing the words on the page – and it's clear that whatever touches her mind touches her body as well:[10] 'There was an uplifted look, a brave, glad, hopeful light in the gray eyes generally so troubled in their expression. A sacred song rose on the evening air, a solemn but beautiful hymn' (14). Beulah is communing with text and nature here – her face 'index[ing] very accurately the emotions' she feels. And like her 'changing countenance,' the reading-song bespeaks a romantically unguarded state of being. The song is spontaneous, uninhibited, and unaffected. The narrative presents Beulah's singing as a physical, even instinctual response to emotional and intellectual stimuli, one that ends in a silent prayer to 'the Great Shepherd' (14). Thus, mind and body work *on* and *through* each other as Beulah turns reading into an affirmation of self and faith (an affirmation that reflects the refinement and sensitivity we saw encoded in her forehead and nose). More significantly, Beulah's reading body is not ugly in this scene. Far from it. Rather, it's the house, the vehicle, and the agent of an 'immortal bard' and beatified Christian devotion – nothing less than the 'perfect instrument of Art' that Evans glorified.

The same idyllic mind/body dynamic is perhaps better illustrated in Beulah's response to a 'soothing, plaintive melody' that Guy Hartwell plays for her after a grief-inspired nightmare has sent her into convulsions. Because the episode so vividly dramatizes the body play that informs Beulah's reading experiences, it is worth quoting in full:

Beulah sat entranced, while [Guy] played on and on, as if unconscious of her presence. Her whole being was inexpressibly thrilled; and, forgetting her frightful vision, her enraptured soul hovered on the very confines of fabled elysium. Sliding from the couch, upon her knees, she remained with her clasped hands pressed over her heart, only conscious of her trembling delight ... [A]s the musician seemed to play upon her heartstrings, calling thence unearthly tones, the tears rolled swiftly over her face. Images of divine beauty filled her soul, and nobler aspirations than she had ever known, took possession of her. Soon the tears ceased, the face became calm, singularly calm; then lighted with an expression which nothing earthly could have kindled. It was the look of one whose spirit, escaping from gross bondage, soared into realms divine, and proclaimed itself God-born. (75)

Again, in this passage the body – its movements, gestures, and expressions – both mirror and magnify an exemplary subjective condition, one marked by 'divine beauty,' 'nobl[e] aspirations,' and an outward 'calm.' For Beulah, listening to music is no less an embodied experience than reading Longfellow in the woods, and it likewise leads to an idealized religious experience. More importantly, the body in these intervals does not simply signify or reflect Beulah's ideality; rather, it is a formative agent of the womanly perfection that she represents. Taken all together, Beulah's corporeal signals – her supplicant posture, the hand she presses to her heart, her trembling, her tears, and the expressions on her face – signify and advance an archetypal psychosomatic event. In other words, Beulah's corporeal expressions and gestures are intricately bound up in the 'God-born' sense of self she achieves.

Interestingly enough, through the character of Guy Hartwell (a physician) the novel directly implicates this exemplary psychosomatic state in the theory and practice of domestic medicine, aligning the physiognomic truths we've already encountered with sociomedical truths disseminated in household medical references. As the musician in the scene above, Beulah's doctor-guardian has essentially prescribed this receptive experience for her because he's just found her 'lying across the foot of the bed ... grasping the post convulsively' (74). And the prescription works: in the afterglow of Guy's musical tonic, Beulah becomes a vector of 'divine beauty.' The prescription works because Victorian science – the principles outlined in Lavater's physiognomy and the principles that inform domestic medical literature – posit such reciprocity between mind and body that the 'right' stimulus (be it a Longfellow poem or a piano serenade) can serve as a cordial for disorder and a conduit of ideality.

Like Lavater, nineteenth-century medical commentators saw potent, causal connections between the mind and body.[11] As Charles Rosenberg notes, Victorian medical discourse skirted distinctions between 'soul, mind, and soma – and concentrated instead on elucidating the presumed interaction between body and mind, emotions and physiological dysfunction, internal and external environment' (75). For example, *Aristotle's Masterpiece* (1798) – republished throughout the eighteenth and nineteenth centuries – explained that '[t]he Body and Mind are so disposed by the Author of nature, that they cannot act separately' (365). And *Beach's Family Physician* (1859) confirmed that '[s]uch is the connexion between the body and the mind, that one cannot be affected without a correspondent or sympathetic affection of the other' (Beach

132). Mind and body were believed to be so intimately correspondent in medical circles that the more immaterial 'mind' was indistinguishable from the biological, material brain (Flint 53). As Alexander Walker writes, 'Mind is a general term expressing the aggregate of the acts or functions performed by the nervous organs situated chiefly in the head' (3). According to accepted dictums, the nerves mediated this corre- spondence between body and mind, self and spirit. 'The most we know is, that the nerves are the connecting medium between the soul and the body,' Wooster Beach, MD, writes, 'Hence certain passions or mental affections have great influence over the system, and likewise whatever affects the body must, in like manner, affect the mind' (132). This liter- ature articulates the medical vehicle – the mind/body continuum – that shapes Beulah's reading physiognomy and the more idealized respon- sive encounters analysed above.[12] Through it, we come to understand the physiological machinery that awakens, agitates, and alters the body as she reads.

Domestic medical manuals (passion theory in particular) encourage the recognition that Beulah's body should be understood as an exacer- bating, rather than a causative, agent of womanly perfection. In other words, according to this physiological lens, the body can nourish and amplify ideality – or diminish and drain it. That systemic connection explained states of psychosomatic health and disease. For example, within medical advice literature, particular 'passions' or emotional states – love, grief, fear, anger, and so on – were a formidable influence in the onset, prevention, and cure of physical disease and psychological disorder: 'emotions out of balance meant physiological function out of balance' (Rosenberg 77). So it's not surprising that domestic references exhaustively outlined the psychosomatic effects of feeling. Anger, for example, 'ruffles the mind, distorts the countenance, hurries on the cir- culation of the blood, and disorders the whole vital and animal func- tions. It often occasions fevers, and other acute diseases; and sometimes even sudden death' (Buchan 114). The pathology of the passions graph- ically illustrates the interplay between body and mind that defined the human subject within mainstream Victorian medicine. Like physiog- nomy, 'passion theory' foreclosed the possibility that mind and body were singular or divisible aspects of being. As William Buchan wrote in his widely reprinted *Domestic Medicine* (1812), 'there is established a reciprocal influence between the mental and corporeal parts, and that whatever injures the one, disorders the other' (114).

Yet, when the mind/body continuum works for good – as it does

when Beulah engages with Longfellow in the woods – 'the mental and corporeal parts' can read in service to an idealized religious experience. So much so that the reading mind and the reading body fuel an empowering devotional exercise. Significantly, we find Beulah reading Longfellow in the woods just before she will be forced to withstand great emotional trauma – before her sister is adopted and she must leave the orphan asylum for domestic servitude. Indeed, she sings the fifth verse of Longfellow's 'Psalm of Life,' sensing 'that an hour of great trial was at hand, and this was a girding for the combat,' and the reading-song culminates in a prayer to the 'Great Shepherd' (14). This auditory reflex strengthens and ennobles her, serving as a sacred guard against the 'bivouac of life' that looms ahead of her (14). At the close of her reading-song, Beulah is equipped with 'the shield of a warm, hopeful heart and the sword of a strong, unfaltering will' (14). And to her credit, she is marked by a 'self-possession ... unusual in children of her age' (15). In this instance, the mind/body continuum nourishes Beulah's spiritual resolve and her capacity to endure: she's centred, calmed, and empowered by the connections between her reading mind and body.

We can more fully appreciate the therapeutic effects of Beulah's reading in this scene with reference to a passion that Wooster Beach, MD, terms 'Love to the Creator.' 'There is,' Beach explains, 'no passion which exercises such a healthful and important an influence as pure, celestial love' (133). Because her reading serves as a psychosomatic cordial – suffusing mind, body, and spirit with the passion of 'celestial love' – Beulah experiences a holistic rejuvenation at the resolution of this textual encounter. Her faith is affirmed, her heart warmed, her will emboldened to such an extent that she exhibits a self-control beyond her years.

The psychic strengthening that Beulah gains through the embodied dimensions of her response to Longfellow (not to mention Guy's piano serenade) re-encodes what *Guide to Health and Long Life* (1849) affirms in 'On the Passions': 'The mind can be cultivated to withstand the shocks of disasters common to the world, and also to resignation for those which can not be averted' (Culverwell 41). More provocatively, domestic medical literature allows for the possibility that this mental cultivation can come through bodily elements: exercise, air, diet, climate. Thus, rural scenery and gardening are curatives for the disorders of love, and sailing is an antidote to the pathology of grief. Reflecting these productive crosscurrents between body and mind, as Beulah reads Longfellow's verse her mind is 'gird[ed] for the combat' *through* the physical incarnation of her

response: the song. In other words, Beulah's responsive song is part and parcel of her ability to harness the strength-giving power of celestial love. Put simply, her fully embodied reaction to the text fuels and foments an exemplary state of being.

Beulah's reading is so idealized here that it's this responsive act – this inaugural scene of reading – that first draws Guy Hartwell, her future guardian and husband, to her. Unbeknownst to Beulah, Guy 'lean[s] against a neighboring tree' and 'regard[s] her very earnestly' as she sings (14). And as the novel progresses, Beulah's reading body/mind is the object of a male gaze that grows increasingly erotic. In a subsequent scene, Guy's attraction to Beulah crystallizes as she reads Thomas De Quincey's 'Analects from John Paul Richter': '*No sooner were her eyes once fastened on her book, than his rested searchingly on her face*. At first she read without much manifestation of interest ... After a while *the lips parted eagerly*, the leaves were turned quickly ... Her long, black lashes could not veil the expression of enthusiastic pleasure. Another page fluttered over, *a flush stole across her brow*; and as she closed the volume, her whole face was irradiated' (127, italics mine). The seductive, sensual potency of Beulah's reading body/mind is obvious here. In this passage, the continuity between reading mind and reading body positions Beulah fully within the courtship narrative, rendering her a full-fledged romantic heroine – a paragon of hetero-erotic ideality.

Yet despite such sensual overtones, the 'animal life' and subversive 'bodily power' latent within Beulah's physiognomy are kept in check in these passages; the framework of 'right' (moralistic, devotional, self-improving) reading ensures that she is not enslaved by carnal appetites or licentious fancies. Indeed, Beulah resolves to read De Quincey's essay as 'a guide-book to [her] soul, telling of the pathway arched with galaxies and paved with suns, through which that soul shall pass in triumph to its final rest!' (127).

While the seduction narrative might be temporarily forestalled, the sociomedical narrative continues to unfold. These scenes demarcate and define the anatomy of the woman reader that centres this story. Fundamentally, Beulah is the human subject defined within physiognomic texts and household medical manuals: she is literally a psychosomatic being – an embodied mind and a psychic body. And thus it follows that her body is a building block of whatever ideality she achieves in and through her reading experiences.

Still, it's tempting to say that Longfellow's poetry or De Quincey's 'Analects' preclude any other possibility. It's tempting to privilege the

text – the external stimulus – over the continuum that receives it, as if the text itself holds the key to gender ideality. And *Beulah* lends that supposition a certain weight. When Guy 'test[s]' Beulah's faith with the textual 'specter of Atheism,' the mind/body continuum registers the success of his experiment:

> She sat down and read. [Guy] put his hand carelessly over his eyes, and watched her curiously through his fingers. It was evident that she soon became intensely interested. He could see the fierce throbbing of a vein in her throat, and the tight clutching of her fingers, and the lips were compressed severely. Gradually the flush faded from her cheek, an expression of pain and horror swept over her stormy face. (128)

While the book in this scene is unnamed, its psychosomatic power is obvious. Beulah's body – the throbbing vein, clutching fingers, compressed lips, pallid cheeks, and mortified facial expression – index the moral and intellectual consternation she's experiencing in the grips of a godforsaken passage. And the books in Guy's library are so potent – so dangerous – that he warns her away from them: '"Beulah, do you want to be just what I am? Without belief in any creed! hopeless of eternity as of life! Do you want to be like me? If not, keep your hands off my books!"' (129). Guy's warning leaves the reading subject prostrate before the book, as if the mind/body continuum is a passive weathervane of psychic and physical currents.

Certainly, within the axioms of domestic advice books and medical manuals some texts were deemed more godforsaken than others. Cultural invectives against novel reading in particular have become legendary in the annals of literary scholarship.[13] Harvey Newcomb, for example, declared in his *Young Lady's Guide* (1846) that

> [n]ovel reading produces just the kind of excitement calculated to develop this excessive and diseased sensibility, to fill the mind with imaginary fears, and produce excessive alarm and agitation at the prospect of danger, the sight of distress, or the presence of unpleasant objects; ... If you wish to become weak-headed, nervous, and good for nothing, read novels. (201)

Likewise in *On the Preservation of Health of Women at the Critical Periods of Life* (1851), E.J. Tilt advised:

> Novels and romances, speaking generally, should be spurned as capable of

calling forth emotions of the same morbid description which, when habitu-
ally indulged in, exert a disastrous influence on the nervous system, suffi-
cient to explain that frequency of hysteria and nervous diseases which we
find among the highest classes. (qtd. in Flint 58)

With this apocryphal rhetoric, authoritative discourses granted the text
an inordinate power over the reading mind and reading body. And if
this power holds within the context of *Beulah*, then its protagonist can-
not lay a firm claim to whatever reading ideality her character repre-
sents: where novels can produce a nervous, debilitated femininity, Guy's
library can create a godless one, and in any case the text controls the
reader, dictating and determining her psychosomatic character. Accord-
ing to this critical trajectory, the 'warm, hopeful heart,' 'God-born
spirit,' and 'divine beauty' fostered in Beulah's first responsive experi-
ences are accidental by-products of a textual encounter that proves
much more formidable than her own subjectivity.

Body 'Bad,' Mind 'Good'?: The Disordered Reading Subject

As we shall see, the novel will go on to resist the power of the text,
underscoring the self-determined force of Beulah's reading practices
and her ability to penetrate – and manipulate – a text. But it's important
to note that Beulah's grasp on reading ideality is indeed fragile and
transient. In fact, she reads herself out of the fold of womanly perfec-
tion that she occupies at the novel's opening, growing thin, pallid, and
enfeebled by her intellectual exploits. As Beulah's reading becomes a
compulsion, her friend Clara Sanders observes: "'Sometimes, when I
come in, and find you, book in hand, with that far-off expression in your
eyes, I really dislike to speak to you. There is no more color in your face
and hands, than in that wall yonder. You will dig your grave among
books, if you don't take care'" (161). Thus, *Beulah* reveals that the rela-
tionship between reading, gendered excellence, and the body was a
troubled one. The reading body/mind could not be trusted to fix ideal-
ity in character, and the threat of disruption and disorder haunts the
continuum between them.

As her physiognomy indicated, Beulah exhibits a predisposition to
disordered reading practices early on in the novel, and whatever hold
she has on 'true' (reading) womanhood is an uneasy one. Almost imme-
diately, we learn that Beulah 'studies too much,' reading 'alone in the
cold' through the night at the orphanage. As both the lay community

and practicing psychologists well knew, such intense application to study was an established precursor to insanity.[14] In fact, reading played a prominent role in lay accounts of mental deterioration transcribed in hospital casebooks. For instance, one father wrote to the Pennsylvania Hospital for the Insane that as his son's grip on reality rapidly diminished, he burned his books, saying that his younger brothers 'should not have a chance to pore over them as he had done'; and another father said that his daughter's declension into insanity was first evidenced in her 'unsteady pursuit of objects of excitement, first books, then visiting ... to the neglect of all else' (Tomes 96, 102). In light of this symptomatology, when Beulah sacrifices sleep and warmth to read, she flirts with a harbinger of delusion and derangement.

Compounding her predilection to distemperate reading habits, in the opening chapters Beulah displays a disturbing vulnerability to self-centred reading reverie and inappropriate identification. For example, as the Martin baby recovers from an extended illness, Beulah reads Irving's *Sketch Book* and becomes so 'absorbed in the volume' that 'her thoughts wandered on with the author, amid the moldering monuments of Westminster Abbey' (39). Beulah's identification with Irving enables her to wander through the ruins of Westminster Abbey and occupy another subject position and space – a dangerous proposition within an ideology of true womanhood. More specifically, Beulah's mental travelling disturbs an ideology that worked hard to position women firmly within the kitchen, the parlour, the nursery, the sickroom, and the bedroom. The 'cult of true womanhood,' as Caroll Smith-Rosenberg explains, 'prescribed a female role bounded by kitchen and nursery, overlaid with piety and purity, and crowned with subservience' (13). When Beulah reads outside or beyond those bounds, *Beulah* testifies to the reality that reading might manifest itself as a form of social-forgetfulness – a relaxation of consciousness that conflicts with the other-centred ethics of domestic femininity.[15]

Even more troubling, Beulah inhabits texts at her own discretion – without guidance or censor – and such intellectual autonomy could license the 'wrong' lessons. As a testament to this danger, when Beulah is again inspired to voice her response to a text she betrays a highly suspect associative reaction. Moved to recall the life of the English poet Thomas Chatterton (1752–70) Beulah sighs, '"Ah if we could only have sat down together in that gloomy garret, and had a long talk! It would have helped us both. Poor Chatterton! I know just how you felt, when you locked your door and lay down on your truckle-bed, and swallowed

your last draught!'" (39). Although '[t]here is not a word about [Thomas] Chatterton' in the sketch before her, Beulah calls him to mind because she identifies with the social and psychological alienation he represents: he was not laid to rest in the Abbey 'under sculptured marble,' Beulah muses, '[rather,] his bones were scattered, nobody knows where' (40).

Thomas Chatterton came of age in eighteenth-century Bristol, the son of the sexton of St Mary's. Though he did not read until he was eight, once initiated into literacy he read everything he could lay hands on; he wrote his first poem at age eleven, and at twelve or thirteen he assumed the persona of a fifteenth-century priest, Thomas Rowley, and continued composing. With unscrupulous ambition, he claimed his poems were copies of medieval manuscripts housed at his father's church, and sent several to Horace Walpole. When Walpole discovered the con, he returned the poems and ended the correspondence. At seventeen, Thomas went to London and struggled to make it in literary circles. After starving for three days, he poisoned himself. Not exactly a veritable role model for a young, pubescent girl in mid-century America: Chatterton does not exemplify temperate reading practices, stoic self-sacrifice to social duty, or pious resignation to a life of suffering. Yet Beulah dwells self-formatively on the association. Admittedly, her mind often turns to Thomas Chatterton '"[b]ecause he was so miserable and uncared-for; because sometimes I feel exactly as he did"' (40). Beulah's associative connection with Chatterton may be integral to her own identity, but it's not a particularly instructive or ennobling bond. Thus this reading experience – in its all-encompassing absorption and its inappropriate associative end – is clearly at odds with the ideal reading behaviours we've seen before.

More importantly, that Beulah is again moved to *voice* her response to a text stands as a telling narrative parallel to the reading-song that marked a more fitting textual encounter. Just as before, the body operates in the service of a larger psychosomatic response: 'her mind was filled with weird images, that looked out from her earnest eyes,' the narrative relates. 'At length she closed the book, and passing her hand wearily over her eyes,' Beulah speaks aloud her thoughts of Chatterton (39). More pointedly, Beulah's sighing address to Chatterton ministers to a particular psychic construct: '"I often think of him"'; '"I feel exactly as he did"' (40). Again, the physical response (the eyes, the hand, the voice) augments and expresses a coexistent emotional state. And again, Guy Hartwell covertly observes this textual encounter, reinforcing the

embodied (and hetero-erotic) dimensions of Beulah's reading practices. Despite these narrative connections, in this instance the reading body/mind does not reinforce overarching moral or social constructs, not because the *Sketch Book* is an inappropriate text or because Irving is an improper literary companion for the woman reader,[16] but because Beulah's character – her lived experiences and affective associations – render this a countercultural reading practice. The interactions between the mind and the body – between Beulah's memories, thoughts, emotions, and words – make this scene culturally suspect, which means that it's *not* the text that undoes Beulah's reading ideality in this interval. It's *not* her body that betrays her. Rather, it's the interplay between her reading mind and reading body that is ultimately unpredictable and unstable.

What's finally at issue when Beulah reads is *the power* of her reading body/mind: there's something about Beulah's psychosomatic make-up that renders reading a volatile exercise for her. The books don't wear her out, Beulah herself explains, but 'the thoughts they excite' do (199). '"For instance,"' she details to Clara, '"I read Carlyle for hours, without the slightest sensation of weariness. Midnight forces me to lay the book reluctantly aside, and then the myriad conjectures and inquiries which I am conscious of, as arising from those same pages, weary me beyond all degrees of endurance"' (199). As Beulah makes clear, the book itself is not the toxicant. Rather, it's Beulah's receptive system – the 'conjectures and inquiries' that arise from the pages – that drains her mentally and physically. It's her reading mind and reading body that prove a more formidable force to reckon with than any given text.

At first glance, the volatility of Beulah's body/mind seems to fall in line with Victorian visions of an unruly female physiology: 'Physicians saw woman as the product and prisoner of her reproductive system' (Smith-Rosenberg and Rosenberg 112). The female sexual anatomy determined and defined female character and rendered the female body a mercurial mechanism. 'Each month, for over thirty years, these organs caused cyclical periods of pain, weakness, embarrassment, irritability, and, in some cases, even insanity,' Caroll Smith-Rosenberg details (183). These sociomedical assumptions encourage us to see Beulah's receptive system as a by-product of her reproductive system – as if ovary and uterus hold her troubled reading psyche in their unforgiving grip.

But the tenacity of Beulah's reading body/mind conflicts with physiological truths that made female subjectivity synonymous with delicacy and susceptibility. Indeed, despite Beulah's exhaustion, neither her

mind nor her body is weak or lethargic. Beulah has the physical and intellectual capacity to 'read for hours'; she engages extremely arduous texts and she reads them vigorously and critically. Thus it's the strength of Beulah's body/mind that compels her reading program:

> From her earliest childhood she had been possessed by an active spirit of inquiry, which constantly impelled her to investigate, and as far as possible explain the mysteries which surrounded her on every side ... It was no longer study for the sake of erudition; these riddles involved all that she prized in Time and Eternity, and she grasped books of every description with the eagerness of a famishing nature. What dire chance threw into her hands such works as Emerson's, Carlyle's and Goethe's? Like the waves of the clear sunny sea, they only increased her thirst to madness. Her burning lips were ever at these fountains; and in her reckless eagerness, she plunged into the gulf of German speculation. (208–9)

Underscoring the power of Beulah's reading body/mind, the narrative explains her reading practices with recourse to hungers that are both physical and intellectual: 'an active spirit of inquiry,' a 'famishing nature,' a 'thirst' for knowledge. Beulah reads, it seems, because body and mind leave her no alternative. Thus, the threat to her (pious, moralistic) reading ideality is not that sensual aspects of her responsive experiences will subsume the spiritual and the intellectual. Nor is it that Beulah will be taken over by the carnal, pulsing 'animal life' that lurks within her. The threat is that her intellect is itself embodied – that her mind hungers – and that she will choose to feed that hunger, sculpting a subjectivity that resists and defies normative gender ideals.

But feed that hunger she does. And when the novel again deploys physiognomy to index her character, her body testifies to a holistic discomposition of her reading ideality. After three years in Dr Hartwell's home, 'The placid element was as wanting in her physiognomy as in her character, and even the lines of that mouth gave evidence of strength and restlessness, rather than peace' (109). Although the narrative calls attention to the feminine elements of her physicality – her 'slender form' and 'luxuriant black hair wound in a circular knot' – the 'strength and restlessness' registered in her face is 'unsexed' by Victorian standards. Reinforcing Beulah's questionable gender identity in this passage, the narrative records this physiognomy as Beulah reads a decidedly unfeminine text: a geometry book. Hence, Beulah's physiognomy ultimately works to expose the gender trouble that is latent within her character.[17]

With the juxtaposition of its inceptive (and embodied) scenes of read-ing – one an exemplary encounter and the other a cautionary fore-shadow – *Beulah* pushes the revelation of pivotal definitive principles. 'Bad' reading practices are not simply excessively embodied reading practices; they're not simply mind-numbing acts of self-pollution or titil-lating encounters with novels and romances. Unlike the nineteenth-century's infamous novel readers or Evans's Southern matrons, Beulah is not catapulted into a degenerate sensual state; she does not read pas-sively or gluttonously, and her reading is not a stimulus to masturbation. But she does read herself out of an idealized subject position, and the Victorian continuity between mind and body renders that an omnipres-ent possibility.

Only when Beulah relinquishes her books and ceases to quest intel-lectually does she regain the paradigmatic status that she lost. Eventu-ally, we see Beulah in 'a Godless world' as 'a Godless woman': 'On all sides, books greeted her ... These well-worn volumes, with close "mar-ginalias," echoed her inquiries, but answered them not to her satisfac-tion. Was her life to be thus passed in feverish toil ...?' (370). Faced with the 'cold metaphysical abstractions' housed in her library, Beulah must amputate her voracious reading body/mind from her character to regain 'the holy faith of [her] girlhood' (371). In one of the last images we have of Beulah with a book, we see again that spiritually armoured sense of self she achieved with Longfellow's poems in her lap, only this time it's not a product of her reading: 'She took up a book she had been reading that morning, but it was too dim to see the letters, and she con-tented herself with looking out at the stars, brightening as the night deepened. '"So should it be with faith," thought she, "and yet, as trou-bles come thick and fast, we are apt to despair"' (396). Thus, the pivotal affirmation of faith that re-secures Beulah's ideality is completely divorced from the text: it isn't inspired by any particular passage and it comes after she has turned away from reading. From this point forward, the only book Beulah holds is her Bible – the one text that can, appar-ently, fix ideality in character (or, at the very least, not threaten it). In fact, the novel ends as Beulah lays the good book on her husband's lap, engaged in the 'holy work' of his conversion (420).

Ultimately, the individual reading body/mind proves too tempera-mental – too wayward – to anchor female ideality. And nothing under-scores its power, and its threat, more than the circumspection of Beulah's reading habits that concludes the novel. Therein lies a distinct irony. As a domestic novel, *Beulah* itself attempted to use the mind/body

continuum to foster ideality among its readers. As Nina Baym writes, deploying a 'grippingly affective reading experience,' the domestic novel 'aim[s] to forward the development in young, female readers, of a specific kind of character' (*Woman's Fiction* xix). But as Beulah's character teaches us, the reading mind and reading body cannot be fully governed by the text. In the end, Beulah's books couldn't effectively contain or restrain the psychosomatic nature of their reader. Thus within its pages *Beulah* enfolds the sociomedical truth that haunts the age: that the 'young, female reader' is always already reading beyond or outside this psychosomatic fence-row of self-improvement; that she's transfiguring and transforming herself as she reads; and that her mind – and her body – are in control.

NOTES

1 On the contrary, Evans broke off her engagement with Yankee journalist James Reed Spaulding because he argued that secession was akin to treason and economic suicide. Her wartime journalism qualifies as ardent Southern propaganda; she travelled regularly to the Confederate front, and with the publication of *Macaria* (1863) she hoped to glorify the cause. After the war, she refused to receive any man who had served in the Federal army, even when it meant turning away the literary brass that would have advanced her career (Evans Papers).
2 As Eugene D. Genovese remarks, slaveholders 'adapted the messages of bourgeois domesticity, economic and scientific progress, and socially responsible Christian charity to local conditions and values' (xv).
3 Among general domestic medical references, I rely primarily on Dr William Buchan's *Domestic Medicine*, John C. Gunn's *Domestic Medicine*, and Dr Wooster Beach's *Family Physician*. According to Joan Burbick, Buchan's and Gunn's texts rank among the century's most popular lay manuals written by regular physicians (18). In addition, Burbick argues that medical manuals are deeply implicated in the rhetoric of nation-building. That rhetoric likewise informs theories of reading. This common nationalistic aim underscores the fact that although this essay centres on a woman reader, the reading body isn't just a gendered entity; it's a coagulation of multiple identity markers (age, race, class, region, and nation). For a discussion of the prototypical tenets of female physiology within this literature, see Diana Price Herndl (34–8).
4 The twentieth-century equivalent of this methodology and the logic behind

it can be seen in feminist analyses of the body that affirm the interchange between discursive representations and lived reality – between the way that popular media image the female body and the way that individual women understand their own physicality. See, for example, Susan Bordo (45–70, 139–214).

5 Kate Flint devotes a chapter to medical and physiological theories of reading in Victorian Britain (53–71); she also considers the variances of reading in the library, the bedroom, and the railway car (102–6). But her study is limited to British discourses. Cathy N. Davidson, Richard H. Brodhead, Barbara Sicherman, James L. Machor, Susan K. Harris, and Janice A. Radway understand that women read as women, and they attend to the gendered aspects of reader response, but they don't locate gender in the lived body. In other words, they don't attend to the physicality of gendered reading, and that is the conceptual gap I hope this essay will speak to.

6 Judith Butler's *Bodies That Matter*, Susan Bordo's *Unbearable Weight*, and Elizabeth Grosz's *Volatile Bodies* are representative of this trend.

7 By 1810, the *Fragmente* 'had gone through no fewer than sixteen German, fifteen French, two American, two Russian, one Dutch, and twenty English editions.' In his lifetime, Lavater achieved 'tremendous celebrity' and developed a 'cult following' that remained vitally alive throughout the nineteenth century. Serious sciences and scientists, including Franz Joseph Gall's phrenology, Carl Gustav Carus's craniology, and Alexander von Humboldt's physical anthropology, 'owed a great deal' to Lavater's theories, and Goethe 'openly acknowledged' his debt to physiognomy as he disseminated 'his own notions of osteology and morphology' (Shookman 2, 5).

8 I've outlined the construction and practices of the ideal woman reader more fully in 'Susan Warner's *The Wide, Wide World*, Conduct Literature, and Protocols of Female Reading in Mid-Nineteenth-Century America.'

9 George Lippard's bestselling novel *The Quaker City* reinforces how deeply suspect this 'animal life' was for a woman in the nineteenth century:

For this is the doctrine we deem it right to hold in regard to woman. Like man she is a combination of an animal, with an intellectual nature. Unlike man her animal nature is a passive thing, that must be roused ere it will develop itself in action. Let the intellectual nature of woman, be the only object of man's influence, and woman will love him most holily. But let him play with her animal nature as you would toy with the machinery of a watch, let him rouse the treacherous blood, let him fan the pulse into quick, feverish throbbings, let him warm the heart with convulsive beatings, and the woman becomes like himself, but a mere animal. *Sense* rises like vapor, and utterly darkens the *Soul*. (85)

Thus, the more carnal elements of Beulah's physiognomy encode the seeds of her own fall from ideality.

10 Granted, voice has a certain cognitive component, but Beulah's singing (and later her audible reactions to texts) can constitute a *physical* incarnation of response because, with its concern for proper elocution and vocal training, the nineteenth century itself considered the voice a physical organ. And because Beulah's song is such a spontaneous, reflexive act, it seems more of the body (and its instincts) than of the mind.

11 For a comprehensive history of domestic medical literature and an overview of its contents, see Risse, Numbers, and Leavitt (11–49, 73–93). Flint traces the psychological and medical 'truths' that were most relevant to women's reading in her *The Woman Reader* (53–70). McCandless details more concretely how the body/mind continuum informed mid-century psychology, specifically its reliance on moral treatment as a cure-all for psychic disorder (84–7).

12 Highlighting the significance of this body/mind within the norms of both reading and gender, Flint notes that such physiological principles founded 'an implicit theory of [women's] reading': '[S]uch instincts as sympathetic imagination, and a ready capacity to identify with the experience of others, are unalterable facts about [a woman's] mental operations, and hence, by extension, her processes of reading' (57).

13 See, for example, Davidson (38–54) and Baym, *Novels, Readers, and Reviewers* (44–62).

14 Nancy Tomes affirms this fact in *A Generous Confidence* (94). And interestingly enough, the South is peculiarly implicated in the history of insanity and its treatment in this country. According to Peter McCandless, the first public mental institutions in the United States were in Virginia, Kentucky, South Carolina, and Maryland (3–4). Contrary to prevailing conceptions of the South as a psychiatric outback, the Southern asylum actively participated in the scientific mainstream, especially in the antebellum decades. That doesn't mediate the fact that the South was uniquely (and increasingly) invested in racial difference and segregation, but like their Northern counterparts, Southern asylums 'were influenced by avant-garde ideas of moral treatment and therapeutic optimism' (McCandless 5).

15 I am indebted to Kate Flint's recognition that portraits of women reading in the nineteenth century also manifested this 'relaxation of outward social awareness' (4).

16 On the contrary, Beulah lays hands on the book through the authoritative auspices of her friend Eugene, and *The Young Lady's Own Book* lists the *Sketch Book* among the texts in its 'select library' (102, 103).

17 I borrow this term from Judith Butler's book by the same name, and I define
it as she does. As I understand it, gender trouble happens when a gendered
performance destabilizes the 'signifying gestures through which gender
itself is established' (viii).

WORKS CITED

Aristotle's Masterpiece Completed: In Two Parts. New York: Flying Stationers, 1798.

Ashworth, Suzanne M. 'Susan Warner's *The Wide, Wide World*, Conduct Litera-
ture, and Protocols of Female Reading in Mid-Nineteenth-Century America.'
Legacy 17.2 (2000): 141–64.

Baym, Nina. *Novels, Readers, and Reviewers: Responses to Fiction in Antebellum Amer-
ica.* Ithaca: Cornell UP, 1984.

– *Woman's Fiction: A Guide to Novels By and About Women in America, 1820–1870.*
2nd ed. Champaign: U of Illinois P, 1993.

Beach, Wooster, M.D. *Beach's Family Physician and Home Guide for the Treatment of
Diseases of Men, Women, and Children, on Reform Principles.* Cincinnati: Moore,
Wilstach, Keys, 1859.

Bordo, Susan. *Unbearable Weight: Feminism, Western Culture, and the Body.* Berkeley:
U of California P, 1993.

Brodhead, Richard H. *Cultures of Letters: Scenes of Reading and Writing in Nine-
teenth-Century America.* Chicago: U of Chicago P, 1993.

Buchan, William. *Domestic Medicine; or, A Treatise on the Prevention and Cure of
Diseases, by Regimen and Simple Medicines.* New York: Scott, 1812.

Burbick, Joan. *Healing the Republic: The Language of Health and the Culture of
Nationalism in Nineteenth-Century America.* Cambridge: Cambridge UP,
1994.

Butler, Judith. *Bodies That Matter: On the Discursive Limits of 'Sex.'* New York:
Routledge, 1993.

– *Gender Trouble: Feminism and the Subversion of Identity.* New York: Routledge,
1990.

Chartier, Roger. *The Order of Books: Readers, Authors, and Libraries in Europe Between
the Fourteenth and the Eighteenth Centuries.* Trans. Lydia G. Cochrane. Stanford:
Stanford UP, 1994.

Culverwell, Robert James. *Guide to Health and Long Life; or, What to Eat, Drink, and
Avoid.* 2nd ed. New York: Redfield, 1849.

Davidson, Cathy N. *Revolution and the Word: The Rise of the Novel in America.* New
York: Oxford UP, 1986.

Evans, Augusta Jane. *Beulah.* Ed. Elizabeth Fox-Genovese. Baton Rouge: Louisi-
ana State UP, 1992.

– Papers. W.S. Hoole Special Collections Library. University of Alabama, Tusca-loosa, AL.

Flint, Kate. *The Woman Reader 1837–1914.* Oxford: Clarendon P, 1993.

Fox-Genovese, Elizabeth. Introd. to *Beulah,* by Augusta Jane Evans. Ed. Elizabeth Fox-Genovese. Baton Rouge: Louisiana State UP, 1992.

Genovese, Eugene. *The World the Slaveholders Made: Two Essays in Interpretation.* Hanover, CT: Wesleyan UP, 1988.

Graham, John. *Lavater's Essays on Physiognomy: A Study in the History of Ideas.* Berne: Peter Lang, 1979.

Grosz, Elizabeth. *Volatile Bodies: Toward a Corporeal Feminism.* Bloomington: Indiana UP, 1994.

Gunn, John C. *Domestic Medicine; or, Poor Man's Friend.* Pittsburgh: Edwards and Newman, 1839.

Harris, Susan K. *19th-Century American Women's Novels: Interpretive Strategies.* Cambridge: Cambridge UP, 1990.

Herndl, Diana Price. *Invalid Women: Figuring Feminine Illness in American Fiction and Culture, 1840–1940.* Chapel Hill: U of North Carolina P, 1993.

Hodge, Hugh L. *On Diseases Peculiar to Women, Including Displacement of the Uterus.* 2nd ed. Philadelphia: Henry C. Lea, 1868.

Jabet, George. *Notes on Noses.* London: 1852. FTP:newcastle.edu.au/department fad/fi/race/phrenol.htm.

Lippard, George. *The Quaker City; or, The Monks of Monk Hall.* Ed. David S. Reynolds. 1845. Amherst: U of Massachusetts P, 1995.

Machor, James L. 'Introduction: Readers/Texts/Contexts.' In *Readers in History: Nineteenth-Century American Literature and the Contexts of Response,* ed. James L. Machor, vii–xxix. Baltimore: Johns Hopkins UP, 1993.

Mackarness, Mrs Henry. *The Young Lady's Book: A Manual of Amusements, Exercises, Studies, and Pursuits.* London: Routledge & Sons, 1876.

McCandless, Peter. *Moonlight, Magnolias, & Madness: Insanity in South Carolina from the Colonial Period to the Progressive Era.* Chapel Hill: U of North Carolina P, 1996.

Newcomb, Harvey. *The Young Lady's Guide to the Harmonious Development of Chris-tian Character.* 7th ed. Boston: J.B. Dow, 1846.

Radway, Janice A. *Reading the Romance: Women, Patriarchy, and Popular Literature.* 2nd ed. Chapel Hill: U of North Carolina P, 1991.

Risse, Guenter B., Ronald L. Numbers, and Judith Walzer Leavitt, eds. *Medicine Without Doctors: Home Health Care in American History.* New York: Science History Publications, 1977.

Rosenberg, Charles E. *Explaining Epidemics and Other Studies in the History of Medi-cine.* Cambridge: Cambridge UP, 1992.

Shookman, Ellis. 'Pseudo-Science, Social Fad, Literary Wonder: Johann Caspar Lavater and the Art of Physiognomy.' In *The Faces of Physiognomy: Interdisciplinary Approaches to Johann Caspar Lavater*, ed. Ellis Shookman, 1–24. Columbia: Camden House, 1993.

Sicherman, Barbara. 'Sense and Sensibility: A Case Study of Women's Reading in Late-Victorian America.' In *Reading in America: Literature and Social History*, ed. Cathy N. Davidson, 201–25. Baltimore: Johns Hopkins UP, 1989.

Smith-Rosenberg, Carroll. *Disorderly Conduct: Visions of Gender in Victorian America.* New York: Oxford UP, 1985.

Smith-Rosenberg, Carroll, and Charles E. Rosenberg. 'The Female Animal: Medical and Biological Views of Woman and Her Role in Nineteenth-Century America.' In *Women and Health in America*, 2nd ed., ed. Judith Walzer Leavitt, 111–30. Madison: U of Wisconsin P, 1999.

Tomes, Nancy. *A Generous Confidence: Thomas Story Kirkbridge and the Art of Asylum-Keeping, 1840–1883.* Cambridge: Cambridge UP, 1984.

Walker, Alexander. *Woman Physiologically Considered, as to Mind, Morals, Marriage, Matrimonial Slavery, Infidelity and Divorce.* New York: J. & H.G. Langley, 1839.

The Young Lady's Own Book: A Manual of Intellectual Improvement and Moral Development. Philadelphia: Key & Biddle, 1833.

4 'I Should No More Think of Dictating ... What Kinds of Books She Should Read': Images of Women Readers in Victorian Family Literary Magazines

JENNIFER PHEGLEY

John Ruskin's emphatic warning to parents in 1864 to 'keep the modern magazine and novel out of your girl's way' exemplifies the precarious relationship that existed among critics, popular literature, and women readers in the nineteenth century ('Of Queen's Gardens' 66). Ruskin's and other critics' concerns about the dangerous effects of print culture on women were intimately linked to the explosive growth of the periodical industry. As literacy rates rose, printing technologies improved, and taxes on newspapers were revoked, periodicals began to dominate nineteenth-century literary culture. Between 1824 and 1900 as many as fifty thousand periodicals were published in Great Britain (North 4), and by the middle of the century there were over one thousand journals devoted solely to literary subjects (Thompson 3). The development of this mass of periodical literature had such an impact that the eminent Victorian critic George Saintsbury declared in 1896:

> Perhaps there is no single feature of the English literary history of the nineteenth century, not even the enormous popularisation and multiplication of the novel, which is so distinctive and characteristic as the development in it of periodical literature ... [I]t is quite certain that, had ... reprints [from magazines] not taken place, more than half the most valuable books of the age ... would never have appeared as books at all. (166)

In order to combat the overwhelming abundance of inexpensive magazines and the novels contained within them, many critics took it as their mission to direct readers to choose the proper texts and read in the 'right' ways.

These critics characterized women as the most susceptible victims of

the 'disease of reading' that was believed to be a threat to the sanctity of the family and to the social order of the nation.[1] The specific dangers of reading were often only vaguely alluded to, though they were most frequently associated with women behaving in ways unbecoming of a proper wife and mother. In other words, many critics feared that what women read (especially if it happened to be sensational or scandalous) and how women read (particularly if it was quickly and uncritically) would at best infect them with romanticized expectations that would leave them dissatisfied about their lives, or at worst with immoral thoughts that could lead to immoral behaviour. Critics' definitions of good and bad literature were strongly influenced by discussions of what constituted 'proper reading' for women because both the subject matter and the methods of women's reading were considered central to the production of good wives and mothers.

However, not every critic or literary magazine was concerned about protecting women from reading material and reading habits that could contaminate them. In fact, the newly emerging genre of the family literary magazine, which included periodicals such as the *Cornhill*, edited by William Thackeray, and *Belgravia*, edited by Mary Elizabeth Braddon, opposed the argument that women were inherently uncritical readers who were unable to make good decisions about reading.[2] Instead, these magazines invited women to become active members of their middle-class reading audience, to exercise their critical thinking skills, to improve their literary knowledge, and to raise the entire nation's cultural status through reading.

Unlike more elite journals such as the *Saturday Review* and the *Quarterly Review* – which assumed an all-male audience – and domestic periodicals such as the *Englishwoman's Domestic Magazine* – which were focused on women's household duties – family literary magazines sold themselves as friendly cultural instructors for men, women, and children. These shilling monthly magazines balanced serial fiction with factual articles on subjects of current interest, including science, art, history, and, to a lesser extent, political events. It was due largely to the inclusion of women in literary and intellectual discussions that the genre of the family literary magazine became the most popular periodical format of the 1860s. Considering the importance of women readers to the success of these magazines, it is crucial to document the ways in which they constructed a particular image of the woman reader in their articles, novels, poems, and illustrations.[3] I argue that both the *Cornhill* and *Belgravia* overtly combated the portrayal of improper reading as a

particularly female malady and attempted to reshape attitudes towards women readers by visually and textually depicting them participating in intellectual development through reading. These periodicals, then, transformed the literary debate surrounding women readers by insisting that women could read critically and productively.[4]

Both magazines asserted that women should be empowered to read what they wanted; however, they diverged in the degree to which they accepted that women should read without regulation or supervision. In this essay, I will show that the *Cornhill* consistently depicted women who were guided in their reading choices by the magazine itself and who read in the presence of men for the benefit of their families, while *Belgravia*, the more radical of the two magazines, featured images of solitary women who chose their own books and read for their own enjoyment and edification. Although *Belgravia* makes a more revolutionary statement regarding the relationship of women to literary (and not-so-literary) texts, I will first turn to representations of women readers in the *Cornhill* because it had a more dominant voice in the period and serves as a more typical gauge of the alternative public image of the much-maligned woman reader. The *Cornhill*'s prestige was linked to the fact that it was issued by the respectable Smith, Elder, and Company, edited by the revered Thackeray, and featured novels written by critically acclaimed authors such as George Eliot, Elizabeth Gaskell, and Anthony Trollope.[5] *Belgravia*, on the other hand, was issued by the maverick publisher John Maxwell and managed by Braddon, whose illicit relationship with Maxwell and reputation as the 'queen of the sensation novel' garnered critical disrespect. Braddon's magazine also showcased her own sensational novels, which were reviled by critics. The reputation of each magazine had a profound effect on its relationship to women readers, as *Belgravia* was in a position to take risks defending its primary consumers, while the more reputable *Cornhill* took a progressive but safe route to promote women readers.[6]

The *Cornhill*, the most famous and successful of the family literary magazines, showed respect for its women readers by maintaining not only that women were educable, but that they should be educated for the good of the middle-class family and the British nation. In fact, the *Cornhill* advocated the improvement of women's formal education – and, to a lesser degree, women's movement into the professions – as a means of assisting the development of the 'professional gentleman' who was emerging as the leader of the British nation. To keep potential wives occupied while upwardly mobile gentlemen took more time to establish

themselves financially before marrying, the *Cornhill* urged readers to consider the benefits of intellectual advancement and professional employment for women.[7] Even before Ruskin delivered his speech 'Of Queen's Gardens' to Manchester housewives in December 1864, the *Cornhill* supported a similar philosophy of broadened reading experiences for women that was explicitly linked to the fulfilment of a domestic ideal of womanhood. Both believed that if women read widely they would not only be able to engage in more meaningful conversations and thus build stronger bonds with their husbands, but also pass on their new-found knowledge to their children. Sharon Aronofsky Weltman argues that Ruskin explicitly urged women to take on a queenly – and inherently public – role by reading widely and exerting their critical faculties, particularly on matters related to morality and social justice. Since Ruskin also implied that women should share their thoughts on such matters with the world (the extended 'home'), Weltman declares that his speech obliterated 'the inside/outside dichotomy that forms the basic division of Victorian sex roles' (112). However, for both Ruskin and the *Cornhill*, the intellectual capabilities women gained through reading would primarily be used in the service of their families. While women's intellectual development might have a public function, that function was still required to reinforce domesticity, to be an extension of good housekeeping. Furthermore, neither Ruskin nor the *Cornhill* addressed women's intellectual activity as a form of self-fulfilment. Both saw women's reading primarily as a means of satisfying the family's or the nation's needs.

Harriet Martineau, well known for her advocacy of women's rights, makes the *Cornhill*'s approach to women's intellectual development clear in her article 'Middle-Class Education in England – Girls' (November 1864). In this essay, Martineau moulds her claims to the magazine's agenda concerning women readers as she argues that girls should be taught Latin, Greek, and other serious subjects in addition to domestic training because it is 'desirable that the mothers of the next generation should have a large intelligence and rich culture' to pass on to their children and, ultimately, to strengthen the nation's citizens (563). For the *Cornhill* the 'briars and brambles' had to 'be cleared away from women's avenue to the temple of knowledge' for the good of the family and the nation, but not necessarily of the woman herself (Martineau 567).

While Martineau's article reconciled the gap between the intellectual woman and the domestic one by pointing out the need for well-educated mothers, G.H. Lewes (who sporadically served as editor of the *Cornhill*)

took a slightly different approach to delivering the magazine's message about the value of women readers. Lewes argued that women should be well read because what they read symbolized the state of the nation's culture. In 'Publishers Before the Age of Printing' (January 1864), Lewes seems to provide a straightforward history lesson that touches on the important role books played in the lives of Romans at the height of that civilization. However, it becomes clear that Lewes is writing more than a history lesson; he is arguing for more serious reading practices, particularly for women, in Victorian England. He points to women's reading practices as a vital indicator of a nation's level of cultural development and implies that England should not merely emulate the fallen civilization, but surpass and outlast it. Lewes explains that although Roman women did not have Mudie's Circulating Library, they did have extensive collections of books in their homes as well as free public libraries, which gave them better access to reading material, even in an age before the invention of the printing press. Thus, he concludes, 'Stockings would have been as blue then as now only stockings had not been invented' (28). While he pokes fun at intellectual women by playing with the term 'blue stocking' and by stating that '[t]he women were as well read in the current literature as our idle ladies who subscribe to Mudie's,' he reassures male readers that intellectual women are not a new and dangerous breed, but are symbols of any advanced culture (28). Lewes's message is clear: women readers – all readers for that matter – should be encouraged to take full advantage of the vast resources available to them as a result of the dominance of print culture. Accordingly, Lewes urges a revival of the 'fashion' for books that he identifies in Roman times and calls on his readers to construct their own libraries as monuments to the nation's superior culture (29). Presumably, the *Cornhill* would itself make a suitable start to such a collection of literary treasures.

In suggesting itself as a proper purveyor of culture, the *Cornhill* defied many elite (and elitist) reviewers who saw periodicals as a major cause of the downfall of the nation's literature and of women's unhealthy reading practices. Periodicals were criticized for contributing to the proliferation of texts that made it more and more difficult to distinguish between good and bad literature and for encouraging careless reading habits such as skimming and skipping that resulted from the miscellaneous format and serialized contents. To combat such negative views of the effects of reading magazines, the *Cornhill* used a variety of strategies to promote proper reading practices. The magazine published 'serious' nonfiction articles that required a critical engagement with politics, his-

tory, and economic issues; featured 'quality' fiction that provided readers with role models for respectable middle-class behaviour; and included commentaries on taste to instruct readers how to judge literary texts. One of the most famous of these commentaries on literary taste was Matthew Arnold's 'The Literary Influence of Academies' (August 1864). Arnold's influential essay praises the French academy's ability to determine which literary works were worthy representations of the nation's cultural achievement and should therefore be made available to the public. Arnold uses this foreign example to impress upon his fellow citizens the cultural benefits of a formal system of literary regulation. Like Lewes, Arnold promoted the idea that a nation's literature, and thereby its reading, were lofty symbols of its power and status. However, Arnold's glorification of the academic 'culture police' was not wholly embraced by the *Cornhill*. The magazine would 'set standards' and 'create ... a force of educated opinion' but would not 'rebuk[e] those who fall below these standards' (Arnold 160–1). Furthermore, instead of merely choosing the proper texts for its women readers, the magazine would teach them to distinguish between high and low cultural texts while permitting them to consume both. The fact that the magazine allowed both high and low cultural works to be consumed is significant because in the elite press the dangers of obsessively reading periodicals were second only to the dangers of reading sensation novels – the quintessential low cultural form of the century that was particularly associated with women readers.

Lyn Pykett succinctly summarizes the connection between anxieties about sensation as a genre and the developing divisions between high and low culture in her analysis of Henry Mansel's scathing critique of the sensation novel in the April 1863 *Quarterly Review*:

> Mass-produced for mass consumption, the sensation novel was used by some critics to mark the boundary between high art and popular artifact. Unlike the productions of high culture, it was argued, sensation novels were not written to 'satisfy the unconquerable yearnings of an artist's soul', rather they were produced by the 'market law of supply and demand' and were 'redolent of the manufactory or the shop' ... In short, sensation fiction disturbingly blurred the boundaries between the classes, between high art, low art, and no art (newspapers), between the public and the private, and between the respectable and the low life or demi-monde. (9)

Likewise, the frequent equation of sensationalism with the deterioration

of femininity had become a commonplace by the 1860s. Sensation fiction presented readers with exciting and intricate plots focusing on supposedly respectable middle-class citizens, often women, who were secretly involved in criminal activities such as bigamy, arson, forgery, and even murder.

Though many critics viewed this type of fiction as dangerous, the *Cornhill* treated it differently. Through its editorial commentaries in 'Our Survey of Literature and Science,' written primarily by Lewes, the *Cornhill* distinguished between entertaining or sensational fiction, such as Wilkie Collins's *Cornhill* contribution *Armadale* (November 1864–June 1866), and serious or realistic fiction, such as George Eliot's *Cornhill* serial, *Romola* (January 1862–August 1863). Instead of perpetuating the hysteria surrounding women's consumption of the low cultural genre of the sensation novel, the *Cornhill* maintained that reading for entertainment was an acceptable practice, as long as the reader remained aware of its purely recreational purpose. This point is made in the magazine's defense of Mary Elizabeth Braddon's *Lady Audley's Secret*:

> Granting, as we must, that works of this class merely appeal to the curiosity – that they do nothing more than amuse the vacant or wearied mind, if they do *that*, it is something. They may be transitory as fireworks, and raise no loftier emotions. But a frivolous and wearied public demands amusement ... and the public may be grateful when such amusement leaves behind it no unwholesome sympathy with crimes and criminals ... Its incidents are not simply violations of probability, but are without that congruity which, in a skillful romance, makes the improbable credible. (Lewes, 'Our Survey: *Lady Audley's Secret*,' 135–6)

The *Cornhill*, then, gave women enough respect to permit them to read an otherwise defamed fictional form with an understanding that they were not likely to be harmed by it. However, the magazine condoned such reading only if readers had enough self-awareness of the categories of literature to understand that sensation novels lacked artistry, failed to provide cultural enrichment, and were therefore suitable only for frivolous entertainment.

While the *Cornhill* proclaimed sensation fiction to be acceptable if approached sensibly, it actively promoted realistic fiction as a higher cultural form. Realism was elevated above sensationalism because it was believed to teach readers about real life, serve as a model for proper behaviour that would make readers better middle-class citizens, and

embody the kind of art that would be likely to pass muster with an imaginary Arnoldian academy. In a review of Trollope's *Orley Farm* in another installment of 'Our Survey of Literature and Science,' Lewes outlines the benefits of reading realist literature for women and their families. He claims that realism could improve women's relationships with their fathers, husbands, and children by developing their powers of sympathy. For example, Trollope's realistic presentation of 'human beings, with good and evil strangely intermingled' rather than the black-and-white depiction of 'angels and devils' might allow readers to gain a deeper understanding of the moral and psychological motivations of real people (702). To emphasize his point, Lewes claims that Trollope's fiction encourages 'pity for the weakness out of which wickedness springs' (702–3), thereby increasing sympathy and thus femininity. Lewes's endorsement of Trollope's realism focuses on the ways in which it encourages the melding of those feminine and emotional qualities that make women well suited for domesticity with those rational and intellectual abilities that allow them to serve as Arnoldian judges of literary quality.

The *Cornhill* offered a significant improvement in the rhetoric surrounding women readers by insisting on the link between the intellectual development of women and their roles within the family and by trusting them to read for both entertainment and enlightenment while also declaring that they could learn to distinguish between the two. The *Cornhill*'s focus on traditional roles adapted to intellectual abilities can also be seen in the illustrations for the magazine. I will examine two illustrations accompanying the magazine's serialized fiction that emphasize the inseparability of women readers from their roles as wives, mothers, and daughters. These women readers are able to use their intellectual abilities to serve the needs of their families despite the doubts and fears of some of the men in their lives.

'The Blind Scholar and His Daughter' (fig. 4.1) is an illustration by Frederic Leighton that accompanied the premier installment of Eliot's *Romola* in July 1862.[8] This illustration, placed in its context within the novel and the magazine, casts the woman reader as a devoted daughter whose intellectual abilities contribute to the success of her family. This depiction suits the attitude of the magazine since it promotes learning that contributes to the pleasure and pride of male authority figures but not intellectual activity that goes beyond the strict confines of masculine supervision. Leighton's illustration depicts Romola, a fifteenth-century Italian woman, conducting academic work in the service of her father who sits clutching a book as she stands patiently by his side reading to

Fig. 4.1. 'The Blind Scholar and His Daughter,' *Cornhill Magazine* (July 1862): 1.

him. Romola stands majestically over her father with a lantern in her hand, shining light on his permanent darkness. This image suggests that Romola is in a position of power; however, her placid facial expression and outstretched arm, placed on the back of her father's chair, indicate that her task is a daughterly duty undertaken to assist her beloved father. In the text, we learn that Romola selflessly serves her father by applying the education he has provided for her to meet his ambitions and desires rather than her own. Her father rather unappreciatively describes her as 'endowed beyond the measure of women ... filling up to the best of her power the place of a son,' and marvels at her capricious memory, which 'grasps certain objects with tenacity, and lets fall all those minutiae whereon depends accuracy, the very soul of scholarship' (August 1862, 153, 149). Although she may not find the details valued by her father worth remembering and feels inadequate as a result, Romola takes pleasure in her intellectual activities and in her ability to further her father's academic pursuits. She is, however, equally ready to give up her scholarly role if asked.

Romola does just that to marry Tito, a mysterious wanderer who displaces her as her father's primary assistant. While Tito distances Romola from her identity as a scholar, he does not completely displace her intellectual life. In fact, he is unable to attend to her father as consistently and devotedly as she does. In Tito's increasing absences, she continues her work: 'It was not Tito's fault, Romola had continually reassured herself ... [I]t was in the nature of things that no one but herself could go on month after month, and year after year, fulfilling patiently all her father's monotonous exacting demands' (December 1862, 722). When Romola's father dies without having completed his scholarly goals, Tito betrays her by dividing and selling her dead father's library to make some quick cash. Even after her father's death, Romola wishes to serve her father by granting his dying wish that his library be donated to the community. Tito's violation of her life's mission, along with his adulterous relationship with a peasant and his shady political activities, cause Romola to seek an independent life. When she discovers that Tito has been murdered by his own father (whom he also savagely betrayed), she uses both her intellectual abilities and her innate sense of duty to serve others by seeking out Tito's mistress and children in order to take on a new role as guardian for this makeshift family. Serving as a sort of father figure to this new family, she guides Tito's son towards a life that is more humane than the one lived by his father. Romola's real power, then, lies in her ability to both intellectually and morally transform the next gen-

eration. Within the context of the *Cornhill*, it is vital that Romola's intellect and domesticity are compatible even if Tito is unable to recognize that fact.

While it is clear that fathers can benefit from their daughters' intellectual engagement, the *Cornhill*'s reading women have a more difficult time convincing potential husbands that they will not be distracted from their wifely roles by undertaking literary endeavours.[9] In George Du Maurier's illustration for Elizabeth Gaskell's November 1863–February 1864 *Cornhill* serial 'Cousin Phillis,' the lead character, whose reading is also encouraged by her father, is shown seated in a corner of the kitchen studying Dante's *Inferno* (fig. 4.2). Phillis Holman has taken time out from her domestic duties to steal a peek at her beloved book, but she still holds a kitchen utensil as she reads, indicating that she is able to shift quickly from one activity to another and that she must soon return to her 'real' work.[10]

In the text of 'Cousin Phillis' Peter Manning peers over his cousin's shoulder to monitor her attempts at scholarly activity. Phillis asks him to help her translate the Italian book into English; however, he cannot even identify the language the text is written in, let alone translate it. Though Phillis assures him that she 'can generally puzzle a thing out in time' and can do without his help, Peter maintains his vigil (December 1862, 689). While surveilling an intellectual activity he doesn't comprehend, Peter arrives at a new realization: 'A great tall girl in a pinafore, half a head taller than I was, reading books that I had never heard of, and talking about them too, as of far more interest than any mere personal subjects, that was the last day on which I ever thought of my dear cousin Phillis as the possible mistress of my heart and life' (689). The illustration captures the moment of this rejection; even though Phillis is depicted in a kitchen and as dutifully domestic, her books make Peter doubt her fitness as a potential wife. Later, Peter introduces his boss Mr Holdsworth to Phillis as someone who can serve as a Greek and Latin tutor. Although Holdsworth is attracted to Phillis's intellect and leads her to believe he will marry her, he eventually deserts her as well. Neither Peter nor Holdsworth can imagine how to fit an intellectual woman into his life because neither is sure how such intellectual activity can coincide with domesticity. Although Romola's husband Tito more drastically dramatizes the critique of men who cannot appreciate intelligent women, Peter and Holdsworth are in the same general category. These men reveal their anxieties about intellectual women, but both Romola's and Phillis's otherwise passive and even angelic demeanours cast asper-

Fig. 4.2. 'Cousin Phillis and Her Book,' *Cornhill Magazine* (December 1863): 688.

sion on the cowardly gentlemen who reject them rather than on the reading women themselves. Thus, the *Cornhill* chastizes men like these who refuse to accept the compatibility of intellectual activity and traditional domesticity.

In *Belgravia Magazine*, Mary Elizabeth Braddon took the *Cornhill*'s encouragement of women readers one step further by arguing that women should read not only for the benefit of others, but for their own intellectual fulfilment and leisurely enjoyment. What's more, Braddon made this argument while using her magazine to showcase her own sensation fiction. In an effort to defeat the high/low cultural split, Braddon set out to counteract critics' rampant fears of sensationalism as a sign of an infectious, mass-produced low culture that corrupted its women readers. In fact, one of *Belgravia*'s primary purposes was to refute the *Cornhill*'s assertion that women should only read sensation novels for amusement; the magazine maintained that realism and sensationalism were on equal ground and could each be beneficial to women's moral development. Braddon accomplished her goals, in part, by employing a bevy of critics who forcefully argued that sensationalism was merely an intensified realism that could have even greater benefits for women readers by teaching them to read not only books but also people and situations more critically.

The most famous of *Belgravia*'s critics was George Augustus Sala who, in 'The Cant of Modern Criticism' (November 1867), defines sensationalism as a heightened form of realism that is no more harmful to readers than the daily news: 'in all these novels the people walk and talk and act ... like dwellers in the actual, breathing world in which we live. If we read the newspapers, if we read the police reports ... we shall take no great harm by reading realistic novels of human passion, weakness, and error' (53). Sensation novels, Sala claims, are literally drawn from the headlines and therefore cannot be accused of being more outrageous than real life. Sala declares that the public deserves such thrilling and real presentations and that adult readers – even women – can handle such fiction: '[We] want novels about that which Is, and not about that which never Was and never Will be. We don't want pap, or spoon meat, or milk-and-water, or curds-and-whey, or Robb's biscuits, or boiled whiting, or cold boiled veal without salt. We want meat; and this is a strong age, and we can digest it' (54). In this passage, Sala tacitly declares that realist fiction, which is typically praised by critics, is no more than a bland and lifeless idealization of human behaviour (cold boiled veal without salt). Sensation fiction, on the other hand, is a heartier, stronger version of life that is, nevertheless, closer to 'reality.' Far from

destroying the minds (or the digestive tracts) of readers, Sala argues that sensationalism provides readers with a better understanding of the world as it is, rather than as it should be. For Sala and Braddon, realist novels were not 'real' but 'ideal' representations of life that did not deserve to be valued over sensation novels.

Braddon's *Milly Darrell* (November 1870–January 1871) is a prototypical sensation story that effectively illustrates *Belgravia*'s literary philosophy. Milly is an innocent young girl whose wealthy businessman father prevents her from marrying Angus Egerton, the impoverished aristocrat she loves. When Mr Darrell unexpectedly dies, Milly's friend Mary, also the story's narrator, discovers that Milly's young stepmother once had a secret relationship with Angus. Upon her husband's death, Mrs Darrell attempts to resume her relationship with Angus. When she is rejected, she seeks revenge by slowly poisoning her stepdaughter. When Mary uncovers her murderous intentions and thwarts her plan, Mrs Darrell commits suicide. Milly recovers from the partial poisoning, marries Angus, and lives happily ever after with her friend and saviour by her side. Such romantic intrigues and criminal activities among female characters are abundant throughout *Belgravia*'s fiction. But, in contrast to the *Cornhill*'s relegation of sensationalism to a minor form that serves only as amusement, *Belgravia* insists that sensationalism actually surpasses realism in both entertainment and educational potential. This story, according to Braddon's defense of sensationalism, would fulfil a reader's desire for excitement while also teaching her to question authority and to be aware of the circumstances around her. It is, in fact, the story's narrator who serves as the model woman reader who is able to protect her more passive friend. Mary becomes an amateur detective, reading clues that allow her to save Milly's life. The contrast between Milly and Mary demonstrates that passively accepting what one is told is a greater danger to women than reading the world critically and creatively without regulation.

Belgravia's insistence on the merits of the sensation novel for women is the subtext of many of its nonfiction articles. For example, an article titled 'Insanity and its Treatment' articulates a rationale not only for exposing the horrors of insane asylums but also for exposing women to sensational subjects in everyday life:

We have taken the readers of *Belgravia* for a while out of their own geographical district to ... places and subjects which are hardly congenial, however important they may be. But it is good for us sometimes to see the

'night-side' of things – to have laid bare our social scourges both of the moral and material kind, in order that we may with one heart and mind unite in striving to rectify those evils which madden peoples and hurry nations to premature decay. (478)

Together *Belgravia*'s fiction and nonfiction articles stress that although sensationalism dwells on the 'night-side' of life, the reading practices required by the genre instruct women to detect and prevent unrespectable or even criminal behaviour, thereby preventing cultural decay rather than causing it. Braddon and the critics she hired maintained that the education and simulated worldly experience provided by sensation fiction would allow women to become active readers of life and fiction who could make more informed moral choices that would be good for themselves and for the nation. In *The Woman Reader*, Kate Flint echoes Braddon's view of the positive social power of sensationalism when she explains that sensation fiction mocked

> the belief that women read uncritically, unthoughtfully: the very character-istics which their authors were themselves accused of engendering. [Sensation authors] refute the idea that a woman reader is mentally passive and accepting of what she consumes, and emphasize her capacity to act as a rational, rather than as an emotional, being ... [T]hey stimulate, simultaneously, their readers' capacity for self-awareness and social analysis and judgment. (15)

Though Braddon was clearly motivated by a desire to promote her own scandalous brand of fiction as culturally beneficial, she also worked hard to reshape the critical discourse surrounding sensationalism by creating a positive image of women readers. In fact, these dual goals were inseparable due to their incessant link in contemporary reviews. A defense of women's reading skills was thus necessary for any complete defense of the sensation novel. Consequently, Sala firmly defends the right of women to choose their own books. He argues that '[n]ovels are written for grown people and not for babes and sucklings'; therefore, 'grown women should be free to choose whatever reading material they desire' (53). He speculates that if he had a daughter, 'When she came to be one and twenty, or got married, I should no more think of dictating to her as to what kinds of books she should read, than as to what kinds of stays she should wear – if she wore any at all' (54). Referring to women's undergarments as equivalent to her reading material is a very

clever strategy because it excludes men from having any say in the matter at all; it maintains that what women read is their own business. Through a combination of fiction and criticism, *Belgravia* thus took a stand against the regulation of women's reading materials. The next step for the magazine was to deter the elite critics from meddling with women's reading practices.

T.H.S. Escott used his May 1869 article 'Vagueness' to speak out against the charge that women were uncritical – and therefore corruptible – consumers of print by turning the table on the defenders of high culture. Ironically, Escott asserts that the readers who are most in danger of 'a habit of slovenliness ... which is absolutely destructive of all mental improvement or discipline' are not women but *critics*, 'who believe they see everything at once and feel they can grasp complexity and think that nothing can be hidden from their view' (412–13). Escott laments the dizzying proliferation of print since 'every morrow brings with it ... fresh newspapers to be read, fresh magazines to be skimmed, new works of fiction or science or politics through which [readers] must gallop at express rate, without cessation or pause' (410). In mentioning newspapers and scientific and political treatises, Escott implicates a male, rather than a female, audience, particularly one that quickly consumes texts for professional purposes. He makes it clear that professional men are the most likely victims of 'vagueness' because they read under harried circumstances for money. The inherent arrogance of professionals – especially critics – and the intense pressure to make a reputation for themselves and their magazines put them in a more vulnerable position than amateur (women) readers, who could take a more leisurely approach to the consumption of print. According to Escott, leisure allows thorough digestion of information and results in the formation of more thoughtful opinions. With this argument, Escott acquits women of the slanderous charges frequently lodged against them and legitimates them as more skilled consumers of print (and implicitly of sensation) than critics themselves.

Under Braddon's leadership, the magazine worked to legitimize women as respectable readers who could read what they wanted, by themselves, in any way they chose. Unlike the *Cornhill*, which endorsed a certain amount of Arnoldian regulation to ensure that women could distinguish between high and low cultural texts, *Belgravia* maintained that those categories were inherently flawed and should, in fact, be disregarded. The power of *Belgravia*'s support for the independence of women's reading is most striking when its illustrations of women readers

are compared to those featured in the *Cornhill*. Just as Sala argues that what women read is their own business, *Belgravia's* illustrations consistently depict women readers whose activity is conducted independently for their own personal benefit rather than for the good of others. Braddon's magazine provides images of women who experience pleasure and the fulfillment of fantasies through reading. In this way, the magazine enhanced its textual arguments in support of women readers through the positive visual images it displayed, presenting stories with outcomes that remained compatible with the behaviour expected from a proper middle-class woman and thus emphasizing that reading was not as threatening as critics implied.

The ability to read independently allows the woman reader portrayed in 'In the Firelight' to explore her fantasies in a healthy manner through reading as she falls asleep with a book on her lap, the visions of her imagination swirling around her head (fig. 4.3). This woman reader lounges in a chair, one arm dangling at her side, one arm still clutching the oversized book. Her dream visions of dramatically costumed figures, just barely visible in the background, hover around her as she rests. As Sally Mitchell notes, women's daydreams are often pleasurable mental stories that 'provide expression, release, or simply indulgence for emotions or needs which are not otherwise satisfied either because of psychological inhibition or because of the social context' (32). 'In the Firelight' presents reading as just such an emotional outlet that is satisfying but also safe because the final result of this self-indulgence, as we are told in the accompanying poem, is a socially acceptable dream about marriage. In the poem, the woman imagines two lovers being torn apart against the background of the French Huguenot War. After the bloody turmoil of war plays out, the scene brightens and the separated couple happily emerge at the wedding alter. The vision ends when the woman unexpectedly awakens to recognize herself and Frank, presumably her real-life beau, as the main characters of her fantasy (W.T. 66).

Surprisingly, the poem itself does not mention reading as the impetus for the dream. In the poem the woman sits alone at night gazing into the fire; however, the fireplace is only a bit player in the illustration – we can just see the edge of the mantle at the left margin of the picture. Instead, the fire is replaced by what many nineteenth-century critics saw as an equally dangerous element: a book. While Charles Dickens's Louisa Gradgrind notoriously gets into trouble by gazing into the fire and 'wondering,' *Belgravia's* independent woman reader shows that such fancy can be healthy and normal, even when the flames are replaced with printed

Fig. 4.3. 'In the Firelight,' *Belgravia Magazine* (March 1868): 66.

words. Whether the book in the woman's lap is a gothic romance (a forerunner of the sensation novel) or a historical account of seventeenth-century France, she is able to read it on her own without dangerous results. In fact, her imagination transforms a chaotic scene of death and destruction into a conventional courtship narrative that reinforces society's expectations for her as a woman. This image suggests that even if women were to allow their minds to wander into dangerous territory, they would not be likely to present a real threat to patriarchal society.

Even when reading fulfils a fantasy of rebelliousness, as it does in the story and accompanying illustration 'One Summer Month' (fig. 4.4), it is ultimately depicted as a safe imaginative exercise. In this story, Miss Royes, a self-denying governess, dreams of the satisfaction of reading a book for her own pleasure, but she never actually does so. Instead, she remains devoted to her ungrateful pupil and her aloof employer. After falling in love with a man who proposes to her, she sacrifices the opportunity to escape her drudgery by refusing the proposal. Then she selflessly reunites her potential fiancé with his first love from whom he has been estranged. In the story, Miss Royes's sole pleasure stems from the fantasy of acting on her own will instead of someone else's by escaping from her oppressive duties to read something other than a lesson-book as she relaxes on the beach. While she does not take the opportunity to escape her servitude in the story, this pleasurable beach reading scene becomes the only visual representation of Miss Royes included in the magazine. It is as if merely imagining the fulfillment of independent reading is enough to prevent her from shirking her duties. Thus, *Belgravia* figures the enjoyment of reading – even if it is only imaginary – as productive rather than destructive, permitting the possibility of the healthy self-indulgence that Miss Royes otherwise goes out of her way to avoid. By choosing professional duty over romantic love, however, Miss Royes is able to keep her fantasy of independence alive while enacting what seems to be self-sacrificing behaviour.

Belgravia's device of depicting seemingly dangerous activities as harmless once their context is understood is typical of the magazine's strategy. Once again, Braddon's magazine highlights the positive aspects of women's reading while also acknowledging and assuaging public fears about its dangers. Braddon hoped that those who feared the boldness of women's independent reading would be appeased by the pictures they saw, for it would seem that women, given a bit of room to make their own decisions, would willingly use them to improve their traditional roles rather than to overturn them.

Fig. 4.4. 'One Summer Month,' *Belgravia Magazine* (August 1871): 197.

Both the *Cornhill* and *Belgravia* opposed the popular conception of the woman reader as susceptible to disease and contamination by emphasizing that reading could preserve and even strengthen the domestic sphere while also encouraging women's intellectual improvement and allowing them to make their own informed reading choices. However, the *Cornhill* preserved the right of male authorities to regulate how women's reading would be conducted – by insisting on the maintenance of cultural divisions – and for what purposes women's reading would be used – by requiring that it enhance family life. *Belgravia*, on the other hand, argued that even these choices should be left up to women themselves. Despite these differences, together the magazines reveal that there were active and powerful defenders of women readers in the nineteenth-century press, though their voices may not have been the dominant ones. By the end of the century, moreover, these minority voices had significantly contributed to an atmosphere in which women's formal education was on its way to becoming standard for middle-class women. Family literary magazines were not overtly political in nature, but they participated in a wide public debate that affected the roles of women and the function of literature in their lives for years to come. As a result of magazines like the *Cornhill* and *Belgravia*, women's growing intellectual abilities and independent reading practices became less controversial and more acceptable as an inevitable part of societal progress.

NOTES

I would like to thank the Ohio State University Press for allowing me to reprint in this essay portions of my book, *Educating the Proper Woman Reader: Victorian Family Literary Magazines and the Cultural Health of the Nation* (Columbus: Ohio State UP, 2004). Thanks also to the Ohio State University library for the use of their copies of the *Cornhill* and *Belgravia*.

1 For more on the conception of reading as a disease, see Flint, Gilbert, and Mays.

2 When I use the term 'family literary magazine,' I am referring to that class of magazines typically called shilling monthlies, including *Macmillan's* (1859), *Temple Bar* (1860), *St James's* (1861), *The Argosy* (1865), *Tinsley's* (1867), and *St Paul's* (1867). Instead of using the more commonly recognized label, I have coined the term 'family literary magazine' because, in my estimation, it

more accurately describes the attributes of these magazines than the simple designation of their price.

3 My methodology assumes that editors, contributors, and readers interact to create the particular character of a magazine, a character that is larger than the sum of its parts, that permeates even the seemingly disparate and discrete sections of the collection of works in any given issue. Therefore, works included in periodicals are not only equivalent to their author's intentions or related to the context of the magazine in a secondary way, as is often assumed. Instead, such works gain deeper meaning when examined in their periodical context. I will focus on publications featured in the *Cornhill* and *Belgravia* during – roughly – each magazine's first five years of publication (1860–4 for the former and 1866–70 for the latter), a time when each periodical was developing its own character and agenda.

4 The genre of the family literary magazine went beyond offering lightweight entertainment for its women readers, as some scholars have alleged (see, for example, Schmidt; Turner, 'Gendered Issues'). Indeed, these magazines provided a more open intellectual forum for women than other contemporary periodicals.

5 Thackeray edited the periodical from January 1860 until May 1862. After his resignation, the *Cornhill* was conducted by an editorial board consisting of George Smith, Frederick Greenwood, and G.H. Lewes (May 1862 until August 1864). When Lewes resigned in 1864, Greenwood became the sole editor until 1868, when Lewes, Smith, and Dutton Cook took over. Finally, in 1871 Leslie Stephen was hired, giving the magazine a unified editorial identity once again, but with a continued decline in sales (Huxley 118).

6 The *Cornhill* also had a much wider circulation than *Belgravia*. According to John Sutherland, the first issue of the *Cornhill* sold 109,274 copies (106); by 1865, that astounding figure had dwindled to around 40,000 largely because of the increased number of competing magazines like *Belgravia* (Glynn 143). In contrast, Bill Scheuerle records the average circulation of *Belgravia* at 15,000 (31–2).

7 For a thorough exploration of this argument, see my 'Clearing Away the "Briars and Brambles."'

8 For more extensive analyses of Leighton's illustrations for *Romola* see Malley, Turner, 'George Eliot v. Frederick Leighton.'

9 Interestingly, this kind of father-daughter relationship parallels Thackeray's relationship with his own daughter Anne. He was particularly concerned that she was 'going to be a man of genius' rather than a proper wife (Ritchie 23). In her 'Notes on Family History,' Anne explains that just before his death her father told her he was afraid that she would have 'a very dismal

life' when he was gone (Ritchie 129). With no marriage prospects on the horizon for a daughter who seemed to reject the traditional occupations of middle-class women, Thackeray decided to accept and nurture Anne's intellectual ability by allowing her to write for the *Cornhill.*

10 The object Phillis holds – which appears to be a rolling pin – is unmistakably phallic and is thus an additional sign of the threat she poses to her cousin.

WORKS CITED

Arnold, Matthew. 'The Literary Influence of Academies.' *Cornhill Magazine* (August 1864): 154–72.

[Braddon, Mary Elizabeth]. 'Milly Darrell.' *Belgravia Magazine* (November 1870–January 1871).

Eliot, George. *Romola. Cornhill Magazine* (January 1862–August 1863).

Escott, T.H.S. 'Literary Bagmanship.' *Belgravia Magazine* (February 1871): 508–12.

– 'Vagueness.' *Belgravia Magazine* (May 1868): 407–14.

Flint, Kate. *The Woman Reader 1837–1914.* Oxford: Clarendon P, 1993.

Gaskell, Elizabeth. 'Cousin Phillis.' *Cornhill Magazine* (November–February 1864).

Gilbert, Pamela K. *Disease, Desire, and the Body in Victorian Women's Popular Novels.* Cambridge: Cambridge UP, 1997.

Glynn, Jennifer. *Prince of Publishers: A Biography of George Smith.* London: Allison and Busby, 1986.

Huxley, Leonard. *The House of Smith Elder.* London, 1923.

'Insanity and its Treatment.' *Belgravia Magazine* (February 1870): 466–78.

[Lewes, G.H.]. 'Our Survey of Literature and Science: *Lady Audley's Secret.*' *Cornhill Magazine* (January 1863): 135–6.

– 'Our Survey of Literature and Science: *Orley Farm.*' *Cornhill Magazine* (November 1862): 702–4.

– 'Publishers Before the Age of Printing.' *Cornhill Magazine* (January 1864): 26–32.

Malley, Shawn. '"The Listening Look": Visual and Verbal Metaphor in Frederic Leighton's Illustrations to George Eliot's *Romola.*' *Nineteenth-Century Contexts* 19:3 (1996): 259–84.

Martineau, Harriet. 'Middle-Class Education in England – Girls.' *Cornhill Magazine* (November 1864): 549–68.

Mays, Kelly J. 'The Disease of Reading and Victorian Periodicals.' In *Literature in*

the Marketplace, eds. John O. Jordan and Robert L. Patten, 165–94. New York: Cambridge UP, 1995.

Mitchell, Sally. 'Sentiment and Suffering: Women's Recreational Reading in the 1860s.' *Victorian Studies* (Autumn 1977): 29–43.

North, John. S. 'The Rationale – Why Read Victorian Periodicals?' In *Victorian Periodicals: A Guide to Research*, eds. J. Don Vann and Rosemary T. Van Arsdel, 3–20. New York: MLA, 1978.

Phegley, Jennifer. 'Clearing Away the "Briars and Brambles": The Education and Professionalization of the *Cornhill Magazine*'s Women Readers, 1860–65.' *Victorian Periodicals Review* 33:1 (Spring 2000): 22–43.

Pykett, Lyn. *The Sensation Novel.* London: Northcote House, 1994.

Ritchie, Hester Thackeray, ed. *Thackeray and His Daughter.* New York: Harper and Brothers, 1924.

Ruskin, John. 'Of Queen's Gardens.' In *Sesame and Lilies*, 48–79. New York: Everyman's Library, 1965.

Saintsbury, George. *A History of Nineteenth Century Literature.* London: Macmillan and Company, 1896.

Sala, George Augustus. 'The Cant of Modern Criticism.' *Belgravia Magazine* (November 1867): 45–55.

Schmidt, Barbara Quinn. 'The *Cornhill Magazine*: The Relationship of Editor, Publisher, Chief Novelist and Audience.' PhD dissertation. Saint Louis University, 1980.

Scheuerle, William H. '*Belgravia.*' In *British Literary Magazines*, ed. Alvin Sullivan, 31–4. London: Greenwood, 1983.

Sutherland, John. '*Cornhill*'s Sales and Payments: The First Decade.' *Victorian Periodicals Review* 19 (1986): 106–8.

Thompson, Nicola Diane. *Reviewing Sex: Gender and the Reception of Victorian Novels.* New York: New York UP, 1996.

Turner, Mark W. 'Gendered Issues: Intertextuality and *The Small House at Allington* in *Cornhill Magazine.*' *Victorian Periodicals Review* 26 (Winter 1993): 228–34.

– 'George Eliot v. Frederic Leighton: Whose Text is it Anyway?' In *From Author to Text: Re-reading George Eliot's Romola*, ed. Caroline Levine and Mark W. Turner, 17–35. Aldershot, U.K.: Ashgate, 1998.

Weltman, Sharon Aronofsky. *Ruskin's Mythic Queen.* Athens: Ohio UP, 1998.

W.T. 'In the Firelight.' *Belgravia Magazine* (March 1868): 66.

5 The Reading Habit and 'The Yellow Wallpaper'

BARBARA HOCHMAN

During Charlotte Perkins Gilman's engagement to Walter Stetson, a friend offered her a copy of Walt Whitman's *Leaves of Grass*. Gilman refused to accept the volume, saying that she would never read Whitman. Discussing this incident, Anne Lane attributes Gilman's refusal of the book to the influence of Stetson, who apparently 'accepted, at least for his fiancee, the conventional view of his day that defined Whitman's poetry as unseemly and unsavory' (Lane xi). Any anxiety Stetson may have had about the consequences of reading *Leaves of Grass* would have rested upon another perfectly 'conventional view' of the day, the notion that one's reading could have an enduring impact on one's life – significant effects, whether benign or pernicious.

Much has been written about Gilman's relation to the 'work' of writing, but her relation to reading deserves more attention than it has received. At the end of the nineteenth century many writers, reviewers, and educators were preoccupied by the pros and cons of what was widely referred to as 'the reading habit.' This essay will historicize 'The Yellow Wallpaper' by suggesting that the story reflects culturally typical anxieties about certain kinds of fiction-reading, especially the practice of reading for escape, through projection and identification. Whether or not Gilman shared these anxieties – and I believe that she did – her most famous story provides an oblique but powerful image of a woman reader who is temporarily exhilarated but ultimately destroyed while absorbed in a mesmerizing text. The figure of the narrator in 'The Yellow Wallpaper' reflects Gilman's own intensely conflicted relation to reading, including her painful inability to read at all during the period of emotional upheaval on which the story is based. Attention to the story's self-reflexive concern with the dynamics of reading elucidates

not only Gilman's own reading practices but also her commitment to fiction 'with a purpose' (as she referred to 'The Yellow Wallpaper' in an exchange with William Dean Howells [*The Living* 121]).

Although Gilman's 'purpose' in writing 'The Yellow Wallpaper' was misunderstood by many of her contemporaries, the strong emotional impact of the story was never in doubt. When Horace Scudder rejected the story for the *Atlantic*, he wrote Gilman: 'I could not forgive myself, if I made others as miserable as I have made myself' (*The Living* 119). Less well known than Scudder's famous response to the story are the comments of a reader who sent a letter of 'protest' to the *Boston Transcript* after 'The Yellow Wallpaper' appeared in the *New England Magazine.* Charging that 'such literature contains deadly peril,' the letter devotes particular attention to the story's powerful grip upon its reader. 'It is graphically told, in a somewhat sensational style, which makes it difficult to lay aside, after the first glance, til [*sic*] it is finished, holding the reader in morbid fascination to the end' (*The Living* 120). This description of reading 'The Yellow Wallpaper' bears an uncanny resemblance to the way Gilman's story itself represents the narrator: 'morbidly fascinated' by the wall-paper, increasingly preoccupied with it, and determined to follow its pattern to 'some sort of conclusion' (19).[1] In the course of the story, the narrator herself becomes a reader – an avid, indeed an obsessive reader of the paper on the walls that surround her. From a nineteenth-century point of view, the narrator becomes what Nancy Glazener has recently called an 'addictive' reader – one who reads incessantly and who, while doing so, loses her last remaining hold on reality (chap. 3).

Gilman's nameless protagonist enters an action-filled world that she creates by inference from a printed design. As a result, her depression and despair are temporarily dispelled. Like a reader absorbed in an exciting tale, the narrator 'follow[s] the pattern about by the hour' (19). Soon she finds that '[l]ife [is] much more exciting than it used to be.' She has 'something more to expect, to look forward to' (27). Like a reader who can't put a book down, she no longer sleeps much 'at night for it is so exciting to watch developments' (28). Like the reader of a detective story (a popular genre at the end of the last century), the narrator's assiduity pays off and she 'discerns something at last' (29).[2]

To perceive the narrator as a kind of fiction reader is to see that Gilman's story projects a brilliant nightmare-version of what many nineteenth-century commentators represented as a common reading practice – and a dangerous one. In a phrase that might have been used

by any anti-fiction critic of the period, Gilman's narrator herself notes
the paper's 'vicious influence' (16).[3] Literary journals of the period
repeatedly distinguished the valuable 'habit' of consuming books for
'pleasure and improvement' from the kind of reading 'habit' associated
with inferior reading matter and with an inferior reader (often, though
not always, a woman). If we reflect upon 'The Yellow Wallpaper' in this
context, it can be seen as a kind of cautionary tale about nineteenth-
century reading – especially, but not exclusively, women's reading.[4]

To put some historical pressure on both the idea of the narrator as a
reader and that of the wallpaper as a 'text,' let us set aside the character-
istic emphasis on the content of the story implied by the wall-paper.
Like the narrator herself, critics of the last twenty years have devoted a
great deal of attention to the writing on the wall and have suggested that
the wall-paper – like Gilman's story – tells the tale of nineteenth-century
women, rendered querulous, infantile, and passive by the restrictions
imposed upon them.[5] With this aspect of the story well established,
much can be gained by seeing the wall-paper not only as a symbolic text
but as a more literal (indeed a fictional) one.

Understood metaphorically, the problem of 'reading' in 'The Yellow
Wallpaper' has been much discussed. The idea that the narrator comes
to understand her own existential situation by reading herself into the
wall-paper has provided a key to the story for almost twenty years. Many
critics interpret the wall-paper – with its dominant pattern, its subordi-
nate pattern, and its emerging image of a woman behind bars – as the
'patriarchal text' in which literary women, in fact all women, are
trapped.[6] Of course, the wall-paper is not always taken as a constricting
or constraining text; sometimes it is seen as one that enables the narra-
tor to confront her own situation and gain access to long-suppressed
feelings. 'Blocked from expressing herself *on* paper,' Judith Fetterley
writes, the narrator 'seeks to express herself *through* paper ... [S]he con-
verts the wallpaper into her text ... and recognizes [in it] elements of
her own resisting self' (164). The wall-paper, in short, is repeatedly seen
as a kind of text; yet it is never exactly a text that the narrator writes, nor
is it exactly a text that she reads.

The wall-paper has neither words nor pages. Perhaps that is why it has
so often been seen as an image of the narrator's life, never as an ana-
logue of Gilman's writing, or of other fictional works. Still, the narrator
'follows' the paper as if it were a story with a plot. Through the image of
the narrator Gilman inscribes a kind of protocol of reading into her
story:[7] the narrator's 'addictive' reading provides a forceful image of

how Gilman's tale is *not* to be read. This image points to a reader who was widely presumed to exist in nineteenth-century America. I mean the kind of fiction reader who was repeatedly attacked for what one doctor at mid-century called a 'profitless, pernicious habit [that] ... poisons the imagination [and] dissipates the mind' (qtd. in Zboray, *A Fictive People*, 14–15; cf. Borus, 195–6).

The Reading Habit

'The Yellow Wallpaper' sets out to modify contemporary conceptions of readers and reading by emphasizing the social as well as the psychic consequences of the narrator's reading 'habit.' If we see the narrator's relation to the wall-paper as the relation of a nineteenth-century reader to a fictional text, we have a schematic representation of a practice that was severely criticized in the 1880s and 1890s. The anti-fiction prejudice and the widespread ambivalence about the potential effects of the reading 'habit' were deeply ingrained elements of the literary culture within and for which Gilman wrote.

In the eighteenth and early nineteenth centuries, men of letters regarded the emerging genre of the novel with suspicion. Although disapproval of fiction lost much of its force between the 1860s and the 1890s, it did not disappear. Even at the end of the century, editors, educators, and reviewers often denounced a mode of reading that was presumed to result in a loss of borders and therefore of the reader's sense of reality. This way of reading, moreover, was generally associated with fiction that, like the wall-paper itself, often seemed flamboyant, inconsistent, or outrageous. As many commentators saw it, fiction in general, and certain kinds of fiction in particular, fostered an imaginary merger between the reader and figures who never existed. Sentimental fiction, historical romance, and other popular genres were repeatedly charged with encouraging passivity, escapism, and emotional extravagance. The 'novel-reading habit' in particular was identified with a lack of control. Associated with lower appetites, intemperance, and even corruption, it was seen to foster delusions, indiscriminate desire, and the possible breaking of social boundaries. Carried away by impossible visions graphically represented, a reader might well lose his or her sense of 'place' and even self.[8]

Such an outcome was quite different from that attributed to active, critical reading – the kind promoted at mid-century by writers like Melville or Thoreau and praised in many contexts both before and after

the Civil War.[9] Between the 1850s and the 1890s educators, writers, and reviewers repeatedly differentiated between reading that was passive or frivolous and reading that was serious, active, and conducive to self-development. Towards the end of the century many commentators stressed the innumerable benefits to be gained by 'spending less than an hour a day' on reading. As one such article titled 'The Reading Habit' put it, 'Of all the habits that can be cultivated, none is more productive of pleasure and improvement than that of reading, provided the books be well chosen' (60). Throughout the century, similar formulations appeared in manuals with titles like *How to Read a Book, The Choice of Books,* and Noah Porter's influential *Books and Reading: What Books Shall I Read and How Shall I Read Them?*[10] Such discussions regularly stressed the critical faculty – the need for activity, choice, and purposiveness in reading.

As an adolescent and a young woman, Gilman saw herself as just the kind of diligent and purposive reader projected by cultural custodians like Noah Porter, Edward Everett Hale (Gilman's uncle), or her own librarian-father, Frederick Perkins. Gilman's 'learned father,' as she describes him on the first page of her autobiography, was the author of *The Best Reading,* a reference book that 'was for long the standard' (*The Living,* 4). Indeed, Gilman claims that she always associated the word 'father' with 'advice about books and the care of them' (5–6). When Gilman was seventeen she wrote to her absentee father, asking him to provide a list of books that she could use as a starting point for her most ambitious goal: 'improvement of the human race' (36, 47).

Between the ages of sixteen and twenty-one Gilman believed that her 'steady reading' would give her access to 'the larger movements of the time' (61). She read voraciously, seeking a way 'to help humanity' (70) and disciplining herself with all her 'powers of ratiocination' (75). As Gilman represents this phase of her life, the image of her reading-self suggests a passionate commitment to the sort of vigorous, reality-bound reading praised by nineteenth-century commentators. It is not surprising to find that fiction-reading plays virtually no role in Gilman's account of her development.[11]

In writing 'The Yellow Wallpaper,' Gilman entered a highly contested literary field where many fictional genres jockeyed for position. She had a clear sense of what her own fiction was not to provide: escapist visions and vicarious emotional gratification. One could say of Gilman's fiction in general what Ann Lane says of Gilman's utopia: it 'leads us back to reality,' not away from it (xxxiv). Even Gilman's most fanciful stories –

'When I Was a Witch,' or 'If I Were a Man' – employ whimsy for didactic and pragmatic ends, creating a sharp focus on social conventions in contemporary America.[12] Before I examine the narrator's reading practices in 'The Yellow Wallpaper' more closely, a brief look at another Gilman story will suggest how Gilman could inscribe a protocol of reading into her text with a few deft strokes.

A minor character in 'The Girl in the Pink Hat' is 'a romantic soul,' who is always reading 'foolish stories' in 'her interminable magazines' (39, 46). Towards the end of the story, this girl – an innocent victim of male duplicity and aggression – immerses herself in 'one of Leroy Scott's doubly involved detective stories, [and] forget[s] her own distresses a while following those of other people' (46). The girl's 'escapist' reading in this context seems harmless enough. Yet this character, seduced by the fictions of a con man, has failed to act rationally on her own behalf. Only the narrator's intervention saves the 'girl in pink' from destruction. She is rescued because the narrator, seated behind her on a train, pays attention to the troubles of a fellow passenger rather than whiling away her time with 'foolish stories.' Although Gilman seems to concede that there might be some advantages to a tale that simply 'take[s] up your mind' and diverts it (46), she mocks such stories for didactic purposes.

'The Girl in the Pink Hat' can be taken as a gloss on Gilman's sense of the contrast between escapist fiction and her own work. There was a crucial difference for Gilman between reading that might become a substitute for the 'real' world, and reading that might lead one to confront it. No story of hers engages this problem more forcefully than 'The Yellow Wallpaper.'

The Narrator Reads

Presented in the form of a diary, 'The Yellow Wallpaper' begins with a focus on the narrator's writing. Her writing is a pervasive motif for almost half the narrative. Many discussions of the tale emphasize the narrator's frustrated need and desire to write. However, as Annette Kolodny and Richard Feldstein have noted, the focus on writing disappears entirely by the middle of the text (156, 276–7). The last reference to the narrator's writing appears at the beginning of the fourth section ('I don't know why I should write this' [21]). As her effort to write is abandoned, it is replaced by a growing determination to read the pattern inscribed in the wall-paper.

The narrator turns out to be far more persistent as a reader than she has been as a writer, and her commitment only increases as the story continues. Early on, the narrator repeatedly seeks a way out of the room where she is confined. Once she becomes engrossed in the wall-paper, however, her desire to escape diminishes and then disappears. She becomes 'fond of the room ... *because* of the paper' (19), and determined to satisfy her curiosity about its design. The narrator grows increasingly absorbed in the paper and intensely possessive about it. 'There are things in that paper that nobody knows but me or ever will,' she insists (22).

Although the narrator is not represented as much of a reader until the middle of the story, certain details point to her reading habits as early as the opening section. In her initial description of the house she inhabits, the narrator notes: 'It makes me think of English places that you read about' (11). These lines do not specify a particular text that makes the narrator 'think of English places,' but they do establish her as a reader. When she subsequently notes that if the house were 'haunted' she would reach the 'heights of romantic felicity' (9), we may well infer that she has been reading gothic fiction.[13]

The narrator's 'romantic' sensibility is elaborated through many details in the text, and has often been seen as part of the contrast between her and her husband, a contrast sharply drawn along stereotypical gender lines. While the narrator seeks 'romantic felicity,' John is 'practical in the extreme' (9). From John's point of view, his wife's 'imaginative power and habit of storymaking' only exacerbate her 'nervous weakness' (15). References to her 'silly fancies' (22) and 'foolish fancy' (24) abound. As critics have noted, John's view of the narrator as fanciful serves his effort to dismiss her ideas, keep her from creative 'work,' and confine her to domestic functions.

At the outset, however, the narrator's response to the wall-paper itself is far from fanciful or romantic. Instead it is critical and somewhat detached. 'I never saw a worse paper in my life,' she declares in her first description of it; '[o]ne of those sprawling flamboyant patterns committing every artistic sin' (13). Many of the narrator's statements about the wall-paper suggest that she is familiar with the vocabulary of aesthetic discourse. Repelled by the wall-paper's 'flamboyant pattern,' she stresses its 'artistic' limitations (13) and asserts, 'I know this thing was not arranged on any laws of radiation, or alternation or repetition or symmetry, or anything else I ever heard of' (20). These comments designate the paper as an aesthetic object, which the narrator initially considers

from a relatively analytic point of view. She approaches the paper with a set of assumptions about aesthetic unity and what she calls 'the principle of design' (20). Thus the narrator is represented not only as a middle-class woman and fiction reader, but also as an educated person whose reading has not been confined to ghost stories.

The categories used by the narrator, however, often seem unsuited to a description of wall-paper and indeed more appropriate to discussion of a narrative. If we imagine the wall-paper as a fictional text – some-times dull and repetitive, but also flamboyant, outrageous, self-contra-dictory, and repellant – we might see it as a sentimental or sensational work, the sort denounced by many nineteenth-century critics, especially those who were partial to realism. It will seem less fanciful to think of the wall-paper in these terms if we take a closer look at how the story renders the narrator's increasing desire to 'follow' the printed pattern on the wall.

While the narrator offers intermittent remarks about the aesthetic composition of the paper until late in the story, her commentary reflects a growing disposition to read the pattern like a plot – a sequence of events – structured around human agents. The narrator's tendency to see the paper as a form that harbours human life is evident from early in the story.[14] At first she attributes human qualities to iso-lated elements of the design – its 'broken neck' or 'unblinking eyes' (16). 'Up and down and sideways they crawl, and those unblinking eyes are everywhere,' she notes (16). But 'lolling necks' and eyes are not the only animated features of the pattern. 'Looked at in one way,' the narra-tor suggests in the third section, 'the bloated curves and flourishes – a kind of "debased Romanesque" with *delirium tremens* – go waddling up and down' (20). The paper's 'curves and flourishes' are not explicitly identified as human figures here; but they are nothing if not animated. First they 'waddl[e]'; soon they 'run off ... in full chase' (20). Moreover, the narrator identifies the 'curves and flourishes' with *delirium tremens*, a strictly human affliction (and one that gains additional resonance in the context of the narrator's own emerging 'habit'). As the narrator continues to contemplate the paper, its trembling animation only seems to increase. At times the narrator reads the design as you might read a tale of adventure, throwing herself imaginatively into the midst of the action. Her efforts to 'follow' the pattern are repeatedly frustrated, but her desire to do so is a recurrent, in fact a pervasive emphasis. She is preoccupied with the design's 'lack of sequence' (25) and bent upon resolving the seemingly irrational pattern into some sort of mimetic

representation – one with a beginning, a middle, and an end. 'I WILL follow [the] ... pattern to some sort of conclusion' (19), she insists.

What we might call the climax of the narrator's reading experience occurs when 'at last' she discovers the woman behind bars (29). This, of course, is the image that has galvanized readers of the last twenty years into reclaiming 'The Yellow Wallpaper' for the literary canon in general, and feminist criticism in particular. But since the main focus of the present argument is the process or experience of reading, rather than the implications of domestic ideology, the point to emphasize here is that the narrator gradually discerns a distinct storyline in the pattern that she 'follows.' This storyline centres on a figure that takes on human features, motivations, and finally a specifically human shape. Soon the narrator identifies herself with both the figure and the plot that she has discovered (or projects). Indeed, towards the end of the story she merges with that figure and enters that plot.

Addictive Reading or Creative Practice?

The narrator attributes human features and motives to the paper until the end of the story, but gradually the image of the woman behind bars becomes the central focus of her attention. As discussions of 'The Yellow Wallpaper' have noted, the narrator comes to read the wall-paper primarily by seeing her own situation – her entrapment, frustration, and anger – reflected back to her, first through the 'strange, provoking, formless sort of figure' (18) whose identity is unclear, and finally through the woman who 'shake[s] the pattern, just as if she wanted to get out' (23).

Many readers of the story have argued that the narrator's developing relation to the wall-paper is a process of self-recognition, one that boldly confronts reality, even though the price is high.[15] However, the narrator's identification with the figure of the imprisoned woman can be seen as a practice that divorces her from reality. By the time the narrator triumphantly announces, 'I've got out at last ... [and] you can't put me back' (36), she no longer differentiates between herself and the woman in the paper at all. It is in this sense that the narrator's behaviour looks like an extreme version (perhaps even a parody) of novel-reading as antifiction critics imagined it – an activity that by eliciting the reader's own fantasies could render her (or him) useless for the real 'business' of life.

Writing in *Forum* in 1894, Hjalmar Hjorth Boyeson expressed characteristic anxieties about the detrimental effects of sensational and 'infe-

rior' fiction. Using the trope of addiction, he reflects upon Jean Jacques Rousseau's representation of reading in *The Confessions*. According to Boyeson, Rousseau 'was unfitted for life by the reading of novels' (724). *The Confessions*, he argues, shows how Rousseau sought refuge in fiction from 'the "sordid" reality which surrounded him' (724). He read 'with a ravenous appetite for the intoxication which he craved ... more and more ... Like the opium habit the craving for fiction grew upon him, until the fundamental part of him suffered irreparable harm' (724). Boyeson emphasizes that the 'detrimental effects' caused by Rousseau's 'intemperance in the matter of fiction' were the typical result of 'dwelling too long' in an alternative reality constructed by reading (724).

In an essay entitled 'The Novel-Reading Habit' published in 1898, George Clarke, like Boyeson, elaborated the seductive powers of fiction by comparing 'the effects of novel-reading ... with those of indulgence in opium or intoxicating liquors' (674). Emphasizing that '[t]he sensations excited by fiction ... are superior in rapidity of succession to those of real life,' Clarke notes that fiction seems to offer 'escape' from 'tedium and anxiety' (671, 674). Among the 'easiest victims,' he explains, are '[p]ersons who ... have an abundance of leisure time, and who have not acquired by education a healthy interest in subjects of serious study or a taste for what is best in literature' (674). The narrator of 'The Yellow Wallpaper,' subjected to the enforced 'rest' of a 'cure' for depression and prevented from exercising whatever interest she may have had in 'the best' literature, reads the wall-paper precisely for relief from 'tedium[,] ... anxiety,' and the pressures of 'real life.' But for her, as for Boyeson's Rousseau or Clarke's addicted novel reader, what begins as diversion ends as intensified debility and even obsession.

When nineteenth-century commentators emphasized that if a reader were to identify too completely with a fictional character he or she might have trouble returning to the demands and the limits of daily reality, they drew upon another common assumption about reading: the idea of the novel reader as a self-involved and isolated person.[16] By 1890 an 'excessive indulgence in novel-reading' had long been associated with the image of the solitary reader. The act of reading itself – private, silent, infinitely absorbing – was seen as a kind of metonymy for the dangerous moral and social situation of every fiction reader, first cut off from daily life in the very act of reading, and then later, as a consequence, radically dissociated from appropriate social roles and responsibilities.[17] I suggest that by elaborating the narrator's preoccupation with

the woman in the wall-paper until it reaches fantastic proportions, Gilman sought to prevent her own readers from identifying uncritically with the narrator's situation and thereby in a sense reproducing it. If 'The Yellow Wallpaper,' as Fetterley suggests, is 'a text that can help the woman reader to effect an escape' from the constrictions of domesticity (such as Gilman herself achieved in her own life), it is such a text only insofar as readers employ a particular reading strategy, one that enables them to differentiate between their own experience and that of Gilman's narrator (164).

Like all Gilman's work, 'The Yellow Wallpaper' has clear didactic purposes. Gilman meant her story to be read as social criticism – not merely, let us say, for excitement and suspense, like detective fiction or a ghost story. But Gilman well knew that there could be a considerable gap between an author's intention and a reader's response. How could she lead her reader to perceive the wider social issues implicit in the narrator's experience? I have been proposing that Gilman designed her tale to discourage her readers from identifying with the narrator as the narrator identifies with the woman in the subpattern. From this point of view there is a certain irony in the fact that feminist readings of 'The Yellow Wallpaper' have relied so heavily on identification with the narrator.

As Susan Lanser pointed out in 1989, feminist interpretations of the story have often been shaped by 'an unacknowledged over-identification with the narrator-protagonist. I now wonder,' Lanser wrote, 'whether many of us have repeated the gesture of the narrator ... [determined to] read until she finds what she was looking for. ... [W]e may have reduced the text's complexity to what we need most: our own image reflected back to us' (420). Feminist readers, of course, do not literally identify the woman in the wall-paper as themselves; nor do they (like the narrator) see the printed text as their own habitat or antagonist. Thus, as Lanser notes, the final move of many feminist discussions has been to shift the focus of attention from the narrator to the author of the tale. The story encourages this move in part by the structural anomaly created when the narrator stops writing. In the course of the story, the narrator's preoccupation with the wall-paper displaces her desire to write in her diary and culminates in her quixotic attack on the material text. Stripping paper off the walls, crawling around the floor of the nursery, she cannot be imagined as writing at all, and at this juncture if one asks whose writing we are reading, the figure of Gilman herself comes into view.

The Author as Reader

Like the narrator/protagonist whom she created, Gilman was both a writer and a reader. Gilman's own defiance of the doctor's orders – her persistence as a writer – is well known to students of her work. Yet her reading practices, which have received little emphasis, are equally relevant not only to the design of 'The Yellow Wallpaper,' but to the experience on which the story draws. I have already suggested that Gilman's reading as a young woman provides a sharp contrast to that of both the narrator and the 'addicted' novel readers so graphically imagined by certain commentators of the period. Indeed, like Edith Wharton, and other upper- and middle-class women of her generation, Gilman was forbidden to read novels as a child (*The Living* 30).[18] Reconstructing her childhood in her autobiography, Gilman (like Wharton again [*Backward Glance* 33–5]) emphasizes the powerful attraction of scenes created by her own imagination. She describes how she devoted a portion of each day to imagined scenarios until the age of thirteen, when she was required by her mother's disapproval to 'give them up' (*The Living* 23). It was after renouncing the pleasures of what she calls 'wishing' that Gilman wrote to her father for a list of the 'best books.' From this point on, as Gilman tells it, she read for the logic and hard facts of natural history, philosophy, and science. She would seem to have internalized the disapproval widely associated with fictional worlds in late-nineteenth-century American culture.

As we have seen, Gilman's 'reading habit' helped her shape large ambitions for herself and her society. In this sense her experience as a reader corresponds to a pattern that recent feminist historians have traced. By drawing on the letters, diaries, and commonplace books of nineteenth-century women, as well as the work of response critics and theorists of reading, Mary Kelley, Barbara Sicherman, and others have shown how, for many women of the period, reading became an active and 'creative' practice with 'transformative potential' (Kelley 404). This view of nineteenth-century women's reading constitutes a challenge to the image of the passive or addicted fiction reader. It also challenges an idea proposed by Wai-Chee Dimock: that 'The Yellow Wallpaper' was designed for a woman reader who did not exist at the turn of the century.[19] The nineteenth-century women whose reading habits Kelley and Sicherman describe were the forerunners of the 'professional' readers who rediscovered Gilman's tale a century later.

Up to a point, the work of Sicherman, Kelley, and others restates the

idea of women's reading as a private encounter in which a book – often a novel – stimulates the fantasy or imagination of a solitary reader. But these historians represent the reading experience as empowering and creative, not solipsistic or self-destructive. Describing the reading habits in one Victorian middle-class family where reading was a central activity, Sicherman emphasizes 'the freedom of imagination women found in books ... Reading provided space – physical, temporal, psychological – that permitted women to exempt themselves from traditional gender expectations, whether imposed by formal society or by family obligation' ('Sense and Sensibility' 202). Discussing Alice Hamilton and her siblings,[20] for example, Sicherman underscores the imaginative intensity of the reading experience. There are times, to be sure, when this intensity itself suggests the very dynamic that elicited the concern of the anti-fiction critics. Writing in her diary in 1890, the young Agnes Hamilton describes herself as living 'in the world of novels all the time' and expresses anxiety about her '"insane passion" for reading' (207–8). Comparing it to 'an addiction,' Hamilton notes that she has 'resolved not to read another novel for a week at least, and [that she] consequently feels like a reformed drunkard' (qtd. in Sicherman 207–8). The imagery of addiction and intemperance should sound familiar by now; but it is important here to stress the differences between Hamilton's 'insane [reading] passion,' and the 'addictive' reading imagined by anti-fiction critics, or by Gilman in 'The Yellow Wallpaper.'

Insofar as Hamilton's reading threatened to overwhelm her at times, she herself was aware of this as a problem, and reflected upon the issue. But more than that, Hamilton's reading, like that of her sisters and many other nineteenth-century middle-class women, took place not in isolation but in the framework of a highly supportive interpretive community where books were often read aloud in company and discussed in a variety of contexts.[21] Many nineteenth-century women were avid consumers of books; but they did not necessarily read alone. Indeed, for American women of the period, reading was often what Mary Kelley has called a 'collective practice' (420). 'The female culture of reading,' Sicherman writes, 'fostered friendship and love, healing and learning, [and] reinforced individual efforts at self-creation' ('Reading and Ambition' 79).

Unlike the women described by Kelley and Sicherman, the narrator/reader of 'The Yellow Wallpaper' is denied both peer support and self-expression through writing. Since her enforced isolation makes reading her *only* activity, the desires stirred by her reading have no constructive outlet and are forced back upon themselves under the coercive con-

ditions of the 'rest cure.' By contrast, Gilman herself can be taken as another example of a nineteenth-century woman whose reading became a ground of constructive self-fashioning. If the interpretive conventions denounced by anti-fiction critics are in some sense analogous to those of Gilman's narrator, the reading practices described by Sicherman and Kelley are in some sense analogous to Gilman's own. The story of Gilman as a reader does not end as disastrously as that of the narrator in 'The Yellow Wallpaper.' But it does not end as happily as Kelley's narrative of 'learned women' in antebellum America or Sicherman's tales of 'female heroism.' A lasting and little-noted consequence of Gilman's 'breakdown' (as she refers to it in her autobiography) was a permanent inability to read at all with any ease or pleasure. Her refurbished life and her enormous productivity as a writer and lecturer are all the more amazing in the light of this enduring handicap. At one point in *The Living* Gilman attributes her 'ruin' in part to 'the rigid stoicism and constant effort in character-building of my youth; I was "over-trained" and had wasted my substance in riotous – virtues' (98). If Gilman's self-analysis is correct, she paid a heavy price for her renunciation of 'wishing' and other imaginative outlets. Her lonely and rigorous attempts at self-shaping through 'the power of ratiocination' may have contributed not only to significant achievement, but also to inordinate pain.

Gilman's autobiography tells the story of a child who read 'eagerly, greedily,' a girl who read steadily, with warm interest, in connected and scientific study' (99), and a woman who 'lost books out of [her] life' (100). 'The Yellow Wallpaper' was written at a time when Gilman 'could read nothing' (99); years later the effort to read still turned her mind into 'boiled spinach' (99). In this context the narrator's determination to 'follow' the design of the wall-paper and make it cohere may also reflect Gilman's own desperate – and futile – struggles with printed matter during her most difficult days.

Feminist readings of Gilman's story have elided both the figure of the narrator as an isolated, fantasy-ridden reader and the figure of Gilman as a tormented one. It is worth bringing these images back into focus because 'The Yellow Wallpaper' is informed by two contrasting and historically specific images of women reading: isolated, 'addicted,' and identifying with a phantom on the one hand; capable of 'creative appropriations'[22] that become the ground of far-reaching ambition (but, at least in Gilman's case, also emotional stress) on the other.

'The Yellow Wallpaper' reflects the destructive consequences of solitary reading, reading for escape and for the vicarious satisfactions of

identification and merger. At the same time, the story, like Gilman's autobiography, attests to the 'transformative potential' of reading. If Gilman's narrator fails to realize that potential, Gilman well knew that there were other women like herself who could do so, despite the price. Many of Gilman's readers in the late twentieth century have read 'The Yellow Wallpaper' in that spirit, even if they have not always perceived the story's direct engagement with certain nineteenth-century reading practices – including Gilman's.

NOTES

1 When the story was first published in the *New England Magazine*, 'wall-paper' was spelled both with and without the hyphen. Recent editions of the story vary considerably in this respect. The edition that I am using deletes it, and I have done so when citing from the text, or mentioning the title. Elsewhere I retain the hyphen because it puts a certain emphasis on the wall-paper as 'paper.'

2 On detective stories at the end of the century, see Klein.

3 In the words of one essay on 'the novel-reading habit,' 'When the confirmed novel-reader has an idle hour the craving for his customary dissipation seizes him. Not being conscious of the viciousness of his habit, he offers less resistance than the toper and proceeds at once to indulge it' (Clarke 675).

4 Although, as Glazener notes, 'women were widely charged with addictive reading' (310), men, too, were cautioned that excessive novel-reading could draw one away from the vital concerns of life. For a challenge to the idea that nineteenth-century novels were mainly read by women, see Zboray, *A Fictive People* (chap. 11).

5 For readings of the story along these lines see Gilbert and Gubar, Fetterley, and Kolodny. For a recent reassessment of the way feminist literary studies have engaged separate sphere ideology, see Amy Kaplan.

6 To Gilbert and Gubar, Gilman's tale represents 'the story that all literary women would tell if they could' (145). 'The paper,' they write, 'surrounds the narrator like an inexplicable text' (146). In Annette Kolodny's formulation, towards the end of the story the narrator is 'totally surrendered to what is quite literally her own text – or rather herself as text' (157).

7 In 'First Steps Toward a History of Reading,' Robert Darnton proposes that insight into both readers and texts could be gained by 'comparing readers' accounts of their experience with the protocols of reading' inscribed in literary works (157).

8 On 'unreasonable' fantasies of advancement stimulated by fiction, see Borus (29–30). Glazener notes that 'the problem of literature's becoming a substitute for reality ... preoccupied [contributors to] the *Atlantic*' toward the end of the nineteenth century (105–6). For a discussion of the hostility to novel-reading in the early Republic, see Davidson (39–44 and chap. 3).

9 That 'alert and wakeful' reading was associated with serious, generally male, and elitist pursuits can be clearly seen in the 'On Reading' section of *Walden* (94), or in Melville's review of Hawthorne's *Mosses From an Old Manse.* The exclusionary emphasis of these texts may account for their disappearance from the most recent *Norton Anthology of American Literature.*

10 See Philes, Porter, Richardson. Some commentators criticized the growing emphasis on purposive reading. In 'The Vice of Reading' Edith Wharton directed her irony against what she called 'mechanical' readers, encouraged by the notion of reading for improvement and social advancement (513–21). See also Dunn.

11 Rare exceptions in *The Living* include fleeting references to Scott (1) and *The Virginian* (93). Discussing her attempts to acquire 'desirable traits' in her girlhood, Gilman refers to her project of imitating 'some admired character in history or fiction.' But since, as she explains, she got only 'as far as Socrates' (59), the 'fiction' in question is certainly not the nineteenth-century novel.

Gilman's diary suggests she read more fiction than her autobiography reflects. During the 1880s and 1890s she read fiction by James, Alcott, Fuller, Frederic, Phelps, Poe, Twain, and many others. In general, her references to fiction reading are extremely sparse and matter of fact. Occasionally, however, they reflect the strong ambivalence about the power of fiction to beguile or enthrall that is under discussion here. (See, for example, pp. 19, 37.)

12 Gilman's ghost stories present the most serious challenge to the claim that her fiction 'lead[s] us back to reality.' Yet even 'The Great Wisteria,' one of Gilman's richest ghost stories, makes a forceful point about the stigma attached to unwed mothers. More obliquely and (for this reader) less successfully, 'The Rocking Chair' engages gender relations through its focus on the desirability of 'golden haired' girls.

13 Susan Lanser points to the gothic resonance of 'The Yellow Wallpaper,' linking the narrator's description of the house to that of the house in *Jane Eyre* (427–8). On 'The Yellow Wallpaper' and the 'gothic,' see also Lane (xvii) and Shulman (xiv–xvi).

14 Here again, the narrator's responses are typical of nineteenth-century reading conventions generally. In representations of reading throughout the century, both professional and nonprofessional readers commonly used the

trope of the book as a living thing – friend or foe. 'Books are only makeshifts for men,' in the words of one commentator (cited in Philes 13); or, as Bronson Alcott puts it, 'Good books ... like living friends, have their voices and physiognomies, and their company is prized as old acquaintances' (cited in Baldwin 13). For a discussion of the widespread reading practice of identifying books with people, see my *Getting at the Author,* especially chap. 1.

15 Many readings suggest that the narrator comes to recognize desires that she has suppressed and aspects of her self and situation that she has failed to acknowledge. See Fetterley, Gilbert and Gubar, Kolodny, Lanser.

16 The image of the solitary reader has a long history. It played a role in the polemics of anti-fiction critics well before the nineteenth century, and was taken up in the twentieth century by theorists of the novel like Walter Benjamin, Georg Lukacs, and Ian Watt. In 1977 J. Paul Hunter suggested that the novel is 'naturally' an isolating medium (456, 472, 478). Since then, Roger Chartier has proposed 'the sociability of reading' as 'a fundamental counterpoint to the privacy of the act of reading' (158), and Elizabeth Long has challenged the 'hegemonic picture of reading as a solitary activity' (192).

17 Solitary reading can be seen from a different perspective, of course. 'Private reading is already, in itself, an act of autonomy,' Cora Kaplan writes; 'in turn it sets up or enables space for reflective thought' (123). See also Radway (90–4).

18 Gilman also describes a visit to a ninety-nine-year-old woman who, when asked what she does with her time, answered, "'I read nov-els. When I was young they would not let me read them, and now I read them all the time" (*The Living,* 111).

19 Attempting to historicize Wolfgang Iser's construct of the 'implied reader,' Dimock suggests that 'The Yellow Wallpaper' 'implies' an educated, rational, authoritative woman reader who was 'not quite real' in the 1890s. The 'cultural work' of the story, Dimock claims, was precisely to bring this woman reader into being. But there were many kinds of women readers, including educated and critical ones, in late-nineteenth-century America. Moreover, as Kolodny notes, 'The Yellow Wallpaper' does not exclude the male reader, and can even be seen as directed towards making him a 'better reader' (162). In *The Living,* Gilman emphasizes that 'the real purpose of the story was to reach S. Weir Mitchell and convince him of the error of his ways' (121). To recognize Gilman's designs on a male reader is not to deny the story's feminist concerns.

20 'The Hamiltons of Fort Wayne, Indiana were an intensely and self-consciously literary family,' Sicherman writes; 'Hamiltons of three generations

were distinguished by their literary interests' (202–3). Alice Hamilton became a doctor and the first woman on the medical faculty at Harvard; her sister Edith Hamilton is well known for her work on classical mythology.

21 Reading aloud was a common practice in many middle-class families (Kelley 407; Sicherman, 'Sense and Sensibility,' 206). Gilman's diaries provide ample evidence of the practice. See also Zboray and Zboray, 'Have You Read?' (168–70); 'Books, Reading, and the World of Goods' (588, 590–1, 596–7, 600).

22 On the idea of reading as creative 'appropriation' see Chartier (171). In 'Sense and Sensibility' Sicherman suggests that imaginative identification allows a reader to occupy a variety of subject positions, crossing lines of gender and class, selectively appropriating what can be useful to the self. On multiple subject positions encouraged by reading, see also Cora Kaplan (130–1, 139, 142).

WORKS CITED

Baldwin, James. *The Booklover: A Guide to the Best Reading.* 1884. Chicago: McClurg, 1898.

Borus, Daniel H. *Writing Realism: Howells, James, and Norris in the Mass Market.* Chapel Hill: U of North Carolina P, 1989.

Boyeson, Hjalmar Hjorth. 'The Great Realists and the Empty Storytellers.' *Forum* 18 (1894): 724–31.

Chartier, Roger. 'Texts, Printings, Readings.' In *The New Cultural History*, ed. Lynn Hunt, 154–75. Berkeley: U of California P, 1989.

Clarke, George. 'The Novel-Reading Habit.' *Arena* 19 (May 1898): 670–9.

Darnton, Robert. *The Kiss of Lamourette: Reflections in Cultural History.* New York: W.W. Norton, 1989.

Davidson, Cathy N. *Revolution and the Word: The Rise of the Novel in America.* New York: Oxford UP, 1986.

Dimock, Wai-Chee. 'Feminism, New Historicism and the Reader.' In *Readers in History: Nineteenth-Century American Literature and the Contexts of Response*, ed. James L. Machor, 85–106. Baltimore: Johns Hopkins UP, 1993.

Dunn, Martha. 'A Plea for the Shiftless Reader.' *Atlantic* 85 (January 1900): 131–6.

Feldstein, Richard. 'Reader, Text, Referentiality.' In *Feminism and Psychoanalysis*, ed. Richard Feldstein and Judith Roof, 268–79. Ithaca: Cornell UP, 1989.

Fetterley, Judith. 'Reading About Reading: "A Jury of Her Peers," "The Murders in the Rue Morgue," and "The Yellow Wallpaper."' In *Gender and Reading:*

Essays on Readers, Texts and Contexts, ed. Elizabeth A. Flynn and Partocinio P. Schweickart, 147–64. Baltimore and London: Johns Hopkins UP, 1986.

Gilbert, Sandra, and Susan Gubar. 'From *The Madwoman in the Attic: The Woman Writer and the Nineteenth-Century Literary Imagination.*' In *The Captive Imagination: A Casebook on 'The Yellow Wallpaper,'* ed. Catherine Golden, 145–8. New York: Feminist P, 1992.

Gilman, Charlotte Perkins. *The Diaries of Charlotte Perkins Gilman.* Ed. Denise D. Knight. Charlottesville: U of Virginia P, 1994.

– 'The Girl in the Pink Hat.' In *The Charlotte Perkins Gilman Reader,* ed. Ann Lane, 39–46. New York: Pantheon Books, 1980.

– *The Living of Charlotte Perkins Gilman.* Madison: U of Wisconsin P, 1990.

– 'The Yellow Wallpaper.' New York: Feminist P at the City U of New York, 1973.

Glazener, Nancy. *Reading for Realism: The History of a U.S. Literary Institution 1850–1910.* Durham: Duke UP, 1997.

Hochman, Barbara. *Getting at the Author: Reimagining Books and Reading in the Age of American Realism.* Amherst: U of Massachusetts P, 2001.

Hunter, J. Paul. 'The Loneliness of the Long-Distance Reader.' *Genre* 10 (Winter 1977): 455–85.

Kaplan, Amy. 'Manifest Domesticity.' *American Literature* 70:3 (1998): 581–606.

Kaplan, Cora. 'The Thorn Birds: Fiction, Fantasy, Femininity.' In *Sea Changes: Feminism and Culture,* 581–606. London: Verso, 1987.

Kelley, Mary. 'Reading Women/Women Reading: The Making of Learned Women in Antebellum America.' *Journal of American History,* 83:2 (1996): 420.

Klein, Marcus. *Easterns, Westerns and Private Eyes: American Matters, 1870–1900.* Madison: U of Wisconsin P, 1994.

Kolodny, Annette. 'A Map for ReReading: Or, Gender and the Interpretation of Literary Texts.' In *The Captive Imagination: A Casebook on 'The Yellow Wallpaper,'* ed. Catherine Golden, 149–67. New York: Feminist P, 1992.

Lane, Ann J. 'The Fictional World of Charlotte Perkins Gilman.' In *The Charlotte Perkins Gilman Reader,* ed. Ann Lane, ix–xlii. New York: Pantheon Books, 1980.

Lanser, Susan. 'Feminist Criticism, "The Yellow Wallpaper," and the Politics of Color in America.' *Feminist Studies* 15:3 (Fall 1989): 415–41.

Long, Elizabeth. 'Textual Interpretation as Collective Action.' In *The Ethnography of Reading,* ed. Jonathan Boyarin, 180–211. Berkeley: U of California P, 1993.

Philes, George. *How to Read a Book.* Printed for George Philes: New York, 1873.

Porter, Noah. *Books and Reading: What Books Shall I Read and How Shall I Read Them?* New York: Charles Scribners, 1872; rpr. 1882.

Radway, Janice. *Reading the Romance: Women, Patriarchy and Popular Culture.* Chapel Hill: U of North Carolina P, 1991.

'The Reading Habit.' *The Critic* 30 (July 1892): 60.

Richardson, Charles. *The Choice of Books.* New York: American Book Exchange, 1881.

Shulman, Robert. 'Introduction' to *'The Yellow Wallpaper' and Other Stories,* by Charlotte Perkins Gilman, vii–xxxii. New York: Oxford UP, 1995.

Sicherman, Barbara. 'Reading and Ambition: M. Carey Thomas and Female Heroism.' *American Quarterly* 45:1 (1993): 73–103.

– 'Sense and Sensibility: A Case Study of Women's Reading in Late Victorian America.' In *Reading in America: Literary and Social History,* ed. Cathy Davidson, 201–25. Baltimore: Johns Hopkins UP, 1989.

Thoreau, Henry David. *Walden, or Life in the Woods.* In *Walden and Other Writings of Henry David Thoreau,* ed. Brooks Atkinson. New York: Random House, 1950.

Wharton, Edith. *A Backward Glance.* New York: Charles Scribner's Sons, 1985.

– 'The Vice of Reading.' *North American Review* 177 (1903): 513–21.

Zboray, Ronald. *A Fictive People: Antebellum Economic Development and the American Reading Public.* New York: Oxford UP, 1993.

Zboray, Ronald, and Mary Saracino Zboray. 'Books, Reading and the World of Goods in Antebellum New England.' *American Quarterly* 48:4 (December 1996): 587–622.

– '"Have You Read?" Real Readers and Their Responses in Antebellum Boston and Its Region.' *Nineteenth-Century Literature* 52 (September 1997): 139–70.

6 Social Reading, Social Work, and the Social Function of Literacy in Louisa May Alcott's 'May Flowers'

SARAH A. WADSWORTH

[I]f workbaskets were gifted with powers of speech, they could tell stories more true and tender than any we read.

– Louisa May Alcott, *An Old-Fashioned Girl*

In the preface to her last book, an assemblage of stories called *A Garland for Girls* (1888), published just one month before the author's death, Louisa May Alcott explains that the stories in the collection 'were written for [her] own amusement during a period of enforced seclusion,' adding that '[t]he flowers which were my solace and pleasure suggested titles for the tales and gave an interest to the work' (n.p.). Characteristically, Alcott's summing up of her work is entirely too modest. Not only is the flower symbolism to which she alludes intricately entwined with the motifs of such stories as 'An Ivy Spray and Ladies' Slippers,' 'Pansies,' 'Water-Lilies,' and 'Mountain-Laurel and Maidenhair,' but the stories are further united by a compelling thematic thread that binds together these narrative strands. A fitting, though neglected, capstone to Alcott's career as a woman of letters, *A Garland for Girls* offers an extended, multivalent commentary on gender and reading in nineteenth-century America.

In 'May Flowers,' the first story in the collection, Alcott establishes her theme. In this engaging tale, six blue-blooded Boston girls bearing the historic names of Anna Winslow, Ella Carver, Marion Warren, Elizabeth Alden, Maggie Bradford, and Ida Standish meet 'together, once a week, to sew, and read well-chosen books' (1).[1] Weary of novels and wary of frivolity, the young women turn for inspiration first to *Happy Dodd: or, 'She Hath Done What She Could'* (1878), a pious novel by Rose Terry Cooke, and then to *Prisoners of Poverty* (1887), a dissertation on

'women wage-workers, their trades and their lives' by novelist, reformer, and home economist Helen Stuart Campbell.[2] Roused from complacency by the humanitarian appeal of these texts, the young women become determined to disrupt their comfortable routine and resolve to make themselves useful in their community. Under the guidance of Anna Winslow, the club president, the girls decide that for the remainder of the year each one will secretly conduct a charitable mission of her own choosing. At the end of the season, when the group convenes for the last time before the summer interim, each girl reveals her project and reports on her progress. From Anna, who befriends shop-girls and reads papers to them at their local union, to Elizabeth, who brings books and magazines to hospitalized children, and Marion, who visits a veterans' home and reads history books to learn about the battles in which the residents fought, Alcott shows that the social functions of reading transcend the homely middle-class sociability of the sewing circle.[3]

Through a series of vignettes in which each member narrates her adventures, Alcott demonstrates that reading provides both an intellectual context for social reform and a means through which to bridge the boundaries of gender, class, generation, and ethnicity that separate the girls from the objects of their benevolence. At the same time, however, the narrative continually reminds readers of the differentials in culture and privilege that reinforce those boundaries. Beneath the veneer of a conventional, moralistic tale about the responsibilities of the wealthy towards the poor, 'May Flowers' contains complex and problematic ideas about the relationships among gender, class, and literacy. Thus even as Alcott illustrates how these elite young women strive to aid the disadvantaged, her depiction of the interactions between the upper and lower classes suggests that social reading and social work may ultimately reinscribe social difference.

From Sewing Circle to Reading Club

Being Boston girls, of course they got up a club for mental improvement, and, as they were all descendants of the Pilgrim Fathers, they called it the Mayflower Club. A very good name, and the six young girls who were members of it made a very pretty posy when they met together once a week, to sew, and read well-chosen books. (1)

Margaret Mackey has observed that the opening line of the novel *Little*

Women, containing Jo's lament that '"Christmas won't be Christmas without any presents,"' is 'rightly famous,' as '[i]n a single sentence, Alcott establishes situation, setting, mood, and a certain amount of character, writing with utmost economy' (155). Although understandably less famous, the opening of 'May Flowers' is no less impressive in its economy and scope. Doubly constrained by the restricted length of the short story and the necessarily swift pace and modest compass of juvenile fiction, Alcott manages to situate the Mayflower Club within a geographic and cultural context almost entirely by inference. Not only does she inform readers that the society is 'a club for mental improvement,' but with the phrases '[b]eing Boston girls,' and 'of course they got up a club,' she conveys the sense that the club is one of many, part of a popular trend in contemporary Boston that engaged countless young women in such societies for the collective reading of 'well-chosen books.' Indeed, as research into women's organizations reveals, women's reading groups or literary clubs 'spread across the American scene in the late 1860s, gathering momentum and increasing in number through the early 1890s' (Martin 1). It is from this tradition that Alcott's 'May Flowers' simultaneously emanates and departs.

Historians of the women's club movement have pointed out that the earliest forebears of these groups, loosely organized around individual church congregations, met to sew, read aloud from the Bible and other devotional works, discuss their reading, and, eventually, to contribute to the support of missionary work, temperance groups, and Magdalen Societies 'devoted to the salvation of "fallen women"' (Martin 6; see also Blair 7–13). Later, with the founding of the National Woman's Suffrage Association in 1869 and the Woman's Christian Temperance Union in 1873, women's clubs became independent of religious institutions and began to organize nationally. Tracing the 'genealogy' of women's literary clubs back through Margaret Fuller's 'Conversations,' Elizabeth Peabody's 'Historical Society' and 'Reading Parties,' and Ann Hutchinson's theological discussions, Theodora Penny Martin portrays Boston, 'the Athens of America,' as a hotbed of club activity, a social fact that Alcott seamlessly weaves into her domestic fiction (see also Deutsch 14–15).

Historically linked to the reading society or study club, sewing circles were, as Carolyn J. Lawes notes, 'the oldest and most common form of New England women's voluntary associations,' evolving in the antebellum period into 'permanent, constitutionally based organization[s] with explicit ties to social activism' (54). Gradually, however, social activism and self-culture took precedence over needlework. On the founding of

a real-life Mayflower Club of Cambridge, Massachusetts, in May 1893, a reporter for the *Boston Transcript* archly observed:

> For nearly a quarter of a century Boston has been beset with women's clubs of varying charm and usefulness, organized in fervent spirit and for various purposes. These societies have grown and flourished and have long ago passed through those early stages of development where the Puritan passion for visible usefulness was expressed by crochet work, those eras when a woman could scarcely listen conscience free to a Dante reading or a paper on reincarnation without having her fingers employed with needlework while her mind reached after ideas. (qtd. in Martin 62)

Notwithstanding the evident abandonment of the domestic arts for the liberal arts in contemporary women's reading societies, Alcott's Mayflowers are clearly not ready to trade in their needles and workbaskets for pens and notebooks. As the title page of the 1908 reprint illustrates, some of the girls attend to their sewing while others pause in their work to listen intently to the designated reader (fig. 6.1). This synthesis of literary club, Dorcas society, and sewing circle, a vital convergence in nineteenth-century New England (Lawes 45–81), is a recurrent site of mental, moral, and domestic improvement in Alcott's fictional and autobiographical writings. Her girlhood diary reveals that Mrs Bronson Alcott read Edgeworth and Scott aloud while her daughters plied their needles (*Girlhood Diary* 5). *An Old-Fashioned Girl* (1870) juxtaposes a fashionable sewing circle in which the rich girls gossip while stitching garments for the poor with a less privileged 'sisterhood of busy, happy, independent girls' (196) whose 'minds and tongues [rove] from subject to subject with youthful rapidity' as they discuss '[a]rt, morals, politics, society, books, religion, housekeeping, dress, and economy' (230). And in *Jo's Boys* (published about a year before *A Garland for Girls*), Alcott reveals the full cultural power of 'these household retreats,' where 'with books and work, and their daughters by them, [the March sisters] read and sewed and talked in the sweet privacy that domestic women love, and can make so helpful by a wise mixture of cooks and chemistry, table linen and theology, prosaic duties and good poetry' (243). Alcott remarks:

> It was curious to see the prejudices melt away as ignorance was enlightened, indifference change to interest, and intelligent minds set thinking, while quick wits and lively tongues added spice to the discussions which inevitably followed. So the feet that wore the neatly mended hose carried

Fig. 6.1. *A Garland for Girls* (Grosset & Dunlap, 1908), title page vignette.

wiser heads than before, the pretty gowns covered hearts warmed with higher purposes, and the hands that dropped the thimbles for pens, lexicons, and celestial globes, were better fitted for life's work, whether to rock cradles, tend the sick, or help on the great work of the world. (244–5).

In *Jo's Boys*, too, Alcott provides considerable detail about the intellectual content of Jo's 'sewing-school,' as the artistically inclined Amy provides selections from Ruskin, Hamerton, and Mrs Jameson; imaginative young Josie contributes romances, poetry, and plays; and 'Mrs Jo' gives 'little lectures on health, religion, politics, and the various questions in

which all should be interested, with copious extracts from Miss Cobbe's "Duties of Women," Miss Brackett's "Education of American Girls," Mrs. Duffy's "No Sex in Education," Mrs. Woolson's "Dress Reform," and many of the other excellent books wise women write for their sisters, now that they are waking up and asking, "What shall we do?"' (250).

In contrast to the conventional mid-nineteenth-century image of the 'isolated reader, immersed in her book' (Docherty 361), these various depictions of female reading groups demonstrate that for Alcott the domestic sewing circle could provide both a forum in which home-bound women might learn about social issues, particularly those that concern women, and a means of intellectual training or self-education (which many nineteenth-century clubwomen considered the key to the advancement of their sex). The reading circle in 'May Flowers' is exceptional, however, even among Alcott's numerous progressive portrayals of literary sewing circles, for in this story the fictional readers move beyond discussions of topical social issues, and transcend the acquisition of knowledge for its own sake (the primary goal of the majority of women's study clubs in the late nineteenth century), to achieve positive social action through the agency of literacy. Historians of women's organizations have identified a gradual shift in emphasis 'from the realm of abstract thought to the arena of practical action, from education for self to education for service' and 'from philosophy to philanthropy' (Martin 4; see also Blair) as women became more assured of their own educational standing around the turn of the twentieth century. Anticipating this trend, the antebellum sewing circle experienced a similar shift in focus: 'From sewing to benefit one's family to sewing to benefit society was a charge many women eagerly embraced' (Lawes 54). Fusing the parallel development of literary society and sewing circle, Alcott's 'May Flowers' explores this movement to involve women of privilege directly in the amelioration of social ills.

In *The Sound of Our Own Voices: Women's Study Clubs, 1860–1910*, Martin portrays women's reading clubs as remarkably homogeneous from region to region, indeed, 'almost identical in structure, purpose, and operation' (14; see also Lawes 59–76). Although several features of Alcott's Mayflower Club conform to those recorded by Martin – that the group meets in members' homes, that the club year runs from September to May, that meetings typically lasted two hours, with the first portion given over to business matters, and that members were predominantly white, Anglo-Saxon, and Protestant – on a few key points, the composition of Alcott's reading circle varies significantly from the profile Martin

presents. While the Mayflowers comprise half a dozen patrician eighteen-year-olds who (being unmarried) define themselves as girls rather than women, nineteenth-century women's study clubs typically consisted of at least twenty members, middle aged, married, and comfortably middle class – blue-stockinged perhaps, but not blue-blooded.[4] Another notable departure is that, although Alcott identifies the objective of the May-flower Club as the girls' 'mental improvement,' their reading agenda is substantially less rigorous in content and more spontaneous in mode of selection than those of sister clubs, which typically printed their annual programs in advance and systematically worked through large bodies of literature – a formal program of study – organized by author or subject matter (such as Shakespeare, for example, or American history). In contrast, Anna Winslow, president of the Mayflower Club, arrives at the meeting armed with a selection of suitable titles, chosen, one gathers, on the basis of their moral tone rather than their cultural importance, aesthetic value, or intellectual content.[5]

In her fiction for young people, Alcott frequently guides her readers towards improving reading matter while steering them away from books that she considered useless or even harmful. In *Little Women* (1868), her approach is predominantly descriptive, as she incorporates into the novel myriad details of the March sisters' reading, from the edifying and cherished *Pilgrim's Progress* to the boys' books and sensation novels in which unladylike Jo revels (see Crisler). Subsequent texts are often prescriptive, however, with Alcott liberally dropping the names of authors and titles of books into her narratives and spelling out in no uncertain terms which to read and which to avoid. In *An Old-Fashioned Girl*, for example, the Shaws exemplify young people who indulge in all manner of unsuitable reading, from *Lady Audley's Secret*, in which Fanny becomes utterly absorbed (37), to the sultry European novels Tom reads purportedly 'only ... to keep up [his] French' (210).[6] Near the novel's conclusion, when Polly is faced with the possibility of marriage to a man she does not love, Alcott wryly notes, 'If she had read as many French novels as some young ladies, she might have considered it interesting to marry under the circumstances and suffer a secret anguish to make her a romantic victim' (239). *Eight Cousins* (1874) includes a chapter ('Good Bargains') detailing the demerits of popular juvenile sensation stories, which Alcott criticizes for their peppering of slang and lack of realism. Later, in *Rose in Bloom* (1876), Uncle Alec encourages Rose to form her own conclusions about the immorality of French novels in the chapter entitled 'Small Temptations'; meanwhile bookish Mac develops into a

youth worthy of Rose's love in part through his devoted reading of Shelley, Keats, Emerson, and Thoreau. In 'May Flowers,' Alcott is at her most forceful on this favourite topic of books and reading, as she moves beyond a passive model of reading that stresses the effects of particular types of texts upon the minds of individual readers to a more active model that not only suggests ideas of *what* to read but also provides a template for *how* to read, together with specific illustrations of what to *do* with what one has read. Privately reading the British and American Romantics might serve to elevate the intellect and refine one's sensibilities, just as sensation novels could dull one's moral and emotional makeup. For the girls in 'May Flowers,' however, the combination of uplifting prose, naturalistic reportage, and wholesome companionship provides the inspiration, impetus, and moral support necessary to catalyse a latent impulse of charity into active, usefully directed missionary zeal.

Reading and Reform

After her suggestion of *Happy Dodd* is met with 'a chorus of "I've read it!"' (1), Anna Winslow, who has been devising her plan to encourage the girls in the Mayflower Club to 'do good,' 'turn[s] to her list for another title' (1). By reading *Prisoners of Poverty* with them, she hopes to give them 'hints' (6) and instigate them to action. Quick to anticipate Anna's motive, Elizabeth Alden chimes in with '[l]et us begin with "The Prisoners of Poverty," and perhaps it will show us something to do' (4). The others agree, and '[s]o they began' (6). In considerable detail, Alcott chronicles their reading of Helen Campbell's socioeconomic study of women employed in New York's garment industry:

> For an hour one pleasant voice after the other read aloud those sad, true stories of workingwomen and their hard lives, showing these gay young creatures what their pretty clothes cost the real makers of them, and how much injustice, suffering, and wasted strength went into them. It was very sober reading, but most absorbing; for the crochet needles went slower and slower, the lace-work lay idle, and a great tear shone like a drop of dew on the apple blossoms [she was embroidering] as Ella listened to 'Rose's Story.'[7] They skipped the statistics, and dipped here and there as each took her turn; but when the two hours were over, and it was time for the club to adjourn, all the members were deeply interested in that pathetic book, and more in earnest than before; for this glimpse into other lives showed them how much help was needed, and made them anxious to lend a hand. (6)

Although *Prisoners of Poverty* may have been less inviting to the young women than a sentimental novel like *Happy Dodd*, Alcott presents a poignant tableau of the reading scene, tinged with pathos and suffused with goodwill. In so doing, she indirectly coaxes her real-life readers to sample this more ponderous fare, encouraging them to gloss over the statistics and read out of order, as she models these practices in her fictional readers. Ann Ruggles Gere has commented on precisely these kinds of reading strategies: 'In many clubs reading aloud was a common practice, and ... this practice redefined the nature of reading to make it more communal and corporeal. Rather than interacting in isolation with a written text, club members shared responses, frequently inserting their own voices into the reading' (652). So, too, in Alcott's 'May Flowers,' reading aloud encourages the girls to articulate their responses to the text, to form a consensus about their reading, to relate the information embodied in the text to their own experiences of the world outside the text, and hence to translate abstract ideas into concrete social action.

The responses of historical readers to such communal reading practices are regrettably difficult to recover; nevertheless, it is surely noteworthy that at least one contemporary reviewer recommended *A Garland for Girls* precisely on the basis of the instruction Alcott provides in the arena of reading, exclaiming:

> We are sure we need only mention Miss Alcott's 'Garland for Girls' ... to have it clearly understood that we think every girl ought to have it, to learn how one set of little maids were encouraged to personal effort for others by reading Mrs. Campbell's 'Prisoners of Poverty.' (Review 67)[8]

As this reviewer tacitly acknowledges, the real power of a book such as *Prisoners of Poverty* lies in its potential to move its readers to action.[9] Before reading this documentary text, Alcott's Mayflowers are uncertain how to go about helping the less fortunate, despite their good intentions. Even though all the girls express profound admiration for Cooke's didactic tale of the Christian do-gooder Happy Dodd, a few remain doubtful as to *why* they should help the poor: Maggie Bradford, for one, appears to be more attracted by the fun and mystery of the project than by any lofty humanitarian ideal. '[C]aught by the idea of doing good in secret and being found out by accident,' she vows to 'look round at once for some especially horrid bootblack, ungrateful old woman, or ugly child, and devote [herself] to him, her, or it with the patience of a saint' (5). After sampling the stark journalistic realism of

Prisoners of Poverty, however, the Mayflowers set aside their qualms and resolve to 'shoulder' their burdens – although Anna fears that they 'can't do much, being "only girls"' – and even Maggie declares 'with a resigned expression, and a sanctimonious twang to her voice': 'I shall stand on the Common, and proclaim aloud, "Here's a nice young missionary, in want of a job! Charity for sale cheap! Who'll buy? Who'll buy?"' (7). Ella Carver is more diffident, predicting: 'I shall probably have a class of dirty little girls, and teach them how to sew, as I can't do anything else. They won't learn much, but steal, and break, and mess, and be a dreadful trial, and I shall get laughed at and wish I hadn't done it' (7). Thus, Alcott reassures her readers that a certain amount of trepidation is natural but that it is important nevertheless to persevere. As the meeting concludes, each member is determined to conquer her reservations and seek out '"a little chore" to do for sweet charity's sake' (8).

In her study of women and reform in nineteenth-century New England, Lawes establishes that the antebellum sewing circle, 'the most ubiquitous form of women's organization,' functioned as 'a forum for good fellowship, mutual improvement, and social activism' (6) and 'moved women's labor beyond the realm of domestic production to connect with larger social concerns' (55). Raising money for a variety of local and national reforms, permanent for-profit sewing circles allowed women to '[lay] claim to the right to participate in the political and social development of the community, the nation, and the world' (47) and 'to act upon their concern for creating a more just and moral society' (78).[10] In 'May Flowers,' Alcott demonstrates how a postbellum women's group could 'connect with larger social concerns' not through the labour of needlework directly, but rather by translating ideas acquired through communal reading into purposeful acts of community service and by conveying to others the transformative role of literacy in social betterment. The activities of her characters thus set in motion a potentially self-perpetuating cycle of reading and reform, as Alcott dispatches each of the club members on a humanitarian errand. Fanning out across Boston, the Mayflower girls traverse the urban landscape in search of charitable opportunities, transporting their ideas and ideals beyond the limits of their exclusive domestic circle and across class and ethnic boundaries (see Deutsch 7–8):

Marion was often seen in a North End car, and Lizzie in a South End car, with a bag of books and papers. Ella haunted a certain shop where fancy articles were sold, and Ida always brought plain sewing to the club. Maggie

seemed very busy at home, and Anna was found writing industriously several times when one of her friends called. All seemed very happy, and rather important when outsiders questioned them about their affairs. But they had their pleasures as usual, and seemed to enjoy them with an added relish, as if they realized as never before how many blessings they possessed, and were grateful for them. (8)

The causes the Mayflowers eventually espouse are as various as the girls themselves: Anna helps to improve the working conditions for a pair of toil-worn shop-girls; the enterprising Ella becomes 'a silent partner and co-worker in a small fancy store at the West End' (13), thereby joining the legions of female petty entrepreneurs who inhabited late-nineteenth-century Boston (see Deutsch 115); Lizzie amuses patients at the Children's Hospital; Ida provides food, clothing, and comfort for three neglected waifs; Marion obtains a place in the Soldiers' Home at Chelsea for a disabled veteran of the Civil War; and Maggie becomes a second mother in her own home, keeping house and tending her younger siblings so that her mother can recuperate from a debilitating illness.

Throughout 'May Flowers,' Alcott persistently emphasizes the role of reading and writing in volunteerism and social change, even as she demonstrates a broad range of activities in which charitable young women might engage. When Anna discovers that Maria, one of the shop attendants she meets, is homebound with a lame knee, she asks if she might take her some books or flowers. Later, after she has persuaded the girls' employer to allow them to seat themselves on stools when no customers are present, she becomes involved with the girls' union. When she tells the members of the Mayflower Club that she has been 'reading papers to a class of shop-girls at the Union once a week all winter,' her 'deeply interesting statement' is met with '[a] murmur of awe and admiration' (11).[11] As Alcott hastens to explain, with tongue in cheek, 'true to the traditions of the modern Athens in which they lived, the girls all felt the highest respect for "papers" on any subject, it being the fashion for ladies, old and young, to read and discuss every subject, from pottery to Pantheism, at the various clubs all over the city' (11). Anna begins her course of readings by sharing amusing selections from the journals her brother kept while traveling abroad, 'and when the journals were done ... read other things, and picked up books for their library, and helped in any way [she] could, while learning to know them better' and win their confidence (12–13). Meanwhile, Lizzie amuses hospitalized children by bringing them picture books and papers, among other diver-

sions, and reads and sings to them; Ida enables two destitute children to attend school and lends books to their neighbour, Miss Parsons, 'a young woman who was freezing and starving in a little room upstairs' (29); and Marion, having befriended a veteran, becomes swept up 'in a fever of patriotism' to the point that she begins 'to read up evenings' about the Civil War and becomes 'great friends' with her brother as a result of 'reading together' about all the battles (36).[12] In each of these cases, reading opens up a channel of communication between the young woman and the object of her benevolence, affording a means with which to bridge the gaps arising from disparities in social class, gender, age, and ethnicity.

For all the transformative power of the written word, however, Alcott never ceases to remind her readers of the relentlessly intransigent categories of social difference that define the world depicted in her narrative. Indeed, the protagonists of 'May Flowers' appear considerably less progressive than their reform-minded author (a lifelong advocate of the rights of African Americans, Native Americans, and the poor, as well as of temperance, prison reform, child labour reform, and women's suffrage [Baum 251]), as Alcott continually alerts the reader to the daunting differentials in social caste that separate the Mayflower girls from the humble folks whose lives they strive to improve. This disparity is perpetuated, in part, through the perspectives of the girls themselves, who view their society through a lens of bigotry and prejudice. In a city that was one-third immigrant in 1880 and in which ethnic Irish would soon be a majority (Deutsch 7), Ella refers with evident repugnance to the prospect of washing 'dirty little Pats' and describes with apparent unconcern the escapades of 'some black imps' she encounters playing in a West End street. (The most densely populated area of Boston, the West End had, by the 1880s, distinct Black, Jewish, Irish, Portuguese, and Italian neighbourhoods [Deutsch 7].) Moreover, in narrating the elaborate means through which she lent support to two downtrodden Vermont women, she explains to her friends: 'We did not dare to treat them like beggars, and send them money and clothes, and tea and sugar, as we do the Irish, for they were evidently respectable people, and proud as poor' (18).[13] The stereotype of the indolent Irish (not unusual in Alcott's fiction) surfaces too in Ida's story, in which Mrs Kennedy, the mother of the young children she assists, is 'a shiftless, broken-down woman, who could only "sozzle round" ... and rub along with help from any who would lend a hand' (29). Marion's story is, however, the greatest condemnation of the Irish, for after she donates tea, sugar, a shawl,

and some pennies to a 'little Irishwoman who sells apples on the Common' – a woman she refers to as 'my old Biddy' – she learns from another Irish vendor that 'a drunken ould crayther is Biddy Ryan, and niver a cint but goes for whiskey' (33). Literacy, as Harvey Graff has shown, paled in comparison to the impact of ethnicity in the nineteenth-century city in effecting '[t]he process of stratification, with its basis in rigid social inequality' (114), and Alcott tacitly accepts this sociological fact.

Although the activities these girls undertake represent a momentous departure from the self-culture orientation of the more cloistered women's societies of the period, Alcott's Mayflower Club is fundamentally conservative in impulse, tending ultimately to reaffirm the status quo. This conservatism is nowhere more evident than in Maggie's story, a *pièce de résistance* that completes the narrative cycle by demonstrating that the most admirable contributions are those which girls are capable of making in their own domestic spheres. Recounting her transformation from indulged dependent to second mother with her own burden of domestic responsibilities, Maggie explains:

> 'I didn't say anything, but I kept on doing whatever came along, and before I knew it ever so many duties slipped out of Mamma's hands into mine, and seemed to belong to me. I don't mean that I liked them, and didn't grumble to myself; I did, and felt regularly crushed and injured sometimes when I wanted to go and have my own fun. Duty is right, but it isn't easy, and the only comfort about it is a sort of quiet feeling you get after a while, and a strong feeling, as if you'd found something to hold on to and keep you steady. I can't express it, but you know?' (39–40)

At the conclusion of Maggie's tale, Anna warmly responds with 'Many daughters have done well, but thou excellest them all' (42), an affirmation that unambiguously signals to the reader the relative value ascribed by the text to charitable work outside of and within one's own domestic sphere. True to the prevailing spirit of nineteenth-century women's clubs, 'May Flowers' ultimately valorizes traditional roles for women and conservative goals for social reform.

Social Transformation and Self-Transformation

In a paper entitled 'How Can Women Best Associate,' presented at the First Woman's Congress of the Association for the Advancement of

Woman (1873), Julia Ward Howe appealed to women club organizers 'to draw the circle so that it shall not strengthen the divisions of society already existing, sundering rich from poor, fashionable from unfashionable, learned from simple' (qtd. in Martin 66). Unfortunately, Howe's proposition may have represented an ideal few women's clubs attempted to realize. Indeed, Anne M. Boylan contends that antebellum women's organizations 'permitted individuals to cement their religious commitments and signify their class locations and racial identities' (54) and that the ability of the wealthiest and best connected of these organizations 'to wield political and economic power ... set them off from their less well situated sisters and reinforced differences in their lives, deepening the chasms of religion, race, class, and legal status that separated them from each other' (218). Certainly, Alcott's Mayflowers have not drawn their circle widely, instead restricting their membership to descendants of the Pilgrim Fathers, alike in gender, age, ethnicity, and class. Yet in this story, the eponymous flower is doubly symbolic, referring simultaneously to the impeccable ancestry of the club members (an index both of their patriotism and of their unassailable social status in nineteenth-century Boston [see Martin 38]) and to the trailing arbutus, also known as the mayflower, an evergreen plant associated with transformation and renewal. At the conclusion of the story, Anna pays tribute to the girls' moral regeneration by presenting her fellow club-members with 'real Plymouth mayflowers ... a posy apiece' [42]. With reference to the symbolic significance of the mayflower, Alcott writes:

> So the winter passed, and slowly something new and pleasant seemed to come into the lives of these young girls. The listless, discontented look some of them used to wear passed away; a sweet earnestness and a cheerful activity made them charming, though they did not know it, and wondered when people said, 'That set of girls are growing up beautifully; they will make fine women by and by.' The mayflowers were budding under the snow, and as spring came on the fresh perfume began to steal out, the rosy faces to brighten, and the last year's dead leaves to fall away, leaving the young plants green and strong. (8–9)[14]

Although each of the girls' vignettes ends happily, with some tangible improvement wrought in the personal life of a member of the lower classes (or, in Maggie's case, of her invalid mother), the real transformation, Alcott suggests, is in the girls themselves. Social reading (both

communal consumption of texts and the focus on socially progressive works) has led them to social volunteerism and hence to moral enlightenment – a path clearly foreshadowed in Alcott's earlier novels for young people. Ultimately, however, domesticity and personal growth prevail over activism and social amelioration, while true reform – the restructuring of a society stratified by disparities of wealth and power and divided by inequalities prescribed by gender, class, and ethnicity – seems to elude their grasp.

Yet in the end, Alcott hints of future progress as well, as her Mayflowers possess 'a clearer knowledge of the sad side of life, a fresh desire to see and help still more, and a sweet satisfaction in the thought that each had done what she could' (47). If it ends with an allusion that brings us back full circle to *Happy Dodd; or, 'She Hath Done What She Could,'* the narrative as a whole still beckons onward, inviting us to follow the textual trail marked by the author and join in the imagined circle of Alcott's own reading, where 'prejudices melt away as ignorance [is] enlightened' (*Jo's Boys* 244–5). Turning to *Prisoners of Poverty*, responsive readers might then discover that 'back of every individual case of wrong and oppression lies a deeper wrong and a more systemized oppression' (66), and thus unravelling *A Garland for Girls*, trace in its roots the vital thread: 'Only in the determined effort of the individual, in individual understanding and renunciation forever of what has been selfish and mean and base, can humanity know redemption' (Campbell 185).

NOTES

1 Among those who sailed from Plymouth, England, to Plymouth Rock aboard the Mayflower in 1620 were passengers Edward Winslow, Gilbert Winslow, Robert Carver, John Carver, Richard Warren, John Alden, William Bradford, and Myles Standish.

2 An associate of Charlotte Perkins Gilman's, Helen Campbell (1839–1918) wrote novels for adults under the names 'Campbell Wheaton' and 'Helen Stuart Campbell,' as well as stories for children, short fiction for popular magazines, and a textbook on housekeeping and cooking. In addition to *Prisoners of Poverty*, which was originally commissioned as a series of articles in the *New York Tribune*, her books on reform include *The Problem of the Poor* (1882), *Mrs. Herndon's Income* (1886), *Prisoners of Poverty Abroad* (1889), and *Women Wage-Earners* (1891) (Paulson 280–1).

3 Alcott's 'May Flowers' may have been inspired by 'A Suggestion' in *The Amer-*

ican Girl's Handy Book by Lina and Adelia B. Beard. In their section on Thanksgiving, the Beards advise their readers 'to form a society ... to be called the Thanksgiving Society, whose object will be to provide a real Thanksgiving for other and less fortunate girls, by giving them something to be thankful for before next year's Thanksgiving shall arrive' (313).

4 Naturally, there were exceptions to this profile of women's study clubs, and Martin points to several 'daughter clubs' formed by young women or girls, including the well-known Saturday Morning Club of Boston, founded by the daughters of prominent clubwoman Julia Ward Howe (72–9). For additional information on clubs that ran counter to the 'typical' club profile, see Gere, *Intimate Practices*, and McHenry.

5 In this respect the Mayflowers more closely resemble the antebellum sewing circle described by Lawes, which, 'to guard against excessive chatting, the "reproach to our sex," ... resolved to sew to the accompaniment of an appropriately uplifting text' (60).

6 Although Alcott anonymously authored numerous sensation novels for adults, she clearly did not recommend such reading to her devoted audience of youth.

7 In 'The Case of Rose Haggerty,' the second chapter of *Prisoners of Poverty*, Campbell relates the experiences of an impoverished Irish American girl, the eldest daughter of alcoholic parents, who must provide for several young siblings when her ne'er-do-well forebears die of a fever. After years of profit-less toil, hardship, and exploitation by unscrupulous employers, Rose finally resorts in desperation to 'the one way left' (27), prostitution.

8 Erin Graham's 1897 article 'Books That Girls Have Loved' offers one example of how real-life girls incorporated the literary practices of Alcott's fictional heroines into their own lives. Referring to the Pickwick Club in *Little Women*, Graham explained: 'We had been inspired by the club and the newspaper in which the March family rejoiced. So we four determined to win literary bays, and decided that our Quartette Club should meet in the attic every Thursday afternoon. Our periodical was written on brown paper, and bore the name "Budget of Wit and Novelty." It did not lack for poetry, and there was an abundance of short stories, in which Italian princesses and English dukes played a prominent part' (432).

9 In *An Old-Fashioned Girl*, one of Alcott's characters comments on the failure of most literature to move readers to action, musing, 'Speaking of pitying the poor, I always wonder why it is that we all like to read and cry over their troubles in books, but when we have the real thing before us, we think it is un-interesting and disagreeable' (189). For Helen Campbell, the author of *Prisoners of Poverty*, new journalism offered a possible solution. She wrote: 'I

am by no means certain that ... the plain bald statement of facts, shorn of all flights of fancy or play of facetiousness, might not rouse the public to some sense of what lies below the surface of this fair-seeming civilization to-day' (129).

10 Lawes's research presents a striking contrast to Elizabeth Long's study of women's reading groups in late-twentieth-century Texas, in which Long concludes that although several of the groups she observed 'were aware of the ways in which their nonfiction reading had linked them to wider social currents' (599), women's reading groups lack 'the fascinating quality of organizations spearheading social change' (591).

11 Alcott may have had in mind the Women's Educational and Industrial Union, founded in 1877 as a community service agency to assist the working girls of Boston. In addition to offering classes, this union operated an employment bureau, a dispensary, and a legal aid service for poor workers. Alcott likely drew on chapter 15 of *Prisoners of Poverty* ('Among the Shop-Girls') in composing Anna's story.

12 Alcott's experience as a volunteer nurse in Washington, DC, from December 1862 to January 1863, recounted in *Hospital Sketches*, informs the stories of Lizzie and Marion.

13 These countrywomen seem to be composites of several women Campbell discusses in *Prisoners of Poverty*, for example, the New England milliner of chapter 5 and 'Almiry' (a name Alcott uses for one of her Vermont women), a seamstress from New Hampshire (chap. 12).

14 In *An Old-Fashioned Girl*, Alcott similarly uses the mayflower as a symbol of moral regeneration, writing 'To outsiders that was a very hardworking and uneventful winter to Polly. She thought so herself; but as spring came on, the seed of new virtues, planted in the wintertime, and ripened by the sunshine of endeavor, began to bud in Polly's nature, betraying their presence to others by the added strength and sweetness of her character, long before she herself discovered these May flowers that had blossomed for her underneath the snow' (196).

WORKS CITED

Alcott, Louisa May. *Eight Cousins; or, The Aunt-Hill*. 1874. Boston: Little, Brown, 1996.

– *A Garland for Girls*. Illustr. by Jessie McDermott. Boston: Roberts Brothers, 1888.

– *A Garland for Girls*. New York: Grosset & Dunlap, [1908].

– *Hospital Sketches*. Ed. Bessie S. Jones. Cambridge: Belknap P, 1960.

– *Jo's Boys.* 1886. Boston: Little, Brown, 1994.
– *Little Women or Meg, Jo, Beth, and Amy.* Introduction by Anna Quindlen. 1868. Boston: Little, Brown, 1994.
– *Louisa May Alcott: Her Girlhood Diary.* Ed. Cary Ryan. Mahwah, NJ: BridgeWater Books, 1993.
– *An Old-Fashioned Girl.* 1870. Boston: Little, Brown, 1997.
– *Rose in Bloom: A Sequel to Eight Cousins.* 1876. Boston: Little, Brown, 1995.
Baum, Freda. 'The Scarlet Strand: Reform Motifs in the Writings of Louisa May Alcott.' In *Critical Essays of Louisa May Alcott*, ed. Madeleine B. Stern, 251–5. Boston: G.K. Hall, 1984.
Beard, Lina, and Adelia B. Beard. *The American Girl's Handy Book: How To Amuse Yourself and Others.* 1887. Boston: David R. Godine, 1987.
Blair, Karen. *The Clubwoman as Feminist: True Womanhood Redefined, 1868–1914.* New York: Holmes and Meier, 1980.
Boylan, Anne M. *The Origins of Women's Activism: New York and Boston, 1797–1840.* Chapel Hill: U of North Carolina P, 2002.
Campbell, Helen Stuart. *Prisoners of Poverty: Women Wage-Workers, Their Trades and Their Lives.* Boston: Roberts Brothers, 1887.
Cooke, Rose Terry. *Happy Dodd; or, 'She Hath Done What She Could.'* 1878. Boston: Ticknor & Company, 1887.
Crisler, Jesse S. 'Alcott's Reading in *Little Women*: Shaping the Autobiographical Self.' *Resources for American Literary Study* 20 (1994): 27–36.
Deutsch, Sarah. *Women and the City: Gender, Space, and Power in Boston, 1870–1940.* Oxford: Oxford UP, 2000.
Docherty, Linda J. 'Women as Readers: Visual Interpretations.' *Proceedings of the American Antiquarian Society* 107 (1998): 335–88.
Gere, Ann Ruggles. 'Common Properties of Pleasure: Texts in Nineteenth-Century Women's Clubs.' *Cardozo Arts and Entertainment Law Journal* 10 (1992): 647–63.
– *Intimate Practices: Literacy and Cultural Work in U. S. Women's Clubs, 1880–1920.* Urbana: U of Illinois P, 1997.
Graff, Harvey. *The Literacy Myth: Literacy and Social Structure in the Nineteenth-Century City.* New York: Academic P, 1979.
Graham, Erin. 'Books That Girls Have Loved.' *Lippincott's Magazine* 60 (1897): 428–32.
Lawes, Carolyn J. *Women and Reform in a New England Community, 1815–1860.* Lexington: UP of Kentucky, 2000.
Long, Elizabeth. 'Women, Reading, and Cultural Authority: Some Implications of the Audience Perspective in Cultural Studies.' *American Quarterly* 38 (1986): 591–612.

Mackey, Margaret. '*Little Women* Go to Market: Shifting Texts and Changing Readers.' *Children's Literature in Education* 29 (1998): 153–73.

Martin, Theodora Penny. *The Sound of Our Own Voices: Women's Study Clubs, 1860–1910.* Boston: Beacon P, 1987.

McHenry, Elizabeth. *Forgotten Readers: Recovering the Lost History of African-American Literary Societies.* Durham: Duke UP, 2002.

Paulson, Ross E. 'Helen Stuart Campbell.' In *Notable American Women, 1607–1950: A Biographical Dictionary,* ed. Edward T. James, 280–1. Cambridge: Belknap, 1971.

Review of *A Garland for Girls. The Critic* 12:215 (11 February 1888): 67.

7 'A Thought in the Huge Bald Forehead': Depictions of Women in the British Museum Reading Room, 1857–1929

RUTH HOBERMAN

On 2 May 1857 a new, domed reading room opened in what had been the courtyard of the British Museum. Constructed, like the Crystal Palace, from glass and wrought iron, the room was a design and engineering wonder, attracting 62,000 visitors during the eight days it was open to public inspection. As serious readers followed the gawkers, the new reading room quickly became a centre of London intellectual life. Attendance increased steadily during the later part of the century, moving from 109,000 visits in 1876 to 146,000 in 1890. The recipient of all copyrighted material published in the country, the library was, quite literally, the place to go for information about anything; journalists, politicians, writers, and scholars spent long days there, their feet on the heated foot rests, taking notes as they composed their articles, speeches, and novels. Known as the 'mecca of literary research workers,' the room drew such famous male readers as Thomas Hardy, Arnold Bennett, Samuel Butler, W.E. Gladstone, Leslie Stephen, A.C. Swinburne, George Bernard Shaw, W.B. Yeats, and Bram Stoker.[1]

Less famously, the room also attracted women. Though rarely listed now on the standard lists of famous patrons, these women – among them novelists Olive Schreiner, Edna Lyall, E. Nesbit, Emma Brooke, Beatrice Harraden, and Dorothy Richardson and social activists Annie Besant, Mona Caird, Beatrice Potter, Charlotte Wilson, Charlotte Despard, Eleanor Marx, and Clementina Black – attracted attention, and as the century went on, both verbal and visual representations of women in the reading room became increasingly common in novels and in the popular press. In fact, from the 1860s on, the presence of women in the British Museum Reading Room provided grist for countless journalistic depictions, generally either openly derisory or gently

satirical. At the same time, however, women depicted their own presence in the reading room, in everything from letters and autobiographies to fiction, in more sympathetic terms. I want to argue, in fact, that depictions of women in the reading room became one way in which the British debated the proper role of women, with the reading room itself serving as a kind of stage on which women dramatized their involvement in the public life of the nation.

These depictions took on particular importance because of the vital role the British Museum played in Britain's self-image, as one of the 'knowledge-producing institutions' Thomas Richards places at the 'administrative core of the empire' (4). For the reading room's growth coincided not only with the expansion of the British empire – in east and west Africa, the Far East, Egypt and the Sudan, and India – but also with the increasingly sophisticated means by which it was administered and explained. As surveyors, missionaries, colonial administrators, and practitioners of such new disciplines as anthropology and archeology sent information and artifacts back to London, royal societies, museums, libraries, and universities constructed and disseminated the racist and Orientalist discourse that justified their intervention. This intervention necessitated surveillance, which generated more information, which had in turn to be organized. (The control of knowledge, Richards points out, is a recurring theme of nineteenth-century literature, with degeneration, reverse colonization, and entropy offering constant threats [5].) The British Museum Reading Room, with its vast collection and 374-volume catalogue (finally published in 1900 after a twenty-five-year effort [McCrimmon, *Power,* 148]), was command-central for this late-nineteenth-century knowledge-control industry. Reinforcing this sense of centrality was the fact that the reading room was a literal panopticon. The superintendent, from his raised central platform, could survey the reading benches raying outward like spokes in a wheel. The only figure in the room allowed to wear a top hat (Harris, *Reading Room,* 20), the superintendent, along with his domain, thus epitomized the efficiency of British social surveillance and the centralization of British knowledge and administration.

What happens when women enter such a space? From a Foucauldian standpoint, women simply reinforced the room's disciplinary function. According to Tony Bennett, for example, women aided in civilizing the museum's patrons. Bennett has described an 'exhibitionary complex' emerging during the nineteenth century – which included arcades, exhibitions, galleries, and museums (61). Bennett, following Foucault,

argues that this complex worked 'as a set of cultural technologies concerned to organize a voluntarily self-regulating citizenry,' turning spectators into co-operative participants in civilization, order, and progress as they survey each other as well as whatever is on display. Middle-class women reinforced this process, he suggests, by forcing working-class men to emulate the decorous behaviour of the upper classes out of respect for their presence (63).

But a look at newspapers, novels, and journals during the late nineteenth century gives a more complicated and more conflict-ridden picture, suggesting that the reading room was not just a Foucauldian scene of surveillance and discipline. While Bennett emphasizes the museum's disciplinary role, my own research suggests a tension between that role and the ways in which many women actually used the museum – a tension articulated by the widely varying depictions their presence there inspired. In *The Practice of Everyday Life*, Michel de Certeau argues that Foucault's emphasis on institutions' disciplinary mechanisms overlooks actual consumers' 'ways of operating' (xiv). Actual consumers, de Certeau suggests, reconfigure institutional space through the 'tactic,' a 'calculated action' that 'boldly juxtaposes diverse elements in order suddenly to produce a flash shedding a different light on the language of a place' (37–8). I want to explore the ways women operated, reading their actions in the reading room as well as their and others' depictions of it. In the process, I hope to show that the room's very centrality and conspicuousness made it a public stage: an opportunity for women to dramatize their entry into – or rejection of – public life.

Women's presence in the reading room resulted in a complex battle of representations, in two phases. During phase one, from the 1880s to 1907, women ambitious for a role in public life depict themselves and each other as delighting in the reading room's resources. Their depictions vary in tone, with more conservative writers emphasizing women readers' unobtrusiveness, while those aligned with socialist and feminist causes underline their self-assertion, even disruptiveness. But all see the reading room in positive terms, as facilitating women's move from private into public life. Those opposed to this move, on the other hand – a group including a few women writers, much of the mainstream press, and a number of male novelists – either ridicule women readers as incongruous or pity them as exploited workers who would be happier if married.

While these sides seem clearly drawn, the issues shift in phase two, which begins after 1907, when the reading room was redecorated and

the separate section for 'ladies' seating' removed. The subsequent representations of women readers by women – particularly by Virginia Woolf and Dorothy Richardson in the 1920s – no longer depict the room as a liberating, gender-free space women hope to share, but as an implicitly male space, oppressing the women who work there with its accumulated cultural weight, turning them – in Woolf's famous words – into mere thoughts in the dome's 'huge bald forehead' (*A Room of One's Own* 26). Throughout both phases, representations of women in the reading room respond in complex terms to the behaviour of actual women as well as to the layout of the room itself, as they serve to articulate shifting and conflicting views of the relationship between women and public life.

From its earliest incarnation, the British Museum Reading Room was largely a male domain. While women had never been barred from any of the six reading rooms preceding the 1857 one, they had rarely patronized them. During the ten years after the creation of the first reading room in 1759, according to George Barwick, only three women used it (34). Female patrons of the eighteenth century were occasionally asked to find a companion to study with them, and around 1820, one writer commented, 'It was not considered etiquette for ladies to study in the library of the British Museum' (Barwick 65). During the nineteenth century, female patronage increased; Harriet Martineau, Dinah Mulock Craik, and Eliza Lynn Linton researched their novels in the reading room of the 1840s. On the whole, however, according to Thomas Kelly, women tended to prefer circulating libraries or, where available, ladies' reading rooms (84).

Thus, when the 1857 room attracted women in larger numbers, people noticed. The increase is not surprising, given that this was the period when women became increasingly involved in politics and public life (for example, joining socialist organizations like the Fabian Society, writing for the press, serving on local school and poor boards, speaking for women's suffrage). From the perspective of politically progressive, educated middle-class women, the reading room offered tremendous opportunities: to think through their ideas with the help of research, to discuss them with like-minded friends, and to wield influence by spreading them. Merely by gaining access, they defined themselves as public scholars, for to get a reading ticket they had to describe their research needs and supply a recommendation from a house-holder. They could then use the reading room to gain the intellectual authority and professionalism that come from research, to share in that 'social life of the

intellect' Edith Simcox called for for women in an 1887 article (395), and (taking advantage of their conspicuous visibility as women in a predominantly male-populated panopticon) to enact their identities as public intellectuals and 'new women.'

As the role of women in public life became increasingly controversial, the representation of women in the reading room took on new significance, for, 'mecca' though it might be, the reading room was also an intensely contested space as readers literally competed for scarce seating, as officials debated who could be excluded to make more room, and as the popular press depicted the room as inappropriately overwhelmed by women's bodies. Although the 1857 reading room had been built to provide more room for books and readers (302 people could be seated at its thirty-five tables, two of which were set aside for women [Harris, *History*, 189]), by the mid-1870s it was already overcrowded again (fig. 7.1). Alarmist commentators referred to the steady increase in both readers and books, worrying that seating and shelving were insufficient. An 1877 *Athenaeum* article complained the room was too full of 'triflers' ('Literary Gossip' 700), and W.E. Gladstone wrote in 1890 that despite Panizzi's 'noble design' providing room for 1,200,000 books, 'all this apparently enormous space for development is being eaten up with fearful rapidity' (388).

Some responses emphasizing the need for more seating and fewer patrons focused on the space taken up by women. In 1872, Robert Cowtan pointed out that while two long tables were set aside – complete with hassocks – for female readers, 'a considerable proportion of lady readers sit from choice at the unreserved places' (223–4). In 1878, a battle erupted in the press over this issue. The seating set aside 'for ladies,' one reader complained, was left unoccupied, while the rest of the room was packed: 'ladies,' he wrote, 'are well sprinkled over the general seats, but the inferior sex [men] dare not invade the reserved territory' (Anonymous Student 4). Three women quickly responded in favour of the seats, arguing that some women need the separate seating to feel comfortable. One correspondent even described a confrontation with a fellow reader over the issue, an incident revealing how much anger this competition for space generated. Arriving too late to get a seat in the ladies' section, the correspondent had to sit with the men, but while she was working, the reserved seats opened up. Because she remained where she was rather than move, a man behind her complained that the reserved area was unused and prevented his getting a seat. In fact, she suggested, the seating *was* used and appreciated (Audi 8). Another writer agreed the room was crowded, but

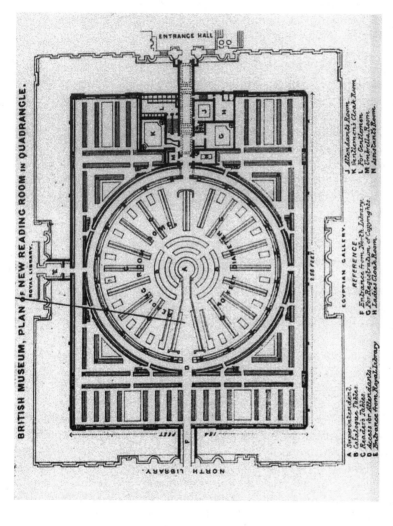

Fig. 7.1. 'Plan of the New [1857] Reading Room'; reprinted from *British Museum: New Reading Room and Libraries* (London, 1857), courtesy of the Trustees of the British Museum; the line points to those seats reserved for women readers.

suggested that rather than remove the 'ladies only' label, the room should be barred to lawyers, surgeons, and lunatics, all of whom take up space and do not really require the room's resources (Faulke-Watling 8). A few years later, though, an article in *Belgravia* repeated the charge that the ladies' reserved seats went unused: 'There are a few desks set apart, like compartments in a railway train, "for ladies only," and one of the standing jests of the place – perfectly supported, too, by experience – is, that these are left solitary and untenanted' (Fitzgerald 163).

The overflowing of women from their designated area deprived the men of their seats, these articles suggest; other accounts imply the women deprive the men of their minds, as well. While the anonymous author of an 1861 article in *Chambers Journal* appears to welcome women, addressing his imagined reader as 'madam' and asking that she take his arm as he leads her to the reading room, he depicts the actual women he finds there as nothing but trouble. After passing several 'Arguses,' the author points out to his female visitor the room's 'perfect light, chasteness, and simple grandeur,' despite which, he sometimes gets nothing done:

> Need I point out to you that the two seats marked 'FOR LADIES ONLY,' do not afford sufficient accommodations for all the fair worshippers of Minerva? They are consequently forced, ma'am, actually forced to sit about amongst the rougher sex; and the consequence, so far as I am concerned, is false quantities, misspelling, mistranslation, and wrong references. ('National Reading Room' 130–1)

Once the author perceives 'the whisk of silk and the rustle of muslin,' he explains, his 'faculties' leave him. The article at once welcomes women – as visitors – and warns them (albeit facetiously) that those women who remain there are seen only in terms of their bodies, which violate the space's 'chastity' and make rational discourse impossible. An 1886 article in *Saturday Review* suggests that the terms of the problem had not changed much in twenty-five years. Summarizing recent complaints about women in the reading room, who are accused of talking, flirting, eating strawberries, and reading novels, the author mentions 'the frou-frou of her silken raiment' and the resultant inhibition male readers feel about scattering ink for fear it might stain those skirts. The only remedy, the author concludes, is patience, since 'attempts to keep a portion of the seats for *dames seules* do not seem very successful' ('Ladies' 213).

Given a designated area yet sitting outside it, these women were doubly visible. As a result, male observers seemed to experience their conspicuous presence as an imposition of bodily imperatives – their clothes, food, and flirtations are most frequently complained of – on an otherwise disembodied, rational workspace. In articles and illustrations throughout the late nineteenth century, women readers appear as emphatically embodied – in ways that conflict with their surroundings. *Punch*, for example, depicts poet Mary Robinson in an 1885 cartoon as an outlandish presence in a room packed with distinguished men – Richard Garnett, Leslie Stephen, and Algernon Swinburne among them (fig. 7.2). She is depicted as incongruously prominent, just off-centre in the foreground, sitting on what must be her chairback or desk. Her position and abstracted gaze remove her from the scene; her presence seems disturbing and purposeless. The book on which her hands rest is entitled *A Handful of Honeysuckle*, hardly the stuff of serious research (in fact, a book of poems by Robinson, published in 1878) ('Valuable Collection' 155). Along similar lines, an 1896 *Idler* illustration of the reading room depicts an elderly, white-bearded man falling from a ladder, books flying, as an elegantly dressed young woman reads a massive volume in the foreground (fig. 7.3). While the article proper makes no reference to women, its title, 'The Horrors of London,' seems at first glance to refer to the dangerous disorder this woman's body and her outsized book have produced (Upward 3). This illustration in turn resembles one that appeared on an 1895 pamphlet entitled *The Truth about Giving Readers Free Access to the Books in a Public Lending Library*: a woman on a ladder looks down at a man on his knees being bombarded by books falling from the shelves, presumably at her instigation (Kelly 179). While the pamphlet's point is to argue against allowing the public direct access to books, its illustration suggests that the threat of disorder originates in women's bodies.

While depictions of well-dressed, oversized women suggest tension about the takeover by upper-middle-class women of the nation's 'administrative core' (Richards 4), a related set of representations depict lower-middle-class women in danger of tumbling into indigence, eccentricity, and ill health. Common to both is the incongruity emphasized between the female body and her labour: Percy Fitzgerald's *Belgravia* article from the early 1880s, for example, describes 'fair "damozels," who work like any copying-clerks, and whose appearance is antagonistic to their drudgery'; and a 'fair and fresh young creature ... grappling earnestly and laboriously with some mouldy and illegible MS' (161, 163).

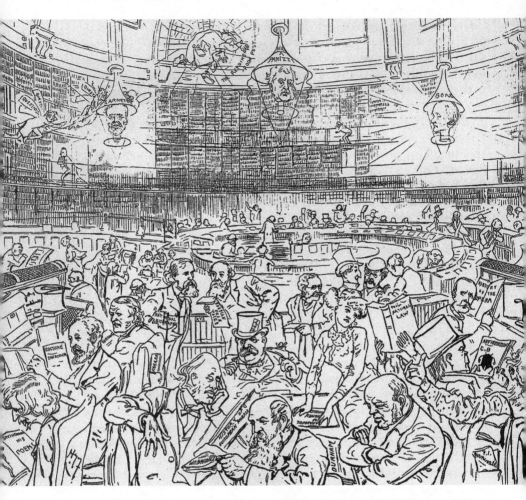

Fig. 7.2. 'Valuable Collection in the Reading Room, British Museum,' from *Punch* (28 March 1885), courtesy of Punch Ltd.

But Fitzgerald's women are not merely physically incongruous; they are exploited, 'fair "damozels"' in need of rescue from a workplace where they do not belong, as they work 'for some literary man who has cash and position' (161) – much like George Gissing's Marian Yule in his 1891 *New Grub Street*, whose work in the reading room for her abusive father makes her pale and cough-prone. Marian's only hope of salvation

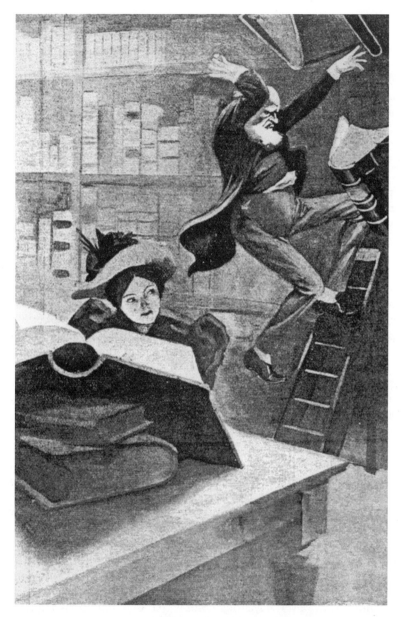

Fig. 7.3. Illustration by Ernest Goodwin, from an article entitled 'The Horrors of London. XI. The British Museum,' *Idler* (January 1897).

is marriage; after potential husband Jasper Milvain deserts her, we see her again at work in the reading room, trying to 'convert herself into the literary machine which it was her hope would someday be invented for construction in a less sensitive material than human tissue' (Gissing 505). Along similar lines, Sarah Beautiman, in E.V. Lucas's 1910 *Mr. Ingleside*, complains of her work in the reading room: 'the air's terrible, and the people I sit between!' Employed in the meaningless task of hunting down everyone important in history named 'Graham,' she comments, 'I believe if I was introduced to anyone named Graham I should have hysterics' (95). The only fully satisfied woman in the novel is Alison Ingleside, who marries and so rescues her body from the oppression and disease caused by professional labour. All these representations of women at work in the reading room thus focus on the misfit between their bodies and the setting in which they find themselves, as well as the tasks in which they are engaged.

Why are women's bodies in the reading room so painfully and problematically visible? For one thing, they are aspirants to a public sphere premised on their exclusion. The term 'public sphere,' of course, comes from the work of Jürgen Habermas, who has traced the development during the eighteenth century of the 'bourgeois public sphere' – a sphere of 'private people come together as a public' – that is, of rational, civic-minded individuals who hammer out among them, via written and spoken discourse, a body of opinion independent of the state (27). Museums and reading rooms are listed by Habermas among the venues where this hammering takes place, in part because they are places where the absorption and exchange of ideas takes place (40), but also because they contribute to a specifically literary public sphere in which 'the subjectivity originating in the interiority of the conjugal family, by communicating with itself, attained clarity about itself' (51). For men, at least, this literary public sphere then fed directly into a political public sphere, where these clarified subjectivities could engage in debate about issues of shared concern. The British Museum Reading Room, where journalists and political activists did the research that would allow them to take public stands, where they met and talked about books and ideas and wrote their articles, was thus a point of convergence between literary and political public spheres: a perfect image for the world that ambitious late nineteenth-century women hoped to enter.

Feminists, however, have long complained that Habermas's notion of a 'public sphere' conflates the middle-class man with citizenship, much as, according to Woolf, the reading room dome (that 'huge bald fore-

head' with the names of male authors engraved around its moulding) conflates masculinity and cultural achievement. Joan Landes, for example, has pointed out that Habermas's 'public sphere' tends to marginalize those who 'would not or could not lay claim to their own universality,' or whose concerns were defined as primarily 'private' – namely, women (142). Building on Landes, Carole Pateman argues that the rational civic individual has in fact been defined *against* the 'disorder of women' and the privacy of the domestic space (44). To the extent that the reading room is a public space and a locus for the production of public discourse, it is by definition a place removed from women's bodies. The fact that women kept spilling over the seating set aside for them – there is scarcely a commentator through the 1870s and 1880s who fails to mention this – must have dramatized, for male readers, the threat posed by this disorder.

That threat is only complicated by the fact that the 'rational civic individual' had, in any case, ceased to exist by the 1880s and 1890s, according to Habermas. Writers and researchers might believe they were moulding public opinion, but in fact the power was now wielded by trade unions and political parties in the political sphere and by newspaper 'hacks' serving circulation-obsessed editors in the literary sphere. This debased literary world is explicitly contrasted in Gissing's *New Grub Street* with the eighteenth-century Grub Street of Johnson and Boswell – that is, the Grub Street of Habermas's original bourgeois public sphere. Alfred Yule and Edwin Reardon, reading room aficionados who fail as writers, are both described as having based their literary ideas on eighteenth-century literary practices. Figures like them appear frequently in the fiction and nonfiction of the time: idealistic intellectuals who begin with high hopes but end up broke and marginalized in a world unwilling to reward disinterested knowledge with either money or attention. Their opposite is the 'hack,' another stock reading room figure, who has accepted the crass terms on which his writing is demanded and flourishes as a result. From a middle-class male perspective, the women in the reading room must have seemed at once complicit in this dissolution of the public sphere – as their mere presence blurred public/private boundaries and as they profited from the expanding market for their writing – and in danger of being polluted by it as intellectual labour became increasingly commodified and financially risky. ('A man might bear the struggle, though it had killed the heart in many a man,' a male character says of work in the reading room in Dora McChesney's 1903 novel *London Roses: An Idyll of the British Museum*, 'but a woman, this woman?' [237].)

No wonder, then, that depictions in the mainstream press emphasize the incongruity of women's bodies in a space associated – in theory – with purely rational, disembodied thought, and – in practice – with the compromises and uncertainties of earning a living through literary labour. In contrast, women novelists and poets, at least those of moderately conservative tendencies, tend to emphasize the quiet, unobtrusive professionalism of their reading women, implying that the space offers a gender-neutral opportunity to those who can work without drawing attention to themselves. In her 1884 novel *We Two*, for example, Edna Lyall describes the pleasure her heroine, Erica Raeburn, feels on entering the reading room, where she is researching the life of Livingstone for an article in her father's atheist paper *The Idol-Breaker*: 'The great domed library of the British Museum had become very homelike to Erica, it was her ideal of comfort.' The room is 'homelike,' but without the disadvantage of her actual home, where 'she could never be secure from interruptions' (2:53). Erica likes the quiet and the books, but most of all she likes to feel that the space is hers, that she has the same stake in it, the same rights, as all the other readers:

> Above all, too, she liked the consciousness of possession. There was no narrow exclusiveness about this place, no one could look askance at her; she – heretic and atheist as she was – had as much share in the ownership as the highest in the land. She had her own peculiar nook over by the encyclopedias, and, being always an early comer, seldom failed to secure her own particular chair and desk. (2:53–4)

Lyall's vastly popular novel celebrates its heroine's involvement in the public worlds of reading room and journalism, depicting them as vital sources of personal growth. The impact of Erica's reading is oddly conventional: she is converted from the atheism of her father (a figure based on Charles Bradlaugh) to Christianity in the process of her work in the reading room. But what strikes me most is Erica's careful combination of professionalism and unobtrusiveness. Because the constant interruptions at home produce 'bad work,' she works at the reading room, and after her conversion to Christianity she continues to publish; she just switches papers. Obviously Erica sees herself as a professional journalist. But she is also poignantly grateful that 'no one could look askance at her,' an immunity she apparently earns by arriving early and remaining within 'her own peculiar nook.'

Even more disembodied is the speaker of Louise Guiney's 1894 poem

'In the Reading-Room of the British Museum.' Invoking the room's domed summit as a 'moon of books' that is 'above/A world of men,' she asks it to:

> Lend to our steps both fortitude and light!
> Feebly along a venerable way
> They climb the Infinite, or perish quite!

Guiney's image turns the reading room into a kind of Platonic staircase out of materiality into the world of ideas. As speaker, she is embodied only through those 'steps,' which move her from the world of 'days and deeds' towards the Infinite: 'Nothing are days and deeds to such as they [our steps, presumably],' she concludes, 'While in this liberal house thy face is bright.' The word 'liberal' is particularly resonant, interconnecting library and liberty, designating, among other things, 'those "arts" or "sciences" ... that were considered "worthy of a free man"' (*OED*). Guiney's reading room thus offers a gender- and body-transcending space in which her speaker, like Lyall's Erica, can gain access to the world of rational, civic discourse.

A somewhat more conflicted depiction appears in Eliza Lynn Linton's 1885 *Autobiography of Christopher Kirkland*. In this autobiographical novel, Linton, apparently uncomfortable with her own role as professional woman, depicts herself as a man, the eponymous Kirkland. Through him, she describes her own research in the reading room of the 1840s, where she wrote her 1847 historical novel *Azeth the Egyptian*. Linton's depiction of the 1840s reading room in which she worked anticipates the 1857 room's intensely visual culture and its uneasy relation to professional women. Kirkland, who reads 'daily at the British Museum, gathering material for [his] magnum opus' (239), finds himself in a tightly knit, mutually observant community, under the all-seeing eye of Antonio Panizzi (Keeper of Printed Books at the time): 'not so much as a mouse squeaked behind the skirting board,' Linton writes, 'but he heard it and tracked the run from end to end' (243).

The other readers are highly visible, and many seem both consciously theatrical (the 'uxorious couple who made embarrassing love in public,' the snob who raises her eyebrows to show her social status) and themselves hawk-eyed ('the mincing prude who ... kept a sharp look-out on the young men and was a very Cerberus to the girls') (252–3). Women readers are prominent in Linton's description, but she singles out one as a 'special friend' of the narrator, who, like him, is there as a profes-

sional: 'She was one of the vanguard of the independent women; but she did her life's work without blare or bluster, or help from the outside' (253). Linton was no friend to the new, so-called wild women she saw emerging in the late nineteenth century, but she was willing to accept the woman who does her work 'without blare or bluster,' that is, without attracting notice. What emerges most powerfully from the description is the room as a kind of theatre where everyone performs a chosen role for the delectation of onlookers, where the readers are both actors and critics of each others' performance, and where the 'vanguard of the independent women' is particularly subject to scrutiny.

Unlike Lyall's Erica and Linton's 'independent woman,' who take what they need from the reading room without creating a stir, other women who worked there impressed onlookers with their energy and unruliness, and some apparently delighted in their ability to shock. The room's emphatic attention to 'lady' readers meant that any activity by women readers would be noticed. While they could not gain instant access to political power and influence, women readers could, by presenting their less-than-proper bodies and inappropriately professional tasks to the public gaze, subtly trouble and reconfigure the space in which they moved. Kate Flint writes of women's autobiographies that they often pinpoint reading – generally, unconventional reading – as a crucial source of identity; 'At the same time,' she points out, 'to recount these moments of rebellion which took place through reading is ... to reinscribe the original violation, celebrating the author's capacity to overthrow received notions of femininity' (14–15). Along similar lines, the more progressive women readers not only behaved unconventionally; they told stories about their own and others' behaviour and even influenced the stories others told, thus reinforcing 'the original violation.'

In the mid-1870s, for example, Annie Besant – in a neat if anticipatory reversal of Erica's conversion – did the reading at the British Museum that led her to break with her religion and her minister-husband. In the process she discovered the publisher Truelove and bought his journal, *National Reformer*. In her autobiography, she delightedly describes the response of an older man on a bus horrified by her reading material: 'To see a young woman, respectably dressed in crepe, reading an Atheistic journal, had evidently upset his peace of mind' (127, 134). Besant's juxtaposition of respectable crepe and atheistic journal resembles de Certeau's explanation of how consumers tactically reappropriate institutional space, their particular actions producing a 'flash shedding a different light on the language of the place' (37).

Richard Garnett, at the time superintendent of the Reading Room, describes the evidently intense impression Besant made on him in 1875: 'I am daily making interesting acquaintances in the Reading Room,' he wrote Mathilde Blind, 'among others, Mrs. Besant, who is judiciously letting God alone for the present, and venting her oppressiveness on the inquisition' (qtd. in McCrimmon, *Richard Garnett*, 80).

Eleanor Marx had a similarly shocking impact on the more proper and ladylike Fabian Beatrice Potter when they met at the library in 1883. Marx worked there frequently from 1877 through the 1890s, taking rooms in 1883 in order to be near the museum (Kapp 1: 283). Meeting Potter in the 'refreshment-room,' Marx impressed Potter as 'comely, dressed in a slovenly picturesque way, with curly black hair flying about in all directions' (Webb 301n–2n). Then, in a portion not quoted in the published version, Potter speculates that Marx has 'evidently peculiar views on love, etc., and should think has somewhat "natural" relations with men! Should fear that the chances were against her remaining long within the pale of respectable society' (qtd. in Kapp 1: 284). Ambivalent about the propriety of women's entering public life, Potter herself worked in the reading room as unobtrusively as possible;[2] Marx's unconventional appearance and conversation apparently struck her, by contrast, as so disruptive that she was unwilling to include the full account in her published autobiography. The encounter reveals both the contrast between the two women's self-presentations – Potter's as unobtrusive researcher and Marx's as wild woman – and the impact rambunctious researchers like Marx had on their fellow readers.

Marx's unconventionality impressed others as well. Olive Schreiner – who herself used the reading room in the 1880s, receiving a ticket in June 1883 – wrote her friend Karl Pearson about a friend who had run into Eleanor Marx at the British Museum. Schreiner quotes the friend as writing, 'I saw Eleanor at the Museum yesterday. She fairly danced with anger. I told her that translation of the Kama Sutra was locked up, in the Library, and refused to women. See if she don't get it!' (qtd. in First and Scott 136n). That Schreiner is passing along a second-hand anecdote about Marx suggests how important that dance of anger was to her, as a staging of women's effort to gain access to knowledge and as a reconfiguration of the museum's otherwise dignified atmosphere.

Just by presenting themselves in public as professional scholars, these women defined themselves in unconventional terms, which their mildly unruly behaviour reinforced. Schreiner, Marx, and Besant adapted the room to their own uses, gave it a personal history and purpose that in

turn had an impact on how others saw it and them. Shaw writes in his preface to *Immaturity* of a girl he saw there 'with an attractive and arresting expression, bold, vivid, and very clever, working at one of the desks' (xl); on her he based Agatha Wylie in *An Unsocial Socialist*, serialized in *To-Day* in 1884. While the novel marries her off, Agatha remains a vivid and independent figure, a worthy match for unsocial socialist Sidney Trefusis. The girl in the reading room had thus, through her self-presentation, spoken to and influenced Shaw. All these women, in short, redefine the role of women in public life and space through their performances in the reading room.

While late-nineteenth-century, politically progressive, middle-class women seem to lay triumphant siege to the reading room, Dorothy Richardson and Virginia Woolf, writing in the 1920s, respond quite differently, treating the room not as a source of knowledge and influence to which they lay claim, but as a specifically male tradition from which they recoil.

Richardson, writing *Deadlock* in 1920, describes Miriam Henderson's visit there with the Russian emigrant Michael Shatov as a movement towards this quite visceral rejection of the reading room. Set around 1900, this sixth section of her twelve-part autobiographical novel *Pilgrimage* depicts a reading room in which women have a comfortable and uncontested presence, yet one in which Miriam herself feels increasingly alienated. In the past Miriam has enjoyed using the library, though she feels herself an outsider compared to the 'lunching ladies ... always in the same seats, accepted and approved,' who 'were so extraordinarily at home there' (3:55). But when she shows off 'her' library to the outsider Shatov, she winds up feeling herself an outsider in a male-dominated institution. As the lunching ladies indicate, Miriam's mere presence there as a female body is no longer an issue. But the substance of the knowledge to be absorbed there is. Shatov introduces Miriam to *Anna Karenina*, 'the story of a woman told by a man with a man's ideas about people.' Finding herself subjected to a male-authored narrative of a female body, Miriam is repelled by what she calls 'foreign poison.' Her response to the reading room changes: 'The large warm gloom of the library, with its green-capped pools of happy light, was stricken into desolation as she read' (3:59, 61). Miriam is, finally, less 'at home' in the library than Shatov, less at home than women like Besant, Schreiner, and Marx, who used the room in the late nineteenth century. For Miriam, the reading room is not a stage on which she can redefine her own role, but a male-authored play within which her part –

like that of Anna in what Shatov calls Tolstoy's 'masterful study' – has already been written.

What had happened to produce such a shift in attitude? One explanation is that as self-supporting novelists who did not rely on the resources of the reading room for their livelihood, Richardson and Woolf were able to be more critical than women like Marx or the fictional Marian Yule, who relied on 'devilling' – locating and copying data for (generally) male writers – and journalism for their income. But I would argue for a less obvious explanation as well: I would argue that it was the very acceptance of women into public life that made a difference, for it was an acceptance premised on their identification with the disembodied, implicitly male world of rational discourse. By 1920, when Richardson was writing, there was an increasing sense that women could transcend their bodies and act 'like men,' as evidenced by, among other things, women's entry into the professions and universities. A microcosmic version of the change occurred in the reading room, where female readership went up dramatically between 1906 – when women were one-fifth of the reading room's daily average – and 1913 – when they made up one-third (Esdaile 144). On a national level, there was a move away from separate reading rooms for women, an idea whose popularity had steadily grown during the late nineteenth century. J.D. Brown supports the move in his 1907 *Manual of Library Economy*, when he rejects the idea of separate women's reading rooms on the grounds that women's bodies are no different from men's:

> The sentimental idea that women are delicate creatures requiring seclusion in glass cases is resented no more strongly than by the ladies themselves, and the mere fact that they do use general reading rooms without complaint or hesitation in places where separate accommodation is not provided is quite enough to demonstrate that such rooms are not essential. (qtd. in Kelly 192)

Architect Amian Champneys, in his 1907 *Public Libraries: A Treatise on Their Design, Construction, and Fittings*, argues similarly that 'most [women] do not care to be considered as creatures apart' (88). While such an argument benefits women by allowing them equal access to men's facilities, it is not unproblematic, as Carole Pateman points out: 'women in civil society must disavow our bodies and act as part of the brotherhood – but since we are never regarded as other than women, we must simultaneously continue to affirm the patriarchal conception

of femininity, or patriarchal subjection' (52). In the representations of post-1907 women writers, women readers are easily absorbed into the reading room culture, and that is precisely the problem. In the process, they must disavow their bodies and join the brotherhood.

Oddly enough, the decor of the reading room itself provides a turning point to mark this change: in 1907, the domed room was refurbished. When it reopened after six months of cleaning and painting, there were two big changes: the 'ladies' section of seats was gone, and a ring of men's names now adorned the mouldings just beneath the dome. Women could now read on the same terms as men, without being explicitly identified in terms of their bodies. But the names revealed what had been less evident before: the room was aligned with a model of cultural achievement implicitly gendered as male. *The Times* described the room's redecoration as an 'exhaustive spring cleaning,' whose most noticeable impact has been to replace the 'grimy chocolate' of the great dome with white decorated by gold ribs and panels bearing 'great names in English literature – from Chaucer to Browning picked out on a gold ground' ('British Museum Reading Room' 9, 22). For Woolf, of course, it is precisely these 'great names' – Chaucer, Caxton, Tindale, Spenser, Shakespeare, Bacon, Milton, Locke, Addison, Swift, Pope, Gibbon, Wordsworth, Scott, Byron, Carlyle, Macaulay, Tennyson, and Browning – that are so oppressive. 'The swing doors swung open,' Woolf writes in *A Room of One's Own*, 'and there one stood under the vast dome, as if one were a thought in the huge bald forehead which is so splendidly encircled by a band of famous names' (26). Since Woolf herself received a reader's ticket in November 1905, she would have been well aware of the room's decor both before and after. In her *Jacob's Room*, published in 1922 but set shortly before the First World War, the narrator notes the recent arrival of those names: 'Not so very long ago the workmen had gilt the final "y" in Lord Macaulay's name' (105), and feminist reader Julia Hedge mutters, 'Oh damn ... why didn't they leave room for an Eliot or a Brontë?' (106).

This is the question *A Room of One's Own* seeks to answer. Set in large part in the reading room itself, *A Room of One's Own* depicts Woolf's persona seeking the truth about women and finding only the products of the angry Professor von X 'engaged in writing his monumental work entitled *The Mental, Moral, and Physical Inferiority of the Female Sex*' (31). Woolf's persona responds tactically: she scribbles a caricature of the imaginary professor rather than taking notes like her scholarly male neighbour, and finally she rejects male scholarship about women as a disguised effort to maintain male domination. Throughout Woolf's work in 1927 and 1928,

in fact, the reading room dome serves as a recurring image for the con-
flation of knowledge and masculinity, a conflation she deconstructs in
Orlando (1928) and *A Room of One's Own* (published in 1929 but read to
societies at Newnham and Girton in 1928). In *Orlando*, Shakespeare is
always recognized by his large forehead, which Orlando compares to the
dome of St Paul's; assuming the 'noble brow' marks the man of genius,
she will later mistake a hump in a carriage cushion for Pope's forehead
(164–5, 205). But in both cases there is a subtext undercutting the link
between genius and male physiognomy: Pope turns out to have 'a fore-
head no bigger than another man's' (205), and *A Room of One's Own*
suggests that Shakespeare's achievement comes at the expense of his
imaginary but plausible sister Judith, destroyed because gender rather
than genius shapes the fate of women writers. Woolf thus reminds us that
while the reading room dome implies an organic connection between
the male mind and literary greatness, this connection is in fact mediated
by the exclusion of women.

Ambitious late-nineteenth-century women aspired to all the privileges
associated with the traditional public sphere: inclusion not just in profes-
sions or in public spaces, but in a well–informed, open conversation
about public policy. 'At last I determined,' Charlotte Despard wrote
shortly after receiving her reader's ticket in 1894, 'to study for myself the
great problems of society' (qtd. in Linklater 86). They felt themselves on
the brink of what looked from a distance like full participation in public
life and wrote enthusiastically about the reading room that would make
that possible. But over time, many of these activists found that to the
extent they succeeded in integrating themselves into public life, they lost
their oppositional stance as women, disappearing into government
bureaucracies or male-dominated organizations. The 1907 redecoration
represented in visual terms both this integration of women into public
life and its price. Its integrated seating and ring of male names redefined
the literary public sphere in Arnoldian terms: as a canonized, implicitly
male national culture with which the heterogeneous genders and classes
now populating the reading room could be encouraged to identify.

In the face of such a move, Richardson and Woolf adapted their
tactics, challenging the values intrinsic to male-dominated public life
through their depictions of the British Museum Reading Room. Woolf's
female reading room readers and Richardson's Miriam want more than
the vote and participation in a 'public sphere'; they want to find and/or
create a mass of cultural achievement linked to women's bodies, needs,
and experiences, so that future subjectivities can bring more complex

and inclusive views of human experience to bear on public life than those defining the public life of the past. In their oppositional stance, they constitute what Nancy Fraser calls a 'subaltern counterpublic' (67) and Rita Felski a 'feminist counter-public sphere,' offering 'a critique of cultural values from the standpoint of women as a marginalized group within society' (167).

Intriguingly, the reading room itself played a crucial role in dramatizing this problematic relation of women to public venues for learning, debate, publication, and consensus-forming. From an institutional standpoint, the British Museum Reading Room looks like a well-regulated panopticon, encouraging identification with British imperial power in the nineteenth century and with British culture in the twentieth. From the standpoint of its female users, however, the reading room and its representations worked in far more complex ways. Both the women before and the women after the turn of the century attempted to influence public discourse; that attempt was dramatized and clarified by the existence of the reading room, as both literal and represented space. Whether they overflowed their seats or sat demurely in the ladies' seating, late-nineteenth-century women could reinvent themselves as public personages through their work in the reading room; the 1907 redecoration, by accepting their presence yet reinscribing them as honorary males, at once acknowledged their ambitions and reconstituted their exclusion on a new plane. Yet that very exclusion, in turn, allowed Woolf and Richardson to turn their backs on the 'huge bald forehead,' conceptualize themselves as outsiders, and write, insistently and productively, in rooms of their own.

NOTES

I would like to thank the Council for Faculty Research at Eastern Illinois University for funding travel related to this project. In the course of that travel, archivists John Hopgood at the British Library and Janet Wallace, Christopher Date, and Gary Thorn at the British Museum were particularly helpful in locating and providing access to unpublished material. Finally, I would like to thank *Feminist Studies* for the useful feedback provided by its anonymous readers and for permission to reprint this essay, which was originally published, in somewhat different form, in *Feminist Studies* 28 (Fall 2002): 489–512.

1 Attendance figures at the reading room's opening and the names of writers who worked there are cited from Harris (*Reading Room* 17, 25); later attendance figures are from Garnett (417). For a meticulously detailed account of the reading room's history, see Harris, *History*.
2 See Lewis on Potter's reluctance to cross 'the boundary into unwomanly behaviour' (11).

WORKS CITED

Anonymous Student. Letter. *Times* (London), 3 September 1878: 4D

Audi Alteram Partem. Letter. *Times* (London), 7 September 1878: 8D.

Barwick, George. *The Reading Room of the British Museum.* London: Ernest Benn, 1929.

Bennett, Tony. *The Birth of the Museum: History, Theory, Politics.* London: Routledge, 1995.

Besant, Annie. *An Autobiography.* London: T. Fisher Unwin, 1893.

'The British Museum Reading Room.' *Times* (London), 30 October 1907: 9.12.22.

Champneys, Amian L. *Public Libraries: A Treatise on Their Design, Construction, and Fittings.* London: H.T. Batsford, 1907.

Cowtan, Robert. *Memories of the British Museum.* London: Richard Bentley and Son, 1872.

de Certeau, Michel. *The Practice of Everyday Life.* Trans. Steven Rendell. Berkeley: U of California P, 1984.

Esdaile, A. *The British Museum Library: A Short History and Survey.* London: George Allen and Unwin, 1946.

Faulke-Watling, Jane. Letter. *Times* (London), 7 September 1878: 8D.

Felski, Rita. *Beyond Feminist Aesthetics: Feminist Literature and Social Change.* Cambridge: Harvard UP, 1989.

First, Ruth, and Ann Scott. *Olive Schreiner.* New York: Schocken, 1980.

Fitzgerald, Percy. 'A Day at the Museum Reading Room.' *Belgravia* 46 (November 1881–February 1882): 156–64.

Flint, Kate. *The Woman Reader 1837–1914.* Oxford: Clarendon P, 1993.

Fraser, Nancy. 'Rethinking the Public Sphere: A Contribution to the Critique of Actually Existing Democracy.' *Social Text* 8–9 (1990): 56–80.

Garnett, Richard. 'The British Museum and the British Public.' *New Review* 5 (November 1891): 414–23.

Gissing, George. *New Grub Street.* 1891. Harmondsworth: Penguin, 1976.

Gladstone, W.E. 'On Books and the Housing of Books.' *Nineteenth Century* 27 (March 1890): 384–96.

Guiney, Louise Imogen. *A Roadside Harp: A Book of Verses*. Boston: Houghton Mifflin, 1893.

Habermas, Jürgen. *The Structural Transformation of the Public Sphere*. Trans. Thomas Burger with the assistance of Frederick Lawrence. Cambridge, MA: MIT P, 1991.

Harris, P.R. *A History of the British Museum Library 1753–1973*. London: The British Library, 1998.

– *The Reading Room*. London: The British Library, 1979.

Kapp, Yvonne. *Eleanor Marx*. 2 vols. New York: Pantheon, 1972.

Kelly, Thomas. *A History of Public Libraries in Great Britain, 1845–1975*. London: Library Association, 1977.

'Ladies in Libraries.' *Saturday Review* 62 (14 August 1886): 212–13.

Landes, Joan. 'The Public and the Private Sphere: A Feminist Reconsideration.' In *Feminism, the Public and the Private*, ed. Joan B. Landes, 135–63. Oxford: Oxford UP, 1998.

Lewis, Jane. *Women and Social Action in Victorian and Edwardian London*. Stanford: Stanford UP, 1991.

Linklater, Andro. *An Unhusbanded Life: Charlotte Despard: Suffragette, Socialist and Sinn Feiner*. London: Hutchinson, 1980.

Linton, Eliza Lynn. *The Autobiography of Christopher Kirkland*. London: 1885. In *Victorian Women Writers Project*, ed. Perry Willett. October 1998. Indiana U. 31 December 1998. http://www.indiana.edu~letrs/vwwp/linton/autokirk3. html 224.

'Literary Gossip.' *Athenaeum* (1 December 1877): 700.

Lucas, E.V. *Mr. Ingleside*. London: Methuen, 1910.

Lyall, Edna. *We Two*. London: Hurst and Blackett, 1884.

McChesney, Dora. *London Roses: An Idyll of the British Museum*. London: Smith, Elder, 1903.

McCrimmon, Barbara. *Power, Politics, and Print: The Publication of the British Museum Catalogue 1881–1900*. Hamden, CT: Linnet, 1981.

– *Richard Garnett: The Scholar as Librarian*. Chicago: American Library Association, 1989.

'The National Reading Room.' *Chambers Journal*, 3rd ser., 15–16 (31 August 1861): 129–32.

Pateman, Carole. *The Disorder of Women: Democracy, Feminism, and Political Theory*. Stanford: Stanford UP, 1989.

Richards, Thomas. *The Imperial Archive: Knowledge and the Fantasy of Empire*. London: Verso, 1993.

Richardson, Dorothy. *Pilgrimage.* Vol. 3. 1921. New York: Knopf, 1967.

Shaw, George Bernard. *Immaturity.* London: Constable, 1931.

– *An Unsocial Socialist.* London: Constable, 1914.

Simcox, Edith. 'The Capacity of Women.' *Nineteenth Century* 22 (September 1887): 391–402.

Upward, Allen. 'The Horrors of London.' Illustr. Ernest Goodwin. *Idler* (August 1896–January 1897): 3.

'Valuable Collection in the Reading-Room, British Museum.' *Punch,* 28 March 1885: 155.

Webb, Beatrice. *My Apprenticeship.* London: Longmans, Green, 1926.

Woolf, Virginia. *Jacob's Room and The Waves.* New York: Harcourt, Brace and World, n.d.

– *Orlando: A Biography.* 1928. New York: Harcourt Brace Jovanovich, n.d.

– *A Room of One's Own.* 1929. New York: Harcourt, Brace and World, n.d.

8 'Luxuriat[ing] in Milton's Syllables': Writer as Reader in Zora Neale Hurston's *Dust Tracks on a Road*

TUIRE VALKEAKARI

> In a pile of rubbish I found a copy of Milton's complete works. The back was gone and the book was yellowed. But it was all there. So I read *Paradise Lost* and luxuriated in Milton's syllables and rhythms ...
>
> – Zora Neale Hurston (1942)

> This is an imperative: the writer must be a constant reader ... I was stimulated at an early age into writing because of my reading.
>
> – Leon Forrest (1988)

> [In *Dust Tracks* Hurston] gives us a *writer's* life, rather than an account, as she says, of 'the Negro problem.' So many events in this text are figured in terms of Hurston's growing awareness and mastery of books and language, language and rituals as spoken and written both by masters of the Western tradition and by ordinary members of the black community.
>
> – Henry Louis Gates, Jr (1991)

In the Afterword to the 1991 HarperPerennial edition of Zora Neale Hurston's autobiography, *Dust Tracks on a Road* (1942),[1] Henry Louis Gates, Jr, emphatically affirms that Hurston's work 'gives us a *writer's* life' (264; italics in the original). His emphasis, trivial as it may appear at first sight, is well placed. Despite Hurston's importance not only as an ethnographer but also as a major fiction writer, critics have devoted little attention to her self-portrait as a literary author in *Dust Tracks*.[2] Hurston's memoir is not usually classified as a 'literary autobiography,' to use Lynn Domina's term – that is, as a text that 'understand[s] the literary career of the author to be significant material and/or impetus for

the autobiography' (208n2). However, while it is true that Hurston explicitly addresses her professional participation in the literary world only in one chapter (chap. 11, 'Books and Things'), the narrative of authorship informs a considerably larger portion of the text: Hurston weaves the story of her literary vocation, particularly in the sense of 'calling,' into the autobiography's first eleven chapters. The key to her self-presentation as a creative writer is her portrayal of herself, especially of the young Zora,[3] as a keen reader. Hurston avoids forcing *Dust Tracks* into the format of an expanded résumé – a chronological itemization of finalized manuscripts, published books, or other professional achievements. Rather, she mainly portrays her authorship in terms of her maturation into the profession. In so doing, she particularly focuses on her early reading, which crucially influenced her later development as a writer.

The 'writer-as-reader' motif is one of the conventional (indeed, constitutive) elements of lettered women's and men's autobiographical works. The phrase 'Take up and read' occupies a pivotal position in Augustine's *Confessions* (167). In his similarly titled book, Jean-Jacques Rousseau barely finishes the paragraph recording his birth and immediate postnatal survival before moving on to address his first readings and their effects on him (7). Harriet Martineau and Mary Darby Robinson, both writing during the gradual professionalization of women writers in Britain, also discuss their readings in their memoirs.[4] In her autobiographical novel *Our Nig* (1859), the African-American author Harriet E. Wilson explicitly ponders the significance of 'book information' for the protagonist Frado (124–5). Charlotte Forten Grimké, a member of an established family of the Philadelphia free black community, launches her dialogue with literary works in the very first diary entry of her posthumously published journals, which extend from 1854 to 1892. Even these few examples suffice to demonstrate that autobiographical texts, especially when written by scholars or literary authors, characteristically engage in dialogue with books and evoke experiences prompted by reading. Although in many ways *Dust Tracks* frustrates the audience's traditional expectations concerning the autobiographical genre, it does conform to the convention of presenting the writer as an avid reader. Hurston, first of all, offers us several lists of the books that she devoured in her childhood, youth, and early adulthood. Second, she casts herself as an individual who had to struggle for access to literature and for whom her reading opened up a new world. Third, she connects this storyline to her narrative of vocation. Her often-overlooked self-portrait

as a keen reader in *Dust Tracks* reveals, in other words, her construction of a writerly identity within the autobiography.

The narrative of authorship in *Dust Tracks* is a significant indicator of women writers' emerging professionalization in the African America of Hurston's era. Multiple aspects of Hurston's autobiography show that she regarded her literary activity as serious, professional work rather than as an amateur venture.[5] For example, her search for a definition of her relationship to her cultural and artistic antecedents indicates professionalism. Versatile in her use of influences, Hurston relates her writing both to African-American vernacular sources and to preceding literary tradition(s). While her incorporation of oral influences in her writing has, with good reason, attracted a considerable amount of scholarly attention, her attitude to her literary predecessors – a dimension of *Dust Tracks* located in the portrait of the young Zora as a reader – calls for further exploration. Despite oral tradition's vital importance for Hurston, no valid intellectual or historical reason exists for pitting the oral and written words against each other in a scrutiny of her self-presentation in *Dust Tracks*. Hurston's life's work was based on a constant dialogue between oral and written modes of linguistic expression, and her project of translating aspects of African-American oral tradition into the written word – particularly her distinctive fusion of the black Floridian vernacular with literary language – is one of the main reasons why she is still remembered and appreciated today.

Zora as a Future Writer – Zora as a Reader

As an autobiographer, Hurston 'contextualize[d] her identity by connecting herself to the social archaeology of her region and family background,' as previous scholarship has aptly stressed (McKay, 'Autobiographies,' 266). Hurston's contextual self-presentation partly consists of her examination of the genesis and components of her identity as a creative writer: she acknowledges in *Dust Tracks* that '[t]ime and place' (*DT* 561) – the early contexts and influences that moulded her personal growth and nourished her later scholarly orientation – shaped her future identity and career as a literary author. Although this storyline, which includes the narrative of Hurston's early reading, is implicit and often almost lost in digressions, it can still be extracted from Hurston's organization and treatment of the material in chapters 1–11. The narrative of the young Zora as an enthusiastic devourer of books informs, most obviously, chapters 4 ('The Inside Search') and 9 ('School Again').

The discussion in chapter 8 ('Back Stage and the Railroad') of the long-time frustration of her yearning for books and education is part of the same storyline.

Preceding this narrative of Hurston's readerly self, multiple elements of *Dust Tracks*' first three chapters also relate to her literary vocation. After narrating the story of the founding of her hometown, Eatonville, Florida (chapter 1),[6] Hurston discusses aspects of her maternal and paternal legacies that empowered her to mature into authorship (chapter 2). She portrays her mother as her earliest educator, who not only helped Zora and her siblings to face school challenges, but also encouraged them to pursue their ambitions and to have faith in their talents (*DT* 572). Hurston's paternal heritage, together with Eatonville's blossoming oral culture, endowed her with a lasting fascination with the art of story-telling. The example of her father – a thrice-elected mayor of Eatonville and a Baptist preacher who served several congregations and therefore 'didn't have a thing on his mind but this town and the next one' (*DT* 580) – also initiated her into the life of 'travel dust' (*DT* 580), as opposed to geographical or domestic confinement. However, while this experience was formative for her later years as a travelling writer and scholar, Hurston's narrative reveals that her father did not lead her to an itinerant way of life by example only: Zora begins her 'Wandering' (the title of chapter 6) as the result of his neglect of her after her mother's death. While emphasizing loneliness, the discourse of wandering strategically places the young Zora in an in-between space, assigning her the double role of an insider among, and outsider to, her community. This location is necessary for her future traffic between two American cultures: in narrating her formative years, Hurston launches the project of negotiating a space for herself between the black and white worlds of the United States, adopting a 'self-appointed' post as an 'interpreter' between these two realms of cultural expression (McKay, 'Race,' 182). This role (a tense position, considering the complexity of her era's identity politics) largely determines Hurston's design of the context for, and the content of, her self-presentation as reader and writer.

The narrative of Zora's contact with the white world and culture, later highlighted by the 'whiteness' of her reading, begins with the story of her birth. According to the 'hear-say' (*DT* 577) that Hurston mediates to the reader in chapter 3 – humorously questioning the truth value of autobiographical birth narratives and leaving us to wonder whether we should believe her own legendary tale – her umbilical cord was cut by a white man. John Hurston's absence from the scene of her birth remains

a void that the narrative partly fills with the presence of this white man, who becomes Zora's close friend in chapter 4. By describing the two friends' reciprocal and dialogic interaction, chapter 4 presents the man – another teller of stories and a supportive, fatherly prompter of Zora's early verbalizing of her own experiences – as another important influence on the personal and linguistic development of the future writer. The narrative associates this man with the direct action and down-to-earth wisdom typical of American frontier mentality (*DT* 587–9), a mentality shared by both the black and white communities of *Dust Tracks*' Florida (*DT* 563–6). Hurston's contextual commentary on the interracial friendship in chapter 4 thus implicitly evokes and continues the account, in chapter 1, of how the 'wilds of Florida' (*DT* 562) were tamed through joint African-American and European-American efforts before the foundation of all-black Eatonville.

As the carefully crafted Eatonville saga, the birth narrative, and the story of the interracial friendship show, Hurston initiates her project of redefining the space allotted to her by the era's predominant racial configurations at the very beginning of her autobiography. More generally, although Hurston opens *Dust Tracks* by 'salut[ing] the culture that made her' (Lowe 57), the 'salutation' of her original community and culture is soon transformed into a narrative of individuation. *Dust Tracks* frequently suggests that Zora was different from her peers, even as a child. One aspect of this discourse of difference stresses her yearning for action. The narrative does not fail to record the fact that this trait is, stereotypically, considered to be more characteristic of boys than of girls (*DT* 585); Hurston, in other words, highlights her rejection of the traditional feminine gender role even while narrating her childhood. Adults frustrate the young Zora's longing for action by giving her dolls – symbols of the 'feminine,' restricted domestic sphere – rather than allowing her to play outdoors with energetic boys, future conquerors of new frontiers. She, however, strikes back by creating an interior world of her own, one full of action: 'So I was driven inward. I lived an exciting life unseen' (*DT* 585). The narrative presents this retreat to the imaginative realm as an act of innovative resistance, rather than one of submission or Freudian sublimation.

From here, the journey is short to the world of books: in *Dust Tracks*, reading nourishes and sustains the 'exciting life unseen.' In keeping with the motif of excitement and adventure, chapter 4 underscores the young Zora's fascination with energetic and physically powerful characters, such as Thor and Hercules, while depicting her early readings at home and in school. In a similar vein, her initial interest in the Bible was

kindled, according to the narrative, by her first encounter with the warrior-king David – another man of action, who 'went here and ... went there, and no matter where he went, he smote 'em hip and thigh, ... sung songs to his harp a while, and went out and smote some more' (*DT* 595). Playfully depicting Zora's early attraction to these fictional embodiments of masculinity, the passage also mentions her parallel rejection of 'thin books about this and that sweet and gentle little girl who gave up her heart to Christ and good works.' In Zora's view, these girls, who 'almost always ... died' of their sacrifice, 'preaching as they passed,' were totally uninteresting – 'had no meat on their bones' (*DT* 594). This passage, notably, serves Hurston's womanist stance: the humorous discourse enables her to restate her rejection of submissive notions of femininity capriciously, but nonetheless emphatically.

This ludic approach to the young Zora's biblical, 'action-oriented' readings also allows Hurston to address a stage in her psychosexual development while simultaneously maintaining the discretion that her contemporaries expected of her. In 'hunting for some more active people like David' (*DT* 595), Zora and her friend Carrie Roberts discover Leviticus, with its revelation of 'what Moses told the Hebrews *not* to do' (*DT* 595; italics mine). Leviticus and the 'Doctor Book,' together with 'all the things which children write on privy-house walls' and which Zora also keenly reads (*DT* 595), teach the girls what they yearn to know about the mysteries of the human body and sexuality. By lumping these three sources of knowledge together, Hurston's narrative playfully strips scripture of its traditional cloth of solemnity, at the same time gently poking fun at the girls' 'elders': 'In that way I found out a number of things the old folks would not have told me. Not knowing what we were actually reading, we got a lot of praise from our elders for our devotion to the Bible' (*DT* 595).

As the focus on childhood reading habits implies, Hurston on various occasions illustrates her giftedness as a 'natural' reader. In contrast to early African-American autobiographers, who often depicted literacy as a key to freedom and to public participation in abolitionism,[7] Hurston portrays access to the world of books as a key to individuation and to the discovery of her individual talent. Ex-slave narrators treated the acquisition of literacy as an event of major political significance; Hurston, by contrast, omits any depiction of how she *learned* to read, and instead directly proceeds to discuss her experiences as a talented and inherently competent interlocutor with literature. In so doing, she consistently underscores skills and faculties essential for a literary author, stressing

the intimate connection between her respective self-portraits as reader and writer. Hurston explains, for example, that her visual imagination – a vitally important mental faculty for creators of fiction – literally 'imaged' the action-packed myths that she devoured. While reading, she 'saw' Thor 'swing his mighty short-handled hammer as he sped across the sky in rumbling thunder, lightning flashing from the tread of his steeds and the wheels of his chariot' (*DT* 594). The portrayal of her first contact with the Episcopal hymnbook, moreover, demonstrates her intuitive and spontaneous ability to read written lyrics with acoustic imagination, a crucial faculty for an author who largely draws on oral folklore as a source of inspiration and renewal. In Hurston's phrase, 'There was no music written there [in the hymnbook], just the words. But there was to my consciousness music in between them just the same' (*DT* 593). In particular, the young Zora preferred hymns whose 'words marched to a throb' that she could actually 'feel' while communicating with the written text (*DT* 593). This formulation calls attention to her sense of rhythm, yet another faculty required for successful translations of oral tradition into written form. All these expressions cast Zora as a reader who experiences what she reads in a holistic manner, bringing her whole existence into creative dialogue with the texts.

Although *Dust Tracks* firmly links the young Zora's talent, or 'genius,' to the activity of reading and the vocation of writing, the Romantic tenet that genius alone is sufficient to make an individual an artist is, in its purist form, foreign to Hurston's autobiography. Her narrative repeatedly stresses the crucial importance of school, books, and self-education for the development of the future writer. Hurston's linkage of genius and education as complementary forces is particularly apparent in the story about the initial discovery of her talent. Her genius first manifests itself in the classroom, through a (semi)public act of reading aloud in front of adults and peers. Two white women from Minnesota visit Eatonville's black village school unannounced. The teacher, eager to present the institution and the fruit of his toil in a favourable light, 'put[s] on the best show' (*DT* 590) that he possibly can at such short notice: he calls on Zora's fifth-grade class to present their reading skills to the visitors. Four or five equally unprepared students first stumble through their assigned paragraphs, extracts from the story of Pluto and Persephone. Then Zora takes her turn, reading her passage aloud not only fluently but also in an 'exalted' (*DT* 591) – inspired and inspiring – manner. She is asked to read the story to the end, and the guests are as impressed as the teacher is relieved. The narrative reveals that Zora

actually knew the myth well, which in part explains the excellence of her performance. This disclosure, however, is not intended to diminish the value of her accomplishment in the classroom. Rather, the passage strategically points to her early reading habits; the 'confession' is part of Hurston's project of complementing her artistic genius with her early passion for self-education.

The classroom episode also underscores the nature of Zora's reading as a performance with improvisatory qualities. She treats the text as a basis for a celebratory reading that she performs in the manner and spirit of an oral storyteller. The narrative gives centre stage neither to the classic myth per se nor to the presence of the white listeners, but to the performance of the child who masters the text so well that she is able to play with, and improvise on, her material. (My comment is concerned with the tone and manner of Hurston's self-representation, not with the in/accuracy of Hurston's rendition of the myth.) During her performance Zora utilizes repetition characteristic of the African-American sermonic chant:

> I was exalted by [the myth], and that is the way I read my paragraph. 'Yes, *Jupiter had seen* her (Persephone). *He had seen* the maiden picking flowers in the field. *He had seen* the chariot of the dark monarch pause by the maiden's side. *He had seen* him when he seized Persephone. *He had seen* the black horses leap down Mount Aetna's fiery throat. Persephone was now in Pluto's dark realm and he had made her his wife.' (*DT* 591; italics mine)

The episode emphasizes Zora's creative agency and demonstrates her early competence at moving between two cultures, as the overtly self-conscious phrase 'that is the way I read my paragraph' indicates. Zora appropriates the story 'for her own use'[8] in a way that highlights her ability both to luxuriate in the text for her own enjoyment and to recast it creatively in a new context. Her transformation of the classic myth into source material for an oral 'performance of blackness'[9] before a racially mixed audience is an integral part of Hurston's project of casting herself as a cultural interpreter, an individual proficient at trafficking between two worlds.

The Narrative of Reading as a Strategy of 'Maroonage'

The classroom subjugation of the classical myth to the dynamics of black cultural expression is a brief but unmistakable instance of a celebratory

performance of blackness. Hurston, however, primarily actualizes her celebration of black agency via a strategy of 'maroonage' (Bhabha 295) while portraying herself as a reader. The term 'maroonage' originates in Houston Baker's characterization of the way of life that emerged in fugitive slaves' maroon communities; adopted and elaborated by Homi K. Bhabha, this concept refers to the strategic utilization of a position of marginality and liminality to attack and disappear again – a tactic reminiscent of guerrilla warfare (Bhabha 295). In Hurston's depiction of her early reading, this strategy translates into a process whereby one discourse repeatedly and necessarily intrudes upon another, creating what Russell Reising has termed 'ruptures ... which actually open up possibilities of meaning almost impossible within the conventions and for the ostensible audiences of [the writer's] time' (75–6). Originally a comment on the writing of the early African-American poet Phillis Wheatley, Reising's formulation aptly describes a dynamic operative both in *Dust Tracks* and in its relationship to the extratextual world. The autobiography's rhetoric of 'gratitude' – labelled by Alice Walker as Hurston's desperate and lamentable fawning over white audiences in the hope of income and cultural acceptance[10] – is frequently interrupted by surfacings of another discourse, which highlights Hurston's agency and reveals her desire to unsettle fixed definitions of American society's racial centre and circumference.

On occasion, such surfacings paradoxically take the form of a gap or omission, or a strategically timed silence. As I mentioned earlier, Hurston refrains from depicting herself as a learner of literacy, in striking contrast to her vivid self-portrayal as a learner of black oral tradition in Eatonville. This omission can be interpreted as a covert counter-reaction to the discourse of thankfulness that frequently characterized ex-slave narrators' depictions of their acquisition of literacy. Hurston's portrayal of the classroom episode and its consequences, in turn, exemplifies a more active strategy of maroonage. A few days after her performance in class, Zora is invited to visit the two white women before they return to Minnesota. This is a major event in her young life; prior to calling upon the 'ladies' at a hotel in Maitland, she is sent home from school 'to be stood up in a tub of suds and be scrubbed and have [her] ears dug into' (*DT* 592). While depicting the hotel encounter, the narrative courteously acknowledges the ladies' hospitality, but the passage is at the same time spiced with humorous irony that underscores the distance between their and Zora's worlds: 'First thing, the ladies gave me strange things, like stuffed dates and preserved ginger, and encouraged me to eat all that I

wanted. Then they showed me their Japanese dolls' (*DT* 592). More significantly, Hurston reveals that her future benefactors tested her reading ability, ascertaining that her reading in the classroom was no fake performance: 'I was then handed a copy of *Scribner's Magazine*, and asked to read a place that was pointed out to me. After a paragraph or two, I was told with smiles, that that would do' (*DT* 592–3). Hurston here complicates her ostensible discourse of gratitude by covertly needling the white distrust in black literacy.

The very next day, Zora receives a gift from the ladies: the Episcopal hymnbook, as well as 'a copy of *The Swiss Family Robinson*, and a book of fairy tales' (*DT* 593). Fascinated by several songs in the hymnal, she immediately 'set[s] about to commit the song words to memory.' Following a familiar pattern, this formulation underscores Zora's talent and her industriousness in self-education, as well as her willingness to adapt print culture to oral culture; again, centre stage is given to Zora and her agency, rather than to white generosity. The passage's criticism of some of the hymns, moreover, functions as an occasion for cross-cultural irony, providing yet another twist to the discourse of gratitude. Hurston even inserts a reference to the expression 'white trash' in the passage, adding a deliberately discordant note to her 'praise' of the benefactors: 'Some of [the hymns] seemed dull and without life, and I pretended they were not there. If *white* people liked *trashy* singing like that, there must be something funny about them that I had not noticed before' (*DT* 593; italics mine).

The second gift from the ladies, which arrives about a month later, is a 'huge box packed with clothes and books' (*DT* 593). Hurston stresses, fittingly, that 'the books gave [her] more pleasure than the clothes.' Again, she carefully itemizes the books: 'In that box was Gulliver's Travels, Grimm's Fairy Tales, Dick Whittington, Greek and Roman Myths, and best of all, Norse Tales' (*DT* 594). All the fiction that Zora devours in *Dust Tracks*, including Hans Christian Andersen's fairy tales and Robert Louis Stevenson's adventure stories, is markedly 'white.' The whiteness of the canon does not, however, automatically translate into the absence of a 'black' perspective in Hurston's narrative of her early reading. While disclosing that Rudyard Kipling's *The Jungle Books* was among her favourites, Hurston singles out only one aspect from the work of the archetypal colonialist: 'I loved his talking snakes as much as I did the hero' (*DT* 594). Well acquainted with the importance of snake symbolism for Haitian and American Voudou,[11] she chooses to highlight the talking snakes, an aspect of *The Jungle Books* that happens to resonate

with a pivotal element of one black American variety of cultural expression and religious faith. This manoeuvre again underscores black agency, demonstrating Hurston's guerrilla strategy and illustrating the aptness of Kathleen Hassall's reference to Hurston as 'an inventive, resourceful, spirited, effective warrior – in disguise' (160).

Called to Authorship, Sustained by Reading

As the story evolves, Hurston gradually transforms the depiction of her access to the world of books into a narrative of hardship. During the 'wandering' that begins after her mother's death, Zora's desire for 'books and school' (*DT* 644) is repeatedly frustrated, but never extinguished. This aspect of the text stresses her perseverance in her calling, the vocation to be a writer. Zora receives this calling through prophetic visions, 'a preview of things to come' (*DT* 596), in her childhood. The incompleteness and inconsistency of Hurston's account of the visions have repeatedly disappointed and frustrated critics.[12] However, when examined as part of the narrative of the calling, rather than a separate storyline, this account can be viewed as a variation of a strategy that autobiographers have often used in struggling with the problem of how to 'maintain a semblance of modesty' (Bjorklund 25) while underscoring their talent and achievement. If Hurston's depiction of her early reading emphasizes her genius, her industriousness, and her desire to 'stretch [her] limbs in some mighty struggle' (*DT* 596), the calling from a divine source (mediated by the visions) gives her self-presentation an air of modesty. It also conveniently 'affirms' her talent, justifying the autobiographical enterprise.

Dust Tracks neither depicts the visions in detail nor explicates the 'commandment' (*DT* 597) that Zora receives through them. Hurston nevertheless connects the visions to her authorial vocation, the link being the motif of 'cosmic loneliness' (*DT* 598). The narrative of the calling opens with the articulation of the 'great anguish' that Zora's early reading experiences bring on her – an overwhelming sense of not belonging in the 'real' world of mundane concerns: 'In a way this early reading gave me a great anguish through all my childhood and adolescence. My soul was with the gods and my body in the village. People just would not act like gods ... I was only happy in the woods' (*DT* 595–6). Hurston's linkage of this solitude to the calling to authorship is most clearly manifest in her brief discussion of Kipling and the long-time *Cosmopolitan Magazine* columnist O.O. McIntyre immediately after the por-

trayal of the visions' onset. Having, as shown above, already 'changed the joke and slipped the yoke'[13] while discussing *The Jungle Books*, Hurston no longer evokes the colonialist Kipling for ironical purposes. She now looks at him and McIntyre as fellow participants in the experience of cosmic loneliness that she considers to be common to all writers. The following passage, with its reference to a spiritual communion of writers, confirms that the 'dust tracks' Hurston explores in her autobiography are, indeed, ones that she left on the road in her journey to becoming an author and scholar:

> Years later, after the last [vision] had come and gone, I read a sentence or a paragraph now and then in the columns of O.O. McIntyre which perhaps held no meaning for the millions who read him, but I could see through those slight revelations that he had had similar experiences. Kipling knew the feeling for himself, for he wrote of it very definitely in his *Plain Tales from the Hills*. So I took comfort in knowing that they were fellow pilgrims on my strange road. (*DT* 598)

Assigning a pivotal role to the images of the pilgrimage and the road, this passage refers back to another journey, the child Zora's wish to 'walk out to the horizon and see what the end of the world was like' (*DT* 583). Zora's wish was later replaced by another passionate desire, suggestive of Hurston's project of working with two expressive cultures: Zora yearned to ride 'a fine *black* riding horse with *white* leather saddle and bridles' to the world's end (*DT* 584; italics mine).[14] Transforming the adventurous ride into a pilgrimage requires yet another alteration in the tone of the narrative voice in chapter 4. The child's wish to conquer the world eventually becomes an inner vocation, a 'calling' in the sense suggested by the Latin verb *vocare* – a condition of being called and sent out into the world by a force more powerful than the (future) author herself:

> I had a feeling of difference from my fellow men, and I did not want it to be found out. Oh, how I cried out to be just as everybody else! But the *voice* said no. I must go where I was *sent*. The weight of the *commandment* laid heavy and made me moody at times ... I would hope that the *call* would never come again. (*DT* 597; italics mine)

Hurston claims that the first 'coming' of the 'call,' mediated by the visions, marked the end of her childhood (*DT* 598), although she was 'not more than seven years old' at the time: 'So when I left the porch

[the location of her first visions], I left a great deal behind me. I was weighed down with a power I did not want. I had knowledge before its time. I knew my fate' (*DT* 596). Hurston even uses specifically christo-logical allusions while portraying her calling: 'I knew that the cup meant for my lips would not pass. I must drink the bitter drink' (*DT* 597). These formulations illustrate her implied suggestion that her calling originated from a higher power. She refrains, however, from identifying this power as 'God' in any traditional, doctrinal sense. In her words, 'the force from somewhere in Space which commands you to write in the first place, gives you no choice. You take up the pen when you are told, and write what is commanded' (*DT* 717).

It is hardly surprising, against this backdrop, that Hurston repeatedly identifies her youth of hardship and poverty as a 'pilgrimage,' a process of yielding to the calling and of obeying the Caller, rather than random drifting: 'No one could spare me my pilgrimage. The rod of compel-ment was laid to my back. I must go the way' (*DT* 634). During the story of the pilgrim's progress, the motifs of reading, self-education, and schooling surface repeatedly. In depicting her unsuccessful attempts to work as a cleaning lady, Hurston reveals that once inside the houses of her employers, she tended to take a deeper interest in books than in cleaning – which, as might be expected, led to trouble: 'I did very badly because I was interested in the front of the house, not the back. No mat-ter how I resolved, I'd get tangled up with their reading matter, and lose my job' (*DT* 636). This anecdote exemplifies Hurston's capacity for a playful tone even while narrating vagrancy and loneliness. On the whole, however, the pilgrimage narrative's tone is serious, even poi-gnant. Hurston's portrayal of her initiation into 'Milton's syllables and rhythms,' with its embedded depiction of her poverty, is the acme of *Dust Tracks'* narrative (and, some would argue, romanticized lore) of hardship:

> But one thing did happen that lifted me up. In a pile of rubbish I found a copy of Milton's complete works. The back was gone and the book was yel-lowed. But it was all there. So I read *Paradise Lost* and luxuriated in Milton's syllables and rhythms without ever having heard that Milton was one of the greatest poets of the world. I read it because I liked it. (*DT* 645–6)

This 'readerly' variation on the Romantic motif of the artist who cre-ates poetic or visual art in poverty – here, a future writer who reads in poverty – highlights the young Hurston's hunger for literature and her

perseverance in the pursuit of knowledge and aesthetic experience. The verb 'luxuriate' strategically emphasizes the contrast between the young pilgrim's lack of material wealth and her capacity to be spiritually strengthened and renewed by the immaterial pleasure of reading. On the other hand, the narrative also implies that Hurston remained faithful to the life of constant reading even when external circumstances did not require an escape from reality. While working as a maid for a travelling Gilbert and Sullivan troupe's lead singer, she did 'some reading' on tour (the tenor of the group being 'a Harvard man' who took books with him on travels and allowed her to read them [*DT* 662]). Hurston depicts the time she spent with the Gilbert and Sullivan group as a precious experience that contributed to her psychological and spiritual growth, offering a new vision of the artist as inherently cosmopolitan.

When the job as a maid – emotionally, a safe haven – ended, Hurston felt equipped for new challenges: she decided to 'take up [her] pilgrim's stick and go outside again' (*DT* 665). In chapter 9, Hurston writes about going to a night high school in Baltimore and studying English under the African-American teacher Dwight O.W. Holmes, whom she calls 'a pilgrim to the horizon' (*DT* 667). This subtle evocation of the child Zora's desire to walk/ride 'to the horizon' highlights the close connection between the images of the adventurous walk, the horse ride to the world's end, and the pilgrimage. Even the notion of trafficking between two worlds – yet another element in the associative imagery of travelling – appears in the episode: Mr. Holmes, the exemplary pilgrim, is in essence a mediator between two cultures. In an episode that remotely echoes the young Zora's performance in the Eatonville village school, white texts again become a living reality through a black performance. This time, Hurston is a silent pilgrim, who experiences a 'spiritual' renewal and reaches a new understanding of her calling while listening to a moving poetry reading in a Baltimore classroom:

[O]ne night in the study of English poets [Mr. Holmes] read *Kubla Khan* by Samuel Taylor Coleridge ... That night, he liquefied the immortal grains of Coleridge, and let the fountain flow ... Listening to Samuel Taylor Coleridge's *Kubla Khan* for the first time, I saw all that the poet had meant for me to see with him, and infinite cosmic things besides. I was not of the work-a-day world for days after Mr. Holmes's voice had ceased. This was my world, I said to myself, and I shall be in it, and surrounded by it, if it is the last thing I do on God's green dirt-ball. (*DT* 667–8)

This experience in the English class prompts Hurston to go to Morgan College and enrol in its high school. She moves to the house of a white clergyman and his sick wife, whom she assists in daily routines. In their private library, she finally has the opportunity to immerse herself, without restraint, in the world of books: 'I waded in. I acted as if the books would run away' (*DT* 669). Again, Hurston lists titles, indicating the broad range of her readings. She also provides a retrospective commentary on what she had devoured before high school. While freely admitting that some of her reading had consisted of 'dime novelists,' she underscores that she already had 'hundreds of books under [her] skin' by the time she entered Morgan. Hurston evaluates this aspect of her reading history as follows: 'I do not regret the trash. It has harmed me in no way. It was a help, because acquiring the reading habit early is the important thing. Taste and natural development will take care of the rest later on' (*DT* 669). The narrative of the natural reader, presented in chapter 4, here fades away, giving way to the self-confident and analytic voice of the autobiographer – a professional writer who is also an experienced reader.

Hurston, as we have seen, mainly discusses her authorship in terms of a pilgrim's progress, a journey rather than the goal. Hurston predominantly situates this storyline, which focuses on reading, in the depiction of her childhood and youth, the phases of the life cycle that epitomize formation and growth. Finally, in a passage that now, after Hurston's 1960 death in poverty and obscurity, seems poignant, she envisions her old age as a string of days spent writing and reading: 'When I get old, and my joints and bones tell me about it, I can sit around and write for myself, if for nobody else, and read slowly and carefully the mysticism of the East, and re-read Spinoza with love and care' (*DT* 768–9). For Hurston, her identity as a writer was inextricably intertwined with her plan to remain an active reader until what she hoped would be 'a timely death' after 'a busy life' (*DT* 768). In her scheme, the writer, a perpetual pilgrim, constantly needed to be nourished by reading.

Hurston's Readerly Self-Portrait and the Issue of African-American Literary Antecedents

Several aspects of Hurston's self-portrait as a reader represent, as my discussion has shown, dynamic strategies of celebrating African-American agency. The same portrait, however, also raises questions concerning her self-understanding as a cultural interpreter that do not lend them-

selves to easy or convenient answers. Most acutely, the literary tradition in which *Dust Tracks'* Zora luxuriates as a reader and future writer is exclusively white. Considering Hurston's project of casting herself as a mediator between the black and white cultural realms, her total silence about African-American literature seems puzzling. While some of this silence can, with relative ease, be attributed to what must have been a limited access to black writing during Hurston's childhood and youth, the argument loses credibility when applied to the narrative of her later life. *Dust Tracks* contains only passing references to the Harlem Renaissance – in sharp contrast, for example, to Langston Hughes's 1940 memoir *The Big Sea* – despite Hurston's importance to this movement and the movement's importance to her. The lack of any explicit dialogue with African-American literature or literary phenomena is an omission in her autobiography that cannot be explained away. This silence, rather, speaks loudly of her uneasy relationship to her African-American literary antecedents and colleagues of the day.

While Hurston's uneasiness with African-American literary tradition is not without either precedents or contemporaneous parallels,[15] her position within this matrix has its own peculiar traits. Her autobiographical portrait as a reader is of crucial help in the effort to outline the ambivalence characterizing her stance. In her essays, Hurston underscores and explicates African-American language use as an innovative art form. She insightfully calls into question, as Gates observes, the distinction between originality and imitation by emphasizing the artistic value of the constant reinterpretation, revision, and repetition with difference that are typical features of African-American expression (*Signifying Monkey* 117–18). Her exclusion of black literature from the depiction of her reading in *Dust Tracks*, however, reflects the limits that she subtly but deliberately sets to her discussion of black linguistic innovation. While her works highlight the creative qualities of African-American *oral* expression, she is reluctant to acknowledge and explore the value of the black American *literary* production that either overlapped with or preceded her career.

Apart from an unwillingness to be associated with a tradition that her contemporaries labelled as wanting in originality,[16] Hurston's reluctance to engage in dialogue with African-American literature seems to have resulted from three interrelated factors: personal schisms with African-American colleagues,[17] a need to secure a niche for herself in the literary marketplace, and a wish to promote a specific cultural agenda. Hurston's strategy of representing and mediating African-American cul-

ture was almost exclusively based on the concept of the 'rural black folk' and the folk's oral tradition (Carby 32).[18] Hurston, moreover, to a certain extent sought to present a strategic, professionally profitable image of herself as the sole competent mediator between Southern black oral traditions and the white world's literary traditions. Her exclusion of black literature from the depiction of her reading in *Dust Tracks* shows that while she wrote her own vocation and cultural agenda into her autobiography, she firmly remained silent about other contributions to the era's process of cultural mediation between the black and white worlds. Puzzled about Hurston's 'brief' autobiographical treatment of her career as a writer, critics have ignored the fact that in *Dust Tracks* Hurston herself is the only African American who is explicitly portrayed as a creator of literary and/or scholarly texts. Black readers of (white) literature are also few in the autobiography's world, which is another sign of Hurston's effort to subtly accentuate the 'uniqueness' of her calling and status as an interpreter between the African-American and European-American realms of cultural expression.

It is vital, however, in assessing Hurston's autobiographical portrait as writer and reader, to bear in mind the massive obstacles that African-American writers of her era faced in getting their works published. In practice, they had to compete with one another within the slot assigned to 'Negro writers.' This was an issue even for an author like Hurston (who, in the early 1940s, had the advantage of long-standing contact with a publishing house, Lippincott's, which had actually initiated the collaboration and continued to express interest in her work).[19] From this perspective, Hurston's heavy reliance on one chosen trope, the cultural stereotype of the 'rural black folk,' appears as a project of cultivating a distinctive literary voice, aimed to render her oeuvre easily identifiable and thus more marketable. The same rationale, the need to compete in the publishing market, seems to have largely motivated her reluctance to present herself as a reader of black texts and as one of the writers of the New Negro Movement, which would have meant acknowledging the literary achievements of African-American antecedents and colleagues. This manipulative strategy is, at least to some extent, understandable in the light of Hurston's sociocultural context; her autobiography after all reflects, in a variety of ways, tensions related to her social status 'as a woman in a male-dominated world and as a black person in a nonblack world' (Gates, 'Afterword,' 264).[20]

Yet, Hurston's manipulative side – her desire to detach herself from other African-American authors, revealed by the exclusive 'whiteness' of

the young Zora's reading in *Dust Tracks* – invites a remark on critic John Lowe's discussion of the late-twentieth-century Hurston revival. In his study of her comic voice and 'cosmic comedy,' Lowe utilizes the trickster imagery fashionable in Hurston criticism while commenting on the rediscovery of the once-forgotten Hurston: 'Zora must be somewhere, riding high and having the last laugh' (1). That 'last laugh' may, however, belong to African-American literary criticism, which has firmly placed Hurston, the individualist, in the company of her fellow writers in the black American literary canon. Perhaps, in some dimension beyond the reach of the literary critic's probe, these two 'last' laughs may merge into one loud and unrestrained cosmic laughter, which celebrates both the individual talent of Zora Neale Hurston and the current public recognition of the artistic riches and nuances of the African-American literary tradition.

NOTES

I would like to thank Vera Kutzinski and Bo Pettersson for their valuable comments on early drafts of this article. I am also grateful to Linda H. Peterson and Robert B. Stepto for nurturing my interest in autobiography at Yale University in the fall of 1999.

1 I refer throughout this article to the Library of America Edition of *Dust Tracks* (1995), henceforth cited as '*DT.*'
2 The persistence of this lacuna in Hurston criticism can be attributed to two factors. First, several scholars have been preoccupied by what Pierre A. Walker – implicitly critical of the unfavourable assessments – summarizes as the book's 'apparent unreliability, its inconsistency or fragmentary nature, and its seemingly assimilationist racial politics' (387). Second, critics have traditionally considered the autobiography's professional focus to be limited, almost exclusively, to Hurston's work and self-understanding as a folklorist and ethnographer.
3 I will refer to young Hurston by her first name, Zora, to maintain, where relevant, the distinction between character and narrator.
4 See, for example, Martineau (26), Robinson (12).
5 First of all, Hurston openly addresses financial matters (see, e.g., *DT* 714–16). By depicting her life as one of constant financial hardship, she skilfully embeds in *Dust Tracks* the claim – expressed, in the African-American context, as early as 1859 by Harriet E. Wilson in the preface to *Our Nig* – that

female authors are entitled to earn a living by their writing. Second, Hurston's deep commitment to her work as literary author and ethnographer also shows in her (tension-ridden) prioritization of vocation over domestic bliss. She primarily depicts her love life in terms of its effect on her career, addressing the difficulty of trafficking between the domestic and the professional (*DT* 746–50).

6 Pamela Bordelon stated in 1997 that Zora Neale Hurston was, in fact, born in Notasulga, Alabama (8). According to Bordelon, who refers to the 'Family Record' page of the Hurston family bible as her source, the Hurstons moved to Florida soon after Zora's birth.

7 The thematization of the link between literacy and freedom in slave narratives has attracted a great deal of scholarly attention since the initial 1979 publication of Robert Stepto's *From Behind the Veil.*

8 According to Hurston, while the African American 'lives and moves in the midst of a white civilisation, everything that he touches is re-interpreted for his own use' ('Characteristics' 838).

9 Kimberly W. Benston's major study from 2000, *Performing Blackness,* focuses on the 'performative ethos' characterizing African-American modernism (2). For a recent discussion highlighting wordplay and humour as essential elements of the 'performance of identity' in Hurston, see Beilke.

10 Alice Walker, the initiator of the late-twentieth-century Hurston Renaissance, sees Hurston as an autobiographer who, because of the consequences of her social powerlessness, compromised too much. According to Walker's infamous phrase, *Dust Tracks* was the 'most unfortunate thing Zora ever wrote' (xvii).

11 See, for example, Speisman (88–9). In addition to *Mules and Men,* which Speisman aptly highlights, Hurston's familiarity with snake symbolism also appears, for example, in her 1939 novel *Moses, Man of the Mountain.*

12 See, for example, Braxton (148); Hemenway (282). For a more sympathetic reading of the narrative of visions, see Rodríguez (36–7). In Rodríguez's view, the visions 'call into question Hurston's own position as subject of her text,' functioning as 'metaphors for a fragmented self and for the self as sign and interpreter' (37).

13 The phrase was made famous by Ralph Ellison, who used it as the title of one of his well-known essays.

14 For an insightful analysis of this image and its implications, see McKay, 'Race' (185–6, 188).

15 Affected by the then-prevalent view that black American literary tradition suffered from a lack of originality, African-American authors of the early twentieth century seldom explicitly expressed pride in or deliberately

emphasized their black literary ancestry (Gates, *Signifying Monkey*, 113–21). Charles Chesnutt (1858–1932), who desired to be remembered by posterity as the first African-American fiction writer, 'wiped the slate of black authors clean,' in Gates's to-the-point phrase, 'so that he could inscribe his name, and inherently the name of the race, upon it' (*Signifying Monkey* 117). Richard Wright, while admitting to being a reader of the African-American tradition, judged his black literary predecessors harshly in his 1937 essay 'Blueprint for Negro Writing,' labelling the majority of them 'prim and decorous ambassadors who went a-begging to white America ... dressed in the knee-pants of servility' (45; see also Gates, *Signifying Monkey*, 119). Slightly softening this statement, he clarified that most black American writing had, in his view, either functioned merely as an instrumental proof of black achievement or had represented 'the voice of the educated Negro pleading with white America for justice' (45). Wright called for a renewal of thematics and style based on the realization that 'Negro life may be approached from a thousand angles, with no limit to technical and stylistic freedom' (51).

16 See note 15 above.

17 Hurston's arguments and disagreements particularly with Langston Hughes and Richard Wright are well known. For Hurston's and Hughes's 1931 dispute over the rights to the jointly written play *Mule Bone*, see, for example, Hemenway (136–48); Hughes (331–4); and Gates, 'Tragedy' (10–14). Hurston's unflattering review of Richard Wright's *Uncle Tom's Children* was published in *Saturday Review*, 2 April 1938.

18 While this strategy has earned Hurston the reputation of a pioneering African-American folklorist, critics of her approach, particularly Hazel Carby, have argued that Hurston deliberately froze black culture at the stage of the oral, folksy, and rural. Hurston, in this view, lamentably made the concept of the folk designate the totality of African-American experience, failing to include in her paradigm the modern urban forms of black culture that had emerged in northern cities in the aftermath of the Great Migration.

19 For Hurston's contact with Lippincott's, see, for example, Hemenway (188–9, 275).

20 See also Meisenhelder (2).

WORKS CITED

Augustine. *The Confessions of Saint Augustine.* Trans. Edward B. Pusey. New York: Modern Library, 1999.

Beilke, Debra. "'Yowin' and Jawin'": Humor and the Performance of Identity in

Zora Neale Hurston's *Jonah's Gourd Vine.*' *Southern Quarterly* 36:3 (1998): 21–33.

Benston, Kimberly W. *Performing Blackness: Enactments of African-American Modernism.* London: Routledge, 2000.

Bhabha, Homi K. 'DissemiNation: Time, Narrative, and the Margins of the Modern Nation.' In *Nation and Narration,* ed. Homi K. Bhabha, 291–322. London: Routledge, 1990.

Bjorklund, Diane. *Interpreting the Self: Two Hundred Years of American Autobiography.* Chicago: U of Chicago P, 1998.

Bordelon, Pamela. 'New Tracks on *Dust Tracks*: Toward a Reassessment of the Life of Zora Neale Hurston.' *African American Review* 31:1 (1997): 5–21.

Braxton, Joanne M. *Black Women Writing Autobiography: A Tradition within a Tradition.* Philadelphia: Temple UP, 1989.

Carby, Hazel. 'The Politics of Fiction, Anthropology, and the Folk: Zora Neale Hurston.' In *History and Memory in African-American Culture,* eds. Geneviève Fabre and Robert O'Meally, 28–44. New York: Oxford UP, 1994.

Domina, Lynn. '"Protection in My Mouf": Self, Voice, and Community in Zora Neale Hurston's *Dust Tracks on a Road* and *Mules and Men.*' *African American Review* 31:2 (1997): 197–209.

Ellison, Ralph. 'Change the Joke and Slip the Yoke.' In *The Collected Essays of Ralph Ellison,* ed. John F. Callahan, 100–12. New York: Modern Library, 1995.

Gates, Henry Louis, Jr. 'Afterword: Zora Neale Hurston: "A Negro Way of Saying."' In *Dust Tracks on a Road,* by Zora Neale Hurston, 257–67. Ed. Henry Louis Gates, Jr. New York: HarperPerennial, 1991.

– *The Signifying Monkey: A Theory of African-American Literary Criticism.* New York: Oxford UP, 1988.

– 'A Tragedy of Negro Life.' In *Mule Bone: A Comedy of Negro Life,* by Langston Hughes and Zora Neale Hurston, 5–24. Ed. George Houston Bass and Henry Louis Gates, Jr. New York: HarperPerennial, 1991.

Glassman, Steve, and Kathryn Lee Seidel, eds. *Zora in Florida.* Orlando: U of Central Florida P, 1991.

Grimké, Charlotte Forten. *The Journals of Charlotte Forten Grimké.* Ed. Brenda Stevenson. The Schomburg Library of Nineteenth-Century Black Women Writers. New York: Oxford UP, 1988.

Hassall, Kathleen. 'Text and Personality in Disguise and in the Open: Zora Neale Hurston's *Dust Tracks on a Road.*' In Glassman and Seidel, 159–73.

Hemenway, Robert E. *Zora Neale Hurston: A Literary Biography.* Urbana: U of Illinois P, 1980.

Hughes, Langston. *The Big Sea: An Autobiography.* 1940. 2nd ed. New York: Hill and Wang, 1993.

Hurston, Zora Neale. 'Characteristics of Negro Expression.' In Hurston, *Folklore, Memoirs*, 830–74.

– *Dust Tracks on a Road*. 1942. In Hurston, *Folklore, Memoirs*, 556–808.

– *Folklore, Memoirs, and Other Writings*. Ed. Cheryl A. Wall. Library of America 75. New York: Literary Classics of the United States, 1995.

– *Moses, Man of the Mountain*. 1939. Hurston, *Novels and Stories*, 335–595.

– *Mules and Men*. 1935. In Hurston, *Folklore, Memoirs*, 1–267.

– *Novels and Stories*. Ed. Cheryl A. Wall. Library of America 74. New York: Literary Classics of the United States, 1995.

Lowe, John. *Jump at the Sun: Zora Neale Hurston's Cosmic Comedy*. Urbana: U of Illinois P, 1994.

Martineau, Harriet. *Harriet Martineau's Autobiography*. 1877. London: Virago, 1983.

McKay, Nellie Y. 'The Autobiographies of Zora Neale Hurston and Gwendolyn Brooks: Alternate Versions of the Black Female Self.' In *Wild Women in the Whirlwind: Afra-American Culture and the Contemporary Literary Renaissance*, ed. Joanne M. Braxton and Andrée Nicola McLaughlin, 264–81. London: Serpent's Tail, 1990.

– 'Race, Gender, and Cultural Context in Zora Neale Hurston's *Dust Tracks on a Road*.' In *Life/Lines: Theorizing Women's Autobiography*, ed. Bella Brodzki and Celeste Schenck, 175–88. Ithaca: Cornell UP, 1988.

Meisenhelder, Susan Edwards. *Hitting a Straight Lick with a Crooked Stick: Race and Gender in the Work of Zora Neale Hurston*. Tuscaloosa: U of Alabama P, 1999.

Reising, Russell. *Loose Ends: Closure and Crisis in the American Social Text*. Durham: Duke UP, 1996.

Robinson, Mary. *Memoirs of the Late Mrs. Robinson, Written By Herself*. London: Whittaker, Treacher, and Arnot, 1830.

Rodríguez, Barbara. *Autobiographical Inscriptions: Form, Personhood, and the American Woman Writer of Color*. New York: Oxford UP, 1999.

Rousseau, Jean-Jacques. *The Confessions and Correspondence, including the Letters to Malesherbes*. Vol. 5 of *The Collected Writings of Rousseau*. Ed. Christopher Kelly, Roger D. Masters, and Peter G. Stillman. Trans. Christopher Kelly. Hanover, NH: UP of New England, 1995.

Speisman, Barbara. 'Voodoo as Symbol in *Jonah's Gourd Vine*.' In Glassman and Seidel, 86–93.

Stepto, Robert B. *From Behind the Veil: A Study of Afro-American Narrative*. 2nd ed. Urbana: U of Illinois P, 1991.

Walker, Alice. 'Foreword: Zora Neale Hurston – A Cautionary Tale and a Partisan View.' In *Zora Neale Hurston: A Literary Biography*, by Robert E. Hemenway, xi–xviii. Urbana: U of Illinois P, 1980.

Walker, Pierre A. 'Zora Neale Hurston and the Post-Modern Self in *Dust Tracks on a Road*.' *African American Review* 32:3 (1998): 387–99.

Wilson, Harriet E. *Our Nig; or, Sketches from the Life of a Free Black, In A Two-Story White House, North. Showing That Slavery's Shadows Fall Even There*. 1859. New York: Vintage Books, 1983.

Wright, Richard. 'Blueprint for Negro Writing.' In *African American Literary Theory: A Reader*, ed. Winston Napier, 45–53. New York: New York UP, 2000.

9 Poor Lutie's Almanac: Reading and Social Critique in Ann Petry's *The Street*

MICHELE CRESCENZO

As Janet Badia and Jennifer Phegley write in the introduction to this collection, the images in Pomegranate's *The Reading Woman* stationery 'make clear that the general image of the reading woman is one very much inflected by white, middle-class ideology' (22). One exception, William McGregor Paxton's *The House Maid*, nicely illustrates the plight of Lutie Johnson, another maid who reads her employer's books, in Ann Petry's 1946 novel *The Street*. And just as 'the house maid,' despite her literacy, cannot transcend her class, neither can Lutie. In fact, *The Street* directly implicates Lutie's reading – or mis-reading – in her fate, as it enacts the dangers that stalk women who unwisely or uncritically attempt to model their lives on literature. These dangers multiply, *The Street* suggests, when the woman reader is a young, black, working-class single mother struggling to make her way in Harlem during the Depression and the Second World War. Yet Lutie insists that 'if Ben Franklin could live on a little bit of money and could prosper, then so could she' (64). Lutie's misplaced reliance on the myth of the American dream, especially her unquestioning acceptance of Franklin's autobiography as a prototype for her own success, clearly forms the crux of the novel. But just as important is Lutie's relationship to print culture more generally. Indeed, paper pervades *The Street* and figures as the principal image in Petry's argument about Lutie as a black woman reader. My essay traces this paper trail in order to show the ways Petry's novel exposes the roles race, class, and gender play in women's relationship to reading in particular and to print culture in general.

Criticism of *The Street* has primarily focused on Lutie's misplaced reliance on the myth of the American dream and, especially, her disastrously misplaced obsession with Benjamin Franklin.[1] Lutie's fascination

with Franklin indisputably reflects her positive accomplishments (beginning with her mastery of literacy) and her worthy aspirations (most notably her desire to take a respectable place in American society). As previous critics have emphasized, however, it also reflects an unrealistic embrace of a model that does not remotely capture Lutie's own situation and possibilities. Franklin's pieties about effort and success thus remain empty signs that lack concrete referents or embodiments in Lutie's life. Moreover, Lutie's fixation on Franklin deadens her to the wisdom of the oral culture that still percolates in the black community in Harlem but from which she is trying to escape. Critics have, by and large, failed to explore Petry's sophisticated and complex treatment of this relation between literate and oral culture in the life of the protagonist and in the novel's larger black community.

Walter Ong and others have illuminated the respective strengths and limitations of oral and literate culture. Oral cultures typically favour a directness and repetition that literate cultures frequently disdain. Thus, oral cultures will deploy narratives that feature heroes and villains – that is, strong representatives of right and wrong. They will further emphasize basic lessons that are to be understood as truths about human nature and that bear endless repetition. Literate cultures, in contrast, favour subtlety and indirection and are especially adapted to the expression of subjective life. The painful irony in Lutie's case is that she blindly selects examples of literate culture and, as a result, the wrong subjectivities as guides. In this respect, the reader of *The Street* is challenged to ask how well Lutie knows herself and how well she succeeds in locating her position between the residually oral culture she is leaving and the more literate culture she is attempting to appropriate. Compounding the challenge are our common assumptions about reading, particularly our assumption about its potential for liberation and self-discovery (after all, it is a commonplace in many a *Bildungsroman* that a young protagonist's discovery of books is the beginning of his or her quest for selfhood). For example, in his 1945 autobiography *Black Boy*, Richard Wright poignantly evokes the importance of books and reading in nourishing his sense of self and in shielding him from the worst ravages of the segregated South:

> The face of the South that I had known was hostile and forbidding and yet out of all the conflicts and the curses, the blows and the anger, the tension and the terror, I had somehow gotten the idea that life could be different, could be lived in a fuller and richer manner ... But what was it that always

made me feel that way? What was it that made me conscious of possibilities? From where in this southern darkness had I caught a sense of freedom? ... It had only been through books – at best, no more than vicarious cultural transfusions – that I had managed to keep myself alive in a negatively vital way. Whenever my environment had failed to support or nourish me, I had clutched at books. (226)

Maya Angelou, in her autobiography *I Know Why the Caged Bird Sings* (1969), echoes Wright's appreciation of books as 'vicarious cultural transfusions' that help to connect marginalized, southern black children to a larger and better world. Angelou writes:

To be allowed, no, invited, into the private lives of strangers, and to share their jobs and fears, was a chance to exchange the Southern bitter wormwood for a cup of mead with Beowulf or a hot cup of tea and milk with Oliver Twist. When I said aloud, 'It is a far, far better thing that I do, than I have ever done ...' tears of love filled my eyes at my selflessness. (84)

Yet even as Angelou participates in what Wright calls the 'conscious[ness] of possibilities' bestowed by books, she also recognizes the importance of oral culture and folk wisdom. Mrs Flowers, the teacher who throws young Angelou her 'first life line' (77), instils in her an appreciation for their cultural roots, alongside a love of literature. '[B]e intolerant of ignorance but understanding of illiteracy' and 'listen carefully to what country people called mother wit ... in those homely sayings was couched the collective wisdom of generations,' Mrs Flowers tells her (83). For Lutie, reading does not lead to the same results – self-knowledge, development, and pleasure – as it does in the *Bildungsroman* or in Wright's and Angelou's works. Nor can it, Petry suggests, as long as Lutie ignores the 'mother wit' Mrs Flowers speaks of and privileges literate culture over oral culture. In short, Lutie's reading of the texts of mid-twentieth-century white culture seems destined to leave her in a kind of cultural limbo, primarily because she divorces herself from her race, class, and gender and turns her back on the kinds of knowledge that are intrinsic to her black cultural roots and the surrounding woman-centred communities.

The novel opens with Lutie's attempt to read an 'Apartment for Rent' sign, which, significantly, the wind keeps displacing. Each time she thinks 'she ha[s] the sign in focus, the wind pushe[s] it away from her' (2). Fearing the influence of her bootlegger father and his girlfriends

on her eight-year-old son Bub, Lutie wants to move out of his house to an apartment of her own. Inquiring about the apartment, she encounters one of the building's tenants, Mrs Hedges, an 'enormous bulk of a woman' with eyes 'as still and as malignant as the eyes of a snake' (5–6). The building superintendent, Jones, whose eyes fill 'with a hunger so urgent that she was instantly afraid of him' (10), shows Lutie the apartment on 116th Street, and despite her instinctive distrust of these two ominous characters, she immediately rents it. This opening scene encapsulates Petry's construction of Lutie as a reader: paralleling her fleeting ability to physically read the sign that is blowing in the wind, Lutie is unable to correctly 'read' the signs of the danger surrounding the apartment. At the very least, one could say that she misguidedly rationalizes away her intuitive and therefore more sound 'reading' of the danger.

Building on this initial scene, Petry later depicts Lutie on the subway reading an advertisement for a 'miracle of a kitchen' inhabited by 'a girl with incredible blond hair' (28). The kitchen is 'completely different from the kitchen of the 116th Street apartment ... [b]ut almost exactly like the one she had worked in in Connecticut' (28). Lutie, like most black women of her time – as the 'incredible blond hair' implies – cannot access the share of the American dream represented in this ad, but she is permitted to labour in such a kitchen. The picture of the kitchen triggers flashbacks through which we learn about the Chandlers, a wealthy white family that employed her as a live-in maid for two years. Lutie has ingested the Franklinesque spirit of the Chandlers, who preach a similar gospel of success through individual effort as they profess that 'anybody could be rich if he wanted to and worked hard enough and figured it out carefully enough' (43). Subsequent flashbacks reveal that Lutie has been struggling for years to achieve 'respectability.' Having lost her mother at age seven, she was raised by her father and grandmother, graduated from high school, and married at seventeen. Lutie and her husband, Jim, suffer the economic fate of most working-class African Americans during the Depression. Due to racial discrimination and the scarcity of jobs, Jim cannot find work, and the couple struggles to pay the mortgage on the house left to them by Jim's mother. Lutie takes in 'State children' to earn a little money, eventually supporting five foster children, her own son, and her husband, 'feeding eight people on the money for five and squeezing out what amounted to rent money in the bargain' (171). The situation collapses when a social welfare worker discovers that Lutie's father is having drunken parties on

the nights he persuades Lutie and Jim to go out, and the State takes the foster children from her.

Desperate to save the mortgage, Lutie takes the job as a live-in maid with the Chandlers in Connecticut, visiting Jim and Bub only every month or two in order to save the train fare. When she learns that Jim has taken up with another woman, Lutie returns to New York, takes her few possessions and her son, and moves in with her father. Although she cannot afford a divorce, the marriage is over. For four grueling years, Lutie works as a handpresser in a steam laundry while going to night school to study typing and stenography, buoyed by the promise of the American dream: 'Every time it seemed as though she couldn't possibly summon the energy to go on with the course, she would remind herself of all the people who had got somewhere in spite of the odds against them. She would think of the Chandlers and their young friends – "It's the richest damn country in the world"' (55). Lutie's reward for this labour and persistence is a job as a file clerk. The 'white collar job' of which she has dreamed pays barely enough for her to support herself and her son in their new apartment (56). The influence of the Frank-linesque Chandlers has, in part, propelled Lutie towards taking the unaffordable apartment despite her gnawing instincts. Once again, then, she represses her intuitive 'reading' abilities and is willing to suspend her disbelief when she listens to the 'texts' provided by the Chandlers. The illusion of the 'miracle of a kitchen' inhabited by 'a girl with incredible blond hair' intertwines with the text of the American dream represented by the Chandlers. Together, they prove to be more seductive to Lutie than the oral and folk wisdom of her own experience.

While living in the building on 116th Street, Lutie learns that Mrs Hedges, a fixture who sits continually in her window watching the events on the street unfold, runs a brothel from her apartment and that life on 116th Street has pushed Jones, the building's superintendent, 'into basements away from light and air until he was being eaten up by some horrible obsession' (56). Yet Lutie does not fear the street's 'influence, for she would fight against it' (56). 'Streets like 116th Street or being colored,' she muses, 'or a combination of both with all it implied, had turned Pop into a sly old man who drank too much; had killed Mom off when she was in her prime,' but '[n]one of those things would happen to her ... because she would fight back and never stop fighting back' (56–7). At Junto's Bar and Grill, Lutie meets Boots Smith, who offers her a singing job with his band. Lutie dreams that the salary will be her ticket out of 116th Street, but after singing in a nightclub all night for a

few nights – and working all day at the office – she realizes that Boots is not going to pay her. Unbeknownst to Lutie, Junto (who owns Junto's Bar and Grill, the casino where Boots's band plays, the building on 116th Street, and apparently everything else in Harlem) has designs on her and has ordered Boots to string her along with the singing job.

Jones, too, quickly becomes obsessed with Lutie, and his presence becomes increasingly menacing. When he attempts to rape her, Mrs Hedges, Junto's business partner, intervenes and tells Jones to stay away from Lutie because 'it's Mr. Junto who's interested in Mis' Johnson' (238). Jones develops a twisted scheme of revenge, employing Bub to steal mail from the surrounding buildings, explaining that they are helping the police to find a criminal. In Jones's fantasy, Bub will be caught and removed to reform school, and Lutie, left alone, will eventually come to Jones for solace. When Bub is caught and taken to the Children's Shelter, Lutie desperately applies to Boots for the money for a lawyer. Boots assures her that he will help, and arranges a meeting in her apartment. But when Lutie arrives, she finds Junto there waiting for her, becomes hysterical, and orders Boots to send him away. Boots privately assures Junto that Lutie will 'come around,' and asks him to come back later (423). Returning to Lutie, however, Boots decides to rape her himself before Junto can 'have her.' In self-defense Lutie hits him with a heavy candlestick, then, fueled by a 'lifetime of pent-up resentment,' beats him to death (430). Realizing what she has done, she concludes that the street has finally won. She decides to abandon her son, who is still in the Children's Shelter, 'because the best thing that could happen to Bub would be for him never to know that his mother was a murderer' (433). Taking half the money from Boots's wallet, Lutie flees New York, boarding a train for Chicago. 'It was that street,' Lutie tells herself on the train, 'it was that god-damned street' (435).

Despite Lutie's interpretation, Petry establishes that, more than the street, it is Lutie's own education, both in the public schools and from her own reading, that fails her by seducing her to believe too strongly in the American dream. Lutie, who probably encountered Benjamin Franklin's autobiography in high school, is so well acquainted with it that walking through Harlem with her purchase of rolls from the bakery reminds her of the scene in which Franklin eats a roll while walking the streets of Philadelphia:

> [F]eeling the hard roundness of the rolls through the paper bag, she thought immediately of Ben Franklin and his loaf of bread. And grinned

> thinking, You and Ben Franklin. You ought to take one out and start eating
> it as you walk along 116th Street. Only you ought to remember while you
> eat that you're in Harlem and he was in Philadelphia a pretty long number
> of years ago. Yet she couldn't get rid of the feeling of self-confidence and
> she went on thinking that if Ben Franklin could live on a little bit of money
> and could prosper, then so could she. (63–4)

Ignoring her own caveat, Lutie fails to remember that she is 'in Harlem
and [Franklin] was in Philadelphia a pretty long number of years ago,'
and it is this failure that proves to be her downfall. Lutie's identification
with Benjamin Franklin obscures what Richard Yarborough identifies as
a major irony of the African-American experience in this country: 'the
disappointing fact that the society which claims to be founded upon the
principles of freedom and equality nonetheless supported a brutal chat-
tel slave system for over two hundred years' (33). In other words, the
principles to which Lutie subscribes are compromised from the start.
When a woman like Lutie, who really is born into 'Poverty and Obscu-
rity,' tries to change her material circumstances, her story is not quite as
simple as Franklin's. Nor is it as simple as the Chandlers'. Lutie fails to
see that the odds against 'the Chandlers and their young friends' are
minuscule, that none of them needed to work for four years at a gruel-
ling job, studying at night, to be awarded the privilege of a filing job that
still does not pay well enough to live decently.

Lutie nonetheless identifies more with these privileged whites than
with any other characters in the novel, a direct consequence of her read-
ing, or mis-reading, of Benjamin Franklin. The philosophy of the Chan-
dlers and their friends, 'this new philosophy' that Lutie absorbs from
listening to their conversations, probably appeals to her because, as a
presumed reader of Franklin's autobiography, she finds it familiar. Lutie
hears, in the Chandlers' home, 'Retire at forty' (43), just as Franklin
had retired from business at forty-two. Similarly, their frequent injunc-
tions to '[m]ake it while you're young ... Outsmart the next guy. Think
up something before anyone else does' echo, albeit more crudely,
Franklin's own philosophy of success (43).

As Keith Clark writes, Lutie 'spends the entire novel trying to deci-
pher Franklin's encoded, phallocentric text – a "white" book blacks
were never meant to read in the first place' (501). Caught between oral
and literate cultures, between black and white, Lutie encounters this
phallocentric text without the perspective from which to read it. But,
importantly, Lutie's lack of perspective is only part of the problem. Petry

suggests that Lutie's reading of Franklin's autobiography has been compounded by her distance from print culture more generally. Indeed, in *The Street* one's proximity to print culture determines material success, a theme conveyed through her implicit comparison of the Chandlers and the Franklins. While Franklin claims in his autobiography that he was born and bred in 'Poverty and Obscurity,' not only can he trace his family in England back at least 300 years, but his father owned his own business as a tallow chandler (414). Through her use of the name 'Chandler,' Petry links Franklin, who owns a printing press, with the Chandlers, who own a paper factory – two families who are not self-made but who believe in the myth of the self-made man – and essentially draws a line between print culture and material success. Lutie, who can read Franklin's autobiography only as a success manual, mistakenly trusts that her relative proximity to print culture will guarantee equal access to material gain. But her proximity is limited to that of a consumer of print culture, while the Franklins and Chandlers have a hand in its production. The tallow chandler, or candle maker, provides light that enables reading at night, the owner of the paper mill provides the raw material for books, and the owner of the printing press brings books into existence. These professions – all of which depend on ownership – allow control over how print culture is created and consumed.

Images of paper in the novel explicitly link the characters' distance from or proximity to print culture with their material circumstances. From the opening image of papers being blown by the wind, Lutie is surrounded by paper. Yet much of what she is denied is based on paper – paper money, a college diploma, a formal divorce, and the next civil service exam. Furthermore, since her civil service classification denies her the position of typist, Lutie, via her job as a file clerk, is simply the caretaker of the written word: while the position of typist would have put Lutie at the point of production and netted her better pay, she would still only have copied what others wrote; and her position as file clerk means that she remains a 'paper pusher' whose job is to file papers upon which other people have written. And just as she remains simply the caretaker of the written word at her job, she seems doomed to be merely the caretaker of the self-reliant, up-by-one's-bootstraps philosophy of Benjamin Franklin. In this economy she can consume and organize the printed page, but she stands little chance of actually producing it. Although Lutie owns no printing press or paper factory, she founds her own subjectivity on her identification with Franklin and thus overlooks his subject position as a white male who, as a printer, owned the

means of production, just as the Chandlers own a paper factory. In other words, she reads his story, but cannot critically 'read' her own. She refuses to acknowledge that her own subject position as poor, black, and female, combined with her hostile environment, make it nearly impossible for her to control the narrative of her own story. As the saying goes, the injunction to pull oneself up by one's bootstraps assumes that one has boots.[2]

Lutie's dependence on print culture is also reflected in her efforts to obtain work as a domestic. To find this employment, Lutie depends on a newspaper want ad, a written reference, and her own ability to write a good letter:

> It was a good letter, she thought, holding it in her hand a little way off from her as she studied it – nice neat writing, no misspelled words, careful margins, pretty good English. She was suddenly grateful to Pop. He'd known what he was doing when he insisted on her finishing school. (31)

Lutie knows that Mrs Pizzini, her grocer, will provide the reference because, since Lutie has an outstanding bill (another instance of paper's pervasiveness in Lutie's life) at the Pizzinis' store, Mrs Pizzini would naturally be happy to see Lutie employed. Although Mrs Pizzini cannot write as well as Lutie, her economic position as a store owner provides better access to print culture than Lutie's position: her reference will count. Furthermore, the Pizzinis have done well enough to send their daughter to college; the daughter, now a schoolteacher, composes the reference for Lutie. The 'precious reference,' along with Lutie's letter, are deposited among the other paper in the mailbox (33). It is ironic that Lutie must depend on her education, or access to print culture, to get a servant's job, and doubly ironic that what she learns at this job – the pernicious influence of the Chandlers – also results from her literacy. Perhaps this is another way in which Petry suggests that Lutie's exclusive dependence on print culture contributes to her ultimately tragic fate. In any case, it is clear that Lutie's material circumstances, however still constrained, depend on the power of the letter.

Further underscoring this dependence, Petry invests paper in general with a power of its own. When the police take Bub, for example, they hand Lutie a piece of paper, which 'refuse[s] to stay still' when she tries to read it (387). Like the 'Apartment for Rent' sign, which the wind moves when Lutie tries to read it, this document literally moves in front of Lutie's eyes, suggesting the protagonist's tenuous control over her

own reading. Similarly, the police paper – or its importance – seems to impress itself on Lutie: 'The last thing she did before she left the apartment was to put the stiff, white paper in her pocketbook. And on the subway she was so aware of its presence that she felt she could see its outline through the imitation leather of the bag' (407). Nevertheless, Petry makes clear again and again that the real power of paper is the power of the people who control it. Lutie's lawyer is shown to be surrounded by paper as he sits at his desk amid notes, envelopes, and the newspaper; the Chandlers' money permits them to turn the suicide of Mr Chandler's brother into an 'accident with a gun on the death certificate' (49), and those who control print media can use paper to turn a thin, ragged black boy into a 'burly negro' after he is killed by a white store owner who claims he tried to rob his store. Lutie realizes that the reporter who transformed this story 'couldn't see the ragged shoes, the thin, starved body ... [seeing], instead, the picture he already had in his mind' (198). Significantly, she compares the reporter to the Chandlers, 'who looked at her and didn't see her' (199), a comparison that tries to construct both the reporter and the Chandlers as mis-readers as well. Yet the irony of Lutie's comparison is evident: while it is true that the Chandlers cannot see Lutie for who she is, neither can Lutie see herself. In fact, she seems to view herself only through the Chandlers' eyes – as someone who could make it if she wanted to – despite the contradictory evidence that is there on 116th Street for her to 'read' every day. Thus, while the Chandlers' mis-readings gather credibility from their positions of power, Lutie's own mis-readings are not assigned the same credibility.

Indeed, those people, like Lutie, who do not have power cannot manipulate print culture for their own benefit. For Lutie's father, whom the white system has turned 'into a sly old man who [drinks] too much' (56), reading is an effort, and Lutie knows when she receives a letter from him that there is 'something wrong for Pop to write' (52). For Jones, the act of writing is also a painstaking effort, if it is even available: when he attempts to complain to the police about Mrs Hedges's brothel, a lieutenant who is obviously in Junto's pocket tears up the paper form that Jones is attempting to fill out; in this case it is Junto who controls the paper. For Bub, a young black male, access to print culture must be 'stolen' (stealing mail is the crime that puts Bub in the Children's Shelter). And for Lutie, who does seem to have at least some access to print culture compared to the others, paper in the form of 'the gas bill and rent bill and the light bill' still haunts her daily life (83). In fact, as she struggles to support herself and her eight-year-old son on her salary, the

next civil service exam is her only means of doing better; marriage is not an option because she cannot afford the piece of paper that signifies a legal divorce. All of these documents, which represent the government or the corporate world, control Lutie's life as powerfully as that other 'official' document of American culture, Benjamin Franklin's autobiography.

Junto's name is another reference to Benjamin Franklin. Franklin's Junto, or Leather Apron Club, was a group dedicated to self-improvement and 'the "wish to do good" that would also bring them advantages, or even profit' (E. Wright 37–8). Petry's implication is that Junto, as a white man who has 'pulled himself up by his bootstraps,' is heir to Franklin's values, no matter how far outside the law Junto may be. And as a white man who owns nearly everything that controls Lutie's life, he is also the personification of capitalism. Franklin's Junto club may be thought of as the first working-class networking organization, but the group was also in part a literary society. Perversely, by naming such a disreputable character after this group Petry associates capitalist enterprise with monopoly, self-improvement with 'helping oneself,' and print culture with power.

Furthermore, those who do have power – the Chandlers of the world – have come so far beyond access to print culture that they can take reading and education for granted in a way that Lutie cannot comprehend. Until she works for the Chandlers, who produce types of paper that do not get written on, Lutie believes that 'whites wanted their kids to be President,' and she is surprised to discover that education is not important to the Chandlers. Although they attend Yale, Harvard, and Princeton, afterwards they 'read nothing but trade magazines and newspapers.' Products of the most elite schools in the country, wealthy enough to have libraries in their homes, they are exposed as Philistines. In fact, Lutie notices that the effort of Mr Chandler's reading leaves 'him a little tired, just like Pop or Mrs. Pizzini' (42). Mrs Chandler, who can afford to buy 'fat, sleek magazines' and 'all the newest books' – and who also has the leisure time in which to read them – passes them on, unread, to Lutie. For Lutie, reading them is 'almost like getting a college education free of charge' (50). The Chandlers of the world are free to read 'nothing but trade magazines and newspapers' or, like Mrs Chandler, read nothing at all because their real education is in how to become 'filthy rich' (43). They do this by exploiting 'new markets. If not here in South America, Africa, India – Everywhere and anywhere' (43): that is, by exploiting people of colour, and by extension Lutie herself.

Rather than identify with these exploited people of colour, Lutie
'absorb[s] some of the same spirit,' as '[t]his new philosophy [begins to
creep] into her letters' to her husband (43). Thus, while Lutie reads all
of Mrs Chandler's books and magazines, she fails to critically 'read' the
real story behind the Chandlers' success.

Yet Lutie is not always a naïve or trusting reader. The first scene of her
reading, when she encounters the 'Apartment for Rent' sign at the
novel's start, shows her as a wary and cynical reader. Lutie reads the sign
– 'Three rooms, steam heat, parquet floors, respectable tenants. Reason-
able' (3) – and she immediately deconstructs this text:

> Parquet floors here meant that the wood was so old and so discolored no
> amount of varnish or shellac would conceal the scars and the old scraped
> places, the years of dragging furniture across the floors, the hammer blows
> of time and children and drunks and dirty, slovenly women. Steam heat
> meant a rattling, clanging noise in radiators early in the morning and then
> a hissing that went on all day ... Respectable tenants in these houses where
> colored people were allowed to live included anyone who could pay the
> rent, so some of them would be drunk and loud-mouthed and quarrelsome
> ... Reasonable – now that could mean almost anything. On Eighth Avenue
> it meant tenements – ghastly places not fit for humans. On St. Nicholas
> Avenue it meant high rents for small apartments; and on Seventh Avenue it
> meant great big apartments where you had to take in roomers in order to
> pay the rent ... 'Reasonable' here in this dark, crowded street ought to be
> about twenty-eight dollars, provided it was on a top floor. (3–4)

One of Lutie's many likeable qualities is her good-humoured, healthy
cynicism, a cynicism that is greatly at odds with her optimistic determi-
nation to transcend her circumstances. While Lutie clearly demon-
strates her ability to read the apartment sign critically, despite its
movement, she remains credulous and accepting of Benjamin Frank-
lin's autobiography and fails to accurately read the 'story' of the Chan-
dlers' success.

In contrast to Lutie, Mrs Hedges is presented as a good 'reader' who
knows how to survive on the street, and Min, the woman who lives with
Jones, is constructed as ultimately more resourceful than Lutie because
she has not renounced her ties to African-American culture. As black
women who survive outside of the environmental determinism of
Lutie's tragic fate, Mrs Hedges and Min represent alternatives for Lutie.
Keith Clark notes that Mrs Hedges and Min employ the techniques of

the trickster figure, subverting the quest for the American dream to achieve their own, modified, version of it (496). Mrs Hedges, almost a parody of the Horatio Alger archetype, is scavenging through garbage cans in search of food when she meets Junto. Scavenging himself for 'broken bottles, discarded bits of clothing, newspapers,' Junto suggests they work together, selling rags and junk from pushcarts (242). Eventually, it is Mrs Hedges who suggests that he 'branch out,' buying more pushcarts and hiring more men. Junto's enterprise expands to real estate; when he buys his first building, he hires Mrs Hedges as janitor and rent collector. When Lutie moves to Harlem, Junto and Mrs Hedges own apartment buildings, Junto's Bar and Grill, the casino where Boots Smith and his orchestra play, and two brothels. While in the Alger archetype a poor boy progresses from rags to respectability through thrift, industry, honesty, and temperance – echoing the Benjamin Franklin model – Mrs Hedges is a poor woman who progresses from rags to disrepute through thrift, industry, illegal activity, and peddling young women's bodies. She has, nonetheless, learned to survive, and through her power in the role of Junto's 'overseer' is able not only to 'read' the street, but to authorize and author its events.

Min, like Mrs Hedges, also appears at first glance to be ill equipped to survive on the street. Uneducated and poor, she is abused by the white women whose houses she cleans and by the men with whom she is involved. When Min perceives that Jones is becoming obsessed with Lutie, she resolves to take action, explaining:

> I ain't never had nothing of my own before. No money to spend like I wanted to. And now I'm living with him where they ain't no rent to pay, why, I can get things that I see. And it was all right until that Mis' Johnson come here to live. He'll be putting me out pretty soon ... I ain't goin' back to having nothing. Just paying rent. Jones don't ask for no money from me and he wasn't never this mean until that young Mis' Johnson come here. And I ain't goin' to be put out. (119–20)

In 'the first defiant gesture she ha[s] ever made' (126), Min visits a 'root doctor,' the Prophet David, using the money that she had been saving to buy false teeth. 'Belief in magic is older than writing,' writes Zora Neale Hurston in her anthropological work on black folk culture, *Mules and Men* (183), and Min is plainly a product of this culture. She believes that the Prophet David's root magic will keep Jones from putting her out. Importantly, in contrast to Lutie who relies on eighteenth-century Euro-

pean rationalism, Min turns to root work, or hoodoo, or conjuring, which originated in Africa.

The Prophet David, whose 'eyes were deep-set and ... didn't contain the derisive look she was accustomed to seeing in people's eyes,' encourages Min with his calm and patient manner to pour out her story (133). He listens to her story, then instructs her to put one drop of red liquid in Jones's coffee every morning, burn two white candles every night at ten o'clock, hang a cross over her bed, and sprinkle a green powder on the floor if Jones gets violent. But the Prophet's attention to Min does more for her self-esteem than the prospect of conjuring: 'she thought talking to him had been the most satisfying experience she had ever known' (136). This is the first time anyone has listened to Min with full attention – none of her husbands, her lovers, her 'madams' whose houses she cleaned, or even her doctors had ever really listened to her before. Helen Jaskoski claims that the Prophet David 'is the only adult in the novel capable of a truly disinterested and sympathetic response to another person. Min's encounter with him represents the only alternative the story even suggests to the failure of love, work, religion, family, and every other element of an exploitative society' (103). In the end, it is Min who decides to leave Jones: whether or not the conjure actually works, Min has become empowered through her encounter with the Prophet David, and although she will probably latch onto another man for financial support, she has at least found a way to avoid Lutie's fate.

Other models of working-class women who do not resort to running a brothel, as Mrs Hedges does, or to hoodoo, as Min does, are Lutie's Granny and Mrs Pizzini. Minor characters compared to Min and Mrs Hedges – to whose points of view the narrative occasionally shifts – Granny and Mrs Pizzini adhere to more orthodox conduct. Although nothing in the text suggests that the Pizzinis could have achieved as much had they been African American or that Granny had 'made it' in the Chandlers' sense of the phrase, these two women do suggest possible alternatives for Lutie. However, Lutie only sees their relative distance from print culture and thus overlooks the value of both women.

Explicitly rejecting the folk wisdom and oral culture that are a part of her heritage as an African American of her time and class, Lutie ignores Granny's wisdom – which at times could have helped her – because Granny is poor, black, and uneducated. Lutie also mocks the oral tradition, ridiculing Granny's '[t]ales that had been handed down and down and down until, if you tried to trace them back, you'd end up God knows where – probably Africa' (15–16). By apposing 'Africa' with 'God

knows where,' Lutie reveals her true feelings about her heritage; having learned well her lessons in white supremacy, she seems to regard Africa as an inscrutable heart of darkness. The product of a 'rational' education, Lutie also learns not to trust her instincts. When she first looks at the apartment, as noted above, she senses that the superintendent, Jones, is a threat yet dismisses the feeling, telling herself that she is 'as bad as Granny. Which just went on to prove you couldn't be brought up by someone like Granny without absorbing a lot of nonsense' (15). Lutie's instinct not to move into the apartment on 116th Street, however, is far from being 'nonsense,' and had she 'read' it properly, she might have averted the novel's subsequent tragedy. Lutie also ignores Mrs Pizzini's warning not to take the job in Connecticut: 'Not good for the woman to work when she's young. Not good for the man' (53). Mrs Pizzini's fears prove to be justified, as Jim, left with Bub for a month or two at a time over a period of two years, eventually finds another woman who will sleep with him and do his housework. The only white character in the novel who is kind to Lutie, Mrs Pizzini functions as a kind of proxy for Granny with her earthy wisdom and her 'dark, weather-beaten skin' (53). Suggesting that Mrs Pizzini has access to oral as well as written traditions, Petry makes clear that she both 'listen[s] to Lutie's story' and 'follow[s] the writing on Lutie's letter' (31). Since, until at least the 1920s, Italian Americans (as well as other southern and eastern European immigrants) were not considered 'white' by American culture, Mrs Pizzini's ethnicity suggests a kind of bridge between black and white, oral and literate. The text, then, links Mrs Pizzini, who admits that she herself can't 'write so good' (33), with Granny through their folk wisdom and distance from print culture. And in ignoring their advice, Lutie shows that her education has led her too far from the folk wisdom of an oral tradition that equips the others to survive on the street.

Lutie's singing is another example of how she privileges literacy over orality and the material over the spiritual. When, alone with Jones in a dark hallway, she senses his menace, she unconsciously begins to hum to herself an old song of Granny's, 'Ain't no restin' place for a sinner like me' (17). Perhaps this is another instinctive warning, which she dismisses, not to take the apartment. Later, when she starts to sing along with the jukebox record at Junto's Bar and Grill, her singing is so arresting that the crowd stops their drinking to listen to her. Lutie's 'voice had a thin thread of sadness running through it that made the song important, that made it tell a story that wasn't in the words – a story of despair, of loneliness, of frustration. It was a story all of them knew by heart'

(148). Boots, impressed by her voice, offers her a job singing with his orchestra. When Lutie appears at the casino to rehearse, the musicians, assuming she is another of Boots's 'girlfriends,' are skeptical. Yet when she finishes the first song, they stand up and bow to her, 'their way of telling her they were accepting her on merit as a singer, not because she was Boots's newest girl friend' (222). The text implies that, under more favourable circumstances, Lutie really could have succeeded as a singer. Yet Lutie, who wants the singing job because it would pay well, shows no regard for her voice as an outlet for self-expression or artistic creation, just as she ignores Granny's voice in her head.

Another consequence of Lutie's education is the isolation that results from her individualism. By no means a typical black woman for her time, Lutie is socially mobile, has lived in better neighbourhoods in Queens, and at one time she and her husband even had a small inheritance in the form of his mother's house. Even during the Second World War, when women had more access to jobs, it would have been unusual for a black woman to have an office job, as only about 1.3 per cent of African-American women were employed in clerical positions (Jones 200). Consequently, Lutie looks down on other working-class blacks in her community. Although she perceives that their poverty and what she would call their immorality are rooted in racism and an exploitive economic system, she declares that '[n]one of [this] would happen to her' (57). She judges other African Americans harshly, mentally jeering at Jones's difficulty with writing, thinking of Pop's roomers as 'riff-raff' and of her neighbours as 'dirty, slovenly women' (23, 56, 3).

Like Emerson and his transparent eyeball, self-reliant Lutie observes but remains detached: 'She reached the street at the very end of the crowd and stood watching them as they scattered in all directions, laughing and talking to each other' (58). Lutie's insistence that '[n]one of these things would happen to her' suggests that she feels superior to the other African Americans in her neighbourhood because she associates their poverty with personal failure. Lutie's detachment also prevents her from establishing bonds with other women. She demonstrates a remarkable grasp of women's commonalities as she projects her own experiences onto her speculations about the women who work in her office:

Remembering bits of conversation she had heard in the rest room, she knew they had husbands and children and sick mothers and unemployed fathers and young sisters and brothers, so that going to an occasional

movie was the only entertainment they could afford. They went home and listened to the radio and read part of a newspaper, mostly the funnies and the latest murders; and then they cleaned their apartments and washed clothes and cooked food, and then it was time to go to bed because they had to get up early the next morning. (395–6)

Yet Lutie feels no real kinship with these women: 'She didn't know any of them intimately. She didn't really have time to get to know them well, because she went right home after work and there was only a forty-five-minute lunch period,' during which Lutie usually eats alone (395). Her isolation is so complete that she cannot even comprehend an event as commonplace as a woman joking with the butcher. While the other women waiting in line laugh, Lutie gripes to herself, 'It's not even funny' (61). To return to Walter Ong, Lutie has estranged herself from the oral communication that spawns communal values, favouring instead the solitary activities of literate culture that 'throw the psyche back on itself' (69). From Benjamin Franklin to Horatio Alger to Andrew Carnegie, the American ideology of success has incorporated secularism, humanism, and, above all, individualism. Lutie's foibles as a reader of her own culture stem from the self-involvement characteristic of literate cultures.

Most women in Lutie's situation would regard a female community as a lifeline. In her history on black women and labour, Jacqueline Jones emphasizes the community's role as an important resource for women in Lutie's time (195, 198). Unlike her real contemporaries, Lutie is proud that 'she had been able to get this far without help from anyone' (63). Even Mrs Hedges and Min have a moment of communal bonding when Min approaches Mrs Hedges for help in finding a root doctor. Mrs Hedges, who knows everything about everyone on the street, tells Min that her 'girls' recommend the Prophet David. Min is so grateful for having found the Prophet David and so heartened by her visit with him that she buys Mrs Hedges a houseplant in thanks, having noted while in Mrs Hedges's kitchen that she is fond of houseplants. Lutie, it would seem, barely speaks with other women, among whom the narrative formalizes only her interactions with Mrs Hedges and Mrs Chandler. The only woman in the novel for whom Lutie seems to feel anything is her grandmother, but Lutie's reminiscences of her are always tinged with affectionate mockery of her folk wisdom. Clinging always to her 'phallocentric text,' Lutie can see no value in female affiliation. In her life and in her reading, there is no place for women, just as there is no place for

the influence of African-American oral culture: Lutie's choice of texts forestalls the realization of black, female subjectivity.

Although no one models herself on any one text, Lutie's wholesale acceptance of the American dream and the up-by-one's-bootstraps philosophy exemplified by Benjamin Franklin's text prove in the end to be her undoing. She is a naïve and accepting reader who fails to apply her usual cynicism to Franklin's text; at other times, she fails to 'read' events and people. Yet the assertion that Lutie wrongly chooses Franklin's autobiography as a model for her own success itself implies a choice. What texts, instead, might she have chosen? Would another classic American success story, the autobiography of Frederick Douglass, have been more appropriate as an example of a successful American who has overcome great odds, much greater than those faced by Benjamin Franklin? Jaskoski suggests possible answers to these questions when she notes the parallels between Min's visit to the root doctor in *The Street* and an incident from *Narrative of the Life of Frederick Douglass, an American Slave*, in which Douglass carries a root in his pocket as protection against the brutalities of a temporary master. Although Douglass is sceptical of the power of conjure to solve his problem, with the root in his pocket he resists the next beating, fights, and wins. Jaskoski concludes that conjure, in African-American writing, 'is the power and wisdom of those who are denied power and learning by an oppressive society' (107). While in *The Street*, conjure functions to empower Min in the same way, Lutie's Age-of-Reason scepticism prevents her from finding a similar solution.

More important, even if Lutie had been open to the possibilities of conjure, Douglass's text probably would not have been available to Lutie; it is unlikely that she would have encountered it in a public high school in the 1930s. For a woman reader, furthermore, even Douglass's autobiography would have its limitations. Books by female slaves, such as Harriet Wilson's *Our Nig* (1859) and Harriet Jacobs's *Incidents in the Life of a Slave Girl* (1861), might have offered better templates for realizing female subjectivity, had Lutie had access to them, but it was not until the 1980s that their authorship was verified and the books were reprinted.[3] Discounting works of fiction from Lutie's 'canon' – although Lutie does live in Harlem at about the time the Harlem Renaissance is winding down, it is inconceivable that she would encounter black writers among Mrs Chandler's cast-off books – there is no text comparable to Benjamin Franklin's autobiography. Lutie has no access to success stories written by poor African-American women. Rather than seeking alternative ways to survive, as Min and Mrs Hedges do, Lutie tries to do

it 'by the book.' Yet there is no book for her – no Horatio Alger stories written for black girls. Her own proximity to print culture is reduced, by the novel's end, to scrambling for a few pieces of paper as she steals paper money to buy a paper train ticket. Moreover, Lutie's proximity to print culture never progresses from the passive activity of reading to writing, and despite her struggles to author and authorize her own story, she is left, at the novel's end, drawing a series of circles – or zeroes – on the window of a train. Ultimately she is permitted to write nothing, literally. As the circles she does write remind Lutie of the handwriting exercises she practiced in grammar school, she recalls the teacher who told her, 'Really ... I don't know why they have us bother to teach your people to write' (435). Now, on the train, Lutie questions the deception inherent in a public school education that provides Franklinesque models for success to the Lutie Johnsons of the world. 'What possible good has it done,' asks Lutie, 'to teach people like me to write?' (436). 'Why teach people to write,' asks Barbara Christian, 'why give them the illusion that they are free when they are actually imprisoned? The street, Petry concludes, is no different from the plantation, except that many of the slaves do not understand that they are slaves' (67).

Frederick Douglass, in his *Narrative*, recalls an owner's reaction upon discovering that his wife has been teaching the alphabet to Douglass: '"Now," said he, "if you teach that nigger (speaking of myself) how to read, there would be no keeping him. It would forever unfit him to be a slave"' (36). As if tracing the effects of this legacy, in *The Street* Petry dramatizes the persisting importance of the link between the material circumstances of African Americans and their proximity to print culture in the twentieth century. Lutie's literacy 'unfits' her to be a slave, yet her race, gender, and class conspire, in the novel's overdetermined environment, to 'fit' her for nothing else. Thus, Lutie's reading results in limitation rather than liberation. Petry is not, of course, saying that African-American women cannot or should not have access to print culture; following the parameters of naturalism, her novel is descriptive rather than prescriptive. Instead, she implies that they must balance that culture with their own culture in order to be successful in a white-controlled world. Lutie can be said to lack what Du Bois called a double consciousness common among early-twentieth-century blacks. A product of two distinct cultures, African-American and American, Lutie turns her back on her black roots. Additionally, she is a product of both male and female culture who turns her back on female affiliation. *The Street* posits that identifying exclusively with 'white' and 'male' texts is a calamitous mis-reading for this reading woman.

NOTES

I am grateful to Barbara Foley and Elizabeth Fox-Genovese for generously sharing their time and insights throughout the development of this essay.

1 For discussions of the Benjamin Franklin theme in *The Street,* see Clark, McKay, and Yarborough.
2 Perhaps Petry had this in mind when choosing Boots's name: Boots has done nothing to pull himself up by his bootstraps, yet he lives very well on his salary from Junto. A bitter and cynical man who previously worked as a Pullman porter, Boots owes his material success to a combination of luck and a willingness to do anything it takes, including pimping Lutie for Junto, to maintain his lifestyle. Boots takes the American ideal of individualism to an extreme, despite his apparent distance from print culture. He succeeds, however, because he avoids print culture and exploits what is available to his race and class (as do Min, the woman who lives with Jones, and Mrs Hedges), whereas Lutie's downfall is that she tries to imagine herself outside of those confines. It is important to note that, as one of Lutie's sexual assailants, Boots also represents male power, which he is able to exploit to his own advantage.
3 The authorship of both books was questioned for nearly a century. Henry Louis Gates, Jr, is credited with rescuing *Our Nig* from obscurity after he discovered it in an antiquarian bookstore in 1981. He authenticated the authorship and published a new edition in 1983. The authorship of *Incidents in the Life of a Slave Girl* was likewise questioned, but a new edition published in 1987 by Harvard University Press named Harriet Ann Jacobs as the true author. See Gates, Jr, introduction to *Our Nig,* by Harriet Wilson (xi–lv), and Yellin (xiii–xxxiiii).

WORKS CITED

Angelou, Maya. *I Know Why the Caged Bird Sings.* New York: Bantam, 1973.
Christian, Barbara. *Black Women Novelists: The Development of a Tradition, 1892–1976.* Westport, CT: Greenwood P, 1980.
Clark, Keith. 'A Distaff Dream Deferred? Ann Petry and the Art of Subversion.' *African American Review* 26:3 (Fall 1992): 495–505.
Douglass, Frederick. *Narrative of the Life of Frederick Douglass, an American Slave.* 1845. New York: Dover, 1995.
Du Bois, W.E.B. *The Souls of Black Folk.* 1903. New York: Dover, 1994.
Franklin, Benjamin. *The Autobiography.* 1868. In *The Norton Anthology of American*

Literature, ed. Nina Baym et al., 3rd ed., vol. 1, 408–523. New York: Norton, 1989.

Gates, Henry Louis, Jr. 'Writing "Race"—and the Difference it Makes.' In *'Race,' Writing, and Difference*, ed. Henry Louis Gates, Jr, 1–20. Chicago: U of Chicago P, 1986.

Hurston, Zora Neale. *Mules and Men*. 1935. New York: QPB, 1990.

Jaskoski, Helen. 'Power Unequal to Man: The Significance of Conjure in Works by Five Afro-American Authors.' *Southern Folklore Quarterly* 38 (June 1974): 91–108.

Jones, Jacqueline. *Labor of Love, Labor of Sorrow: Black Women, Work, and the Family from Slavery to the Present*. New York: Vintage, 1986.

McKay, Nellie Y. 'Ann Petry's *The Street* and *The Narrows*: A Study of the Influence of Class, Race, and Gender on Afro-American Women's Lives.' In *Women and War: The Changing Status of American Women from the 1930s to the 1950s*, ed. Maria Diedrich and Dorothea Fischer-Hornung, 127–40. New York: Berg, 1990.

Ong, Walter J. *Orality and Literacy: The Technologizing of the Word*. New York: Routledge, 1988.

Petry, Ann. *The Street*. 1946. Boston: Houghton, 1991.

Wright, Esmond. Introduction to *Benjamin Franklin: His Life as He Wrote It*. Cambridge: Harvard UP, 1990.

Wright, Richard. *Black Boy, A Record of Childhood and Youth*. New York: Harper, 1945.

– *Native Son*. 1940. New York: Perennial, 1966.

Wilson, Harriet. *Our Nig; or, Sketches from the Life of a Free Black*. 1859. New York: Vintage, 1983.

Yarborough, Richard. 'The Quest for the American Dream in Three Afro-American Novels: *If He Hollers Let Him Go, The Street*, and *Invisible Man*.' *MELUS* 8:4 (Winter 1981): 33–59.

Yellin, Jean Fagan. Introduction to *Incidents in the Life of a Slave Girl, Written by Herself*. Cambridge: Harvard UP, 1987.

10 'One of Those People Like Anne Sexton or Sylvia Plath': The Pathologized Woman Reader in Literary and Popular Culture

JANET BADIA

Loosely based on Shakespeare's *The Taming of the Shrew*, the film *10 Things I Hate About You* (1999) tells the story of Kat Stratford, a darkly cynical and socially outcast teenager who has renounced dating after losing her virginity to the untrustworthy boy now pursuing her younger sister Bianca. Having completely and contemptuously rejected the conventional high school scene, Kat is despised by her peers at Padua High and frequently referred to as that 'heinous bitch.' While it is certainly true that Kat occasionally behaves badly – on one occasion she purposely smashes her own car into her former boyfriend's new convertible – she is hardly the Midol-deprived, 'muling, rampallian wretch' her peers and teachers make her out to be. Quite to the contrary, Kat sees herself more as a nonconformist who simply locates her self-worth in her rejection of both conventional high school life and the patriarchal order that surrounds her. Emphasizing this aspect of Kat's character, the film portrays Padua High's student body as a collection of absurd cliques (the 'cowboys,' 'future MBAs,' and 'coffee kids' are a few) and the patriarchal order as an oppressive apparatus effectively symbolized by both Kat's father, whose initial 'house rule' forbids the two sisters to date, and Mr Morgan, the English teacher who routinely sends Kat to the principal's office for 'terrorizing' his class, including once after she challenges the omission of important women writers in his lectures.[1] But even as Kat regards herself as a nonconformist above the rigid boundaries that shape her peers and her family, the film typecasts her in another way: seething with sarcasm, grungily dressed, and a fan of riot-grrl music, she is a millennial version of the angry feminist intellectual, or at least one in the making.

The reason for my portrait of Kat Stratford at the opening of this essay

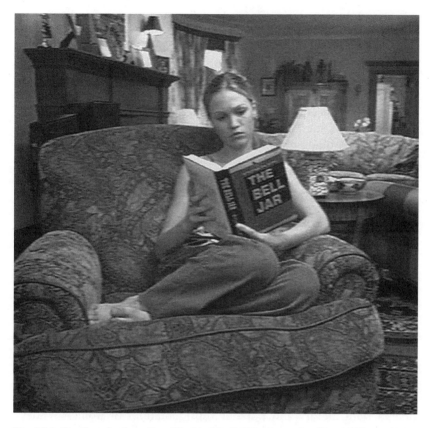

Fig. 10.1. Kat Stratford reading Plath's *The Bell Jar*, from the film *10 Things I Hate About You* (1999). ©Touchstone Pictures. All rights reserved.

is clear if one also considers another important fact about Kat: she is a Plath reader. Indeed, it is Sylvia Plath, among other feminist writers, whom Kat wishes to see added to Mr Morgan's syllabus. Underscoring this initial allusion to the poet, the film also offers a revealing look at Kat as she sits in a family-room chair reading Plath's best-selling novel *The Bell Jar*. To insure viewers do not overlook the importance of the scene of Kat reading, the camera carefully pans through the front window of the Stratford home, resting directly on Kat and centring deliberately in its frame the open cover of *The Bell Jar* (fig. 10.1). To those viewers who recognize the novel Kat holds in her hands, the implication of the scene is unmis-

takable: all that we need to know about Kat to prepare us for her current behaviour in school and at home can be encapsulated by a single scene that, in Hollywood shorthand, figures her as the quintessential Plath reader. By referring to Kat as a Plath reader, then, I hope to point to the image *underlying* the reality of her reading material, rather than simply the fact that she is portrayed as someone who reads Sylvia Plath's writings. That is to say, Kat is a Plath reader not simply because she reads *The Bell Jar* but because she embodies an image that in many ways reflects the stereotype of women readers of Plath's writing.

As a scholar who once devoured Plath's writings in daily doses, I am intrigued by this figure of the Plath reader. How did she come about? How exactly did a young woman reading one of the most important bestsellers of the second half of the twentieth century come to signify so much in a Hollywood movie? Even more important to my purposes in this essay, what does her presence express about women readers, their reading practices, and society's perceptions and valuation of both? Underlying all of these questions, of course, is the assumption that Kat's existence as a reader can and does tell us something important about cultural attitudes, not only towards Plath and her readers, but towards women readers more generally. In fact, the principal aims of my examination of Kat Stratford are to call attention to the cultural attitudes that give her image its resonance and power and to trace the origins of such attitudes within literary history itself. Specifically, I want to argue that Kat Stratford – especially insofar as she and her reading are pathologized in the film – reveals the nexus of anxieties that are often embedded in both literary and popular representations of women readers, anxieties about what women read, how women read, and the effects both are perceived to have on the well-being of the reader herself and society more generally.

Of course, this figure of the young Plath reader is hardly new, even in Hollywood. In many ways, Kat Stratford is merely an updated version of the image Woody Allen evokes in his 1977 film *Annie Hall* when Allen's character, *Ariel* in hand, describes Plath as an 'interesting poetess whose tragic suicide was misinterpreted as romantic by the college-girl mentality.' Expanding Allen's image to include Anne Sexton's readers as well, Meg Wolitzer's 1982 novel *Sleepwalking* concretizes this college-girl mentality by chronicling the interactions of three Plath- and Sexton-obsessed Swarthmore students who, the narrator explains, 'had banded together, apparently drawn to each other by the lure of some secret signal as unintelligible to everyone else as the pitch of a dog whistle is to human

beings,' a lure that earns them a reputation on campus as 'the death girls' (3). As the narrator's analogy suggests, the image of a band of death girls who read Plath's and Sexton's poetry (while sitting around candles in the dark, one imagines) is meant not simply to draw laughs but also to elicit a particular response from viewers and readers, a nod of recognition, a 'Yes, I know the type.' In other words, if the image is funny, it gathers its humour from the cultural iconicity of the particular woman reader evoked, for just as 'the death girls' are instantly recognizable to the students on the Swarthmore campus, the Plath-Sexton reader, as I would like to call this expanded figure of the Plath reader, is instantly recognizable to us today, even without props like *The Bell Jar*.

And if she is recognizable, it is not entirely because of her cinematic or fictional legend. Indeed, the Plath-Sexton reader owes her existence at least partially to those notorious 'real' readers who have become virtually synonymous with both poets' names, including the fans who have persistently chiselled off the name 'Hughes' from Plath's gravestone in England; the young women who have written editorials to the London *Guardian* protesting Ted Hughes's alleged abuses as executor of Plath's literary estate, as well as his neglect of her grave; the poet Robin Morgan, who has written about Plath's 'murder' at the hands of Hughes; and the hundreds of women who wrote fan letters to Sexton over the course of her career.[2] All of which is to say, the Plath-Sexton reader's presence is palpable and historical, even as she is circumscribed by stereotype and cliché. Whatever the nature of her existence, two points about her are clear: first, she is nearly as big a cultural icon as Plath and Sexton themselves; and second, like both poets, she has been defined by her own apparent depression and obsession with death.

While hardly identifiable as one of Meg Wolitzer's 'death girls,' even the rather sanitized Kat Stratford bears the trace of depression that signals she is more than simply a girl reading a book. When we see her curled up in a chair holding her anniversary edition of *The Bell Jar*, it is difficult not to impose an aura of depression and darkness around her, especially since she is so effectively foiled by a sister appropriately named Bianca. Often dressed in white, Bianca is, at bottom, everything Kat is not: she is perky, popular, and for the most part superficial. Contrasted so sharply against Kat, Bianca foregrounds the darkness, one might say melancholy, that lingers over Kat from the film's opening scene when the blare of her Joan Jett music drowns out the pop song coming from the car of a group of popular, Bianca-like girls. The importance of scenes like this one lies not only in how they prepare us for the

moment of Kat reading, but also in how they prepare us *to respond* to her as a woman reader by inviting us to see her as dark and depressed. The film, in fact, counts on us to impose this aura of darkness and depression upon her. It hopes we do, I would argue, because only then can we accept the transformation of Kat from boy-hater to love-driven teen that is central to the film's closure as a romantic comedy. To insure this response, then, the film constructs Kat as a young woman who not only reads Plath's work but actually mirrors the much-accepted public image of the poet herself: the abandoned daughter, the woman scorned by male betrayal, and the intellectual who haughtily desires to be above it all. As significant as these similarities are, the most revealing image of Kat as a reflection of Plath comes towards the film's end when, in a gesture towards the film's title, Kat recites a poem she has written for her literature class. The poem, written for her new boyfriend Patrick after she discovers he has been paid to date her, catalogues all the things she hates about him, reveals the betrayal she feels, and all the while discloses her desire to still be with him. It is a confessional poem modelled as much after Plath's poetry as it is the Shakespearean sonnet Kat was assigned to imitate, and importantly, it appears to owe its existence not to Kat's innate creativity but to a boy who inspires the very emotions the poem catalogues. In other words, it would seem that Patrick plays Ted Hughes to Kat's Sylvia Plath.

As I hope this portrait of the Plath reader shows, Kat Stratford serves as a particularly revealing example of a pathologized woman reader: a woman whose reading practices are defined symptomatically, which is to say, either as a sign of her illness or as a potential cause of it. Her construction, then, grows out of cultural anxieties concerning what she reads, how she reads, and what effects her reading might produce. Throughout literary history, as I think many of the essays in this collection show, such anxieties have often rendered women 'bad readers' in dire need of protection from the corrupting influence of certain kinds of literature.

For the most part, Kat is no exception to this image. Towards the climax of the film, for example, Kat is asked to the prom by Patrick and is thus placed in a situation in which she must 'read' his motives for dating her. The moment is especially important because it marks, for the first time, Kat's doubts about Patrick's motives: oblivious to the fact that Patrick is being paid to date her by the two boys scheming for Bianca's attention, Kat simply cannot understand why he wants to go to the prom, a symbol for her of the very high-school scene she and Patrick

have rejected.[3] But she does decide finally to accompany him to the dance, and when his financial motives are exposed at the prom, Kat leaves in tears, a victim not only of the plot hatched by the young men but of her own 'mis-reading' of Patrick. Reinforcing this image of Kat as a 'bad reader,' her misjudgment of Patrick echoes a series of previous misjudgments on her part, including her peer-pressured decision to lose her virginity to the arrogant, self-absorbed Joey Donner. The film suggests, in other words, that Kat not only misreads situations but that her misreading has left her in an unhappy, if not altogether depressed, state.

Importantly, the film alone conveys only a small part of the larger portrait of Kat I have been trying to reconstruct. As I think my own reading of the film suggests, what makes Kat such a compelling example of the Plath reader is the way our understanding of her depends on – and even calls for us to apply to it – a pre-existing discourse about women readers in general and the Plath-Sexton reader in particular. While it pervades popular culture today, this discourse originates, I would argue, with the reception of Plath's and Sexton's work within the literary establishment. Indeed, I propose that what makes Kat so interesting and germane to the questions raised in this collection of essays is the way her popular image reflects literary constructions of the Plath-Sexton reader that were first posited in the reception of both poets' work. To demonstrate this relationship, I would like to turn first to a general discussion of Plath's and Sexton's reception histories and then to a more focused examination of those key moments that have given shape to the image of the pathologized woman reader Kat so strikingly embodies.

As a close examination of the reception of Plath's and Sexton's work reveals, critics have continually placed women readers at the forefront of debate over the value of each writer's work, often regarding them as either an obstacle to a serious consideration of Plath's and Sexton's poetry or as evidence of its inferiority. In either case, a clear portrait of the poets' readership had emerged by the 1970s, if not earlier: Plath's and Sexton's readers were perceived to be young (implicitly white) women who – in overprivileging the disturbed pathologies that ostensibly fed the poetry – had 'misinterpreted' not only the tragedy of the situation but the work itself. Put more simply, the early reception of both poets' work genders the Plath-Sexton reader female, diagnoses her as depressed and sick, and assesses her as an uncritical consumer of bad literature.

As I discuss in the larger study of Plath and Sexton from which this

essay comes, the reception and critical histories of both poets' works involve anxieties about genre, subject matter, and audience that are often masked behind what appear to be purely aesthetic concerns. Of particular interest to me in this essay is how these anxieties emerge specifically at the location of the reader. In fact, what emerges from a close examination of reviews from the 1960s, 1970s, and 1980s is a clear preoccupation with readers, who – even above the poet and the poetry – turn out to be the principal object of concern for critics. Among those critics who shared, if not engendered, this preoccupation within Plath and Sexton criticism were Irving Howe and James Dickey, respectively. Deeply troubled by the popularity Plath and Sexton had achieved, as well as by the direction in which their brand of confessional poetry had taken literature, Howe and Dickey set out to debunk what they saw as the Plath-Sexton mythology pervading literary and popular culture in the late 1960s and 1970s by dismissing both writers as mere cult-poets whose work appeals only to the most narrow quarter of readers. However transparent their efforts may seem to us now, Howe and Dickey nonetheless succeeded in establishing a powerful and pervasive discourse about Plath-Sexton readers that continues to inform and shape our perceptions of them today. A close examination of their criticism reveals, moreover, that in many ways Kat Stratford is merely symptomatic of the negative construction of Plath's and Sexton's women readers that begins as early as the 1960s with Dickey.

Dickey's strong dislike of Sexton's poetry is almost legendary in some literary circles.[4] As probably most writers would, Sexton took his dislike of her work very personally, often writing about it in letters to friends and colleagues. In one such letter, written to her literary agent Cindy Degener in 1974, Sexton refers to a group of poems she had hoped to see published in a popular magazine only to advise Degener not to send them to *Esquire* because, as she puts it, her 'arch enemy James Dickey would vomit on the manuscript if he were in any way forced to publish it' (416). Without knowing the history between Sexton and Dickey, one might be tempted to dismiss Sexton's characterization of their relationship as overly dramatic or, to borrow Charles Gullans's words, as another instance of 'hysterical melodrama,' when in fact Sexton had good reason to expect such a response from Dickey (497). Indeed, on at least two occasions Dickey had responded to Sexton's work as if he were utterly unable to contain his dismay as a reader. In his 1963 review of *All My Pretty Ones* for the *New York Times*, for example, he delivered the following pronouncement about the poet: 'It would be hard to find a writer

who dwells more insistently on the pathetic and disgusting aspects of bodily experience, as though this made the writing more real, and it would also be difficult to find a more helplessly mechanical approach to reporting these matters than the one she employs' (50).[5]

In this statement, Dickey seems to suggest that Sexton's shortcomings as a poet are the result of a lack of poetic skill; she simply does not possess formal mastery over her material. In this way, Dickey's assessment of *All My Pretty Ones* echoes his earlier assessment of Sexton's first book, *To Bedlam and Part Way Back*, which he describes as a collection that 'lack[s] concentration, and above all the profound, individual linguistic suggestibility and accuracy that poems must have to be good' (*Babel* 134). His concern with Sexton's poor poetic skill is further evident in his review of *All My Pretty Ones* when, later in the review, he complains that Sexton's poetry is 'as contrived and mannered as any romantic poet's harking after galleons and sunsets and forbidden pleasures.' Clearly Dickey has a very specific complaint about the aesthetic quality of Sexton's poetry, perhaps even a legitimate one. The complaint becomes suspicious, however, at the point at which Dickey identifies just what it is about Sexton's poetry that seems 'contrived and mannered': its 'habitual gravitation to the domestic and the "anti-poetic."'

As his irritation with Sexton might suggest, Dickey was one among a host of critics who looked unfavourably on the direction of post–Second World War poetry. While his general dissatisfaction is implied throughout the *New York Times* review of *All My Pretty Ones*, it is reflected most clearly in his opening statement, in which he complains, 'What poetry needs nowadays is a new sense of consequence, a feeling that what is said in poetry matters.' That he later points to what he calls Sexton's gravitation towards the 'domestic' and '"anti-poetic"' certainly sheds light on Dickey's idea of what matters. This idea is further illuminated by his final assessment of Sexton's poetry: 'Miss Sexton's work,' he writes, 'seems to me very little more than a kind of terribly serious and determinedly outspoken soap-opera, and as such will undoubtedly have an appeal in some quarters.'

Taken together, Dickey's characterization of Sexton's poetry as 'domestic,' '"anti-poetic,"' and 'outspoken soap-opera' certainly brings his perception of Sexton's readership, as well as his sexist biases, into focus. While Dickey never explicitly defines Sexton's readership, he does identify it implicitly as a readership of women – women who apparently consume Sexton's words along with their daily doses of soap opera. The possibility that Sexton's poetry might appeal to this quarter of read-

ers – indeed, might 'matter' to women – is not enough, apparently, to warrant a serious consideration of how or why it might be appealing to them not as 'outspoken soap-opera' but as poetry. With the thinly veiled bias of Dickey's review exposed, it would perhaps be appropriate to offer a critique of Dickey's shortcomings as a critic, to refute his reading with a counter-reading that redeems the domestic of Sexton's poetry as poetic; such refutations have in fact been the foundation of feminist critics' efforts to recover Sexton's reputation and work. But for my purposes here I wish instead to continue to focus on the construction of readership that emerges out of Dickey's assessment of *All My Pretty Ones* and, I would argue, gives shape to, even preoccupies, the larger critical conversation about Sexton's work.

The influence of this construction begins to emerge in Charles Gullans's 1970 review of Sexton's *Live or Die*. Like Dickey, Gullans is concerned as much with the quality of Sexton's readers as he is with the poetry itself, albeit in a much more explicit manner. Whereas Dickey's negative characterization of Sexton's readers is only implied, Gullans's negative characterization is explicit, serving in fact as the foundation for his critique. Describing the feelings of pity the poems ostensibly provoke in the reader, he implies that readers have allowed this feeling to stand in for critical reading practice, and further argues that 'to mistake such feeling for literary response implies a confusion among readers and critics of cause and effect' (497). Sexton's poems, he further concludes, 'are not poems, they are documents of modern psychiatry and their publication is a result of the confusion of critical standards in the general mind' (498). For Gullans, then, Sexton's readers are confused readers who mistake 'suffering and sensitivity' as prerequisites for poetry. However, even as he locates the confusion at the point of the reader, he also suggests that the problem has been compounded by a lack of readerly agency. That is, for Gullans Sexton's poetry is imposed on readers in a way that appears to deny the reader her rights. In fact, one of Gullans's major complaints is that he has been made 'third party' to the poet's conversation with her psychiatrist 'without right.' Unlike the general reader, one presumes, Gullans is able to escape Sexton's subversion of his readerly agency through his own critical agency, through his capacity for resisting the 'confusion' that Sexton's poetry tends to produce in its readers. In this way, Gullans's concern with readerly agency seems to be an extension of some of the more innocuous comments that have been made about literary judgment throughout the reception of Sexton's work, comments like the one made by Hayden

Carruth in his rather reserved review of *Live or Die* in which he claims that the literary quality of the poems is finally 'impossible to judge' (698). In any case, I would argue that Carruth, in explaining the question of the value of Sexton's work in this way, encapsulates the dilemma posed by the poetry: how does one respond to a body of work that so clearly resists conventional paradigms of reading, that exceeds available discourse, and that seems to subvert any kind of judgment? For Dickey and Carruth, the answer to the dilemma lies in a critique of readership, whereby subject matter and audience are entangled in such a way that to discount one is to discount the other. The fact that their approaches to the critique differ – whereas Dickey's critique focuses on gendering the reader, Gullans's focuses on assessing her as uncritical – matters little since each serves to reinforce the singularity of the image of the uncritical woman reader and thus her marginalization within literary culture, a marginalization that gains significant momentum from the critical conversations surrounding Plath's work around this same time.

In his seminal 1972 essay 'Sylvia Plath: A Partial Disagreement,' Irving Howe echoes James Dickey's rhetoric of uncritical consumption, if not also his sexist tone, and reveals his own harsh biases against Plath's readers. Unlike with Dickey, however, Howe's biases are more subtle and emerge out of a far less explicit link between the poetry's aesthetic value and its readers.

Regarding the aesthetics of Plath's work, Howe is unquestionably clear, describing *Ariel*'s aesthetic shortcomings as 'a kind of badness that seems a constant temptation in confessional poetry, the temptation to reveal all while one eye measures the effect of the revelation.' Contributing to the 'badness,' Howe explains, is what he sees in a poem like 'Lady Lazarus' as 'a willed hysteric tone, the forcing of language to make up for an inability to develop the matter' (90). For Howe, then, Plath is simply guilty of cutting literary corners. This suggestion is further evident in his discussion of 'Cut,' a poem in which Plath seems to mistake rhetorical posturing for poetic achievement, demonstrating in the process her 'inability to do more with her theme than thrust it against our eyes, displaying her wound in all its red plushy woundedness' (90). As his comments about 'Cut' and 'Lady Lazarus' demonstrate, Howe would have us think that the fault he finds with Plath results from the recurring problem she has with developing theme and subject matter. Yet his reading of another poem, 'Daddy,' suggests that there is in fact little Plath could have done poetically to redeem the poems. Describing 'Daddy,' Howe writes:

What we have here is a revenge fantasy feeding upon filial love-hatred, and thereby mostly of clinical interest. But seemingly aware that the merely clinical can't provide the materials for a satisfying poem, Sylvia Plath tries to enlarge upon the personal plight and give meaning to the personal outcry by fancying the girl as victim of a Nazi father. (90)

As those familiar with Howe's discussion of 'Daddy' might guess, Howe's complaint here serves as preface to one of his larger concerns: Plath's adoption – some have argued co-optation – of the Jewish-Holocaust experience. More important to the purposes of this discussion are his characterization of the poem as being 'mostly of clinical interest' and the concomitant tension that pervades Howe's reading of the larger corpus of Plath's poetry. When looked at as a piece, Howe's readings of individual poems become hard to reconcile with each other: he faults Plath for not developing the theme and subject matter of the poems even as he suggests that the subject matter, insofar as it is 'merely clinical,' cannot be the basis of a 'satisfying poem' (90). Such tensions lead one to question the nature of Howe's complaints. Indeed, one cannot help but ask, what is it about Plath that really bothers Howe?

For starters, Howe is troubled by what he describes, in a (mis)appropriation of Elizabeth Hardwick's words, as the '"deeply rooted"' and '"little resisted"' '"elements of pathology"' central to her work (90).[6] As my quotation of Howe ventriloquizing Hardwick makes clear, Howe simply cannot stomach what he identifies as Plath's vision for her poetry. This vision, to summarize Howe, is predicated on 'the personal-confessional element' that seemingly dooms the poetry to being no more than 'local act' (89). His choice of the phrase 'local act' is critically important to the question I have been exploring here. For Howe, good confessional writing by nature begins as 'local act' but arrives at larger meaning through 'sustained moral complication' and 'the full design of social and historical setting' (89). Insofar as the lyric form does not allow for either, the confessional poem, it follows, can only fail to transform confession from local act to larger meaning. Certainly for a social-minded critic like Howe, this relegation of poetry to the status of mere 'local act' undermines the *raison d'être* of the literary project. By his or her very nature, the confessional poet from Howe's perspective cannot but fail to reflect society sufficiently and thereby transform it through his or her writing.

But to understand Howe's relegation of Plath to 'local act' as a mere reflection of his preoccupations as a social critic would be to overlook a

second tension that pervades the review: Howe's own discussion of Plath makes clear that she is unquestionably more than a local act, if I may play with his use of the term. Howe's own words – including his description of 'the noise' that surrounds this 'darling of our culture' – suggest that Plath has reached more readers than Howe would care to admit (88). His discussion of these readers and his correlative casting of Plath as a cultural 'darling' reveals, moreover, that Howe, while bothered by Plath's confessional tendencies, is equally troubled by her ability to attract a large reading public. To be sure, the very project of Howe's essay – 'A Partial Disagreement,' he calls it – is to take issue not only with Plath but with those readers who have elevated her above the status she truly deserves as 'an interesting minor poet.' The question then becomes, who are these readers?

Howe himself suggests an answer to this question in the opening paragraph of the essay when he explains: 'A glamour of fatality hangs over the name of Sylvia Plath ... It is a legend that solicits our desires for a heroism of sickness that can serve as emblem of the age, and many young readers take in Sylvia Plath's vibrations of despair as if they were the soul's own oxygen' (88). The issues that emerge out of Howe's rhetoric here are myriad. Most interesting perhaps is the rhetoric of consumption so central to his characterization of Plath's readers, for just as Howe transforms Plath from serious poet into glamour girl and 'priestess' (88), he also transforms her young readers from serious readers into cult followers: Plath, no longer perceived as a poet, puts out life-sustaining 'vibrations' that are taken in, not read, by those who admire her. In other words, for Howe, the very act of reading and the critical faculty it involves have been supplanted by a mystical process of consumption that leaves the young intellectually and emotionally crippled, one presumes, by the lack of real oxygen.

It is with this suggestion of mystical consumption that we begin to see the two parallel concerns that run throughout Howe's essay: his concern with Plath's exaggerated status as a poet and his concern with the corruption of legitimate reading practices responsible for the exaggeration. This link between his two concerns is crystallized when, later in the essay, he dismisses Plath's admirers altogether, arguing vis-à-vis the poem 'Daddy' that 'one must be infatuated with the Plath legend to ignore the poet's need for enlarging the magnitude of her act through illegitimate comparisons with the Jewish-Nazi holocaust' (90). Issues of Plath's Holocaust imagery aside, Howe's characterization of the reader here reveals, I would argue, a kind of rhetorical desperation on his part.

Aware that his position as a dissenter leaves him vulnerable – indeed, in his own words, at the risk of 'plunging into a harsh *kulturkampf*' – Howe establishes a defensive stance from the essay's outset (88). His weapon, as his description of the Plath reader makes clear, is circular logic disguised in simple aesthetic concerns: those who find 'Daddy' an aesthetically worthy poem, one not rendered undeserving of the merit bestowed upon it because of its imagery, must be too preoccupied with the glamour of Plath as icon to be good readers of her poetry.

Given the importance Howe places on the poet's 'need for enlarging the magnitude of her act' (remember, it is in this respect that Plath's poetry fails), the implications of Howe's statement about the reader are in no way small. On close examination, in fact, what emerges from Howe's essay is the sense that he might be inclined to agree with a positive assessment of Plath's work if it were not for the way she has been celebrated as an 'authentic priestess' and thus transformed into an icon by her readers. At the very least, it is clear that Howe, despite his own admission at the essay's opening that to do so would be unjust, allows his own 'irritation with her devotees to spill over into [his] response to her work' (88).

I think, then, that we have gotten to the bottom of what bothers Howe about Plath. In tracing it as I have here, I have tried to show the intricacies of an argument about Plath that is driven first by deep anxieties about who reads Plath and how and why they read her, and second by a desire to contain Plath as poet – to put her back in her place as a 'minor' woman poet. The possibility that Plath could be both icon and serious poet never appears to enter Howe's mind, or if it does, it is not a possibility he wishes to entertain. His understanding of confessional poetry, in fact, precludes the possibility insofar as he sees the confessional poem as an unfortunate emblem of a culture preoccupied with 'self-exposure, self-assault, self-revelation,' the very qualities a good poem shuns (89). For Howe, moreover, these are the same qualities that in readers' minds lend Plath her authenticity as priestess and icon. In this way, Howe's argument reflects the common assumption that pervades Plath criticism, and this includes criticism written both in her favour and against it: Sylvia Plath, the poet, has to be extricated from the romanticized, one might say Hollywoodized, icon she has been transformed into by an adoring readership, for only then can the actual merit of her poetry be determined. The most common strategy for debunking the myth is one Howe himself employs in his own critique: expose the typical Plath reader as an uncritical consumer who is as sick as the poet herself.

As my concluding point about Howe's and Dickey's concern with the corruption of legitimate reading practices, I want to emphasize just how far their rhetoric went towards establishing a discourse about the Plath-Sexton reader by turning, though only briefly, to Susan Wood's review of *Words for Dr. Y.*, a volume of Sexton's uncollected poems published in 1978. Demonstrating the force of Howe's and Dickey's formulation of the Plath-Sexton reader and further eliding the woman reader in her own way, Wood writes:

> Who will buy this book? I think, from hearing them speak at poetry read-ings and in poetry workshops, it is primarily young girls and women who admire Sexton for all the wrong reasons, making her a martyr to art and feminism; who seem, out of their own needs, to identify with her patholog-ical self-loathing and to romanticize it into heroism. It has very little to do with poetry and it does neither poetry nor Anne Sexton a service. (3)

If my review of the criticism thus far left any doubt about the construction of Sexton's and Plath's readership as a body of uncritical, misguided, and pathological women, Wood's review must certainly answer it. What her review does in fact is bring together and make explicit the connections among the many anxieties that were often only implicit in the critical history up to this time, including a worrying over the public's book-buying habits and, more importantly, a concern for the young women readers who presumably read, if not incorrectly, then certainly for the 'wrong reasons.' That these anxieties are present in a review that seeks to recuperate or at least preserve Sexton's reputation, rather than dismantle it, shows perhaps just how ingrained the very terms of the debate, especially concerning women readers, had become.

That these anxieties are also present, if only residually, in the film character Kat Stratford shows the full force of the terms as well. As I tried to suggest earlier, Kat, in all of her evolutions, brings to the fore-front a culture's anxieties about women readers. Because she is so thoroughly grounded in these anxieties, it is not at all surprising to find that by the film's end Kat, an avid reader of women's writing, appears to have relinquished her books for a prom gown. I say appears, because I think the film leaves the slightest room for a second, albeit perhaps counterintuitive, reading. Most notably, while Kat dons the normalizing garb of the prom gown for a night, she eventually abandons it too and returns by the film's end to her dark but artistically and intellectually expressive self (one who plays guitar, draws, and plans to attend Sarah Lawrence

College in the fall), a return that is easily overshadowed by the final coupling of her and her paid date by the end of the film. Perhaps, then, the character of Kat Stratford opens the door, if only slightly, for a recuperation of the figure of the woman reader I have been discussing here. I like to think so, and I think other recent constructions of the Plath-Sexton reader work towards a similar recuperation.

Take, for example, the recent works by cultural critic Elizabeth Wurtzel. Apparently intent on casting herself as the consummate autopathographer, Wurtzel constructs herself as the quintessential Plath-Sexton reader in her 1994 memoir *Prozac Nation* and again in 1998's *Bitch*. In the prologue to the first of the two, the then twenty-something-year-old Wurtzel previews her struggles with depression and her ambivalent attitude towards the drugs that keep her from 'constant-level hysteria': 'I've been off lithium less than a month and I'm already perfectly batty. And I'm starting to wonder if I might not be one of those people like Anne Sexton or Sylvia Plath who are just better off dead, who may live in that bare, minimal sort of way for a certain number of years, may even marry, have kids, create an artistic legacy of sorts, may even be beautiful and enchanting at moments, as both of them supposedly were' (8). That Wurtzel should compare herself to Plath and Sexton – and in the process implicitly construct herself as someone who has read their work – is perhaps not all that surprising. Evoking the poster-women of what Wurtzel herself calls 'aching, enduring suicidal pain' underscores the extent of Wurtzel's illness and drives home the point of the prologue, which is after all entitled 'I Hate Myself and I Want to Die.' At the same time, the comparison allows Wurtzel to accomplish a less obvious goal, one interwoven with her own identity as a writer. Indeed, if Wurtzel is like Plath and Sexton because she, too, may be better off dead, she is also like them because she shares their desire to 'create an artistic legacy of sorts.' As her qualification of the legacy indicates, Wurtzel is well aware of the constructedness of Plath's and Sexton's authorial identities, of the way they 'supposedly were.' Such hedging on her part also suggests she is just as aware of the constructedness of the Plath-Sexton reader, especially of the way she, too, can construct herself as one and thus capitalize on the image of the poets themselves. Her evocation of Plath and Sexton, therefore, serves as a kind of masterful incantation that establishes her authority not only as a reader but as a writer with an astute awareness of her subject matter. In this way, the image of the Plath-Sexton reader for Wurtzel is an image of empowerment, one that helps to explain her narrative, certainly, but also one that authorizes her identity as a reading and writing woman.

Kat Stratford, I would argue in closing, resembles Wurtzel in more ways than one. Most obviously, she shows signs of Wurtzel's depression. At the same time, she displays a similar empowerment that comes in part at least from her reading of women's writing, most notably Plath's. Kat, in fact, could well serve as another example of the difficult and unruly women Wurtzel celebrates in *Bitch*. Even in the presence of such promise, however, one cannot overlook the fact that Kat is based on the figure of the shrew in Shakespeare's play and, like her Shakespearian namesake, is destined to be tamed by a boy precisely because she is unruly and empowered. Casting her as a Plath reader, then, appears to be simply another way for the film's writers to put her and her reading back in their place. Still, while her empowerment is undoubtedly constrained first by the film's own limitations as a Hollywood romantic comedy based on a Shakespearian play and second by previous constructions of women readers, the tension she embodies suggests an evolution in the image of the Plath-Sexton reader, one that commandeers the very discourse critics once used to dismiss this reader and, in the process, begins to challenge deeply embedded cultural expectations about women readers and their reading practices.

NOTES

1 Kat's contempt for and rejection of patriarchal society is brilliantly displayed in one of the first scenes of the film, which, in addition to containing Kat's critique of Mr Morgan's syllabus, depicts an in-class confrontation between Kat, Mr Morgan, and other students from the class. The exchange begins when one of Kat's classmates responds to the teacher's invitation for discussion about *The Sun Also Rises* by calling Hemingway a 'romantic.' Dripping contempt, Kat responds to the comment by calling Hemingway 'an abusive, alcoholic, misogynist.' When a late-arriving student interrupts the discussion to ask what he missed, Kat quickly inserts, 'the oppressive, patriarchal values that dictate our education.' Pointing to the irony of Kat's own position as a privileged white woman – and, one wonders, her protests that (privileged white) women writers have been ignored in favour of writers like Hemingway – Mr Morgan, an African-American man, sarcastically thanks Kat for her point of view, especially, he notes, in light of 'how difficult it must be for [her] to overcome years of upper-middle class, suburban oppression.' Of course, Mr Morgan's own position as a black man complicates any straightforward reading of his

character as a symbol of patriarchy: on the one hand, it is clear that his primary role in the film is that of the male authority figure who keeps Kat in line. On the other hand, the fact of his race suggests that his character is also meant to underscore Kat's privileged position and thus undercut her claims to oppression.

2 One might say that the figure of the Plath-Sexton reader is a kind of fictional composite of the 'historical' readers who have made headlines over the years through their actions. Further explanation of the readers I discuss here follows: Plath's gravestone has been vandalized four times; each time the vandal(s), who are presumed to be Plath 'fans,' have chiselled off the name 'Hughes' from the stone so that it reads simply 'Sylvia Plath.' After each instance, Ted Hughes had the stone removed for repair, often leaving Plath's grave site unmarked for a period of time. College students Julia Parnaby and Rachel Wingfield wrote to the editor of the *Guardian* describing their experiences as they tried to find Plath's unmarked grave and excoriating Hughes for 'failing to replace the headstone and thereby leaving Plath's grave unidentifiable,' thus denying and devaluing 'her place in the tradition of women's literature.' The letter appeared in the 7 April 1989 issue of the paper and was followed by a flurry of responses, many in support of the young women's letter, as well as one from Hughes entitled 'The place where Sylvia Plath should rest in peace' (*Guardian*, 20 April 1989). In his letter Hughes explains the delay in replacing the stone and accuses Parnaby and Wingfield of 'living in some kind of Fantasia.' Robin Morgan is author of the now notorious poem 'Arraignment,' which accuses Hughes of, among other things, Plath's murder. The poem appears in *Monster: Poems* (1972). Finally, during the fifteen-year period between her emergence as a poet and her death, Sexton received close to a thousand letters that for all intents and purposes are best described as 'fan letters,' the majority of which were written by women. The letters are housed with other archival material from Sexton's career at the Harry Ransom Humanities Research Center at the University of Texas, Austin. I discuss the letters in more depth in my dissertation.

3 Because the girls' father has forbidden Bianca to date until Kat does (a new house rule he imposes because he thinks it will prevent both girls from dating since Kat had previously renounced boys altogether), one of Bianca's devotees, Cameron James, develops a scheme to get Kat to date so he can then take out Bianca. As part of the scheme, he offers to broker a date between Bianca and Joey Donner, another boy who is also interested in Bianca, though for less innocent reasons, and who has loads of money to offer Patrick in exchange for taking out Kat. Once Kat begins dating Patrick, Cameron is able to ask Bianca to the prom.

4 In fact, Dickey's dislike of Sexton has been the subject of an essay by Carrie
 Martin recently published by *The James Dickey Newsletter.* Entitled '"There are
 more important things than judgment involved": James Dickey's Criticism of
 Anne Sexton and the Search for Self,' the essay essentially sets out to 'justify
 [Dickey's] damnation of Sexton's poetry' by explaining it as the natural result
 of his basic 'tenets' for good poetry, thereby denying any possible gender
 biases that, I argue, clearly inform his criticism (17).
5 All subsequent quotations from Dickey's review of *All My Pretty Ones* are from
 p. 50, unless otherwise noted.
6 The uncontextualized quotation of Hardwick in Howe's essay is rather dis-
 turbing when Hardwick's words are placed back in their original context. In
 her work on Plath, she writes, 'In Sylvia Plath's work and in her life the ele-
 ments of pathology are deeply rooted and so little resisted that one is disin-
 clined to hope for general principles, sure origins, applications, or lessons'
 (100). Howe's quotation of only those words I have requoted in my discussion
 leads the reader to think Hardwick would agree with Howe's reading, when in
 fact her reading of Plath's poetry is much more positive than Howe's own.

WORKS CITED

Annie Hall. Dir. Woody Allen. MGM Pictures, 1977.

Badia, Janet. Private Details, Public Spectacles: Sylvia Plath's and Anne Sexton's
 Confessional Poetics and the Politics of Reception. PhD diss., Ohio State
 University, 2000.

Carruth, Hayden. 'In Spite of Artifice.' Review of *Live or Die*, by Anne Sexton.
 The Hudson Review 19 (Winter 1966–7): 689–98.

Dickey, James. *Babel to Byzantium: Poets and Poetry Now.* New York: Farrar, Straus
 and Giroux, 1968.

– 'Dialogues with Themselves.' Review of *All My Pretty Ones,* by Anne Sexton.
 New York Times, 28 April 1963: 50.

Gullans, Charles. 'Poetry and Subject Matter: From Hart Crane to Turner
 Cassity.' Review of *Live or Die,* by Anne Sexton. *Southern Review* 6 (Spring
 1970): 497–8.

Hardwick, Elizabeth. 'On Sylvia Plath.' In *Ariel Ascending: Writings About Sylvia
 Plath,* ed. Paul Alexander, 100–115. New York: Harper & Row, 1985.

Howe, Irving. 'Sylvia Plath: A Partial Disagreement.' *Harper's,* January 1972:
 88–91.

Hughes, Ted. Letter. 'The place where Sylvia Plath should rest in peace.'
 (London) *Guardian,* 20 April 1989: n.p.

Martin, Carrie. '"There are more important things than judgment involved":
 James Dickey's Criticism of Anne Sexton and the Search for Self.' *The James
 Dickey Newsletter* 13:2 (Spring 1997): 17–24.

Morgan, Robin. *Monster: Poems.* New York: Random House, 1972.

Parnaby, Julia, and Rachel Wingfield. Letter. (London) *Guardian* 7 April 1989:
 n.p.

Sexton, Anne. *Anne Sexton: A Self-Portrait in Letters.* Ed. Linda Gray Sexton and
 Lois Ames. Boston: Houghton Mifflin, 1977.

10 Things I Hate About You. Dir. Gil Junger. Touchstone Pictures, 1999.

Wolitzer, Meg. *Sleepwalking.* New York: Random House, 1982.

Wood, Susan. 'Words for Dr. Y.: Uncollected Poems by Anne Sexton.' Review of
 Words for Dr. Y., by Anne Sexton. *Washington Post Book World,* 15 October 1978:
 E3.

Wurtzel, Elizabeth. *Bitch: In Praise of Difficult Women.* New York: Doubleday, 1998.

– *Prozac Nation: Young and Depressed in America.* New York: Riverhead Books,
 1994.

11 The 'Talking Life' of Books: Women Readers in Oprah's Book Club

MARY R. LAMB

> Reading is solitary, but that's not its only life. It should have a talking life as well.
>
> – Toni Morrison

Feminist scholars from a range of fields have written about *The Oprah Winfrey Show* to determine its feminist significance. Some argue for the talk show's feminist work, some for the limits of this feminist work.[1] In September 1996, Winfrey launched Oprah's Book Club, her first televised book club, which featured approximately one book a month until April 2002, when the original club ended. She initiated a new 'classics' version of the club in February 2003 and soon after announced John Steinbeck's *East of Eden* as the first work of the revived club. While both book clubs complicate the task of assessing the potential feminist work of her show, in this essay I will focus specifically on the cultural work of the original club, examining Winfrey's performance as the book club's host and the construction of women readers that emerges from the discussions she moderated.[2]

Although the original book club has received enormous popular attention, it is only beginning to be studied by academic scholars. R. Mark Hall, for example, observes the importance of 'individual and cultural advancement' in Winfrey's literacy practices (646). While Hall notes that Winfrey succeeds as a 'literacy sponsor' for her promise of uplift, he also argues that she overlooks the complex aspects of literacy, namely, the relationship between literacy, race, and power in America (662). Missing from Hall's account are the gendered implications of Winfrey's popular version of literacy, implications that John Young

begins to examine. He argues that 'we should consider Toni Morrison's appearances on "Oprah's Book Club" as a register for the new cultural avenues Winfrey has created for Morrison and other women writers of color' (4). In other words, Oprah's club deserves attention because through it, she created a popular cultural space for celebrating women writers, including women writers of colour. It also deserves attention for its performance and celebration of reading practices aimed at an audience constituted primarily of women. Indeed, Winfrey blended rhetorical strands from primarily white American women's oral consciousness-raising as well as African-American women's rhetorical oral tradition to celebrate the importance of reading. While she popularized and advocated literacy as empowering and transformative, her performance of reading limited women's reading practices in troubling ways. Specifically, her show advocated for women readers a reading practice consonant with a mediated, apolitical version of consciousness-raising that emphasizes individual adjustment to social ills rather than critical imagining of social alternatives.

For each televised meeting of the original book club, Winfrey selected a few readers from viewers who wrote in about their experiences reading the novel. Those selected attended a dinner party with the author where they also discussed the novel. Segments of the dinner party were then aired on the show. In addition to discussion of the novels themselves, the book club episodes devoted considerable airtime to reading practices in general. For example, on 18 October 1996, Winfrey describes Toni Morrison's response to her query about whether it is customary for readers to have so much difficulty with texts that they have to go over and over the words: 'That, my dear, is called reading' ('Newborn' 24). Discussing *Paradise*, the second Morrison novel chosen for the club, Morrison responds to Winfrey's insecurity about the necessity of a study group to understand the novel: 'Novels are for talking about and quarreling about and engaging in some powerful way ... Reading is solitary, but that's not its only life. It should have a talking life, a discourse that follows' ('Book Club' 9). Winfrey's venue, then, emphasized the 'discourse that follows' rather than the texts themselves, primarily because her televised venue could highlight and promote only certain aspects of reading even as it celebrated reading in general. Thus, Winfrey demonstrates that rather than thwart print literacy, electronic media might simply shape what properties of reading are emphasized, in this case the social, rhetorical aspects of reading and its role in women's self-improvement.

Rhetorical Reading

Winfrey's literary interpretation engages in what Kenneth Burke calls the rhetorical parlour of ideas, in this case, pertinent cultural conversations on feminism typifying our era (110–11). Steven Mailloux persuasively expands Burke's premise in his rhetorical history of texts, defining rhetoric as the 'political effect of trope and argument' (59), a definition I use here to illustrate the cultural context and political implications of the gendered claims in Winfrey's interpretation. Rhetoric, then, is a framework for describing the political effect of Winfrey's 'trope and argument' in her book club, an effect that popularizes a version of the woman reader and her literacy practices. In this way, I move beyond the common reader response topos of examining how texts produce readers to how Winfrey's interpretive rhetoric produces women readers. Since, as Janice Peck notes, 76 per cent of Winfrey's audience are eighteen years of age and older (134), it is clear that her rhetoric is primarily aimed at women. In addition, she develops her rhetorical ethos as a woman speaking to other women about similar problems. One premise for this study, then, is that Winfrey's literary interpretation both reflects and shapes ideas about gender. Indeed, Patrocinio P. Schweickart argues for such rhetorical properties of interpretation when she urges us to recognize 'validity not as a property inherent in an interpretation [but] rather as a *claim* implicit in the *act* of propounding an interpretation' (56). Schweickart's rhetorical view argues that 'validity is contingent on the agreement of others' and frames the problem for feminism in general and feminist literary criticism in particular as one of persuasion and assent (56). According to this view, since Winfrey acts as a populist critic who interprets books in hopes of garnering a large audience of women, her popular success indicates not necessarily audience agreement with all her claims, but rather audience interest in the cultural values and issues discussed.[3] In this scheme, Winfrey's rhetoric both reflects social attitudes and constructs her ideal woman reader as emotional, relational, and inexperienced with complex literature, reading primarily for the improvement of self and family.

Winfrey's program raises generic expectations about the book club and, subsequently, shapes the rhetorical possibilities of Winfrey's ideal woman reader. As Lynn Spigel explains, daytime television programming facilitates 'women's work,' the cultural work traditionally associated with women, which includes their constant self-improvement for the betterment of family, self, and society and the increasing profession-

alization of their roles as wife, mother and, often today, career woman. The economic drive of television replicates Betty Friedan's claims that the media of the 1950s capitalized on (white, middle-class) housewives' 'guilt over the hidden dirt' (217) in order to secure an audience who needs the advertisers' 'solutions' (products) to their 'problems.' While today television producers recognize roles for women other than that of homemaker, they nevertheless aim advertising and programming towards women who try simultaneously to be professional mothers, wives, and paid workers. Indeed, Elayne Rapping explains that 'advice makes up most of the daytime programming between 10 a.m. and 5 p.m. – after the men and kids leave ... To view these shows is to be astonished at what women are expected to integrate and absorb. While men are to be informed and children handled, women must do, do, do' (134). Because the book club operated within this televisual genre traditionally reserved for people doing women's work, it is not surprising to find that Winfrey's rhetoric advocates literacy as a means for improving women's lives.

In addition to its televisual constraints, Winfrey's potential cultural work is limited by social expectations about book clubs and public speaking about literature. Crucial here is that Winfrey calls her project a 'book club,' evoking all the cultural connotations of such a reading experience. In many ways, because of her media-created membership and wide, geographically dispersed audience, the club functions like the Book of the Month Club or a book list, such as those created by the *New York Times Book Review* or *Women's Review of Books*. While analysis of how the club functions in this regard is warranted, in this essay I analyse the rhetorical performance of Winfrey's book discussions during her televised dinner party and with her studio audience to illuminate the literacy she advocates. This performance is similar to the face-to-face clubs Elizabeth Long notes have been in America since 1813, when women in Charlestown, Massachusetts, met to discuss literature ('Women' 591). At the turn of the century, book clubs grew out of the women's club movement and perpetuated the cultural work of the clubs (Long, 'Women,' 591). Today, although more men are joining book clubs to offset limiting, specialized jobs, club members are still predominantly made up of women, who focus primarily on the personal growth and social interaction literature brings (Long, 'Textual,' 498). Familiar with this pragmatic use of literature for personal and social interaction, Winfrey grew up speaking in her church and reciting poetry, which continues a tradition Shirley Wilson Logan has

traced in her work on nineteenth-century African-American women who spoke out against social subordination.

While Winfrey's discussion draws on these cultural precedents, it is also shaped by televisual characteristics. In fact, Dixon argues 'this combining and blurring of genres is Oprah's highest achievement' (173). In Winfrey's mediated club, readers become 'members' by watching the program after reading the book; they may even join virtual conversations on her web site. Thus, Winfrey simulates the experience of a face-to-face book club, drawing on what Janice Peck calls television's 'mediated intimacy,' its ability to create a sense of 'intimacy and immediacy' that produces a sense of participation rather than passive viewing in the audience ('Mediated' 137). In fact, drawing on historical book club practices and television's intimacy, Winfrey encouraged readers in the club to recognize the social, intimate aspects of reading rather than the solitary ones usually associated with reading. Her emphasis on sharing books over food further reinforces social interaction, conjuring images of the African griot sharing oral stories replete with communal knowledge and women talking around kitchen tables rather than individuals reading silently in isolated study carrels in the library. Her discussion focused on recipes, historical information, and readers' responses rather than on the actual text primarily because of historical precedent and because she recognized this social aspect of reading was more easily televised than textual exegesis and private reading. Nevertheless, Winfrey's televised reading clearly seeks to offset the isolation of print literacy with the simulated intimacy of television. Underscoring this quality of her book club, Winfrey said that 'books connect us and bring us all closer' ('Oprah's,' 25 September 1998, 3), an interpersonal quality of book clubs that Peck argues media simulate. Similarly, in defending her treatment of literature against critics – including David Streitfeld at *The Washington Post* who accused her of including too much about food and not enough about books – Winfrey retorted, 'Just like books, food is a shared experience' ('Oprah's,' 22 September 1997, 12). Following Winfrey's lead, women readers approach the books with a sense of immediacy and emotional involvement and anticipate discussion with others, either on the show itself, virtually on web message boards and discussion groups, or vicariously by watching the show. Thus, Winfrey's club posits women as social and relational rather than solitary readers. In constructing women readers in this way, Winfrey's rhetoric further suggests that novels can actually draw families together since reading can be a shared, social activity – a suggestion that not only mitigates any guilt

women might feel because they are spending time away from their family but also reinforces social norms that women are first and foremost relational beings obligated to various familial demands. In line with women's 'work,' then, Winfrey invites women readers not to read as an escape from their problems, as Janice Radway argues women romance readers do, but as a way to adjust to their problems and to improve self and family.

American Feminist Consciousness-Raising

This cultural work of sustaining community and familial connections evokes for readers the feminist historical precedent of women meeting together to share personal stories and experiences – feminist consciousness-raising. Consciousness-raising, a practice prevalent in the late 1960s and 1970s, grew out of the idea that social change would happen if women could merely recognize that their personal frustrations and problems result from systemic sexism rather than their personal weakness or misfortune.[4] The practice is also associated with religious testifying and the African-American civil rights movement, both of which assume the primacy of sharing personal experience. In fact, in her study of African-American women's literacy practices, Jacqueline Jones Royster notes, 'bearing witness functions vibrantly in the creation of a "true" and honorable self. A valuing of "truth," "authenticity," and the "genuine" creates a pathway that is knowable, and it makes transformative power available for the writer and for her audiences' (67). Sharing personal experience was central to the form of consciousness-raising developed by the New York Radical Women that achieved greatest popular praxis for the women's movement. The Redstockings split from the New York Radical Women and further codified consciousness-raising practices. 'The Redstockings Manifesto' proposed developing a 'female class consciousness through sharing experience and publicly exposing the sexist foundations of all our institutions,' but the practice was troubled from the beginning both by its own tendency to universalize its shared experiences to all women, thus eliding differences among women, and by critics who called it apolitical and ineffectual (535). Nevertheless, consciousness-raising helped spread feminist ideas and enlarged the women's movement. The belief in the importance of sharing individual experience, the awareness of women as a class of people, and the concurrent recognition of the limited political efficacy of these ideas achieved vast cultural currency.

Salient here for assessing Winfrey's interpretive claims are conscious-ness-raising's rhetorical properties – discursive practices aimed at attitudinal persuasion through the sharing of personal experience. Consciousness-raising seeks first to persuade to a state of mind or attitude rather than to a certain political position or course of action. In her essay delineating a rhetorical genre of women's liberation, Karlyn Kohrs Campbell argues that '"consciousness raising" is a rhetorical mode of interaction or a type of rhetorical transaction uniquely adapted to the rhetorical problem of feminist advocacy' (78). According to Campbell, the rhetorical features that achieve consciousness-raising include use of 'affective proofs and personal testimony,' 'participation and dialogue,' 'self-revelation and self-criticism,' the shared goal of 'autonomous decision making through self-persuasion,' and techniques for 'violating the reality structure' (82). The personal stories of particular oppression central to consciousness-raising function rhetorically to 'translate public demands into personal experience and to treat threats and fears in concrete, affective terms' (83). These strategies are similar to Winfrey's reading strategies, which advocate reading as a form of consciousness-raising.

In fact, many consciousness-raising goals and strategies – especially those focused solely on personal improvement – permeate mainstream fiction, film, and popular media. Television mediates much of our experience with public and political life, including feminism, with its predominant argumentative narrative mode.[5] In particular, Lisa Maria Hogeland, in her analysis of the consciousness-raising novel's role in the women's movement, locates talk shows as 'one of the primary arenas in United States culture for the self-help versions of "soft" CR' (163). According to Hogeland, 'soft' consciousness-raising validates personal experience without theorizing it, while 'hard' consciousness-raising theorizes women's oppression in order to promote political action (27). Although Winfrey's book discussion often simulates some consciousness-raising moves, her rhetoric repeatedly advocates reading as soft consciousness-raising. To illustrate the feminist implications of how these strategies operate in Winfrey's venue and how they construct women readers, I will analyse a variety of transcripts from the book club episodes. However, I will focus mostly on the club's discussion of *The Reader*, written by German author Bernhard Schlink. The novel traces the sexual romantic relationship between a fifteen-year-old boy, Michael, and his middle-aged lover, Hannah, an ex-Nazi concentration camp guard. The novel's themes are Michael's coming of age and his experience learning of Hannah's past during her trial for war crimes. Although the novel is not

explicitly feminist in content or theme, Winfrey's discussion calls forth a community of women readers and encourages reading strategies consonant with an apolitical form of consciousness-raising.

Reading Women in Winfrey's Book Club

Winfrey's interpretive claims draw on affective proofs and personal testimony, important rhetorical moves in consciousness-raising designed to validate individual experience. Performing this testimonial element of consciousness-raising, Winfrey often features authors on her show and treats novels as evidence of their lives shared for the benefit of readers. One example of this is the 18 November 1996 episode featuring Toni Morrison. Winfrey, delightfully nervous about Toni Morrison's visit to the book club dinner at her house, rhetorically enlists the audience in viewing Morrison as a celebrity. Despite the fact that they are good friends, Winfrey gazes into the camera, paces across the stage, and says, 'She's here! Agh! She's here. I don't know, shall we salute? What should we do?' ('How'd They Do That?' 12). Later, Winfrey shifts from treating Morrison as a celebrity to treating her as an average person sharing her personal experience with the audience. For example, Winfrey explains that Morrison's house burned on Christmas morning just weeks after the author won the Nobel Prize. Emphasizing the author's connection to her audience, Winfrey explains that '[t]he original MS of *Song* was gone. But like Milkman [Dead], it, too, has learned to fly. From the burned ashes of Toni's home to a place where it always belonged, the best-seller list' (13). Winfrey follows through on the notion of the novel as shared experience with readers, noting, 'To give it a new life that is larger than its original life is a revolution' (13). While Winfrey emphasizes an author's ideas being shared with others, her rhetorical strategy of celebrating readers' participation advocates a personal relationship between readers and authors. Morrison creates, but the audience's reading brings the novel to full fruition – it becomes 'more' than original. Further remarking on this co-creation, Morrison muses: 'Oh, I love to hear it when they say this remarkable thing: "I had to read every word." And I always wanted to say, "Yeah – and I had to write every word"' (13). Winfrey gently chides, 'that, my dear, is called writing' (16). As this one episode illustrates, readers are encouraged to view novels as 'personal testimony' from authors, with whom they are in conversation. Consequently, Winfrey emphasizes women's affective relationship with texts as extensions of authors' lives, an important consciousness-raising use of

fiction. The positive result is that Winfrey fosters women readers who view books as gifts from the author to be experienced in dialogue rather than as self-contained objects for consumption.

Unfortunately, Winfrey denies the complexity of readers' responses by staging simplistic interpretive questions that not only retain an audience eager to hear the next response, but also limit the consciousness-raising potential that occurs during the discussion or in readers' minds later. In 'hard' consciousness-raising, the tension between conflicting interpretations might provoke theorizing or testing out claims based on individual experience against larger social institutions and experiences. Here, however, television's qualities thwart this type of theorizing and instead provide the requisite solvable dilemma that retains viewers interrupted by childcare and housework. In addition, in order to produce viewable action and conflict, Winfrey stages hermeneutic questions that the author can answer, such as when she queries author Alice Hoffman about whether the latter intentionally 'writes about women getting lost and finding their way back' ('Oprah's,' 9 April 1998, 12). Hoffman, however, resists using authorial intention as a standard for interpretive claims, explaining, 'I didn't kind of plan for things to happen. These characters just took over and things happened' (12). Hoffman continues to posit the romantic version of authorship: 'my intentions for this book was [sic] completely different than where it wound up' (20). Winfrey, in turn, is duly impressed with this version of writing. Her reading paradigm plays out like this: authors are real people who write books to share with others, but the texts take on social connotations beyond the control of the author; readers bring to texts their own experiences and concerns, which further shape the meaning of the text. Since Winfrey accepts authors' personal experience to support interpretive claims about books, she must subsequently accept their word when they insist textual meaning is beyond their control. Thus, Winfrey encourages women to draw their own conclusions about textual meaning even as the interpretive dramas she stages to engage audience interest ultimately constrain interpretive possibilities. At the same time, her rhetoric construes an uncritical, beginning woman reader who does not examine the suppositions of the fiction beyond her own personal reaction to the fiction. While this response is a valuable part of our experience with literature, Winfrey encourages few variations in emotive responses. Furthermore, she limits responses to individual feelings and adjustment to problems rather than critical, imaginative readings that might lead women to transform their worlds.

Similarly, Winfrey's emphasis on novels as authors' testimony advo-

cates the consciousness-raising goal of violating the reality structure by providing positive examples of women's achievements despite social restrictions, but the move falls short of achieving its full potential. According to Campbell, women's liberation rhetoric uses 'confrontative, non-adjustive strategies designed to "violate the reality structure"' (81). These strategies 'violate the norms of decorum, morality, and "femininity"' (81). In Winfrey's version, although she venerates authors' craft and the labour of their accomplishments, she tends to praise traditional notions of feminine attributes rather than challenge our thinking about these qualities. For example, her hyperbolic celebration of authors' writing as personal accomplishment casts in sharp relief the material conditions of women writers, who often face duties as primary caregivers of children, and reiterates the importance of women's voices in our literary and cultural conversations.[6] This hyperbole is evident in Winfrey's decision to host Jacqueline Mitchard, who wrote *Deep End of the Ocean* as a widow with five children to support, as well as in her conversation with Morrison when she emphasizes that Morrison wrote while raising her two sons. Morrison herself shares that her son spit up orange juice on the manuscript: 'and I distinctly remember writing around it because I thought I had this really perfect sentence that might not come back if I stopped and wiped up his puke' ('How'd They Do That?' 13). Reiterating feminist work that describes the particular working conditions of women, Winfrey downplays inspiration and talent and instead praises Morrison's 'resolve' for receiving the Nobel Prize in literature in 1993. Morrison agrees: 'It's remarkable. A young black girl growing up in a steel town in the Depression goes on to win the Nobel Prize. That is a story' (13). Here, Winfrey encourages women to 'violate the reality structure' by lauding oppositional examples of women's success despite a racist, sexist society.[7] However, her valorization of women who manage to do more than full-time childcare may merely reinforce stereotypes that women – and only women – are responsible for childcare, a cultural belief still evident in child-rearing practice despite the women's movement and slowly shifting attitudes about men's roles in child rearing. Even when she praises Wally Lamb, one of the few male writers in the club, for writing between folding laundry and picking up children from school, she does so as a laudable exception to social practices, which, in turn, reinforces the stereotype that women are 'naturally' more nurturing. Although her emphasis on women's accomplishments may indeed inspire some viewers to reconsider entrenched stereotypical attitudes, the strategy most likely simply reinforces gendered thinking patterns

that women are responsible for childcare. While Winfrey's essentializing move might have been laudable and progressive two or more decades ago, today, given the current cultural climate, her strategy resounds with the post-feminist premise identified by Bonnie J. Dow that 'patriarchy is gone and has been replaced by choice' (95). In such a scenario, feminism's systemic analysis is unnecessary since problems women face can be overcome by personal choices alone.

Another way Winfrey advocates but fails to deliver on violating the reality structure is through her creation of female class consciousness that homogenizes rather than complicates our notions of gender and gendered literacy practices. Indeed, as Hogeland argues, consciousness-raising's goal to create class consciousness as women has been achieved and permeates all of culture; but this consciousness is often used to create marketing niches rather than to propel creative alternatives to restrictive social institutions. For example, Winfrey celebrates the 'validity of personal experience,' but features only mass-produced and thus limited variations of this experience. She does this in part by excluding from the discussion responses that indicate cognitive difficulty in decoding the text, and instead privileges difficulty brought about by the intensity of emotional investment the novel is likely to arouse in readers. For instance, she announces Mitchard's novel with a caveat: 'It's really intense. It's not like beach reading. Mother's worst nightmare' ('Pregnant' 23). However, for many readers, the novel is perfect beach reading not because of content but because of its straightforward narrative and adherence to the tenets of realism. Here, she denies the possibility that readers might actually have cognitive difficulty reading the text and circumscribes her audience by assuming shared values of emotional investment with the narrative. When one reader does not find the novel as intense as she did annoying because of the main character's self-absorbed, egocentric mourning at the expense of her other children, Winfrey fails to address this complication of stereotypical feminine caring. Rather, she maintains the novel's 'difficulty' based on the emotional work of empathizing with Beth's predicament. Even as she foregrounds empathy and introspection, she limits possible responses to stereotypically feminine emotions, excluding others such as anger, frustration, and indignation. Furthermore, she elides other types of literacy practices, like intellectual challenge or critique of America's ideology of motherhood. By limiting these responses, Winfrey assumes the role of women in society is unchangeable though individual women can alter their emotional responses to this role.

Although *Deep End of the Ocean* lends itself to addressing an audience of women who share experiences similar to those of its female protagonist, Winfrey also elicits gendered responses to novels with male protagonists, such as Bernhard Schlink's *The Reader*. While the novel focuses on a male protagonist 'reading' the life of his female lover, in the show featuring *The Reader* Winfrey rhetorically creates an audience of women who experience social problems similar to those in the novel. First, she frames the novel in terms of a gendered moral dilemma: 'He was 15, she was 36, a forbidden affair, one heated book discussion' ('Oprah's,' 31 March 1999, 1). Next, she dissolves geographic and temporal barriers by airing clips from readers (mostly women) over the past three years from all over the world, including Australia, the Caribbean, Canada, South Africa, and Zambia (1–2). In addition to assuming common concerns across geographic and political boundaries, she creates an audience based on gendered emotional responses by highlighting points from the previous month's discussion of *Jewel*, a novel about a mother's relationship with a daughter inflicted with Down's syndrome. These clips air responses from parents – all women – who gave up a child with Down's syndrome for adoption. Reinforcing the gendered rhetorical community who share maternal feelings, Winfrey brings the discussion back to *The Reader*, stating: 'Nobody ever says this – they never say this – and I think I've heard just about everything – and [Schlink is] probably going to get a lot of letters, I'm sure' and 'From – a lot of women who feel – feel like [the characters] do' (3). Here, Winfrey frames the theme of the current novel, *The Reader*, by reminding the audience of the previous selection, *Jewel*, an uncommon tactic on the show that works to focus the cultural work of *The Reader* in gendered terms – judging the morality of the relationship from a woman's point of view. Thus, Winfrey posits her women readers as capable of only certain responses and interested in only 'women's issues' related to mothers raising sons.

Again, this 'class consciousness' as women is precisely what feminist consciousness-raising hopes to instil. Winfrey's rhetoric proffering books for an audience of women who are suffering, lonely, and in need of the companionship of books seems to lead to the first goal of consciousness-raising: the recognition that patriarchal practices hurt women. However, if Winfrey's discussion evokes a community of women readers who share similar anxieties and problems, it does not analyse the problems in terms of either biological imperative or patriarchal or misogynist social practices. Rather, her discussion assumes women's suf-

fering as inevitable and proffers the solution of reading for personal growth as a means of individual emotional adjustment to social problems. Furthermore, because Winfrey performs a form of mediated consciousness-raising typical of talk shows, which, Hogeland argues, retain 'tight control' over performances that air only 'analyses of individual pathology' (164), any systemic analysis that may result from individual's sharing stories is glossed over in favour of individual emotional responses to novels. In other words, even when Winfrey does suggest a social 'cause' of women's suffering in the form of the episode's theme, she does not suggest a cure beyond individual adjustment, achieved in this case through reading, nor does she provide a social or aesthetic framework for arriving at interpretations of the reading. This lack of analytical framework for assessing the narratives in the novels as well as those of the guests and audience may perpetuate what Donald Lazere calls 'a mood of at least passive assent' to the current oppressions facing Americans (292). As a reading strategy, this means that Winfrey posits the importance of individual interpretation while her mediated version fails to give full play to these interpretations.

In the case of *The Reader*, this tactic of both praising individual readings while simultaneously limiting the possibilities of such readings is evident as Winfrey models using books for deepening self-knowledge but then fails to fully debate the moral, social, or political implications of such an interpretive premise. For instance, after reading from a letter by two schoolteachers who call her choice of *The Reader* 'reckless' because the novel is about a fifteen-year-old boy who has an affair with a thirty-six-year-old woman ('Oprah's,' 31 March 1999, 5), she simply states her personal belief rather than argue her case:

> I – I – you know, I expected all of this, but you know, I've been around – I have been a reader for a long time. This is all I have to say about it. And there are lots of things that I have read about – racism, devastation, horrible things happen to people in many books that I read that I consider to be part of the literature landscape. But I don't, you know, disown them or not embrace them because they are stories that are not comfortable for me to hear. That's all I have to say about that. (6)

Here, her rebuttal admirably denies the 'censorship' approach to literature and posits the reader's role in constructing and resisting 'lessons' and meanings, but she also refuses debate about social or political frameworks for interpreting novels. Instead, she assumes an extreme

individualism that posits readers as active participants rather than help-
less imitators of books who read stories that 'are not comfortable for us.'
However, Winfrey does not encourage the expanded discussion that
such active participation elicits. For example, to illustrate her version of
active reading during the discussion of *The Reader*, Winfrey features a
comment from a reader who was 'bothered' by the relationship but who
'had a better appreciation of it after our book club discussed it' (6).
Rather than use the cognitive and emotional dissonance novels produce
to critique social practices or imagine social alternatives, however, Win-
frey's rhetoric merely suggests readers adjust emotionally, using books as
one means of personal change. In this way, she locates the interpretive
work with the readers – determination of textual lessons and their
morality – but also disallows debating a social or moral context that
might help readers make sense of the fictional claims.

In addition to curbing discussion about the complexity of moral,
political, or social issues, Winfrey limits consciousness-raising's theoriz-
ing potential by discouraging debates about the exact tenor and artistic
casing of meaning. Her performance determines both the issues in the
book open for discussion and the type of acceptable responses to these
issues, even as she ostensibly praises individual reactions. After two read-
ers criticize *The Reader*'s choppy style and lack of imagery, Winfrey
returns to the moral dilemma, noting, 'You can love the book without
loving the relationship' (6), and features a woman who articulates Win-
frey's reading theory:

> Because I'm German ... And that was the first time something really, really
> made me think about what my family did, what my relatives did, what my
> grandparents did ... I didn't read books about it. And now I'm very,
> very interested and I've started asking my father questions. I've asked him
> about – my grandfather who served in the war with – with – with the army
> and I – I – for that reason, I thought it was a wonderful book. (7)

Winfrey reinforces this affective reading response, saying 'well, if
[Schlink] just did that, that is – well, then it doesn't matter if she didn't
like it ... or thought it was choppy or what – after that' (7). Here, the
interpersonal use takes precedence over stylistic and formal consider-
ations of the book. Notice also that because Winfrey's normative state-
ment dismisses a reader's response to the novel's formal qualities,
Winfrey assumes 'meaning' is a stable quality of the novel. Winfrey
elides readers' responses that indicate any reading other than 'realistic'

ones, thus advocating this strategy for women readers. Further, Winfrey's interpretation delineates the tenor of the 'realistic' knowledge that readers should apply to personal problems. In fact, it is not uncommon for Winfrey to stop encouraging open-ended responses when she has an approach she would like to reinforce. During the discussion of *The Reader*, for example, she asks four open-ended questions to the audience, four to Schlink. Of the four posed to the audience, about half ask for general reactions; the others pose a specific issue. Twice she asks the audience 'Why?' and once she elicits examples with 'Like?' However, eleven of her questions require only yes/no or factual data as answers. Eleven other questions merely repeat what people have said or ask for clarification of their response. In this way, Winfrey constrains a sustained discussion of the issue, here society's complicity in the Holocaust and other atrocities.

A clear example of how Winfrey exercises control over the discussion occurs when she reinforces one woman's response to the novel because it suggests using the novel to explore our reactions to the Holocaust:

> Winfrey: So if it made you for the first time, after all that's been written about the Holocaust ...
> Woman #17 [self-identified German]: Yes.
> Winfrey: ... after the Academy Award ...
> Woman #17: Right. Right.
> Winfrey: ... and Schindler's – *Schindler's List*, after everything that's been written about the th –
> Woman #17: I didn't want to watch it. I didn't want to think about it.
> Winfrey: You didn't want to, right. But you pick up this book, that's what's beautiful about a great story.
> Woman #17: Right.
> Winfrey: ... is it makes you think about them as real people.
> Woman #17: Every line, especially in the second half of the book, makes me think about it. He questions, questions, questions. And I just spent hours really looking back and thinking about what I had not asked and what I need to ask.
> Winfrey: Well, there you have it. There you have it. My God! (7)

Certainly, this reflective reading strategy is not meant to produce better or more complex literary interpretations, but rather 'self-persuasion' in the sense of deeper self-knowledge about moral issues. Moreover, Winfrey continues to direct readers to engage these moral issues only

on the individual level, asking, 'isn't there a double standard? Now all of my friends with sons ... felt that it was abuse ... And I think – and in some European countries, there is a double-double standard in terms of the seduction of young males' (9–10). Readers follow, debating whether the relationship is wrong or not. One reader tries to bring up systemic issues, that boys seem to be 'groomed' for this, but Schlink thwarts discussion by simply stating that this morality question is only 'in American discussions' (10). Winfrey does not contradict him or pursue the reader's comment, as she is wont to do in other discussions if she agrees with the audience member. In this way, Winfrey discourages readers from debating either aesthetic grounds for literary judgment or a moral framework for arriving at a consensus or imaginative alternatives to the status quo. Instead, since she has excluded any theorizing potential, what follows is one individual response after another to the moral issue she has identified. Thus, while Winfrey's discussion admirably praises literature's ability to induce critical thinking about social issues, it does not fully model a discussion that encourages such thinking.

From here the discussion of *The Reader* dissolves into the moral question of why Schlink 'made' the boy fifteen (as if Schlink himself engaged in the affair), thus portraying an unhealthy relationship, until one reader brings up another moral question – what she would have done in the Holocaust. The segment ends with Winfrey: 'OK, if you were a Nazi, I'll let you answer when we come back' (13). After the commercial break, she refocuses the work of the club as individual responses to social issues: 'OK. We love books because they make you question yourself. For instance, what would you have done if you lived in Germany during the war, forced to take sides, forced into life and death dilemmas?' (13). Readers muse on what they might have done in Hitler's Germany, but Winfrey resists closure, stating, 'We don't know the answer to that question' and 'None of us really knows the answer to that question' (14). Once again, then, while she encourages reflection on the issue she has proposed, her relativism offers no moral or rhetorical framework for adjudicating these narratives, just solicitation after solicitation of 'What do you think?' However, she does provide an implicit means of answering the moral questions raised by *The Reader*: literacy.

In order to advocate for the importance of reading, Winfrey emphasizes the personal and social costs of illiteracy through her treatment of the novel. In *The Reader*, Hannah is on trial for war crimes during the Holocaust. Her young lover Michael, now grown, married, and a lawyer, attends the trial. Through the proceedings, he learns that Hannah is

illiterate. Central to the case is a report she 'wrote' that implicates her in war crimes. Admitting her illiteracy might have expunged her guilt or at least provided mitigating circumstances, but instead she chooses to hide her 'shameful' illiteracy. In their discussion of the novel, the audience debates whether she should have confessed her illiteracy and whether Michael should have informed the judge in order to save her. In an apparent *non sequitur,* Winfrey intervenes: 'But I did – and you're going to see in Remembering Your Spirit today, I mean, I – we deal with people all the time who live with the shame of not being able to read' (15). After people who are illiterate are 'outed' on a video segment, Winfrey argues 'it frees them' (15). When a reader tries to continue to debate the moral implications of the trial, Winfrey concludes discussion by simply agreeing, 'that would have been the best thing' (15). What follows is a series of exchanges between Schlink and Winfrey that more or less close down the debate because Winfrey has another agenda: 'OK, OK, OK, another question. When did you first know – when did you first know that she couldn't read?' (16). One reader resists Winfrey's tactic and attempts to pursue the moral debate, protesting vehemently ('as a black person') that illiteracy 'does not absolve you from losing your humanity' (16). However, Winfrey disallows the debate by focusing on the 'psychic energy' and 'the secret' of illiteracy.

Since she is constrained by the televisual genre, she focuses on the quick solution – praising individual growth through literacy – without a discussion of the cultural and economic variables of literacy acquisition. To promote her ideal reader, she features John, who agrees with her. John praises the book for its questions and for its being 'unsettling' (18). When Winfrey repeats, 'What would you have done?' (18), readers shade their answer with the previous discussion about literacy, illustrating they have learned from Winfrey's rhetoric. One reader, for example, admits that illiteracy may have affected Hannah's moral choice: 'And then the other part was not being able to read. I don't know what I'd ever do if I – I wasn't able to read because when I – I saw that she couldn't read, I just closed the book and I had tears in my eyes' (18). Another offers that 'being German,' she knows she would have followed orders because German children are 'brought up' 'following rules, not questioning' (19), implying that literacy is a necessary first step to 'reading' authority and questioning moral assumptions. After showing several people who admit they cannot read, Winfrey praises one as an 'inspiration for everybody who thinks they can't turn their life around or can't change. I can't imagine what it is to start to learn to read at 98'

(20). Since the moral and social costs of illiteracy are so great, Winfrey offers literacy as a means for women to participate fully in democratic (and moral and ethical) society. Clearly, then, Winfrey sees moral and social benefits in this version of literacy in which women readers use novels only as means of personal adjustment to endemic social ills. Since the framework in which she works, though, remains solidly relative and individualistic, the practices are not likely to lead directly to creative imaginings of political alternatives.

Beyond *The Reader*, Winfrey encourages this populist literacy through support systems and philanthropy, a valuable liberal-feminist approach that emphasizes working within social systems to improve equal access to social means of power.[8] For her 22 September 1997 anniversary show, Winfrey included both celebrity and noncelebrity guests who testify that Winfrey's support inspired reading: 'It's been 20 years since I read a novel'; 'I just want to tell you it's the first time I've read a book in about 12 years' ('Oprah's'). Foregrounding the social impact of her book club, Winfrey says:

> We got readers. We changed the face of the best-seller list. Troubled little girls from Ruth [*Book of Ruth*] to Delores [*She's Come Undone*] to Trudy [*Stones from the River*] were transformed to literary lions. You-all made it happen, and the book world took notice. In late summer, our humble book club got as big as life. Who knew? ... So to honor everybody who bought or checked out a book last year and to ring in our second year, we're having ourselves a book club anniversary party. Come on in and let's celebrate books! (2)

Note here that Winfrey emphasizes that 'troubled little girls' now get a share of popular reading attention. Here, she highlights the democratizing aspect of literacy for women who may be underrepresented in other reading communities and its role for subordinate groups as a means of achieving social success and full participation in existing social systems.

Conclusion

Clearly, Winfrey's original book club both realized and thwarted reading qualities and, subsequently, offered a limited view of women readers. On the one hand, her club popularized reading and literacy on a mass scale not previously possible and undoubtedly invited many reluctant readers to read more. Admirably, Winfrey's use of emotional

response revised the mainstream rhetorical proof to include emotive, personal experience, important qualities in responding to literature. In this sense, her show indicated the popularization of values and habits traditionally labelled feminine – a discourse made visible largely through second-wave feminist efforts but also by an electronic medium that by its nature exhibits characteristics traditionally labelled feminine. In addition, since she staged various, sometimes contradictory responses to literature, Winfrey highlighted reading as an active, constructive process, an important reading habit especially for less experienced readers. Alternatively, since Winfrey could only perform reading rhetorically on television, she emphasized only viewable reading properties. These included discussion and debate about people's reactions to novels staged in simplistic terms of solvable hermeneutic dilemmas. Furthermore, the televisual necessity of self-improvement that characterizes the talk show genre means that Winfrey emphasized limited parts of the texts, which often resulted in didactic, lesson-driven discussions focused on limited emotional responses. Thus, her emphasis naturally elided other valuable reading qualities, including critical thinking, concentrated observation of printed passages, and textual exegesis. In short, then, she celebrated debate, but did not model sustained dialogue and scrutiny of rhetorical appeals; she praised the importance of reading, but did not teach the critical skills necessary for engaging texts fully; she recognized the validity of individual experiences, but did not provide the rhetorical skills needed for adjudicating competing individual demands on social resources.

The gendered implications for the venue follow from these reading characteristics. Winfrey's ideal woman reader in the original club performed the traditional cultural work of nurturing family, sustaining emotional health, and encouraging literacy. While Winfrey's liberal-feminist work limits our recognition of alternative social structures as well as differences among women, she nevertheless adapted her rhetorical practice within a powerful medium to celebrate cultural work traditionally associated with women and to popularize social discourses related to gender, family structure, and child rearing. Unfortunately, since televised reading must focus on discussion and staged dilemmas, the woman reader modelled here reinforced social attitudes that women are more relational and emotional than men. Certainly, Winfrey's rhetorical reading strategies reinforced these qualities, valorizing important qualities that have been called feminine. However, since Winfrey aimed her practice at an audience of women, these gendered strate-

gies became normative, perpetuating stereotypes that women alone are emotional and responsible for interpersonal relationships.

In addition, Winfrey's book discussions tended to focus on inexperienced women readers, thereby construing women as less 'literate' and needing emotional and interpersonal 'support' for the difficult reading tasks at hand. Her appeal to nonreaders is also borne out in her show 'Oprah Goes On-Line,' whose premise is that Winfrey's gentle approach can reach computer neophytes intimidated by the technical complexity of the web. Since her network is dubbed 'Television for Women,' we again are faced with a woman writer similar to Winfrey's original book club woman reader who is inexperienced and less capable of navigating technological literacy than men. Certainly, feminist literacy work should seek to address all types of readers and writers, but Winfrey's media for women tend to paint us all as barely literate and daunted by technology, intellectual critique, and critical thinking. Subsequently, she offers little in the way of aesthetic, moral, or political frameworks – other than generalized self-help individualism – for helping women read the ideological claims in the narratives. Instead, Winfrey's mediated use of fiction as consciousness-raising – and her subsequent popularity – indicates that many feminist discourses have reached mainstream media and function now as entertainment. More troubling, however, is that Winfrey's use of these strategies and discourses indicates that many women still face low self-esteem, abusive relationships, and thwarted opportunities. In response to these systemic problems, her mediated club advocated little beyond individual adjustment. As bell hooks argues about Naomi Wolf's concept of 'power feminism,' Winfrey's club takes part in what hooks labels as a popular media trend that 'turns the movement away from politics back to a vision of individual self-help' (98). As such, her work cannot aim towards the rhetorical work of persuading people to certain political views or actions or even to the 'joy of feminist transformation' resulting from visionary and critical thinking (hooks 100).

Although Winfrey's original book club only simulated the barest outline of such work, it nevertheless made a cultural space accessible for women and fostered the realization of the power of narrative to work through complicated social issues. Further, her approach invited reluctant readers to read more novels about women's experiences and may have raised women's awareness that 'what were thought to be personal deficiencies and individual problems are common and shared, a result of their position as women' (Campbell 79). Since Winfrey encouraged women to read not for escape but for self-improvement, readers could

ultimately move beyond the club's simplistic gendered insights to more complex, critical imaginings about their role in social issues. In this way, Oprah's original book club laid the groundwork for further critical feminist theorizing by inviting readers to enter the conversation about how gender, class, power, and education intersect in the personal, social, and political discourses of their lives.

NOTES

1 For favourable assessments of Winfrey's feminist work, see Haag, Masciarotte, and Squire. For arguments about the limitations of that work, see Epstein and Steinberg, Nudelman, Peck, and Shattuc.

2 As of 21 April 2004 works in her new 'classics' book club included Steinbeck's *East of Eden*, Paton's *Cry, The Beloved Country*, Márquez's *One Hundred Years of Solitude*, and McCullers's *The Heart Is a Lonely Hunter.* While the rhetorical work accomplished in this new book club remains to be seen, the club does seem to extend reading practices beyond emotional responses and harnesses the electronic power of the Internet to animate printed text. Links from the Internet companion to Oprah's book club, such as 'How Do You Read It,' explain generic, literary, and historical features as well as critical reception and tips for twenty-first-century readers of classic texts. Even more delightful is Winfrey's use of visual rhetoric to celebrate, disseminate, and explain print texts, such as the link for *East of Eden* that features scenes of the countryside as words from the novel scroll across the screen and Oprah reads the text. Thus, rather than thwart print literacy, her electronic rhetoric seems simply to change some of our reading strategies and our relationships with texts.

3 I concentrate on her construal of an ideal woman reader within the context of American third-wave feminism. The episodes air both assent and disagreement to Winfrey's interpretations, producing a staged, collective interpretive drama for the audience. I do not claim that Winfrey's popularity indicates audience *assent* to all the disparate ideas presented on the show or in the novels, but rather the audience's high interest in the social problems treated. For a discussion of how these ideas function as epideictic rhetoric that is propaedeutic for political action, see Lamb. Social factors combine with the show's rhetorical constraints to shape potential meaning and audience reception of her performance.

 The case for a range of audience meanings is made persuasively by a variety of scholars; see especially Tompkins (122–4 and 147–50) and Radway, *Reading*

and 'Reading.' In addition, noted television critic John Fiske argues that 'negotiations of meaning' occur in audiences watching television (293); see also Fiske and Hartley. Analogous to Judith Fetterley's formulation of the resisting reader, Fiske notes that some readers are 'ideologically cooperative' and 'read "with" the structure of the text' while others go '"against" the text to deconstruct the dominant ideology' (297). For an argument about the rhetorical limits of possible audience constructions of meaning, see Celeste Condit's formulation of 'polyvalence,' whereby audiences agree on the meaning in texts but not on the value of that meaning. For ethnographic studies of how readers actually 'use' texts, see Simonds (self-help books), Radway (romance readers), Heide (television), and Shattuc (television talk shows). This valuable ethnographic approach would undoubtedly deepen our understanding of Winfrey's club. Following Mailloux, however, I provide here a rhetorical description of Winfrey's practice that is sensitive to cultural and political factors in order to argue for the potential meaning for her audience.

4 My discussion of consciousness-raising in the women's movement is indebted to histories of the movement by Alice Echols and Flora Davis, and to Anita Shreve's history of consciousness-raising.

5 For a fuller discussion of television's narrative argumentative mode, see Berlin (54), Jamieson (13), Shattuc (89), and Lamb (52–62) and (100–12).

6 Feminist and black literature scholar Barbara Christian decries the current academic propensity for philosophical theory that denies literature's relationship to the lives of human beings. This critical discourse, she argues, 'surfaced, interestingly enough, just when the literature of peoples of colour, of black women, of Latin Americans, of Africans began to move to "the center"' (151). Thus, in a way, Winfrey's celebration of authors' accomplishments contributes to Christian's call for affirming language 'as possible communication, and play with, or even affirmation of another' rather than the current academic cynicism about language's ability to communicate (150).

7 Her celebration of the accomplishments of African-American (Maya Angelou, Pearl Cleague, Morrison), Haitian-American (Edwidge Danticat), and German-American (Ursula Hegi) women writers contributes to the cultural work of revising racial and gendered stereotypes and encouraging a variety of stories – the ones of the authors' lives as well as the fictional ones they write.

8 For a discussion of types of American feminism, see Donovan. I locate Winfrey's political position on women's equality within the Enlightenment liberal feminist tradition traceable to Mary Wollstonecraft, Sarah Grimké, Elizabeth Cady Stanton, Susan B. Anthony, and NOW's mission that assumes women are rational, responsible agents who deserve equal legal and political protection (Donovan 1–25). More recent feminist work troubles the notion of legal

equality and suggests broader cultural changes than equal political and economic opportunity. For a discussion of how Winfrey's rhetoric draws on this more recent feminist work valorizing women's epistemology, see Lamb (112–47).

WORKS CITED

'Behind the Scenes at Oprah's Dinner Party.' *The Oprah Winfrey Show.* ABC. 3 December 1996 (Transcript).

'Book Club – Toni Morrison.' *The Oprah Winfrey Show.* ABC. 6 March 1998 (Transcript).

Burke, Kenneth. *The Philosophy of Literary Form: Studies in Symbolic Action.* 1941. 3rd ed. Berkeley: U of California P, 1973.

Campbell, Karlyn Kohrs. 'The Rhetoric of Women's Liberation: An Oxymoron.' *Quarterly Journal of Speech* 59 (1973): 74–86.

Christian, Barbara. 'The Race for Theory.' In *Contemporary Postcolonial Theory: A Reader,* ed. Padmini Mongia. London: Arnold, 1996.

Condit, Celeste. 'The Rhetorical Limits of Polysemy.' *Critical Studies in Mass Communication* 6 (1989): 103–22.

Davis, Flora. *Moving the Mountain: The Women's Movement in America Since 1960.* Urbana: U of Illinois P, 1999.

Dixon, Kathleen. 'The Dialogic Genres of Oprah Winfrey's "Crying Shame."' *Journal of Popular Culture* 35:2 (Fall 2001): 171–91.

Donovan, Josephine. *Feminist Theory: The Intellectual Traditions of American Feminism.* New York: Continuum, 1985.

Dow, Bonnie J. *Prime-Time Feminism: Television, Media Culture, and the Women's Movement Since 1970.* Philadelphia: U of Pennsylvania P, 1996.

Echols, Alice. *Daring To Be Bad: Radical Feminism in America, 1967–1975.* Minneapolis: U of Minnesota P, 1989.

Epstein, Debbie, and Deborah Steinberg. 'All Het Up! Rescuing Heterosexuality on the "Oprah Winfrey Show."' *Feminist Review* 54 (Autumn 1996): 88–115.

– '"American Dreamin": Discoursing Liberally on *The Oprah Winfrey Show.*' *Women's Studies International Forum* 21:1 (January/February 1998): 77–94.

– 'Hetero-sensibilities on "The Oprah Winfrey Show."' In *Gender and Society: Feminist Perspectives on the Past and Present,* eds. Mary Maynard, June Purvis, et al., 95–107. London: Taylor and Francis, 1995.

Fetterley, Judith. *The Resisting Reader: A Feminist Approach to American Fiction.* Bloomington: Indiana UP, 1978.

Fiske, John. 'British Cultural Studies and Television.' In *Channels of Discourse,*

Reassembled: Television and Contemporary Criticism, ed. Robert C. Allen, 284–323. Chapel Hill: U of North Carolina P, 1992.

Fiske, John, and John Hartley. *Reading Television.* New York: Methuen, 1978.

Friedan, Betty. *The Feminine Mystique.* New York: Dell, 1963.

Haag, Laurie L. 'Oprah Winfrey: The Construction of Intimacy in the Talk Show Setting.' *Journal of Popular Culture* 26:4 (Spring 1993): 115–21.

Hall, R. Mark. 'The 'Oprahfication' of Literacy: Reading 'Oprah's Book Club.'' *College English* 65:6 (July 2003): 646–67.

Heide, Margaret J. *Television Culture and Women's Lives:* thirtysomething *and the Contradictions of Gender.* Philadelphia: U of Pennsylvania P, 1995.

Hoffman, Alice. *Here on Earth.* New York: Putnam, 1997.

Hogeland, Lisa Maria. *Feminism and Its Fictions: The Consciousness-Raising Novel and the Women's Liberation Movement.* Philadelphia: U of Pennsylvania P, 1998.

hooks, bell. 'Dissident Heat: Fire with Fire.' In *Outlaw Culture: Resisting Representations,* 91–100. New York: Routledge, 1994.

'How'd They Do That?' *The Oprah Winfrey Show.* ABC. 18 November 1996 (Transcript).

Jamieson, Kathleen Hall. *Eloquence in an Electronic Age: The Transformation of Political Speechmaking.* New York: Oxford UP, 1988.

Lamb, Mary R. 'The Rhetoric of Feminism: Reading and Writing Women's Experience from Oprah to Composition Classrooms.' PhD diss., Texas Christian University, 2001.

Lazere, Donald. 'Literacy and Mass Media: The Political Implications.' In *Reading in America: Literature and Social History,* ed. Cathy N. Davidson, 285–303. Baltimore: Johns Hopkins UP, 1989.

Logan, Shirley Wilson. *'We Are Coming': The Persuasive Discourse of Nineteenth-Century Black Women.* Carbondale, IL: Southern Illinois UP, 1999.

Long, Elizabeth. 'Textual Interpretation as Collective Action.' In *The Ethnography of Reading,* ed. Jonathan Boyarin, 180–211. Berkeley: U of California P, 1992.

– 'Women, Reading, and Cultural Authority: Some Implications of the Audience Perspective in Cultural Studies.' *American Quarterly* 38 (Fall 1986): 591–612.

Mailloux, Steven. *Rhetorical Power.* Ithaca: Cornell UP, 1989.

Masciarotte, Gloria. 'C'Mon Girl: Oprah Winfrey and the Discourse of Feminine Talk.' *Genders* 11 (Fall 1991): 81–110.

'Newborn Quintuplets Come Home.' *The Oprah Winfrey Show.* ABC. 18 October 1996 (Transcript).

Nudelman, Franny. 'Beyond the Talking Cure: Listening to Female Testimony on *The Oprah Winfrey Show.*' In *Inventing the Psychological: Toward a Cultural*

History of Emotional Life in America, ed. Joel Pfister and Nancy Schnog, 297–315. New Haven: Yale UP, 1997.

'Oprah's Book Club.' *The Oprah Winfrey Show.* ABC. 9 April 1998 (Transcript).

'Oprah's Book Club.' *The Oprah Winfrey Show.* ABC. 31 March 1999 (Transcript).

'Oprah's Book Club.' *The Oprah Winfrey Show.* ABC. 25 September 1998 (Transcript).

'Oprah's Book Club Anniversary Party.' *The Oprah Winfrey Show.* ABC. 22 September 1997 (Transcript).

Peck, Janice. 'The Mediated Talking Cure: Therapeutic Framing of Autobiography in TV Talk Shows.' In *Getting a Life: Everyday Uses of Autobiography*, ed. Sidonie Smith and Julia Watson, 134–55. Minneapolis: U of Minneapolis P, 1996.

'Pregnant Women Who Use Drugs and Alcohol.' *The Oprah Winfrey Show.* ABC. 17 September 1996 (Transcript).

Radway, Janice. 'Reading Is Not Eating: Mass-Produced Literature and the Theoretical, Methodological, and Political Consequences of a Metaphor.' *Book Research Quarterly* 2:3 (Fall 1986): 7–29.

– *Reading the Romance: Women, Patriarchy, and Popular Literature.* Chapel Hill: U of North Carolina P, 1984.

Rapping, Elayne. *The Looking-Glass World of Nonfiction TV.* Boston: South End Press, 1987.

Redstockings. 'The Redstockings Manifesto.' In *Sisterhood is Powerful: An Anthology of Writings from the Women's Liberation Movement*, ed. Robin Morgan, 533–6. New York: Vintage, 1970.

Royster, Jacqueline Jones. *Traces of a Stream: Literacy and Social Change among African American Women.* Pittsburgh: U of Pittsburgh P, 2000.

Schlink, Bernhard. *The Reader.* Trans. Carol Brown Janeway. New York: Vintage, 1997.

Schweickart, Patrocinio P. 'Reading Ourselves: Toward a Feminist Theory of Reading.' In *Gender and Reading: Essays on Readers, Texts, and Contexts*, ed. Elizabeth A. Flynn and Patrocinio P. Schweickart, 31–62. Baltimore: Johns Hopkins UP, 1986.

Shattuc, Jane. *The Talking Cure: TV Talk Show and Women.* New York: Routledge, 1997.

Shreve, Anita. *Women Together, Women Alone: The Legacy of the Consciousness-Raising Movement.* New York: Viking, 1989.

Simonds, Wendy. *Women and Self-Help Culture: Reading between the Lines.* New Brunswick, NJ: Rutgers UP, 1992

Spigel, Lynn. 'Women's Work.' In *Television: The Critical View*, ed. Horace Newcomb, 19–45. New York: Oxford UP, 1994.

Squire, Corinne. 'Empowering Women? *The Oprah Winfrey Show.*' In *Feminist Television Criticism*, ed. Charlotte Brunsdon, Julie D'Acci, and Lynn Spigel, 98–113. New York: Oxford UP, 1997.

Tompkins, Jane. *Sensational Designs: The Cultural Work of American Fiction, 1790–1860.* New York: Oxford UP, 1985.

Young, John. 'Toni Morrison, Oprah Winfrey, and Postmodern Popular Audiences.' *African-American Review* 35:2 (Summer 2001): 180–205.

Afterword: Women Readers Revisited

KATE FLINT

In a poem written in the early 1830s, the young aristocrat George Howard (who was to become seventh Earl of Carlisle in 1848) addresses an absorbed woman reader:

> What is the book, abstracted damsel, say:
> The last new novel, or the last new play?
> Some tale of love, whose soft and melting tone
> Reveals its passion, and recalls thine own,
> Thy thoughts diverging as thou readest on ... (89)[1]

Is she, perhaps, escaping into Walter Scott, 'the wizard of our unenchanted age' (89)? Or 'does Cooper lure thee o'er the western deep/ Where red men prowl and boundless prairies sweep' (90)? Perhaps she is hooked by suspense, wondering if Bulwer Lytton's heroes will escape hanging; or she may be chilled by the gothic terrors of *The Mysteries of Udolpho*; or captivated by the romantic fortunes of Frances Burney's characters. A more earnest reader might be attracted by Maria Edgeworth's 'sober humour and serene advice' (91). Other women may be drawn to Lady Morgan's 'friskier pen' (91), or 'Brunton's high moral, Opie's deep-wrought grief' (91), or 'all perfect Austin' [*sic*] (91). The library tour of popular fictional choices concludes with some words of advice, delivered in an air of mock superiority:

> Yet still, whate'er the tale, fond maid take heed
> How seldom ill-assorted loves succeed;
> Mark well what crosses wait the trusting fair;
> List not too rashly to the suitor's prayer,

> Calm the wild tumult, probe the vain desire,
> And – more than all – don't set the bed on fire. (92)

This feeble rhyme of Howard's final couplet co-joins some of the most frequently expressed anxieties concerning the Victorian woman reader: that her imagination, even her expectations, may be stimulated in a way that is totally incompatible with her daily life; that she will become so distracted as to ignore the perils of her immediate environment (or, in other contexts, her duties); and – although I am not sure how far Howard intended the implication – that she will be dangerously sexually stimulated by the print she consumes.

Howard's views represent an orthodox position in relation to women readers in the nineteenth century, an anxiety about woman's use of her leisure time that, as several contributors to this volume attest, continued to be aired in the twentieth century. It is a position that, when researching *The Woman Reader 1837–1914*, I found reiterated time and time again – in creative writing, in advice manuals, in periodical articles, in medical handbooks, in memoirs. It was voiced by women as well as men; it represented an urgent desire not just to monitor behaviour, and the ingestion of ideas and attitudes and role models, but to wrest control over subjectivity. Yet at the same time, the practices of individual readers, so far as one can both gain access to, and trust, the autobiographical accounts of such consumers of print, suggest a very different story. Reading becomes an avenue for escape, for personal exploration and expansion, for the acquisition of knowledge: a means of enhancing one's sense of one's own identity and developing a consciousness of one's possibilities, both actual and imaginative. This continuous dialectic, between constraint and release, is one that is found many times over in the pages of this current collection. As these essays amply demonstrate, this dynamic is not one that disappeared with the nineteenth century, nor is it limited to a particular country or to specific class or racial groups. The icon of the woman reader – whether in the form of an actual image of an intensely absorbed subject, or invoked as a figure designed to prompt readerly identification within a text – is an enduring one.

This volume encompasses two centuries of American as well as British reading practices, and there is plenty of room for future studies to widen geographical boundaries still further. What – we might ask, for example – parallels and what contrasts are to be drawn between scenes of reading in post-colonial contexts and those within countries who

occupy a dominant power position? What ideas about femininity, propriety, and cultural authority are invested in the objections that the parents of the rebellious, anorexic Nyasha, in Tsitsi Dangarembga's *Nervous Conditions*, hold towards their daughter reading D.H. Lawrence's *Lady Chatterley's Lover*? "'I read those books at postgraduate level,' Maiguru [her mother] continued. "I know they are not suitable books for you to read"' (75). Set in Zimbabwe in the late 1960s, this novel, blending nationalist with familial issues, and hence continually interrogating the meaning of authority and literal or symbolic parenthood, traces no developmental model of enlightened attitudes towards reading passing down a maternal line. Maiguru's apparently thwarted intellectual ambitions have become sublimated into an acceptance of the viewpoints of her headmaster husband. Or what of the independent travelling, in her imagination, of Annie John, protagonist of Jamaica Kincaid's first autobiographical novel?

> My most frequent daydream now involved scenes of me living alone in Belgium, a place I had picked when I read in one of my books that Charlotte Brontë, the author of my favorite novel, *Jane Eyre*, had spent a year or so there. I had also picked it because I imagined that it would be a place my mother would find it difficult to travel to and so would have to write me letters addressed in this way:
>
> To: *Miss Annie Victoria John*
> *Somewhere,*
> *Belgium.* (92)

If homebound girls in Britain frequently borrowed their brothers' adventure books, or read works of travel, in order to stretch their mental surroundings and explore the exotic, what promise, if any, did the mundanity of Belgium (seen from an English perspective) hold out to the girl from Antigua? Or are national identities, whether or not filtered through an imperialist-oriented school syllabus, of less importance than the very fact of distance? What, indeed, do we know of reading patterns and their relation to regionalism, whether to Scottish, Welsh, and Irish identity in the British Isles or to the mixed cultural inheritance of the American Southwest?

To ask questions like these is to engage with the relationship between reading and place, in a broad sense: In what ways do texts travel? Does one read a book differently in a location away from its national or regional origin, or away from one's own home? How do these issues

intersect with the material history of the book and with patterns of publishing, distribution, and education?[2] More narrowly, we might ask: What difference does it make to one's reading process if one is consuming a volume in the privacy of one's own room or sharing the reading with others (as around, say, the Victorian fireside)? What difference does it make if one anticipates discussing and sharing what one has just been reading, whether with friends or family, in a reading group (and this volume draws our attention to the enduring power of the communal textual consumption and discussion that has taken place in these diversely formed organizations), or in school or university?

These are questions with implications both for our understanding of the relationship between individual subjectivity and the politics of the institution, and for what one might call the phenomenology of reading: the spatial positioning of the reading body. For if reading is dependent on the eye – and on occasion the ear – one should perhaps ask about the extent to which the immediate stimuli of sight or sound (or for that matter smell) interpenetrate the emotional and cerebral affects of the text. Whilst this is going to be conjectural at best, in terms of reconstructing historical reading moments, even reminding oneself of these variables is a way of opening up the most important fact of all when it comes to considering reading: the fact of its variability from person to person. To read a novel, or poem, or book of essays, or scientific study, or travelogue, or biography (and the variety of responses evoked by such heterogeneity should never be underestimated) is to engage not just with the contents, the rhetoric and the conventions of that particular work, but with the context in which one encounters it – a home, a snatched moment at work, the domed space of the old British Museum Reading Room. This context, in turn, is continually in the process of forming an individual's personal history, establishing the grounds of her emotional and cultural memory. Cultural memory, in this context, involves the accumulation and mental arrangement of not just someone's experiences, but of her projections and imaginary identifications, at once similar to those of others who have read the same texts, and uniquely filtered through, and simultaneously mediating, her own circumstances and desires.[3]

It is the nature of these desires, moreover, and the fact that reading opens up the possibility of exercising these desires in a safe and private space, that makes the activity potentially transgressive – as so many commentators anxiously noted in alarmist terms that it is dangerously easy to relish repeating in order to stress the difference between earlier

times and our own. It can be hard, retrospectively, to know quite how much weight to accord some of the more extravagant apprehensions about the corrupting power of texts. What, after all, might a commentator make, a hundred and fifty years from now, about the hysterical antagonism to Harry Potter and his fellow trainee witches that has been shown in some quarters? ('Not only do you NOT want to read these books to your children, you surely do NOT want Public School teachers assigning these books as required reading; but, Satan surely wants to condition your precious children to accept his values, his religion, and his world view' (Cutting Edge Ministries). But as Judy Blume – herself sometimes banned for what has been seen as the overrealism of her depiction of the angst and activities of teenage girls in her popular fiction – has put it in the National Coalition Against Censorship's newsletter, 'with Harry Potter, the perceived danger is fantasy.' This has always been the peg on which would-be normative social authorities have hung their fears: the possibility that a reader – a woman, a member of the working classes, one belonging to a presumed-inferior race, a child – might dare to dream to be otherwise.

To imagine being other than one is involves calling the frames of one's identity into question. Projecting oneself into a space beyond the one that one customarily occupies may very well entail the dismantling of one's borders of gender or race, of temporal period or age, of nationality or religion. It may be a radical gesture – and that is how we often wish to look at it, particularly if we are hypothesizing women of the past as constrained by their circumstances – but of course it may also be a very conservative one, dreaming after the apparent security or ease that comes with occupying a slot that is well rewarded and highly esteemed within a particular society. What remains true, however, is that reading allows one to recognize one's capacity for plurality.

Recognizing plurality, as I have been noting, is a crucial component of the analysis of reading practices. This volume is valuable, among many other reasons, for its repeated acknowledgment of the different motivations and desires that lie behind reading: self-improvement and education as well as escape, assertion of individuality, and a means of reaching out to others. Discussing books, moreover, helps to break down the distinction between speech and writing, and encourages one to explore the intersections of oral and written forms (as in the consideration of Zora Neale Hurston's autobiographical writing). At the same time, due weight is given to the fact that the *actual* effect on readers of a particular text may be other than that which was hoped for (*Uncle Tom's*

Cabin failed to promote the concerted political action of which Stowe dreamed, despite its powerful sentimental affect), or – and Ann Petry's *The Street* provides a fictional dramatization of this – reading may lead a woman to adopt unwieldy or inappropriate role models. The more detail one has of acts of reading, the harder it becomes to generalize, or, at the very least, the more cautious one has to be about one's generalizations. Yet the very diversity of examples discussed here shows that the fact of gender, however appropriated, or addressed, remains a constant in much discussion of the practice.

It is in attending to plurality that we find not just the direction of future research, but our own obligation to our contemporaries, and to future generations, to record and scrutinize our own reading histories. In his book *The Intellectual Life of the British Working Classes*, Jonathan Rose has demonstrated the wealth of information to be found in published and unpublished autobiographies concerning the sites and occasions of reading, and the availability and impact of texts, in the Victorian period and the early part of the twentieth century. He notes, however, how many more of the accounts from working-class people concerning their reading experiences are by men than by women, something that was strikingly apparent to me in researching *The Woman Reader*. Whilst the reasons for this are easy enough to establish, having to do not just with literacy patterns but with degrees of comfort in using the written word and with the backgrounds of those who believe their lives to have been worthy of record, the fact is nonetheless somewhat frustrating, even if mitigated by the number of upper-middle-class women, in particular, who left accounts of their childhood and adolescent – but far less often adult – reading habits. The fact remained, however, that it was in my own reading of autobiographical accounts, from whatever quarter, that I felt that I was coming closest to what it was like to have been a Victorian woman reader (if you like, I was continually imagining myself into a range of Victorian reading positions). Necessarily I was aware of the pitfalls of autobiography as evidence: the fact that each individual is framing herself, rewriting her life, for an audience sometimes of family (many Victorian women's autobiographies are specifically penned for daughters to read), sometimes of unknown strangers, and almost certainly, at some level, for herself. But whatever the absolute veracity or otherwise of the experiences recounted, two things came across very strongly indeed: the extraordinary variety of reading material consumed by women – often reading two or three very different sorts of books simultaneously – and the danger of generalizing

about women readers from the extraordinary variety of responses, patterns of identification, and stimuli to action that were recounted. As more than one reviewer quite rightly pointed out, in stressing this plurality I effectively undermined the unifying principle suggested by my own title, *The Woman Reader.*

Because I acknowledged how imaginatively stimulating, as well as informative, such autobiographical accounts could be, giving an accumulation of what would be termed in anthropology 'thick description,' I initially wanted to preface my study with an account of my own reading history. Whilst, with the recent autobiographical turn in academic prose, there would not nowadays be anything particularly unusual in this, I was certainly dissuaded from such personalized rhetoric by my publisher. As it is, only a trace remains in the Preface, where I describe how the impetus behind the book came out of my editing Anthony Trollope's *Can You Forgive Her?* for Oxford University Press's World's Classics series, and my deliberations around Trollope's purposefully provocative title. It seemed to me that the question would inevitably be a very different one for women and for men in 1864–5, given the lack of parity in gender expectations, and, indeed, a possible difference in expectations about how both women and men would respond to what they read. Researching the context for this novel, I discovered that Trollope had himself written on the topic of gendered reading difference in two lectures that he delivered shortly after writing *Can You Forgive Her?*, 'The Higher Education of Women' (1868), and 'On English Prose Fiction as a Rational Amusement' (1870). The book, I maintained, took off from there.

But of course the story went much further back. I find it hard to imagine that I would have been so strongly drawn as I was to the topic of woman as reader if I had not already possessed a powerful awareness of the importance of reading not just to the directions that my own intellectual history had taken, but to the very formation of my sense of self, and to the role that books played in this. Belatedly, therefore, I offer what I *might* have said by way of preface to *The Woman Reader,* and in doing so, offer an illustration of how any one person's reading history may be seen to be both of its time and sharply individualized, hence confirming the insight that I arrived at by the end of my book – and one reiterated several times in this current volume – that reading's function is one that is both communal, forging an identity with others, and extremely personal.

My very early reading probably differed little from that of other

English children in the 1950s who were born into families where their parents valued and enjoyed books, and where books formed an easily accessible part of the furnishings of the home. On my first birthday, I was given a copy of Hans Andersen's fairy tales, inscribed to me and bearing the legend 'Her first birthday. Her first book.' I was never officially taught to read, but my mother read aloud to me, following under each word with her finger, and I picked up the practice easily enough – certainly before I was three, I had been found reading out loud from the *Times* and I had been enrolled in the junior branch of Wimbledon Public Library. The first book I borrowed – and the first book I can remember reading for myself – was Phyllis Krasilovsky's *The Cow Who Fell in the Canal*. During the summer of my fourth year – my birthday falls in February – I remember enjoying *Winnie the Pooh* (given me to keep me quiet on a long car journey: I sat in the back of the Triumph Mayflower as we drove from London to North Wales and became familiar with Tigger and Eeyore and Wol) and Alison Uttley's Little Grey Rabbit books. Thinking back to all of these, I can remember the pictures, but not the stories: for all that these were books, perhaps my visual sense was being as strongly formed as my literary one. One thing is certain: I have no sense of anything being gendered in its appeal, or in its effects, at this time. My patterns of identification were with animals rather than humans, and crossed the heavily demarcated gender boundaries of the Uttley books in particular with no difficulty whatsoever.

Then, when I was three and a half, everything changed completely. We moved from suburban London to the north of Cumberland – now Cumbria – just south of Hadrian's Wall, to the wild border country east of Carlisle. My father had a job working on Spadeadam range, on the site where the Blue Streak rocket was being constructed (Britain's ill-fated contribution to the space race). My parents looked for somewhere suitable to rent: first a room in a farmhouse, which still was lit by gas lamps and where the two witch-like women who owned it tossed surplus chicks onto the fire; then a dreary semi-detached modern house on the edge of a small village, which had the novelty, to me, of television; and, finally, Morpeth Tower, in Naworth Castle, which dated back to the fifteenth century. This was one of four solid towers built around a central courtyard, with a Victorian addition round the back, perched on the edge of a ravine and surrounded by woods and moorland. It was an extraordinary privilege to spend four years of my childhood there. It was also extremely isolated. At times, there were other children living in rented accommodation in the castle, but only spasmodically. The near-

est school, several miles away, consisted of only one class – and in any case, I was not old enough, when we arrived, to attend it. My mother taught me from the educational programs broadcast by the BBC, ranging from 'Stories in World History' to 'Singing Together,' and from a small number of Beacon readers, activity books, italic handwriting manuals, and 'B & A Arithmetic.' She also subscribed to a magazine called *Child Education*, although the only item of lasting value that I remember this supplying was a fail-safe recipe for scones.

Reading, it need hardly be said, became extraordinarily important to me, and, since I had no other children to play with, was central in forming my sense of contact with the world. We lacked a television – although 'Childrens' Hour' on the BBC's Home Service was a daily treat – and so my experience of living in books was somewhat atypical of that of many children in the late fifties and early sixties. Books were given to me as Christmas presents or bought with book tokens, and I built up a good collection of Puffins; they were taken from my parents' shelves and borrowed from Carlisle Public Library. A library van used to call weekly, pulling up in the outer courtyard of the castle, and one could request books through this. On rare but memorable occasions, my mother and I would walk half a mile up the castle drive and catch the bus twelve miles into Carlisle, and go to the library itself, its shelves full of promise: above all, I remember the shelves of rather dated children's encyclopaedias and anthologies, whose appeal lay in the very sense of diverse knowledge that they contained – the lure of hard facts, of some kind of mastery. There were neighbours, too, in the castle: Miss Donaldson-Hudson, who had a copy of Enid Blyton's *The Castle of Adventure* that I earnestly commended to my parents as being of far higher literary quality than the Blyton fiction aimed at younger children; Mrs Wright Brown, who had a copy of Thor Heyerdahl's *Aku-Aku*, which I read end to end twice over, fascinated not just by the otherness of the lives of Easter Islanders (what I made of their phallic worship I cannot begin to think) but by the fact that their lifestyle, complete with rituals, was one that appeared simple, with elements that a six year old could very readily imagine emulating.

Above all, it was through books that I tried to learn to be a child, or, rather, to learn what it meant to be a child. I was fascinated by a book called *The Intelligent Parents' Manual* – which my own parents must have bought as a how-to book when I was expected – and which took one through, chapter by chapter, stages of pregnancy, birth, babyhood, the early years of childhood, and on into adolescence (at which point its

subjects became too remote from any experience that I could ever imagine myself partaking in, and hence boring).[4] What particularly appealed to me were the little vignettes of childhood tantrums, of sandpit jealousy, of bedwetting and obstinacy. Whilst I knew that I wasn't *like* these children, they were, nonetheless, my proxy peers. Peter and Iona Opie's *The Lore and Language of Schoolchildren* – which I think my mother borrowed from the library, initially, but which I soon fixed upon – likewise greatly broadened my imagined sense of the world of children that existed, somewhere, out there. But what I really enjoyed was what I took to be realist fiction. Although I read books like *Alice in Wonderland, The Lion, the Witch and the Wardrobe,* and *The Hobbit,* fantasy held little appeal when there was another, more immediate world that was almost as inaccessible to me, except through books and the radio. So my sense of who I wanted to be like was formed by Arthur Ransome's *Swallows and Amazons* books, about two families of children in the English Lake District; by *The Adventures of Tom Sawyer;* and by a series of stories by Anthony Buckeridge, set in a boys' prep school (in English terms, this means a boarding school for boys between seven to eleven) and beginning with *Jennings Goes to School.* If Jennings, Darbishire, and Venables in these books built a hut, I built a hut. If they started a newspaper, I started a newspaper. By the time I was nearly seven, and knew that we would be moving back to London, I used them to prepare me for what school would be like. Borrowing my father's old Latin primers, I dutifully learnt my declensions and conjugations – the serious academic currency at Linbury Court, where Jennings and his friends were at school. It was a shattering disappointment when, at the first day at my junior school, I had to make a tissue paper fairy.

What is notable about all these books is that their protagonists were either boys or, in the case of Ransome's more interesting female characters, Nancy and Peggy Blackett, unequivocally rebellious tomboys. Most girls' fiction simply did not interest me: it was sissy, unadventurous, overfilled with piety (if written in the past), or girls were relegated to a supporting position: plucky, perhaps, but nonetheless less prominent than the male leads (and often narrators), whether in E. Nesbit's *The Story of the Treasure Seekers* or Marjorie Lloyd's *Fell Farm Campers.* When researching *The Woman Reader,* I was hardly surprised to find how many girls in the nineteenth century openly preferred their brothers' books, with the active role models that they offered. I can remember encountering very few factual accounts of contemporary female role models either. The autobiographies of the show-jumper Pat Smythe – *Jump for Joy* and *One*

Jump Ahead – provided one exception, as did that of the three-day even-
ter Sheila Wilcox and the show-jumper and motor rally driver Pat Moss:
what is unclear, retrospectively, is whether I was drawn to all of these
because they contained horses or because the equine world was one in
which women were permitted to be successful and that carried an attrac-
tive energy, competitiveness, and physicality with it. Certainly pony sto-
ries, which I read hungrily – Ruby Ferguson's *Jill's Gymkhana* and its
successors; the novels by Josephine, Diana, and Christine Pullein-
Thompson – offered not just lively, enterprising, and resourceful girls at
their centre, but a world of specialist knowledge in which one could
become authoritative. And they offered the possibility of identifying
with some spirited horses, too.

Yet apart from a drive towards mimetic realism, which very possibly
drew me towards the nineteenth century and towards fiction in particu-
lar, can I see any continuity between my early reading and my subsequent
academic interests? Not easily – and yet there is a definite connection
between these interests and the surroundings in which I spent four years
of my childhood. Living in a castle certainly established an interest in his-
tory: perhaps, indeed, the very fact of its being a castle had a debunking
effect when it came to fairy tale, since there could be little of the distant
and magical for me in the *idea* of a castle. But much more than that,
Naworth Castle, seat of the earls of Carlisle, had been the home of
George Howard, ninth earl (and nephew of the author with whom I
opened): a painter and friend of artists and writers. So I was familiar with
the photograph of Tennyson on a seat in the walled garden where I used
to play; with carved friezes by Burne-Jones; pre-Raphaelite windows in
the local parish church. It was said that the great carved wooden fish –
the Crowned Salmon of Dacre – under whose fins I used to go in and out
of our front door daily, was the original for the Fish Footman in Tenniel's
illustrations to *Alice's Adventures in Wonderland*. Working on the nine-
teenth and early twentieth centuries, periodically encountering the
name of the ninth earl; or the name of his wife Rosalind, who was
extremely active in feminist issues; or, indeed, the name of the seventh
earl, who chaired the banquet of the Metropolitan Sanitary Association
at which Dickens warned the audience against overcomplacency at the
time of the Great Exhibition in 1851, I experience occasional small
shocks of familiarity, somewhere between serendipity and coming home.
And serendipity, of course, led me to the poem on women readers with
which I opened. I ordered up the volume earlier this year, compelled by
curiosity and nostalgia after seeing it in a library catalogue. The nostalgia

was fed by Howard's poem to the jasmine bush that grew on the front steps leading up to the Great Hall at Naworth; the connection with my research – and hence the renewal of the sense that there is some hidden plot underpinning at least the early trajectory of my academic interests – is obvious enough. More objectively, one could point out that these apparent coincidences serve to show very well the interpenetration of different strands of Victorian culture.

The lesson to be extracted from my own reading history – and, doubtless, from the reading history of each one of us – does, therefore, very much follow the lines of *The Woman Reader* and of very many of the essays in this volume. The history of women's reading is made up of the conjunction of individual, circumstantial detail and of broader factors: the availability and distribution of texts, the dominant and counter-hegemonic ideological currents of a period. If some broad outlines concerning the last two centuries have, by now, been laid down with respect to both sides of the Atlantic, much detailed work remains to be done to see how reading helps to develop and inflect identities. 'What genre are you if you were literature,' asks second-generation beat poet Anne Waldman. 'If you were a formal composition./If you were a constitution./If you were a priest. What gender are you?/If you were a scholar what kind of a book would you be?' (81). The process of absorption and ingestion and formation that reading can involve is like a Mobius strip: one takes one's expectations and desires to what one reads; one temporarily may inhabit its covers, and in turn it shapes one's being, one's attitudes. But just as genres may be jumbled together on a bookshelf, on a bedside table, in a reading journal, so may one's identity – including one's sense of a gendered self – become, through reading, mutable, temporarily destabilized. Research on reading – as this volume shows – provides more than a record of cultural practices and preferences: it encourages us to examine the very concept of identity itself.

NOTES

1 Howard's sisters date the poem to c. 1833 or 1834.
2 I address some of these questions in my piece in *Il romanzo*, a comprehensive history of the novel, edited by Franco Moretti.
3 The literature concerning cultural and collective memory is a growing one: although she does not engage directly with the part that reading might play in the establishment of such memory, my own thinking on the matter is particu-

larly stimulated by Svetlana Boym, *The Future of Nostalgia*, especially Part 1, 'Hypochondria of the Heart: Nostalgia, History and Memory.'

4 I now find that I wasn't learning to be an English child, but an American child: Florence B. Powdermaker and Louise Ireland Grimes's *The Intelligent Parents' Manual: A Practical Guide to the Problems of Childhood and Adolescence* (Harmondsworth: Penguin, 1953) was first published in the United States in 1944 as *Children in the Family*.

WORKS CITED

Blume, Judy. 'Is Harry Potter Evil?' *National Coalition against Censorship Newsletter* 76 (Winter 1999–2000). 17 September 2001. http://www.ncac.org/ cen_news/ cn76harrypotter.html.

Boym, Svetlana. *The Future of Nostalgia*. New York: Basic Books, 2001.

Cutting Edge Ministries. 'Harry Potter Books – Another Superb Reason to Pull Your Precious Children Out of Public Schools.' 17 September 2001. http://www.cuttingedge.org/ news/n1377.cfm.

Dangarembga, Tsitsi. *Nervous Conditions*. London: Woman's P, 1988.

Flint, Kate. 'Librio in viaggio: Diffusione, consumo e romanzo nell' Ottocento.' In *Il romanzo I. La cultura del romanzo*, ed. Franco Moretti, 537–66. Torino: ITA: Einaudi, 2001.

– *The Woman Reader 1837–1914*. Oxford: Clarendon P, 1993.

Howard, George. 'The Lady and the Novel.' In *Poems by George Howard, Earl of Carlisle*. London: E. Moxon, 1869.

Kincaid, Jamaica. *Annie John*. London: Picador, 1985.

Rose, Jonathan. *The Intellectual Life of the British Working Classes*. New Haven: Yale UP, 2001.

Trollope, Anthony. *Four Lectures*. Ed. Morris L. Parrish. London: Constable, 1938.

Waldman, Anne. 'My Life a Book.' In *A Book of the Book: Some Works and Projections about the Book & Writing*, ed. Jerome Rothenberg and Steven Clay, 80–3. New York: Granary Books, 2000.

Contributors

Suzanne Ashworth is an assistant professor at Otterbein College in Westerville, Ohio, where she teaches early American literature, women's literature, and queer studies. Her research interests include the history of reading, pop culture and media studies, and the history of medicine. Her work has been published in *ESQ, Nineteenth-Century Contexts*, and *Legacy*.

Janet Badia is an assistant professor of twentieth-century American literature at Marshall University in Huntington, West Virginia. She is currently completing a book manuscript entitled 'Confessional Poetics, Women Readers, and the Politics of Reception.' Excerpts from this project are included in *Reading Women, a/b: Auto/Biography Studies* and in a forthcoming collection of essays on Sylvia Plath. In addition to their work together on *Reading Women*, she and Jennifer Phegley have co-written several conference papers on women faculty in academia.

Michele Crescenzo is an assistant professor of English at Mississippi Valley State University in Itta Bena, Mississippi.

Elizabeth Fekete Trubey is a lecturer in English and a college adviser at Northwestern University, where she completed her PhD in 2001. Her dissertation, '"I Felt Like the Girls in Books": Sentimental Readership in America, 1850–1870,' focuses on the relationship between sentimental readership and nineteenth-century ideals of femininity. Her current research focuses on the complexities of sentimental discourse in the South in the years surrounding the Civil War. She has published articles on *The Wide, Wide World* and on *St. Elmo*.

Kate Flint is professor of English at Rutgers University. As well as *The Woman*

Reader 1837–1914 (1993) and *The Victorians and the Visual Imagination* (2000), she has published widely on Victorian and modernist literature and cultural and visual history. She is currently completing *The Transatlantic Indian, 1776–1930*.

Barbara Hochman is associate professor of American literature at Ben Gurion University in Israel. She has published widely in nineteenth-century American fiction. Her most recent book is *Getting at the Author: Reimaging Books and Reading in the Age of American Realism* (2001). Her current project, 'Uncle Tom's Cabin and the Reading Revolution,' explores the relation between fiction and reading practices in the nineteenth-century United States.

Ruth Hoberman is a professor of English at Eastern Illinois University. She is the author of *Modernizing Lives: Experiments in English Biography 1918–1939* (1987) and *Gendering Classicism: The Ancient World in Twentieth Century Women's Historical Fiction* (1997). She is a co-editor, with Kathryn N. Benzel, of *Trespassing Boundaries: Virginia Woolf's Short Fiction* (2004). Her most recent work involves the interrelationship of museums, commodification, and literary modernism; essays on these topics have appeared in *Victorian Literature and Culture, Feminist Studies*, and *Victorian Periodicals Review*.

Mary R. Lamb teaches writing and rhetoric courses at Georgia State University, where she also serves as associate director of Lower Division Studies. Her research includes feminist rhetoric and composition; rhetorical studies, especially feminist and new media; writing program administration; and teacher training.

Antonia Losano teaches nineteenth-century literature and women's studies at Middlebury College in Vermont. She is currently finishing a book on representations of women painters in the works of Victorian women writers.

Jennifer Phegley is associate professor of nineteenth-century literature at the University of Missouri–Kansas City. She is the author of *Educating the Proper Woman Reader: Victorian Family Literary Magazines and the Cultural Health of the Nation* (2004).

Currently affiliated with Yale University, **Tuire Valkeakari** holds a PhD in English from the University of Helsinki, Finland. Her areas of expertise include American literature and the anglophone literatures of the Black Atlantic. Her articles have appeared in *Crossings, The Atlantic Literary Review, The Nordic Journal of English Studies*, and in Finnish publications.

Sarah A. Wadsworth is assistant professor of English at Marquette University. She specializes in nineteenth-century American literature and early American print culture. Her research on Alcott has also appeared in *The Lion and the Unicorn* and *Harvard Library Bulletin* and figures prominently in a book she is currently preparing for the University of Massachusetts Press.

STUDIES IN BOOK AND PRINT CULTURE

General editor: Leslie Howsam